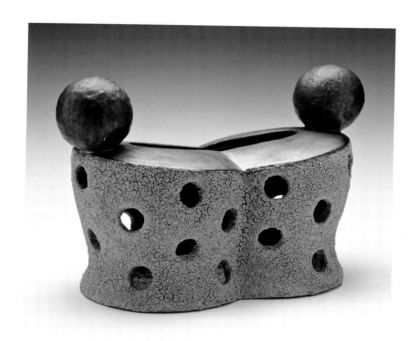

GLAZE

The Ultimate Ceramic Artist's Guide
to Glaze and Color

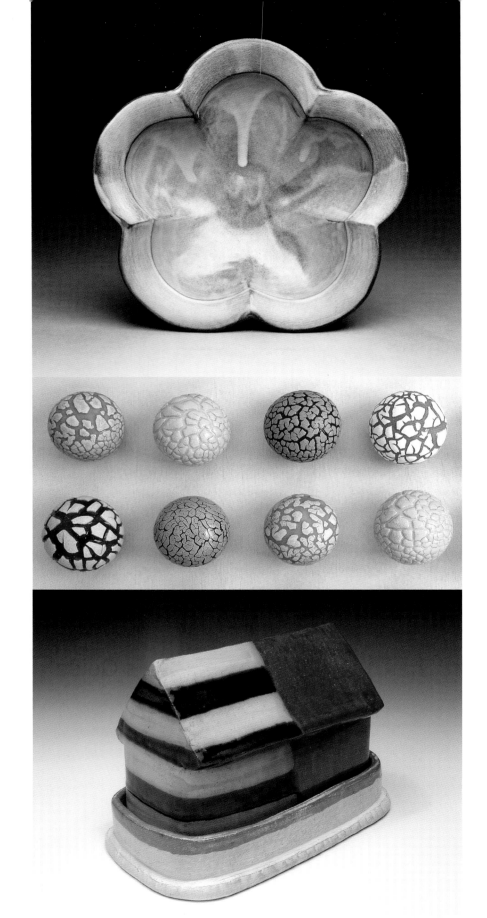

GLAZE

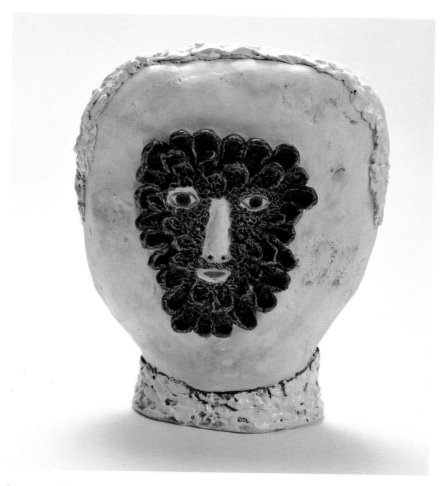

The Ultimate Ceramic Artist's Guide
to Glaze and Color

Brian Taylor and Kate Doody

BARRON'S

A QUARTO BOOK

First edition for the United States and
Canada published in 2014 by Barron's
Educational Series, Inc.

All inquiries should be addressed to:
Barron's Educational Series, Inc.
250 Wireless Boulevard
Hauppauge, NY 11788
www.barronseduc.com

ISBN: 978-0-7641-6642-6
Library of Congress Control No:
2014942859

Conceived, designed, and produced by
Quarto Publishing plc
The Old Brewery, 6 Blundell Street
London N76BH

QUAR.GCWB

Project editor: Lily de Gatacre
Art editor and designer: Jackie Palmer
Copy editor: Liz Jones
Picture researcher: Sarah Bell
Proofreader: Sarah Hoggett
Illustrator: Kuo Kang Chen
Indexer: Helen Snaith

Art director: Caroline Guest
Creative director: Moira Clinch
Publisher: Paul Carslake

Color separation in Singapore by
Pica Digital Pte Limited
Printed in China by
Hung Hing Printing Group Ltd

9 8 7 6 5 4 3 2 1

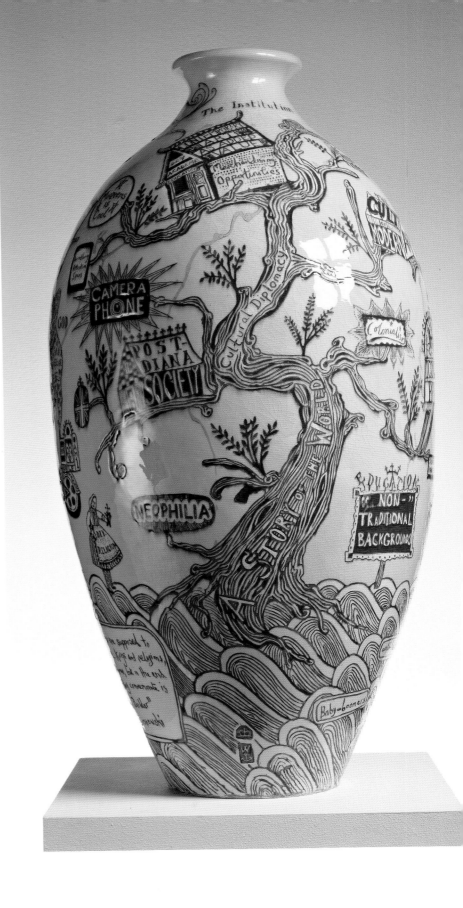

CONTENTS

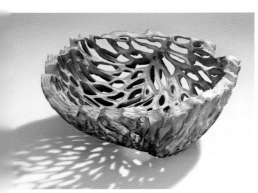

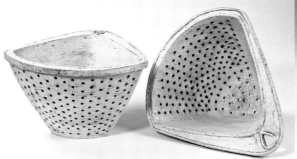

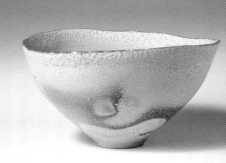

FOREWORD

We were the kids always doodling in the margins of our textbooks; and from a young age, we both knew we wanted to be artists. After separately finding and falling in love with clay, we found each other in 2005 as co-workers at the world-renowned Watershed Center for the Ceramic Arts. From then on, a number of exciting collaborations have taken place. When the opportunity to write a book about glaze and color arose, we could think of no other way than to work on it together, each of us bringing a distinct skill set and unique perspective to the pages within.

We both came to ceramics for its seductive malleability, the endlessly engaging processes, and the inspiring and camaraderie-filled community. Through the course of our respective artistic developments, color has emerged as an essential component in both of our works. The role of color on the psyche, how it incites sensorial enlightenment, and how it can be manipulated to affect our sense of taste and pleasure, and ultimately frame our experience, has guided our artwork in distinct ways. As teachers, we have relished the task of unpacking the mysteries of ceramic chemistry through testing and experimenting with our students. Within each course, new discoveries are made, deepening both our understanding of these complex and magnificent materials, and also our appreciation for their potential. We have strived to bring both our personal affinity for the power of color in ceramics and the breadth of our technical knowledge to the content of this book in order to create a comprehensive guide to glaze and color.

Color in glaze is lauded in this book for its dynamic conceptual associations, its indelible emotive mark on a work, and its ability to be harnessed by some of the most talented artists in the field to create unique and powerful pieces of art. We've curated artists along the spectrum of colors as opposed to any technical facet like firing temperature, atmosphere type, or glaze genre, in order to open up new perspectives on color and glaze. The directory of artists contains some of the most exciting artists in the field today, working in a wide range of formats and finishing techniques. With the surface of each piece in this book being quite particular to the artist's materials, firings, and touch, the recipes and technical information they've offered can be used to give perspective and insight to their process and concept, acting as an in-depth and ideal springboard for your own explorations. Chapters on color theory and the history of color in ceramics, as well as the thorough chapters on understanding ceramic materials and how to make and test glazes, complement the impressive directory. These informative sections give readers the information and technical knowledge they need to apply their ideas in practice. Designed to be useful and inspiring to beginners, students, enthusiasts, and experts alike, we hope that this book finds an integral place in your home and studio!

Kate Doody and Brian Taylor

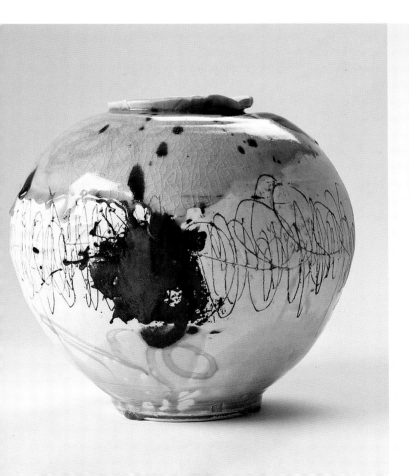

ABOUT THIS BOOK

This book is organized into four chapters, core information on the glazing process and the esthetics of color are contained in the beginning part, and the heart of the book is a directory of 100 ceramicists.

CHAPTER ONE:
UNDERSTANDING GLAZES, PAGES 10–41
Enter the world of ceramic glazes with this thorough introduction. Learn about the history of glaze, how heat is measured, materials you will encounter when working with glazes, glaze defects and remedies, and how to stay safe when working with toxic materials.

CHAPTER TWO:
COLOR, PAGES 42–67
Color is a key concept in the world of ceramics. Here you'll gain an understanding of the history of color in ceramics and the development of color wheels. Then eight individual colors are examined in relation to their use in ceramic glazes.

CHAPTER THREE:
MAKING AND TESTING GLAZES, PAGES 68–99
This chapter contains a wealth of practical knowledge to help bring your ideas to life in the studio. Discover how to understand recipes and how to test, mix, and apply your glazes. Finally, learn how to break the mold and try something new, and move beyond traditional glaze use.

CHAPTER FOUR:
DIRECTORY, PAGES 100–301
The heart of this book is the Directory, where 100 of the leading ceramicists working today have contributed their works and discuss their inspiration, their technical processes, and the unique way that they use glaze and color in their work. Glaze outcomes and results are subject to countless variables and the recipes that have been provided by the artists should be seen as a starting point for your own recipes, rather than instructions with a guaranteed outcome. Alteration, experimentation, and testing are crucial in glaze work, and these recipes will provide insight and inspiration for you to begin to experiment and develop your own, unique glaze palette.

Please note that lead and other toxic materials have been used in some recipes. These should be handled with extreme care. Please follow safety guidelines for all materials you use. See pages 36–41 for information on Health and Safety.

Sometimes the artist has added a credit for the provenance of the recipe, or provided additional information on firing temperatures, recipe ingredients, or special safety precautions.

The recommended firing range/cone temperature for the product or recipe is given. The Technical Description and captions will provide the *actual* cone temperature used in the firing of this piece.

In the case of commercial products, specific product details have been identified where possible.

GLAZE AND PAINT DETAILS

HENSLEY CLEAR GLAZE (REVISED), *cone 10*
This recipe is from Kurt Heiser

F-4 feldspar	37.2
Gerstley borate	12.1
Barium carbonate	4.7
Whiting	7.9
Silica	27.0
Grolleg kaolin	9.3
Frit 3110	1.9
+ Tin oxide	1.0

RYNNE CHINA PAINTS, *cone 017*
China paints in the following colors are mixed with Jane Marcks "magic medium" oil:

Best Black
Cherry Red mixed with Cardinal Red
Bright Orange
Lemon Yellow mixed with Moss Green

Recipes are presented as provided by the artist. Generally the ingredients will add up to 100%, with any additions represented by a "+" sign. In some places, the artist has rounded percentages up or down to simplify the recipe, so the total will not always be 100.00.

Here you'll find information on the ceramicist's artistic philosophy and the background to his or her work.

The Directory is ordered along the color spectrum, by the dominant color in the piece. This is not necessarily the color of the glaze.

Sam Chung

Originally inspired by graphic examples of cloud motifs in Korean art, Sam Chung's exuberant functional wheel-thrown forms gracefully fuse with billowing cumulous shapes. Each piece presents a unique, albeit unanimously playful, feeling, with color leading the charge in drawing out an emotional intensity. The saturated and uniformly bright fields of color help flatten the shapes, with sharp black outlines adding a two-dimensional language that contrasts with the voluminous forms.

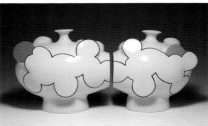

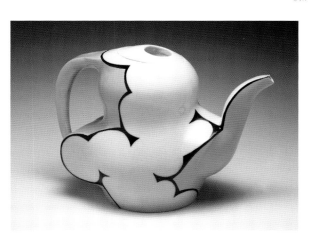

Cloud Vase *14 × 8 × 8 in. (35.5 × 20 × 20 cm), wheel-thrown, altered porcelain, clear glaze fired to cone 10. China painted with 3–5 applications and firings to cone 017. SEE GLAZE AND PAINT DETAILS, BELOW.*

Cloud Bottles *10 × 22 × 7½ in. (25 × 56 × 19 cm), wheel-thrown, altered porcelain, clear glaze fired to cone 10. China painted with 3–5 applications and firings to cone 017. SEE GLAZE AND PAINT DETAILS, LEFT.*

Cloud Teapot *7 × 9 × 5 in. (18 × 23 × 13 cm), wheel-thrown, altered porcelain, clear glaze fired to cone 10. China painted with 3–5 applications and firings to cone 017. SEE GLAZE AND PAINT DETAILS, LEFT.*

Technical Description

After bisque firing, Chung's porcelain pieces are dipped in clear glaze mixed to the consistency of whole milk. Fired to cone 10 with light reduction, the porcelain takes on a cool white hue, as opposed to the warm whites produced in oxidation. The colored china paints are mixed into an oil medium and carefully applied with a fine sponge in one layer and then the piece is fired quickly to cone 017. Second, third, and fourth layers, each followed by firing, are done as needed to achieve a consistent opaque coat. (If applied too thickly at once, the surface appears textured.) The black linework is applied carefully with a fine liner brush once the colors are finished. Chung notes that he fires the china paints with the lid propped open by ½ in. (1.3 cm) to allow for fumes from the oil medium to escape the kiln.

● *Black is used to outline the clouds, referencing the graphic examples that inspired the work.*

● *Each color adds distinct emotional content.*

● *Solid, opaque color flattens the form.*

 GLAZE AND PAINT DETAILS	**HENSLEY CLEAR GLAZE (REVISED), cone 10** *This recipe is from Kurt Heiser.*		**RYNNE CHINA PAINTS, cone 017** *China paints in the following colors are mixed with Jane Marcks "magic medium" oil:*
	F-4 feldspar	37.2	
	Gerstley borate	12.1	Best Black
	Barium carbonate	4.7	Cherry Red mixed
	Whiting	7.9	with Cardinal Red
	Silica	27.0	Bright Orange
	Grolleg kaolin	9.3	Lemon Yellow mixed
	Frit 3110	1.9	with Moss Green
	+ Tin oxide	1.0	

This panel identifies the main surface and finishing techniques used by the artist.

Technical processes, material choices, and firings are explained here. Where the details provided are specific to only one piece, the piece is indicated with an arrow.

Color chips highlight the dominant colors of the artist's main piece, and the effect of his or her color choices is discussed.

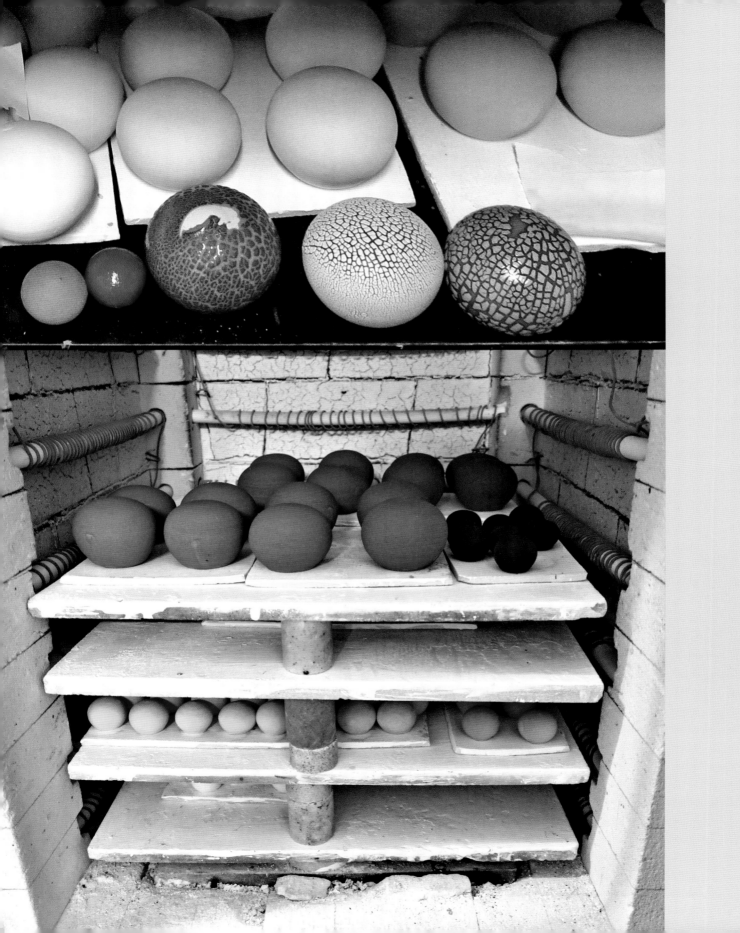

Understanding Glazes

This chapter provides a context for the world of glazing by first offering a brief history of ceramic glaze. The nitty-gritty of glaze materials is revealed through comprehensive descriptions of the technical components of a glaze, and definitions for all relevant materials and processes. A thorough health and safety section will provide you with the know-how to be safe and effective in your handling of these exciting materials.

The History of Glaze

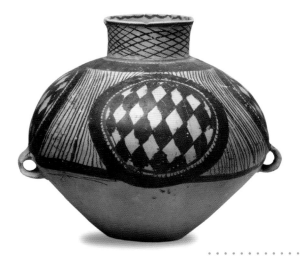

The earliest use of clay and glazes is so far back in time that it is difficult for archaeologists to have a clear picture of exactly how they developed. In recent years, new discoveries have been made as a result of digging at various sites, and the timeline and stories associated with this amazing aspect of human history are continually being added to. Though the exact date and location of the earliest clay pot is not known, archaeologists think that humans were making and firing pottery 20,000 years ago. Shards found in China suggest that during the ice age, humans used ceramic vessels for storing and cooking food some 10,000 years before the advent of agriculture.

Yangshai Vessel

This Neolithic Chinese vessel is from the Yangshao culture dated 2500 BCE and is a good early example of painted decoration using iron oxide on buff-colored clay.

Terra Sigillata

Dating from the 1st century BCE, this Roman bowl is a perfect example of earthenware terra sigillata—a precursor to glaze still used today by many studio potters. The detail in the fine relief decoration on the outside has not been lost by the covering of terra sigillata.

Fired ceramic vessels were created in many cultures across the globe independently and at different times, but archaeologists generally agree that the technique was most likely discovered by accident, either when a clay fire pit turned hard after a fire, or when a woven basket, lined with clay as a sealant, hardened after accidentally catching fire. Clay pots revolutionized early human existence, because they gave people a way of storing and cooking food that was both durable and leakproof.

However, these vessels were still porous, so before the discovery of glaze, there were other solutions for sealing vessels. First, the inside of the vessels were coated with plant matter that would seal the pores, then the discovery was made that burnishing or rubbing the leather-hard clay with a stone would compress the clay particles, creating a less porous skin. Finally, the smallest particles of clay were distilled and made into a slurry, called terra sigillata (Latin for "sealed earth"). It was brushed onto the pots and burnished, compressing the tiniest bits of clay into all the nooks and crannies of the pot's surface and creating a truly impervious container. The Ancient Greeks excelled at this technique and produced beautiful and narrative terra sigillata vessels.

The first glaze was discovered (probably also by accident) in Ancient Egypt around 10,000 years ago. It is said that in a sandy fire pit, salty from the ocean, the components of a glaze (silica from the sand and sodium flux from the salt) melted together to form a hard, glassy coating. Egyptian sandstone, which comes from a feldspathic rock that contains clay, potassium, and sodium, is readily available in Egypt. It was discovered that, once mixed with water, it could be pressed into figurine molds; upon drying, the sodium would essentially create a glaze by migrating to the surface, turning glassy and hard when fired. This self-glazing clay body was the first of its kind and is referred to as Egyptian paste. By 5000 BCE, artisans across the Middle East were using the local ceramic materials quite skillfully to create the notable low-fire alkaline blue-green copper glazes of the region.

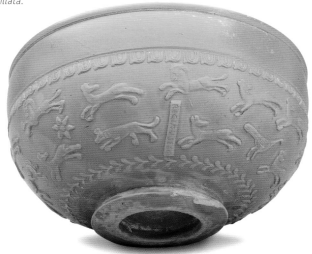

Clay Origins 101

Ceramic materials are minerals (inorganic) and mined from the Earth's crust. The crust can be broken down into roughly 50% oxygen, 25% silicon, and the rest is primarily composed of six major metals: aluminum, iron, calcium, sodium, potassium, and magnesium. Perhaps unsurprisingly, these are the most common materials found in a ceramics lab.

Minerals are composed of chemically bonded earth elements (for example silica, or quartz, which is silica and oxygen—SiO_2), while rocks are made up of various minerals (for example, quartz is one component of granite). Over thousands of years, wind, water, and glaciers have weathered these rocks, breaking them down first into rubble and eventually into very tiny particles, and transporting and depositing them. Newly deposited clay can be found in riverbeds and on ocean floors, while old deposits may be found as great mountains, or deep beneath the surface of the Earth. Mines have been set up all over the world at the site of these deposits to collect, bag, and ship the materials to you in your lab, among other places.

To more fully understand the range of materials used in the lab, see "Materials in the Lab" on page 20.

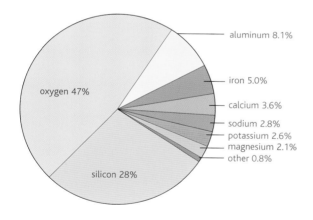

aluminum 8.1%
iron 5.0%
calcium 3.6%
sodium 2.8%
potassium 2.6%
magnesium 2.1%
other 0.8%
oxygen 47%
silicon 28%

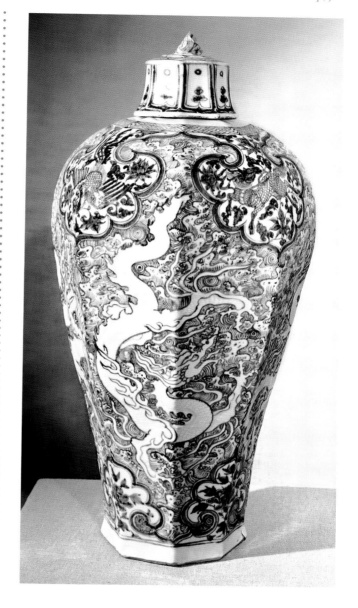

By 1500 BCE in China, advancements in kiln technology and fuel (wood and coal), as well as the discovery of more refractory clay bodies, especially porcelain, allowed for higher temperatures to be reached. This advancement afforded greater fusion possibilities; thus glazes were developed to work in those atmospheres.

Nearing the end of the Ming dynasty, around 1644 CE, Chinese potters knew almost everything we know today about pottery making, with the exception of the discovery of rare earth elements such as zinc, titanium, vanadium, and uranium. With the whole range of firing and glaze possibilities at their disposal, in the centuries since, Chinese artists have developed remarkable glazes and created technically beautiful forms that continue to inspire us today.

Historically, glaze making and testing was done by trial and error, dependent on the potter's deep understanding of the materials' behavior, based entirely on experience. In the 19th century, a method for calculating glaze from the molecular weights of the elements was established in Germany by the ceramic chemist Hermann Seger.

Mei-P'ing Vase

This 14th-century, Yuan dynasty octagonal "Mei-P'ing" porcelain vase is from Baoding, Hebei. With its ornate shape and white and blue decoration, it is a remarkable early example of the Chinese mastery of material, form, and decoration.

Single dip

Double dip

Shiny

Crackle

Crater

Crawl

Satin

Matte transparent

Dolomite

Glaze Samples

The tiles above are testing a variety of base glazes with different surface textures, from shiny to matte. Each tile is dipped in glaze a second time to reveal the possibilities of the glaze, based on thickness.

With this development, the ceramics industry has been able to realize its full potential, and many new discoveries have since been made about these materials' potential applications.

MINING AND AVAILABILITY

The ceramic materials available to the potter change over time for various reasons. Some materials such as grolleg kaolin are very reliable; as a result of the way the clay is mined and processed, it is thoroughly homogenized. Others, like Cornwall Stone, are simply mined and bagged, despite the presence of variable impurities. Much like the rest of the Earth's composition on a larger scale, these materials can be inconsistent. For example, no two granite kitchen counters are identical, and so it is with the mining of many ceramic materials: as a mine is worked through, the material may vary. Even though producers make the materials that come available to us as uniform and predictable as possible, and some are very consistent, they are by nature variable, making working with them quite an arduous task at times.

Sometimes, a material becomes unavailable because the mine is exhausted, or the cost benefit is not great enough for the company to continue mining there. For example, Gerstley borate, which was mined near Boron, California, came off the market when the expense of the company's extraction process exceeded its profit. This caused quite a stir in the ceramics community, because Gerstley borate is a coveted glaze ingredient because of its versatile fluxing abilities and its unique molecular composition—which is capable of creating luscious surface effects, such as Rabbit's Fur, at lower temperatures. The clay company, Laguna, was one of the many manufacturers that responded to the gap in the market; it began

manufacturing a substitute called Laguna borate, which is not a perfect replacement, but in many cases it works just as well. In the future, standard materials used in the ceramics industry will undoubtedly change again.

Though there are thousands of ceramic artists working all over the world, they make up only a fraction of the customers for large mining facilities. Ceramic materials have a wide range of uses in industry, from the more obvious sinks, toilets, and tableware to electrical insulators, ball bearings, and car brakes. Some less obvious industries that utilize ceramics include paper manufacturing (kaolin is used to coat paper), body products (titanium dioxide is found in sunblock), and even digestive aids (calcium carbonate is in indigestion remedies). Ceramics are amazingly versatile.

WHAT IS A GLAZE?

A glaze is essentially a combination of ceramic materials designed to melt and adhere as a glassy coating to a fired ceramic object. Depending on the vision of the artist, a glaze can have a variety of attributes—from translucent and glossy, to opaque and matte, to foamy and voluminous.

Over the course of several hours in a glaze firing (a typical cone 10 glaze firing takes around ten hours to reach peak temperature), the glaze slowly melts. By the time the peak temperature is reached, the materials on the glaze have transformed from separate particles lining the walls with cracks and crevices between them into a molten skin on the ceramic body, with no gaps, sealing the surface of the clay. The heat causes a chemical transformation at the molecular level. The crystalline structure of the glaze materials breaks down and moves into the amorphous, random structure found in glass. When the kiln cools, the

Oxidation and Reduction

Two pots by Mike Reynolds with copper red glaze illustrate the difference between oxidation (left) and reduction (right).

1

2

3

4

5

6

amorphous structure remains, hardening into a glassy veil over the object, and becoming a vitrified and often impermeable surface.

A standard glaze is composed of three main types of materials: Glass former, flux, and stabilizer. Glass formers are acidic, fluxes are primarily alkaline, and stabilizers are generally neutral. The glass former is usually silica, which makes the glaze hard, shiny, and impervious. However, silica melts at a very high temperature, so to help the glaze melt, fluxes are added. The fluxes are added in specific combinations to control the melting point of the glaze. The stabilizer, which is either alumina or clay, helps the glaze "fit" the clay body and controls the glaze's viscosity; it keeps the glaze in place on the side of the pot and gives it volume.

Depending on the proportions of these three basic components, a glaze can be designed to melt at a variety of temperatures. The surface quality and the color development in a glaze can vary wildly depending on how each individual material of a recipe adds its own unique effect. Fluxes are especially important to the way color develops in concert with the colorant oxides. Colorant oxides, opacifiers, and many other materials can be added to a glaze to alter its effects.

Beyond the three main components of a glaze, there are numerous materials that may be added for a variety of reasons. Color development, glaze texture and opacity, and glaze workability are primary ways in which an artist may wish to modify a glaze. Color development can be achieved by the addition of coloring oxides as well as manufactured stains. The effect these additions produce is dependent on the specific ingredients in a glaze recipe. While it is sometimes useful to simplify what a colorant may do—by stating, for example, that copper carbonate produces greens—it is also

misleading. In addition to green, copper carbonate may produce a whole range of colors including pink, red, orange, blue, purple, and black. Even stains, which are manufactured from oxides and fritted (meaning they are fired and ground down to a powder again) to provide stability, at times result in colors that are dissimilar to the color chips associated with them.

Aside from the glaze's ingredients, there are several other factors that affect its behavior and final appearance. The same glaze may come out looking very different if there are variations in the peak temperature and heat work of a firing as well as the atmosphere (oxidation, reduction, wood, salt, etc.). Something as simple as cooling a kiln very fast can completely change the quality of a glaze's surface, making a normally satin matte glaze glossy, and possibly causing cracking from the thermal shock.

Surface Diversity

These glaze test samples show the diversity of surface quality and color that can be produced under selective firing conditions. **1.** *Shiny White, cone 10 reduction on stoneware.* **2.** *Gloss Black, cone 10 reduction on stoneware.* **3.** *Metallic Luster, cone 06 raku.* **4.** *Turquoise Crackle, cone 06 raku.* **5.** *Blue-Green Celadon, cone 10 reduction on porcelain.* **6.** *Glossy Yellow, cone 02 oxidation on white earthenware.*

Firing Kilns and Measuring Heat

Thanks to current kiln technology, the firing of a kiln may seem no more complicated than running the dishwasher: You just load it up, program it, and press "go." However, it's exciting (and prudent) to remember that the kiln is in essence mimicking the forces of nature—turning rock materials into glowing hot pots covered in a molten skin, like lava from a volcano—and it quite literally reaches the same intense heat as one! In fact, a typical volcano spews molten rock out at around 2,000°F (1,093°C), while a cone 10 ceramic kiln reaches a peak of 2,345°F (1,285°C).

Some may find the process of firing a kiln mysterious, and get frustrated at times with the seemingly unpredictable results. It's true that there are events in a firing that are out of the potter's control; however, if you are armed with knowledge of the process, you may experience more pleasant surprises than disasters! In theory, a glaze firing should be simple, but there are several factors that can affect the glaze during the firing: The atmosphere of the kiln, the source of heat, and the rate and duration of the firing—both heating up and cooling down.

ATMOSPHERE AND ENERGY

A kiln can be fired by a variety of energy sources, including electricity and fuels such as natural gas, oil, wood, coal, and sawdust. The type of energy impacts the firing mostly by affecting the atmosphere. The atmosphere depends on the ratio of fuel to oxygen in a firing as well as any volatiles that may be in the chamber with the work. Often the phrase "atmospheric firing" is used to refer to processes such as wood, soda, and salt firing, in which the added materials are volatilized by the heat and interact with the clay and glazes in the kiln. In terms of the fuel-to-oxygen ratio, the atmosphere of a firing can be in oxidation, meaning there is an overabundance of oxygen; in reduction, meaning there is an insufficient amount of oxygen, which does not allow the fuel to burn completely; or neutral, meaning the optimal balance between

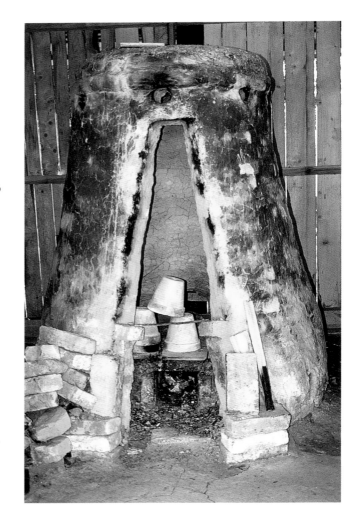

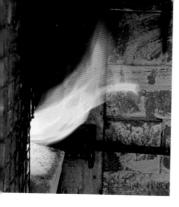

Reduction Firing

The flame of reduction firing searching for air outside the internal kiln atmosphere (above).

Updraft Wood-Fired Kiln

The simplest type of wood-fired kiln is styled on a bottle form (opposite). The fire hearths are under the floor and the flame passes upward through the work, exiting via a narrow flue at the top. This example from the pottery village of Magyarszombatfa in southern Hungary has three fire-mouths equally placed around the base. Typically, the work here is unglazed or partially glazed earthenware. Ceramic roof tiles act as the kiln floor and shelves.

Top-Loading Electric Kiln

Top-loading kilns are convenient for small-scale workshops because they are cheap to buy and easy to install (below left). Some potters feel that top loaders cool too rapidly, having a detrimental effect on their work. Others consider this an advantage because they are able to have a very quick firing cycle.

Front-Loading Electric Kiln

This type of kiln has a more solid metal framework and thicker walls than a top loader, which means that it retains heat for longer (below right). It is also more expensive to buy and install, but is harder wearing.

oxygen and fuel is achieved, allowing the kiln to fire most efficiently and economically.

In carbon-based fuel firings (such as wood and gas), the process of combustion includes a chemical reaction that rearranges the molecules, releasing heat as well as various by-products including carbon monoxide, carbon dioxide, soot, and steam. When the air is restricted to create reduction in the firing, this also affects the ratio of the various by-products produced. Fuel needs oxygen in order to burn, and when the fuel is deprived of oxygen, it produces more carbon monoxide, which is very unstable. It searches for oxygen in order to become carbon dioxide, a much more stable molecule. Oxygen is found in the many oxides that compose our clay and glazes; when they become hot, they readily donate their oxygen molecule. The fuel "pulls" the oxygen out of the body and glazes, chemically separating it, and leaving only the metals, like iron or copper, behind. This process is called reduction. The same glaze in a reduced atmosphere (as opposed to an oxidized one) can produce wildly different colors, because of the way it affects the various metal oxides.

There is no combustion to make heat in an electric kiln (the only combustion comes from the burning-off of organics in the clay and glaze), so this is a sure way to achieve an oxidation atmosphere. An electric kiln should be ventilated, not only because organics burn, but also because some materials volatilize and turn to hazardous gases. In any kind of firing, always follow proper safety procedures—even with very safely designed equipment, the hazards are significant. There is more about health and safety on pages 36–41.

HEAT WORK AND TRACKING TEMPERATURE

Ceramic materials are affected not only by heat, but also by the amount of time they are exposed to that heat. The combined effect of temperature and time on ceramics is referred to as "heat work" and is a very important concept to understand. Think of yourself on a sweltering summer day. If you step outside for a few minutes, you will start to warm up immediately, and maybe break a sweat. You think you can really feel all 98 of those degrees Fahrenheit! However, if you sat out in that heat for two hours, it would have an entirely different effect on you, burning your skin, dehydrating your body, and exhausting you. Well, ceramics isn't all that different. A normally stable glaze could become a puddle around the bottom of the pot if left at peak temperature for a few hours.

While the pyrometer (a gauge to measure the temperature inside the kiln) can tell you exactly what the temperature is in your kiln at any point, it may be deceptive for three main reasons. First, it only detects the temperature in the exact location of the thermocouple and, especially in gas kilns, the temperature may not be even throughout the chamber. Second, the pyrometer is likely to degrade over time, providing less accurate measurements the longer it has been in use. Third, and arguably most important, a pyrometer is unable to detect

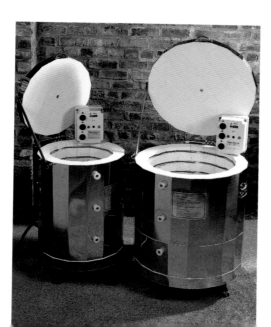

heat work. Despite these drawbacks, pyrometers are very useful devices to help track the rate of rise in temperature for your kiln log as well as the immediate effects of any adjustments you make to your kiln. This is particularly useful for fuel kilns where you are regularly adjusting the amount of fuel, air, and back pressure.

The most accurate way to know how your kiln fires, however, is to use pyrometric cones. Cones are small, colored, triangular-shaped objects made from ceramic materials that are designed to melt at very precise temperatures. Because they are ceramic, they also measure heat work. For example, if you fast-fire your kiln and the pyrometer says you've reached cone 6, or 2,232°F (1,222°C), but

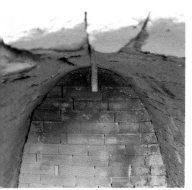

Thermocouple and Pyrometer

You can clearly see the thermocouple sticking down through the ceiling and into the kiln (left). Always identify where this is so that you don't knock it. The digital pyrometer (above left) is connected to the thermocouple and reads the internal temperature.

Triangular Pyrometric Cones

Cones are designed to bend when fired to given temperatures and are a visual clue as to what is happening in the kiln. Made of ceramic material, they will most accurately respond to the effects of both temperature and time on the wares in the kiln.

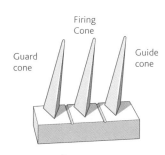

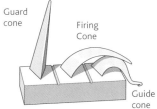

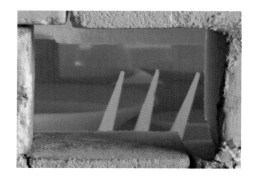

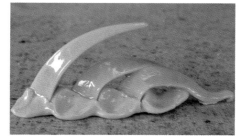

the cones are stiff, then you know that the heat has not yet absorbed into your ceramics work and your glazes are not yet mature. You may then proceed to hold at that temperature until the cones melt, telling you that the work is ready for the kiln to be shut off.

Kilns are all equipped with spyholes so that you can peek into the kiln during firing. You can see cones as they are melting, thus helping you determine the pace of the firing. When cones are placed in view of the spies, they're called "witness cones." The cones should not be placed too close to the spies, though, as the cool air drawn in will interfere with an accurate reading. Spies are beneficial in a number of other ways. You may grow accustomed to the colors of the kiln and how it corresponds to different temperatures, and you may also observe the glassy matrix as it develops on your pots at high temperatures. If you are having problems with the firing, it's possible to do some detective work by peeking into the kiln.

Cones are arranged as packs, pressed upright into a coil of clay. You may put any number of cones in your kiln; at a minimum, the cone pack should include a guide, a target, and a guard cone. The target cone is the temperature you're firing to, the guide is the one just below that, and the guard is the next cone hotter than your target. It's a good idea to have at least two identical cone packs in different places in your kiln so that you can detect any unevenness in the fired results. When the cone melts into an arch with the tip pointing downward and just touching the shelf, the heat work for that temperature has been achieved.

The best way to ensure that your electric kiln does not overfire is to shut it off at the breaker after it has reached peak temperature (based on the cone pack) and completed its program. Older electric kilns often come with a kiln sitter, which is a safety mechanism that automatically shuts the kiln off when the cone melts. While in theory this is a great safety feature, they are not entirely reliable and should never be used to stand in for your presence. You should always be available to tend to your kiln while it is firing in order to avoid any problems and to enable you to keep accurate notes on your firings. Controlling the rate and duration of firing and consistently following a kiln schedule is imperative to achieve the same results from one glaze firing to the next.

Events of the Firing Cycle

Understanding the firing cycle will enable you to control the firing of your kiln and correct any problems that may arise during one firing and in preparation for the next. The chart at right is a guide to how changes in the clay and glaze are triggered by the rising and falling temperature in the kiln. Because of the effects of heat work, the changes may not occur precisely when the pyrometer says that a certain temperature has been reached, but should be within a close range of the temperatures noted here.

** The cones listed reference the closest cone to the corresponding temperatures of that column and should be viewed as an approximation.*

Fahrenheit	Celsius	Cone*	Event	Notes
68–437	20–225	N/A	Water smoking period: Release of water of plasticity	Water of plasticity is water that is mechanically attached to the clay. All but 3–5% may evaporate exposed to just air, but higher temperatures are needed to fully remove all of it. Fire slowly during this phase to prevent defects.
212	100	N/A	Water boils	Physical water should be removed (dried) from the piece before it reaches 212°F (100°C). Before then it will expand in the body and the piece may explode.
439	226	N/A	Cristobalite inversion occurs upon heating	
437–932	225–500	N/A	Organic matter burns off	This may cause a distinct odor, especially with secondary clays. Also, firing speed may be increased now.
932–1,063	500–573	N/A	Chemical water is released (more precisely, this occurs at about 1,022°F/550°C); sintering begins	Also known as metakaolin formation, and as the ceramic change, this point in the firing marks the loss of plasticity from clay.
1,067	575	N/A	Quartz inversion occurs	During quartz inversion, quartz particles expand 1% while the clay body shrinks, and counteract each other's movement. Fire slowly through this stage.
1,300–1,700	704–927	019–09	Carbon, sulfur, and other impurities volatilize and leave the clay	The kiln should be fired moderately slow through this stage to keep gases from being trapped in the clay and causing defects such as carbon-coring and pinholing.
1,472	800	014	Vitrification begins	Glass formation is dependent on composition of recipe and particle size, but begins here.
1,562–top	850–top	012–top	Free quartz can convert to a crystalline form called cristobalite	Cristobalite has a high expansion and contraction rate and can cause defects such as dunting; formation is cumulative, so refiring work can be detrimental. Cristobalite may form spontaneously after several hours above 2,000°F (1,093°C).
1,657–1,945	903–1,063	010–04	Range for bisque firing temperature	
1,922	1,050	04	Common glaze firing temperature	Cone 04 is widely regarded as a standard low-fire glaze temperature, though many artists fire to surrounding temperatures like cone 05 and cone 03.
2,232	1,222	6	Common glaze firing temperature	Though it may not seem like much of a temperature difference, increasing the heat at such high temperatures has a considerable effect on ceramic materials, and cone 6 glazes are often distinctly different from cone 10.
2,345	1,285	10	Common glaze firing temperature	For some potters, cone 10 is the preferred high-fire temperature for glaze firings for potters. Sometimes kilns are fired hotter, even up to cone 13, especially in wood firings.

Materials in the Lab

In order to truly excel in the creation of glazes, you first need a general understanding of the materials in the lab and how you can expect them to behave and interact with each other when exposed to heat and atmosphere. Without this knowledge, glaze testing is simply blind busy work that may yield successful results, but will always remain mysterious. Sure, plenty of mystery will remain in the process of firing ceramics—but armed with as much knowledge as possible, you can make informed decisions and feel more in control. Glaze testing can become much more than weighing powders, and bloom into a creative endeavor of its own.

SEGER AND HIS UNITY MOLECULAR FORMULA

In an attempt to minimize faults and increase reliability while working with manufactured ceramics, Hermann Seger developed a system for understanding and predicting ceramic materials based on their most fundamental composition— their molecular makeup. The Seger system for analyzing ceramic materials is called the Unity Molecular Formula (UMF). The formula is based on each oxide's (element plus oxygen) identifying properties, and establishes proportions of ceramic materials within which a glaze will be successful, as per industry standards. Seger found that when a recipe had proportions outside of these boundaries (too much sodium oxide, not enough alumina, etc.), glazes would develop more flaws after the firing, such as crazing or pinholing.

The system identifies silica as the primary glass former and alumina as the stabilizer. The ceramic fluxes are classified into three main groups: alkaline oxides, alkaline earth oxides, and metallic oxides. The oddity in the system is boron, which has the

This or That: Finding a Suitable Substitution

Though typical ceramic labs around the world are likely to have many of the same materials, some materials used, and found here in this book, may not be readily available in your town. Often this is because of the cost of shipping items mined from far away, in conjunction with the likelihood that there is a comparable material closer to home. To make a substitution, it's important first to look at the main components of your material. Use the handy Directory of Ceramic Materials and their definitions beginning on page 308 to help you understand the materials in your lab and find suitable substitutes. Using the UMF will allow you to break down, analyze, and compare the two materials. Try using a digital UMF calculator (there are many examples online). Bear in mind that any substitution carries with it the potential to change the quality of the glaze, and the best way to predict how it will look is to test it.

If a substitution does not have the desired effect, you could attempt to order the special item from far away, but it may not be worth the cost, especially considering the vastly different results that are possible based on numerous other factors. Your best bet may be to either try a different recipe or learn how to formulate the glazes you desire from your local sources.

Glaze Calculator

The section of chart below shows the composition of materials, analyzed using the Seger system to produce a UMF, which identifies the various component proportions of given ceramic materials for successful glaze calculation.

S	Line Label	1	2
	CUSTER FELDSPAR	100.00	20.00
	WOLLASTONITE		20.00
	FRIT 3134		20.00
	EPK KAOLIN		20.00
	SILICA		20.00

Oxide	1	2
CaO	0.30%	13.77%
MgO		0.02%
KNaO	13.19%	4.78%
TiO2		0.07%
Al2O3	17.36%	11.02%
B2O3		4.62%
P2O5		0.05%
SiO2	69.03%	62.68%
Fe2O3	0.12%	0.18%

Oxide	1	2
CaO	0.03*	0.79*
MgO		0.00*
KNaO	0.97*	0.21*
TiO2		0.00
Al2O3	1.05	0.35
B2O3		0.21
P2O5		0.00
SiO2	7.11	3.35
Fe2O3	0.00	0.00

2	Oxide	1

Categorizing Materials

The Seger system categorizes materials into five departments (see right) for the accurate calculation of glaze components.

** Boron is unique in that it fits in the RO₂ category and is considered a glass former, but is primarily used in ceramics as a very powerful flux.*

Categories of Materials				
Flux: Alkaline oxides (R_2O)	Flux: Alkaline earth oxides (RO)	Flux: Metallic oxides (RO)	Glass former (RO_2)	Stabilizer (R_2O_3)
Potassium K_2O	Barium BaO	Lead PbO	Silica SiO_2	Alumina Al_2O_3
Sodium Na_2O	Calcium CaO	Zinc ZnO	Boron* B_2O_3	
Lithium Li_2O	Magnesium MgO			
	Strontium SrO			

unique properties of being both a glass former and a powerful flux. There are, of course, many other elements found in the ceramics lab, but these are the main ingredients that make a glaze function.

Today many institutions and artists utilize the UMF to calculate glaze compositions to meet specific criteria. It is also often used to analyze an existing glaze and to assist in troubleshooting glaze faults. This science of glaze is especially useful to ceramic manufacturing industries and ceramic engineers, who are geared to achieve precise results based on highly specific needs, and ceramic materials have achieved feats previously unimaginable, such as tiling spaceships and making the sharpest of knives.

For the ceramic artist, Seger's UMF also has great potential. However, rather than investing wholly in the scientific and mathematical side of glaze development, some artists prefer to retain an element of trial and error in combination with their accumulated knowledge to develop their glazes, learning from peers and looking to the vast and rich history of ceramics for ideas, inspiration, and guidance. This may be a much more accessible approach, and it is quite enjoyable to use the well-developed glazes that are already in existence as starting points. Even so, understanding how Seger categorized the materials, their fundamental properties, and their modes of interaction is extremely useful in helping to predict how a glaze will behave. It also provides us with a language that we can use to discuss a glaze's attributes and potential. Understanding the basic oxides in the studio is necessary to augment any good studio artist's empirical testing methods.

While this book focuses on testing glazes through empirical means, there are many wonderful sources for learning about applying Seger's UMF to your studio practice.

While the periodic table of the elements organizes the building blocks of our world into tidy little boxes, the reality is quite different. The elements are usually combined with oxygen, forming what we call oxides. Often, ceramic materials in general are referred to as oxides. In some cases, these oxides combine yet again with carbon dioxide to form carbonates, which are also common molecular formats for ceramic materials. Most materials in the lab are composites of several different oxides in varying proportions, which mirrors their formation in nature: first as minerals and rocks, then moved and manipulated by the powerful forces of heat, pressure, wind, and water, resulting in these unique combinations.

Let's begin the study of oxides by first taking a look at the primary component of ceramic work. Clay itself is composed of silica (oxide of silicon), alumina (oxide of aluminum), and water (oxide of hydrogen) [$Al_2O_3 + 2SiO_2 + H_2O$], as well as any number of "impurities" based on what other minerals, metals, and organics were deposited with it.

Feldspathic rocks, referred to as feldspar, are made up of the clay molecules silica and alumina bonded to the oxides of alkaline elements. Some of the fluxing oxides are also found in the lab in other forms, either as pure oxides or in combination with other elements. For example, sodium oxide can be found in Kona F-4 (a feldspar), in borax (sodium tetraborate), and simply as soda ash (sodium carbonate). Each of these three materials has

Periodic Table of the Elements

Any smart ceramic detective would be wise to first look for clues about a given material in the periodic table of the elements. Don't worry—a little science never hurt anybody! The table is arranged with columns of elements that share similar characteristics. You can see the primary fluxes, the alkaline elements (including lithium, sodium, potassium) in a column to the far left, then right next to them are the secondary fluxes, or alkali earth elements (including magnesium, strontium, calcium). Across the middle are the metals, some of which you will recognize as fluxes, while others are colorants in ceramics (titanium, vanadium, chromium, manganese, iron, cobalt, nickel, copper, zinc—and that's in just the top row!). A favorite duo, alumina and silica, sit side by side on the right, where metals meet semimetals, with silica nestled in with the other acidic elements. Boron sits atop alumina, refusing to fit in.

1 H																	2 He
3 Li	4 Be											5 B	6 C	7 N	8 O	9 F	10 Ne
11 Na	12 Mg											13 Al	14 Si	15 P	16 S	17 Cl	18 Ar
19 K	20 Ca	21 Sc	22 Ti	23 V	24 Cr	25 Mn	26 Fe	27 Co	28 Ni	29 Cu	30 Zn	31 Ga	32 Ge	33 As	34 Se	35 Br	36 Kr
37 Rb	38 Sr	39 Y	40 Zr	41 Nb	42 Mo	43 Tc	44 Ru	45 Rh	46 Pd	47 Ag	48 Cd	49 In	50 Sn	51 Sb	52 Te	53 I	54 Xe
55 Cs	56 Ba	57 La	72 Hf	73 Ta	74 W	75 Re	76 Os	77 Ir	78 Pt	79 Au	80 Hg	81 Ti	82 Pb	83 Bi	84 Po	85 At	86 Rn
87 Fr	88 Ra	89 Ac	104 Unq	105 Unp	106 Unh	107 Uns	108 Uno	109 Une	110 Unn								

Legend:
- hydrogen
- alkali metals
- alkali earth metals
- transition metals
- poor metals
- nonmetals
- noble gases
- rare earth metals

58 Ce	59 Pr	60 Nd	61 Pm	62 Sm	63 Eu	64 Gd	65 Tb	66 Dy	67 Ho	68 Er	69 Tm	70 Yb	71 Lu
90 Th	91 Pa	92 U	93 Np	94 Pu	95 Am	96 Cm	97 Bk	98 Cf	99 Es	100 Fm	101 Md	102 No	103 Lr

fluxing abilities, but because of their different molecular composition each has unique properties.

Aside from the oxides that flux, there are oxides whose main role in glazes is to provide color or opacity. The primary opacifying oxides in glaze are tin oxide, titanium oxide, and zirconium oxide. Other materials can be used as opacifiers, such as kaolins and feldspars, in oversupplied proportions that mean they melt only partially in a glaze. Zinc, which can have powerful effects on colorants, can opacify when used in larger amounts due to its crystallizing effects, but will act as a flux in smaller amounts. Zircopax Plus, Superpax, and Zircosil are brand names for what is commonly listed as zircopax, a popular opacifier using zirconium silicate. While these materials will turn a clear glaze a shade of white (opacify), it is important to note that opacity can also be achieved through the addition of colorants and secondary clays.

The colorant oxides are added to glazes mainly to add color, but also have other effects. For example, copper oxide may act as a flux due to its low melting point while chrome oxide will act as a stiffener due to its highly refractory nature. Colorant oxides also have varying degrees of intensity. Cobalt oxide is a very strong colorant and only a little is needed to make rich blues. As little as 1 or 2 percent of red iron oxide will produce beautiful celadon blues, but it can also be added to a glaze in amounts of 10 or even 15 percent, creating deep, rich browns, like the ones found in traditional Temmoku glazes.

What's in a Name?

Many a ceramicist has pondered the naming of things—in this case, materials in the lab. Why is the same material referred to by more than one name? Much like the labeling of fine wine, it has a lot to do with the way knowledge of ceramics has unfolded over time. A material may be referred to by:

- its chemical composition (e.g., calcium carbonate)
- its mineralogical name (e.g., limestone)
- a name it's been given, presumably by the mining company (e.g., Whiting)
- the location or region from which it is mined (e.g., Cornwall Stone, which is actually a feldspar that contains calcium)

In the ceramics lab, these materials are referred to in a number of ways. In this book, the term "oxide" is often used. Often a material will be referred to with a term that is not technically accurate but is accepted jargon by the studio ceramist. This may be confusing at times, but knowing the materials in the lab will help with understanding. For example, actual flint, which is a form of quartz rock with calcium impurities, was once used to supply silica to clay and glazes, though this is no longer practiced. Today, pure quartz, the macro-crystalline mineral found in nature, is ground down into a fine powder to supply silica in glazes. Still, the terms quartz, flint, and silica are often used interchangeably, though the term silica is actually the most accurate.

While the materials in the lab can be broken down to around roughly 20 oxides, the combinations both naturally occurring and made synthetically offer a cornucopia of possibilities to the ceramic artist. It often takes years to accumulate knowledge about your chosen materials, and as there are so many items in a ceramics lab, it can feel overwhelming at first. Beginning by breaking the materials down into categories is helpful, and learning a little about each oxide is a reasonable task that will save you time and agony in the long run.

KNOW YOUR GLAZE MATERIALS

Based on what you now know about the components of a glaze, you can create six main categories of materials:

- Clays
- Fluxes
- Glass formers
- Colorants
- Opacifiers
- Additives

In the following pages, each category represents a type of material. Each of the main oxides recognized in ceramics is identified and described by defining its main properties, such as melting point, solubility, and toxicity. On pages 308–311 there is a directory of commonly found materials in the lab that can be cross-referenced with the list on the following pages.

Metallic Oxides

Here are some colorant oxides in their dry (unfired) form. Although many of our materials contain traces of these oxides, we can achieve many effects with small amounts of these concentrated materials.

Manganese dioxide

Nickel oxide (green)

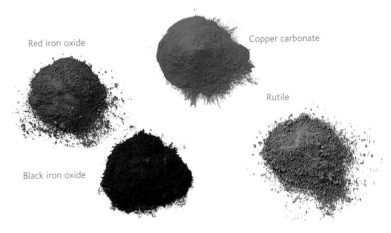

Red iron oxide

Copper carbonate

Rutile

Black iron oxide

Ceramic Materials

The following pages describe many of the materials you will need to know about when working with ceramic glazes.

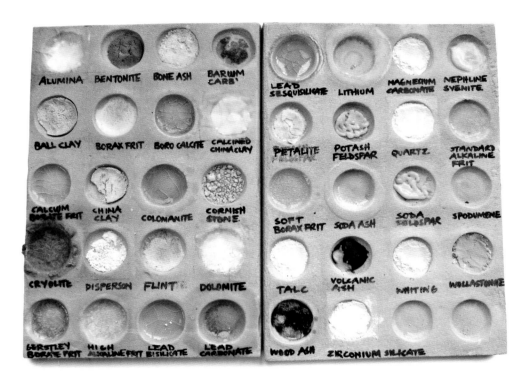

Button Test

The button test is a very good way of understanding how certain materials react to firing. Each of these raw ingredients has been fired to cone 6. By studying their fired state, you will begin to understand how mixing one with the other might produce a smooth or runny glaze.

CLAYS

There are two types of clays: Primary and secondary. Primary clays are deposited at their source and are considered the purest clays. They are also referred to as kaolins, and are the whitest clays that go to make porcelain bodies. Secondary clays, meanwhile, have traveled by the forces of nature and been deposited in a wide range of locations, picking up a variety of impurities along the way. Secondary clays tend to be more plastic and have smaller-sized particles. They include ball clays, fireclays, and earthenwares.

Clay is used in glazes as a stabilizer, or a refractory, meaning that it resists melting. The refractory clay stiffens the glaze, making it more viscous and keeping it on the side of the pot. The clay also gives the glaze more volume and helps the glaze "fit" the clay body.

KAOLINS

Primary clays are almost always kaolins with relatively larger particle sizes and low plasticity, though some kaolins are formed as secondary clays as well. They are the purest clays, because they have not been exposed to other minerals (namely iron) during the decomposition process. Kaolins are highly desirable, because in clay bodies they fire to a dense and hard white when properly vitrified. Without other metal oxide impurities, the whiteness of kaolin provides a more flexible "canvas" for the application of color. Kaolins are also added to glazes, because their whiteness will not interfere with color development but they offer stabilizing properties. The larger kaolin particles add structure to the melting glaze.

Examples of kaolins include:
- Edgar plastic kaolin (EPK)—secondary kaolin
- Tile#6—secondary kaolin
- Grolleg—primary kaolin
- Helmer—primary kaolin

BALL CLAYS

Ball clays are secondary clays that have decomposed into the smallest of all the clay particles, rendering them extremely plastic. On their travels they have picked up varying degrees of impurities, and as a result of the presence of these oxides, fuse more readily. They are used in glazes often, but do not afford the whiteness of kaolins, which can help produce brighter colors.

Examples of ball clays:
- C&C Ball Clay
- OM#4
- Tennessee #10
- XX Sagger

FIRECLAYS

The main property of a fireclay is that it is highly refractory, or resistant to melting. Because of their refractory nature, fireclays are often used in combination with more fluxing materials to add strength and structure to a clay body.

Examples of fireclays:
- Hawthorn Bond
- Yellow Banks
- Cedar Heights
- Lincoln

EARTHENWARES

Earthenwares are the most common of all the clay types. They are highly impure, with a variety of minerals, predominantly iron, giving them a red color. The proportion of additional minerals is so high that these clays have a very low melting point and become fully vitrified at low temperatures. "White" earthenwares refer to clay bodies formulated to vitrify at low temperatures without using actual earthenware clays. They often contain fluxing materials such as talc, wollastonite, or even frit.

Examples of earthenwares:
- Redart
- Lizella
- Albany Slip Substitute
- Barnard Slip Substitute

Properties of Fluxing Oxides

This chart will help you identify and compare important properties of fluxing oxides. The expansion and contraction rates affect the way a glaze will fit a clay body. If the glaze expands and contracts too much or too little compared to the clay body, it can cause defects in the glaze. See Glaze Defects and Remedies on page 34 for more information about this.

The melting point of an oxide is quite straightforward at first glance, but it's important to note that no oxides act alone. When oxides are combined, there is a cumulative effect that causes a greater melt. Combining oxides in the optimum ratios to create the lowest possible melting point (if two substances are combined, the melting point is usually lower than both individual melting points) is referred to as a eutectic. The fluxing power of the oxides is meant to illustrate the ability of that oxide to form a eutectic in melting. This list can be used as a guide and the results should be viewed as approximations.

Fluxing Oxides		
Expansion and contraction (highest difference at top)	Melting point (lowest at top)	Fluxing power (most powerful at top)
Sodium	Boron	Lithium
Potassium	Sodium	Lead
Calcium	Potassium	Boron
Strontium	Lead	Sodium
Barium	Lithium	Potassium
Lead	Zinc	Calcium
Lithium	Barium	Strontium
Zinc	Strontium	Barium
Magnesium	Calcium	Magnesium
Boron	Magnesium	Zinc

ALKALINE OXIDES: PRIMARY FLUXES

A flux, in the context of ceramics, is a material that helps the glaze melt. The fluxes in a glaze are made up of various proportions of oxides. Some oxides come in the form of feldspars, bonded to silica and alumina; others are in combination with other oxides, or are actually carbonates (oxides bonded to carbon dioxide). The alkaline oxides are considered the primary fluxes. These three oxides—lithium, potassium, and sodium—are what make up most of the feldspars used in the lab, and are often found in combination with each other in many common materials such as nepheline syenite. All alkaline oxides produce strong colors.

LITHIUM OXIDE

Lithium oxide makes the strongest and most powerful of the three alkaline fluxes. With the addition of just 5 percent lithium carbonate, a cone 10 glaze can be converted to a cone 6 glaze; just a 0.5–1 percent addition can make a matte glaze turn glossy. (It's important to note that this can affect other properties of the glaze as well!) It has a very low contraction rate

upon cooling, which can be beneficial for flameware, but could cause shivering (glaze cracking) if the amount in a glaze is too high or disproportionate to the clay body. It is often used in high-sodium and high-potassium glazes to help counteract crazing for this reason. Lithium promotes crystal growth and has a tendency to produce more variety in the surface. Because of its powerful fluxing ability and its low viscosity, it tends to "break" along edges, highlighting decorations in the clay surface. It is more reactive than its alkali cousins and is more sensitive to the thickness of the glaze application. All lithium compounds are toxic and should be handled with care.

Effects on color:
Lithium oxide generally produces strong color reactions that can be quite different from those resulting from sodium and potassium oxides. It is known for making brilliant blue with copper and pink with cobalt.

Sources in glazes:
- Lithium carbonate
- Spodumene
- Amblygonite
- Lepidolite
- Petalite
- Some frits

SODIUM OXIDE
Sodium oxide is a very powerful flux that acts similarly to potassium oxide in glazes, but with a slightly more fluid melt, and the surfaces it produces are not as durable. High amounts of sodium can cause a glaze to be quite brittle, and its low viscosity and low surface tension will cause the glaze to run. It has the highest coefficient of expansion of all the glaze oxides and therefore produces crazing. Sodium oxide and most of its compounds are soluble, so it is often introduced to a glaze as part of a feldspar or frit.

Effects on color:
Sodium oxide, like the other alkali earths,

also produces bright, glassy colors. Bright turquoise blues from copper and purples from cobalt and manganese are common. Sodium volatilizes at relatively high temperatures, which produces flashing on the clay, singeing it from a bright orange to deep red. This is the basis of salt and soda firing. Soda is also sensitive to atmospheric copper vapor and may blush a pinkish gray in its presence.

Sources in glazes:
- Minispar feldspar
- Kona F-4 feldspar
- NC4 feldspar
- Soda ash
- Baking soda
- Salt
- Borax
- Unwashed wood ash
- Gerstley borate
- Sodium silicate
- Nepheline syenite
- Many frits

Small amounts can also be found in some potash feldspars, including Custer, G-200, Plastic Vitrox, Cornwall Stone, volcanic ash, and Rottenstone.

POTASSIUM OXIDE
Potassium oxide is an alkaline flux found in many materials in the lab. Most potassium feldspars contain some sodium, and vice versa. Potassium and sodium can sometimes be substituted for each other in a glaze without any major changes in the glaze surface. They are often compared because of their many similarities, but have a few noteworthy differences: Potassium provides a slightly more stable, viscous melt, has a broader fluxing range, and produces a very hard, more durable surface. It has a high expansion and contraction rate, which can often cause significant crazing.

Effects on color:
Potassium can produce bright, glassy colors. Potash feldspars combined with small amounts of iron are responsible for gorgeous, pale, luminous blue celadons.

Glazes with potassium may leave a red-orange flash line along the edge of the glaze on the clay body.

Sources in glazes:
- G-200
- K-200
- Kona F-4
- Custer
- Cornwall Stone
- Plastic Vitrox
- Pearl ash (potassium carbonate)
- Potassium nitrate
- Unwashed wood ash
- Volcanic ash
- Mica

Small amounts can also be found in frits 3110, P25, and 3124, as well as in most soda feldspars.

ALKALINE EARTH OXIDES: SECONDARY FLUXES

The alkaline earth oxides are considered secondary fluxes and are often used in combination with the primary fluxes in order to produce a eutectic (the strongest possible melt). The alkali earths also produce distinct color development.

MAGNESIUM OXIDE
Magnesium oxide, or magnesia, behaves in a similar way in a glaze as calcium, with which it shares a column on the periodic table. They are often found together in minerals, and both add hardness and durability to glazes. Magnesia acts as a secondary flux at high temperatures (often forming a eutectic with calcium oxide) and creates characteristically sensuous, satin-matte surfaces, known as magnesium mattes, or butter-fat mattes. At lower temperatures, magnesium oxide acts as a refractory, resulting in sugary or even dry matte glazes. Magnesium's high surface tension tends to fatten the appearance of a glaze and round the edges, but this same quality also can cause pinholing and crawling, when used in greater quantities. For this reason, along with its high

shrinkage rate pre-firing, it is often used in glazes designed to crawl, such as lichen or lizard-skin glazes. Magnesium oxide has the lowest expansion and contraction rate of the fluxes besides boron, which can dramatically reduce crazing effects in glazes with other high contraction fluxes like sodium.

Effects on color:

Magnesium tends to act as an opacifier, which often also causes color effects to become more muted. Because of its use as a secondary flux, it often does not have a dominant effect on color development in a glaze, but can sometimes cause distinct color responses—for example, mauve with cobalt oxide, yellow-green with low-iron celadon, pink with tin oxide, and liver to pale pink with copper oxide in reduction.

Source in glazes:

- Magnesium carbonate
- Dolomite
- Talc
- Some frits

Magnesium sulfate (Epsom salts) is a soluble form of magnesium that is sometimes used.

CALCIUM OXIDE

Calcium oxide is an alkaline earth flux with a stable melt that is known for producing hard, durable glaze surfaces that are scratch and acid resistant. It is a stable force in a glaze, with moderate viscosity and a higher rate of expansion/contraction and high surface tension. It is most often used at high temperatures, and it's considered the most important and widely used of the auxiliary melters.

In common with magnesium oxide, calcium oxide is used as a flux in small amounts, forming powerful eutectics with other fluxes, but in larger amounts (over 25 percent) it often acts more as a refractory. At low temperatures, calcium does not melt well and creates mostly matte surfaces. A moderate flux at cone 6, smooth stony-satin glazes can be achieved, while at cone 10 it is a very active flux

that is a dependable melting agent. A cone 10 glaze that is high in calcium oxide causes the unique effect of runny matte glazes with rivulets in the surface. Because of their appearance, these glazes are often called "fake wood ash" (wood ash itself is high in calcium). When slow cooled, calcium oxide encourages crystalline growth when in high enough quantities.

Effects on color:

Calcium oxide only moderately enhances color development and mostly has a bleaching effect on small amounts of colorant: iron oxide turns more yellow, copper oxide turns turquoise blue, and cobalt oxide turns mauve; rich, inky blues can be achieved with a higher percentage of cobalt oxide. Calcium oxide is integral to the formation of jadelike celadon greens, as well as the rich surfaces of high-iron glazes such as Temmoku and tomato red.

Sources in glazes:

- Whiting
- Wollastonite
- Dolomite
- Some feldspars
- Most frits
- Gerstley borate
- Colemanite (calcium and boron)
- Ulexite (sodium, calcium, and boron)
- Bone ash (natural)
- Tri-calcium phosphate
- Wood ash

STRONTIUM OXIDE

Strontium oxide is an alkali earth flux with properties that are similar to calcium oxide and barium oxide. As a secondary flux, it requires interaction with other fluxes to become a powerful melting agent. Like calcium oxide, it adds strength and hardness to a glaze and has similar thermal expansion and fluxing powers as well. It has moderate surface tension and viscosity, with a slow melt, creating stable glazes with a wide range of melting temperatures. In high amounts, it can create runny, crystalline matte surfaces. Strontium oxide is not as widely used in industry as

other earth fluxes and is therefore more expensive. It is a good option as a possible substitute for barium oxide, where toxicity would be problematic. Strontium carbonate often contains some calcium oxide from the mining process, and it also may be contaminated with traces of barium carbonate, so it is wise to handle it with care, though strontium oxide itself is not toxic.

Effects on color:

Strontium oxide and barium oxide have similar color responses; however, strontium oxide is rarely as vivid.

Sources in glazes:

- Strontium carbonate

BARIUM OXIDE

Barium oxide is a secondary flux with crystallizing properties that is lauded for its unique ability to produce soft, silky, matte surfaces and vivid colors. While most matting agents (alumina oxide, calcium oxide, magnesium oxide) produce soft, muted colors, barium oxide produces some of the brightest colors, making it a popular material for glazes. It produces stiff glazes due to its high viscosity and moderate surface tension, but it also forms a strong eutectic with other fluxes (boron oxide, in particular) and is very sensitive to rises in temperature that can cause glazes to run dramatically. High-barium glazes have beautiful crystal formation, often matting out even the running glazes. Barium oxide is very toxic both before and after firing. Due to barium's solubility (though this is minimal) and toxicity, it should always be handled with care and it is inadvisable to use it for functional work.

Effects on color:

Barium gives dramatic, bright color enhancement, especially with copper oxide and cobalt oxide, producing intense blues and greens. Bright colors are possible with all the colorant oxides in combination with barium oxide, including chartreuse and bright yellow-greens from chrome

oxide, pink to violet to reddish violet from manganese oxide, red-violet to blue or green with nickel oxide, and soft yellow to yellow-green with iron oxide.

Sources in glazes:
Barium carbonate is the primary source. Barium oxide can also be found in barium chloride, barium sulfate, some frits, and trace amounts in strontium carbonate.

METALLIC OXIDES

LEAD OXIDE

Lead oxide is a powerful flux with an even, glossy, blemish-free melt, and is most often applied to low-fired works. It fuses easily and produces durable surfaces and bright colors. Overall, lead has very desirable effects on glazes with a long history of use—which is unfortunate, because it is extremely toxic! Most institutions and studios have eliminated any pure forms of lead oxide in the lab; however, fritted forms are often readily available, with lead bisilicate being the most popular form.

Fritting lead (chemically bonding it to other materials) makes it less toxic, rendering it less reactive, less soluble, and less volatile, but it is important to note that all forms of lead are highly poisonous and should be handled with extreme care. Sometimes it is difficult to tell whether a frit contains lead oxide, so look carefully at the manufacturer's instructions to ensure it is safe before handling. Even a fritted lead glaze can be toxic after firing if not properly formulated or if fired improperly. It should never, in any form, be used on functional work due to the potential health risk, and when handling it in the studio you should wear personal protective equipment (PPE) at all times. Lead oxide is also dangerous during the firing process, so proper ventilation is imperative.

Effects on color:
Lead oxide produces brilliant colors that usually have a soft, warm appearance.

Most notably: Iron oxide produces gorgeous honey, amber, deep red, and rust; copper oxide produces rich, grassy greens; chrome oxide gives bright orange-reds; manganese oxide yields reddish brown-purples; cobalt oxide yields softer, purple blues.

Sources in glazes:
- Lead sulfide (galena)
- White lead (carbonate)
- Red lead
- Lead chromate
- Lead silicates: litharge, lead monosilicate, lead bisilicate, lead trisilicate, and lead sesquisilicate
- Frits, including frit 3304, 3403, frit 3262, frit P29

ZINC OXIDE

Zinc oxide is an active secondary flux from mid to high temperatures, with unique properties. In small amounts, it produces smooth, silky, blemish-free glazes. Unlike other opacifiers that dry a glaze up, zinc can act as an opacifier without reducing shine. It lends strength, durability, and elasticity to glazes. Its medium thermal expansion can help diminish crazing; however, in high amounts its high shrinkage promotes defects like crawling and pinholing. These defects can be tamed by calcining the zinc, which reduces its initial shrinkage. In high percentages, zinc is well known for producing the amazing structures on crystalline glazes. However, bear in mind that zinc oxide is poisonous and should be handled with care. It is not recommended for reduction atmospheres, as the zinc will volatilize, creating toxic dust that falls from the chimney. Zinc may also be contaminated with traces of lead, due to the two naturally occurring together in the igneous rocks from which it is mined.

Effects on color:
Zinc oxide has significant effects on color that can be quite contrary. Often, it is recommended to avoid additions of zinc because it will "discolor" the glaze; some

of its unique effects include rendering brilliant colors (from iron oxide, manganese oxide, and chrome oxide) brownish and murky. Also, it can hinder the development of copper reds. However, it produces intense royal blues with cobalt oxide, turquoise greens from copper oxide, and pink to brown from tin oxide.

Sources in glazes:
- Zinc oxide
- Calcined zinc oxide

FRITS

Frits are manufactured ceramic materials produced by melting together various raw ceramic materials (mostly fluxes and glass formers). The molten glassy matrix is then poured into cold water, where it shatters due to thermal shock. It is further ground down into a powder, with the intention that it can be added to a glaze as a flux. The frit has the same proportions of chemicals as it did pre-firing, but they are now chemically bonded to one another. This process is employed for a number of reasons, including to drive off gases, to help produce glazes that will have less pinholing in later firings, and to eliminate any undesirable effects the materials may exhibit in their raw state. Frits can render problematic materials such as lead oxide, barium oxide, zinc oxide, and boron oxide more stable, less soluble, and nontoxic (though this "nontoxic" label does not preclude improper glaze formulation and firing). Frits are standardized products for industrial applications that eliminate flaws and create a more predictable, stable, and uniform melt than with a simple mixture of the various raw minerals. There are thousands of frits produced, but thankfully only a handful are commonly used in the ceramics studio.

Effects on color:
A range of effects is possible, and these depend entirely on the oxides in each particular frit.

Sources in glazes (most common):
- Ferro frit 3110 (sodium/some calcium)
- Ferro frit 3124 (calcium/boron/some sodium)
- Ferro frit 3134 (sodium/calcium/boron)
- Ferro frit 3185 (sodium/boron)
- Ferro frit 3195 (sodium/calcium/boron)
- Ferro frit 3269 (sodium/boron)
- Ferro frit 3304 (lead)
- Pemco P-25 (sodium)

GLASS FORMERS

Glass formers are essential to the glaze matrix. They act as the "bones" of a glaze, creating a framework of links between molecules. When fired, their structure takes on an amorphous state, creating the glassy effect.

SILICA

Silica, or silicon dioxide, is the primary glass former in ceramics and is an essential ingredient for the development of glazes. It is the most abundant mineral in the Earth's crust (it makes up 60 percent of it) and, along with alumina and water, is the fundamental building block in clay and glazes. Silica is essentially glass, but it melts at a very high temperature, which is why glazes include fluxes to lower the melting point and achieve a glassy matrix at pottery temperatures. In nature, silica is found in thousands of minerals, most purely as quartz rock. In the lab, it may be referred to most accurately as silica, but sometimes also as quartz or flint. Additionally, it can be added to glazes from clays, feldspars, and silicates such as wollastonite (calcium silicate) and talc (magnesium silicate). Silica is a class 2B carcinogen that causes the lung disease silicosis, but is present in most ceramic materials. Contact with the skin is not hazardous, but you should avoid inhalation. The best protection is to use a respirator at all times when clay particles are dry and/or airborne, and to use best cleaning practices, especially wet cleaning in the studio (see page 36).

Effects on color:
Silica's effect on color is minimal. Mainly, colors are brought out and intensified by being included in a glassy matrix. If the color exists in the clay or a slip on the surface, a clear glaze over the top will deepen that color. Less commonly, high-silica glazes may cause sugary mattes that render colors more pale and dull.

Sources in glazes:
- Silica 200 mesh
- Silica 325 mesh
- Silcosil
- Flint
- All kaolin/clays
- All feldspars
- Wollastonite
- Talc
- Zirconium silicate
- Macaloid
- Bentonite
- Pyrophyllite
- Kyanite
- Silicon carbide
- Sand
- Mica
- Frits
- Wood ash

BORON OXIDE

Boron oxide is unique, because it is both a glass former and acts as a flux. Boron most often occurs in nature in combination with other materials such as sodium oxide, calcium oxide, and magnesium oxide. It melts at a low temperature, which is generally considered a great asset. For this reason it has been used as an alternative to lead oxide in poisonous, low-temperature lead glazes. Because of boron's relatively high solubility, many potters prefer to introduce it into a glaze in the form of a frit. With less than 10 percent in a glaze, boron can alleviate crazing due to its low expansion and contraction rate; however, high amounts may actually increase crazing. Boron glazes tend to be smooth, shiny, and sometimes runny due to their low surface tension, low viscosity, and powerful fluxing abilities.

Effects on color:
Color production with boron oxide is generally very good, with bright alkaline colors easily achieved. It can impart a characteristic bluish, milky tint to glazes, and may be streaky.

Sources in glazes:
- Gerstley borate
- Laguna borate
- Borax (sodium tetraborate)
- Boric acid
- Calcium borate
- Colemanite
- Ulexite
- Many frits

PHOSPHOROUS OXIDE

Phosphorous oxide is a glass former, but is usually present in glazes in trace amounts and is not considered a substitute for silica. When it melts, it remains separate from the silica melt. It has a high expansion and contraction rate and is highly soluble in water. It is often used in the form of bone ash, and in this form adds translucency and vitrification to bone china clay bodies.

Effects on color:
Phosphorus oxide may lend a bluish tint to glazes and encourages an opalescent or iridescent glass, with a tendency toward opacity. This colloidal opacity is a characteristic of Jun glazes.

Sources in glazes:
- Bone ash (calcium phosphate)
- TCP (tri-calcium phosphate, or synthetic bone ash)
- Wood ash
- Plant ash
- Some frits

OPACIFIERS

Opacifiers are used to create glazes that do not allow light to pass through them; they take away their translucency and reflect light back, typically turning a clear glaze white. Often, at higher temperatures, refractory materials such as kaolin are used to opacify a glaze. At low temperatures it is common to see tin oxide, titanium oxide, and zirconium silicates added to a glaze specifically for their opacifying properties; however, it is important to note that they have additional effects on a glaze's behavior and color response.

TIN OXIDE

Tin oxide is the most effective and commonly used opacifying agent, often in amounts up to 15 percent. It has been used for hundreds of years and was the original opacifier for historic majolica glazes at lower temperatures. In high-fire reduction it loses its opacifying ability, leaving a cloudy, gray surface. Tin oxide is slightly refractory, which can help stabilize glazes; however, it increases the chances of some glaze flaws including crazing, pinholing, and crawling, due to its combination of low expansion and contraction rates, surface tension, and viscosity. Tin oxide is more expensive than other opacifiers, but is often preferred for the shade of white and quality of surface that can be achieved.

Effects on color:
Tin oxide produces an attractive soft cream to blue-white. Tin also enhances the color effects of iron oxide, producing warm oranges and reds. It is quite reactive with some of the colorant oxides, again producing chrome pinks and copper reds. It is also susceptible to those colorants when they volatilize and can flash red and pink when they are present in a firing.

Sources in glazes:
- Tin oxide
- Stannic oxide
- Black tin oxide

TITANIUM OXIDE

Titanium oxide opacifies a glaze by developing many small crystals that reflect the light. In this way, it adds interest to the surface and can have exciting effects on colorants, especially in small amounts of just 1–2 percent. Titanium oxide is also a refractory that will harden and stiffen a glaze, depending on the amount added. In amounts from 2 to 5 percent a glaze can take on a variegated mottled satin surface, and in amounts up to 20 percent, a drier crystalline matte surface with muted colors can be achieved. As little as 5 percent is needed for complete opacity in most glazes.

Effects on color:
Titanium oxide produces a soft white to buff color that is responsive to the clay color underneath, producing a warmer cream on iron-laden clays. Effects on colorants are often desirable, with cobalt oxide producing soft greens, bright yellow to orange with iron oxide, and copper oxide producing bluish streaks; in reduction with copper reds, it will yield pearly, purplish-blues.

Sources in glazes:
- Titanium dioxide
- Rutile (iron and titanium)
- Illmenite (granular iron and titanium)

ZIRCONIUM OXIDE

Zirconium oxide is a highly refractory material that does not melt even at high temperatures, leaving its particles suspended and so creating opacity. It is not as powerful an opacifier as tin or titanium oxide, with amounts up to 15 percent added for opacifying effects. It is often used in combination with tin to reduce costs (tin is expensive), which also renders the zirconium white, a softer tone. It has a low expansion and contraction rate, which may reduce crazing, and it is a very strong material that will make glazes durable and hard. Zirconium oxide is most commonly used in glazes fritted with silica, or as zirconium silicate, and in this form, it can actually add to the fluxing action of a glaze.

Effects on color:
Zirconium oxide produces a bright, hard, cool white. It does not have any dramatic effect on the colorant oxides. Fritted zirconium silicates are often used in the formation of commercial stains and glazes to produce solid, opaque colors that are durable and stable.

Sources in glazes:
- Zirconium oxide
- Fritted zirconium silicates: Zircopax Plus, Superpax Plus, Excelopax, Ultrox, Opax, Opazon

COLORANTS

Colors in ceramics can be achieved in many ways; however, the metallic oxides, also known as the colorant oxides, are the primary vehicle for adding color to an existing glaze. The oxides each have a range of effects that are influenced by the ingredients of a glaze—mainly the various fluxes present, the atmosphere of the kiln, and the temperature of the firing.

CHROME OXIDE

Chrome oxide is highly toxic and is classified as hazardous waste. It is a very strong colorant that generally produces deep greens. It is highly refractory, which means that it can dry out a glaze, and may even cause crawling in high amounts. You rarely need more than 2 percent in a glaze, as it will affect color with as little as 0.25 percent. As well as being toxic, chrome oxide volatilizes during firing, so take care (wear gloves and a respirator) when handling it, and avoid exposure to the extremely toxic fumes from firing. Even at lower temperatures the volatile chrome can affect adjacent glazes by "fuming" during the firing, flashing barium oxide and tin oxide glazes pink. Though chrome oxide is known for producing intense greens, it has a range of effects

based on the other materials in a glaze: In the presence of zinc oxide it produces tans and browns; with tin oxide it produces pinks; with lead oxide it can create yellow-orange and red. Bright yellow and chartreuse can be achieved in small amounts with barium oxide and sodium oxide. A brighter green can be achieved in combination with cobalt oxide. With iron oxide, it can go gray to cool blue. In combination with other oxides in high amounts, it is used to help produce deep blacks.

Sources in glazes:
- Chromium oxide
- Potassium dichromate
- Lead chromate
- Barium chromate
- Iron chromate

COBALT OXIDE

Cobalt oxide is the strongest of all the colorant oxides and it is probably the most recognized for its long history of creating rich blues, from deep and inky to brilliantly bright. It is generally unaffected by atmosphere and is a very strong flux, dissolving readily in a glaze. Just 0.25 percent can stain a glaze blue, with 1 percent generally being sufficient for deep color. For metallic bluish-blacks, use 3 percent. Cobalt carbonate is not as strong a colorant as the oxide form, but it produces a more even, less speckly, color. In combination with certain other oxides, a range of colors can be achieved: With the alkali and alkali earths it produces bright ultramarine blues; with lead oxide it can make dark, inky blues; zinc oxide produces gray-blues; magnesium oxide produces a range from pink to purple to blue. In combination with other colorants such as iron oxide and chrome oxide, cobalt oxide is used to make black. Cobalt oxide is toxic and should be handled using gloves.

Sources in glazes:
- Cobalt oxide
- Cobalt carbonate
- Cobalt sulfate

COPPER OXIDE

Copper oxide is most often recognized for producing greens and reds, though it has an incredibly wide range of coloring effects and can be used in proportions as little as 0.3 percent and as high as 9 percent for distinct effects. It is a high-fluxing oxide that dissolves well in glazes and is very reactive to atmosphere. All forms of copper oxide are toxic and it should be handled with gloves. It is also volatile at higher temperatures and fumes should be avoided. Its volatile fumes may flash red or pink on other tin glazes in the kiln. In oxidation, copper produces brilliant grassy greens with lead oxide; turquoise, blue-green, sky blue, and purple with alkaline glazes; and pink, orange, and even gray with magnesium glazes. In reduction copper oxide is known best for its brilliant reds, which can be enhanced with small amounts of tin or iron. It can also produce deep greens, purples, blacks, and metallic lusters.

A note about types of copper: Copper carbonate is the easiest form of copper to work with, producing even coloring, while black copper oxide may produce speckling due to its large mesh size. Red copper oxide particles are coated to prevent oxidation, rendering this substance difficult to mix with water, and it also has the weakest coloring effect.

Sources in glazes:
- Copper carbonate
- Black copper oxide
- Red copper oxide,
- Copper sulfate

IRON OXIDE

Iron oxide is the most common of all the colorant oxides and is the most versatile in terms of its wide range of colorant possibilities and its effect on glazes. Iron is one of the most abundant minerals on Earth, after silica and alumina, so is found in most materials in the lab, often in significant amounts. Even when iron oxide is not added as a colorant, it plays a role in color development by way of its

trace inclusion in various glaze ingredients, and often its more substantial proportions in a clay body. It is common to add iron oxide to glazes in amounts varying from 0.5 to 12 percent, and it can be used in even higher amounts. It is a refractory in oxidation and a flux in reduction, and can produce wildly different color reactions depending on the atmosphere of a firing. It is responsible for the characteristics of many historically prevalent glazes such as celadon blues and greens with 1–2 percent, and in higher quantities Temmoku, hare's fur, and oil spot.

A note about types of iron: There are many sources of iron for glazes, with the most common and accessible being red iron oxide. Each material listed below will have different effects as a result of their overall makeup and chemical composition.

Sources in glazes:
- Red iron oxide
- Black iron oxide
- Yellow iron oxide
- Spanish iron oxide
- Purple iron oxide
- Magnetic iron oxide
- Synthetic red, yellow, and black iron oxide
- Illmenite (granular iron and titanium)
- Light and dark rutile (granular iron and titanium)
- Iron sulfate
- Iron chromate
- Crocus martis
- Burnt umber (iron and manganese)
- Yellow ocher
- Burnt sienna (iron and manganese)
- Rust
- Earthenware clays, including: Redart, Albany, Alberta, Barnard Blackbird, Michigan, Ranger Red, etc.
- Slip clays

MANGANESE OXIDE

Typically, manganese oxide is used to affect color in amounts of no more than 4 percent, which produces a very dark brown to black. In smaller amounts manganese

oxide can produce purple, maroon, pink (especially in alkali glazes), and even yellow. In high amounts, or in combination with copper oxide, manganese oxide can produce gold-metallic glazes. It is a main ingredient in fritted black stains and is often used to stain clay bodies black. It acts as a refractory at lower temperatures but is a very powerful flux at high temperatures, which can cause bloating and even deformation of a piece. It is highly toxic as well as being volatile at high temperatures. Manganese should always be handled with gloves and a respirator and you should avoid the fumes. Fired works are not recommended for food safety and should be tested before use.

Sources in glazes:
- Manganese carbonate
- Barnard Blackbird
- Some ores, including burnt umber (iron and manganese) and burnt sienna (iron and manganese)

NICKEL OXIDE
Nickel oxide is a strong colorant (use 0.25–1 percent) that produces a range of colors, mostly in quite muted tones including subtle grays, smoky blues, greens, browns, yellows, and pinks. However, nickel oxide can produce more distinct color reactions in glazes that have one dominant flux—for example, sharp greens can be achieved with magnesium oxide, and pink and purple can be produced with barium oxide. It is often used to tint a glaze and to modify other colorants such as cobalt oxide or copper oxide. It is used in combination with zinc oxide to create astonishing blue crystalline glazes. Unstable at higher temperatures, nickel oxide has a tendency to migrate and scum the surface of glossy glazes during cooling. Like so many other colorants, nickel oxide is toxic and produces dangerous fumes as a result of its volatility at higher temperatures, and should be handled with care.

Sources in glazes:
- Black nickel oxide
- Green nickel oxide

RUTILE
Unlike the other colorant oxides, all forms of rutile are a combination of oxides that occur naturally as an ore of titanium oxide with varying amounts of iron oxide. The ores are processed to varying degrees, and by industry standards are considered rutile with up to 15 percent iron oxide, and illmenite with over 25 percent iron oxide. Even when processed, color effects can be unpredictable due to the fluctuating proportions of titanium oxide and iron oxide from batch to batch. Though titanium oxide and iron oxide are not toxic, rutile may contain impurities such as chrome oxide and vanadium oxide that are, so take care when handling it. A wide range of colors and textures can be achieved with rutile, and it can be added in amounts from 2 to 14 percent. Color results are similar to the effects of iron oxide, including cream, tan, yellow, orange, and brown in oxidation, and purples and blue-grays in reduction. It can produce interesting results with other colorants, including opalescent purples with manganese oxide, gold and green with cobalt oxide, and yellow-green with copper oxide. The titanium oxide adds opacity to the glazes, creating lovely satin matte surfaces, and in higher amounts will produce a mottled surface as a result of crystal development. Granular types of rutile will produce brown speckling.

Sources in glazes:
- Light rutile
- Dark rutile
- Granular rutile
- Illmenite

OTHER UNCOMMON COLORANT OXIDES
All of the following oxides are toxic, and some are extremely dangerous! Use them sparingly, carefully, and with a full understanding of their health risks. Commercial glazes, stains, and enamels may contain these materials too, so read labels carefully and take proper precautions. Remember, even when fritted, toxic materials may still pose a health risk.

- Antimonite of lead—produces yellow in lead glazes
- Antimony oxide—at low temperatures gives a pale, creamy yellow; stronger yellow with iron oxide
- Cadmium carbonate/Cadmium sulfide—low-temperature glazes and enamels that produce bright yellow, orange, and red; burn out at high temperatures
- Gold chloride—produces pinks and purples; used in lusters; cost prohibitive
- Molybdenum oxide—produces yellow to yellow-green
- Praseodymium oxide—a rare earth oxide, produces bright yellows with zirconium oxide
- Selenium oxide—produces very bright yellow at low temperatures, and orange and red with cadmium, lead, and sulfur; burns out at high temperatures
- Silver carbonate/Silver nitrate—produces soft yellow to green and iridescent lusters; pearly with bismuth, yellow and green with copper; cost prohibitive
- Vanadium pentoxide—produces yellow to orange, often with tin; a strong flux; volatile, creating toxic fumes

STAINS

Stains are fritted colorants designed by manufacturers to render ceramic colors safer and more reliable. By fritting various colorant oxides, a more uniform blend is achieved, affording the stains a wider temperature range and more consistent, reliable, and even colorant effects than those achieved with raw materials. Stains, because they have been fired and ground back to powder, are colored like the effects they achieve. One main incentive for the development of stains is to render toxic colorants safer to use. By trapping the toxic oxides in a glassy matrix, they are not as readily absorbed into the body through the skin or by inhalation. However, it is

important to note that toxic materials that are fritted are still susceptible to leaching if the proper glaze melt is not achieved, and they still may become volatile during a firing.

ADDITIVES

Additives are used in glazes to improve their properties in a number of ways, from making them stronger and more durable when dry, to increasing brushability, to keeping the glazes in suspension for a well-dispersed application. Some are ceramic materials, while others are not and will burn out in the firing.

SUSPENSION AGENTS
Suspension agents are added to a glaze to help keep all the particles from settling to the bottom of the bucket by thickening the existing glaze. They work by altering the electromagnetic charge of the clay materials so that they remain buoyant and evenly dispersed. Most agents also act as binders, making the glaze harder and more durable in its unfired state. For best results, blunge agents well in warm water before adding to the glaze slurry.

Clay minerals
- Bentonite—a very small and very plastic clay material, composed from the mineral montmorillonite, that expands dramatically when added to water; a common studio material used for glaze suspension and clay plasticity; contains iron
- Macaloid—similar to bentonite, but fires very white

Gums
- CMC (sodium carboxymethylcellulose)—a biodegradable, water-soluble polymer; gums can slow drying of glaze, causing drips (see "Vehicles," below)
- Veegum—complex colloidal magnesium aluminum silicate; three different versions, "T," "Pro," and "Cer," are available from ceramic suppliers

Flocculants
- Epsom salts—magnesium sulfate; readily available from grocery stores
- Vinegar—suspension properties only last a few days

DEFLOCCULANTS
Deflocculants are added to thick slurries such as casting slips and some glazes to encourage flow and pourability while minimizing water content. Deflocculants work by altering electromagnetic charges so that clay particles repel each other.

- Sodium silicate—most commonly used with casting slips in combination with soda ash; easy to over-deflocculate
- Soda ash—soluble; often used in casting slips with sodium silicate
- Darvan 7 and 811—alternatives to sodium silicate that aren't as destructive to slip casting molds; more difficult to over-deflocculate; shelf life of two years; should not be frozen

VEHICLES
Glazes typically don't flow well from a brush onto bisqueware because the water is quickly absorbed, leaving the materials clumped on the brush. Adding a vehicle will assist with smooth brushing and will also help to harden the glaze once dry.

- CMC gum—a biodegradable, water-soluble polymer; mix with warm water to form a gel, then add incrementally to glaze and test for brushability
- Glycerine—available at most drugstores as a liquid; can be substituted for some of the water in a glaze to help brushing
- Karo syrup, sugar, gelatine—easily found at the grocery/drugstore and can work well; will ferment and smell if left for any length of time

CALCINED MATERIALS
Calcined kaolin has been fired high enough to remove all plasticity and to drive off chemical water. It is used in glazes with high clay content to minimize shrinkage.

Glaze Defects and Remedies

Glaze defects are a common occurrence in ceramics. And there are many factors that can cause undesirable effects in a glaze. Here we learn to recognize, treat, and avoid some common defects.

Glaze Defects: Causes and Remedies

The primary causes of glaze defects are the techniques used for mixing, applying, and firing the pieces, so defects can easily be remedied by adjusting your techniques. In some cases though, a defect is caused by material phenomena, making it difficult to avoid. Below is a list of common faults with a list of their possible causes and some remedies.

Fault	Description	Causes	Remedy
Blistering	Large bubbles in the surface of the glaze that can be closed or popped open	• Gas trying to escape from glaze or clay body beneath • Glaze not dried completely before firing • Two layered glazes that don't agree • Too much of some materials, such as chromium oxide	• Often, firing the glaze slower at peak temperature will allow blisters to form and then settle flat • Eliminate or lower the ratio of problematic materials • Never layer a shino glaze on top of another glaze
Crazing	A series of fine cracks in the glaze surface, resulting from shrinkage differences between the clay body and glaze	• Glaze expansion and contraction rate is higher than that of the clay body	• Adjust the glaze recipe so that it has a similar expansion and contraction rate to the clay body • Try adding lithium or magnesium oxide
Crawling	The glaze pulls away from itself on the body, forming beads	• Dust or grease on the clay body • High surface tension • Glaze is applied too thickly	• Wash work and let dry before glazing • Reformulate the glaze to reduce surface tension • Apply glaze thinner next time
Pinholing	Small pockmarks that reach through the glaze to the surface of the clay	• Grog or dust on the surface • Burst bubbles that haven't healed over due to gas release	• Wash work and let dry before glazing • Hold the firing at top temperature for longer periods to allow bubbles to settle

Attempting to Refire

If a piece is highly valuable to you and there is a glaze defect, it may be worthwhile attempting to fix the piece by refiring. Some defects such as dunting, crazing, and shivering are not reversible, but by grinding down and/or reglazing where a blister or pinhole defect exists, refiring may help even out the glazed surface.

Occasionally, however, the refiring process causes more problems than it fixes. Each time a glaze is remelted, materials are exposed to the heat for longer, causing them to change their look, by running or crystallizing more. That is not necessarily a bad thing; however, each time ceramics are heated up and cooled, they go through quartz inversion, stressing the body. Also, more cristobalite could form, further increasing its expansion and contraction rate, which can cause problems such as dunting. Sometimes, though, this may give a desirable effect!

Fault	Description	Causes	Remedy
Dunting	A clean-edged crack that runs through the glaze and the clay body, sometimes fracturing the piece	• The kiln was cooled too fast • The glaze does not fit the clay body (too tight)	• Cool the kiln more slowly • Address clay and glaze fit problems by adjusting one or the other
Bloating	Bubbles that push out from within the clay body	• Organics/carbon trapped in the clay body during glaze firing • The clay body has begun to melt and volatilize, releasing gas • Overfiring	• For earthenware, fire bisques as hot or slightly hotter than the glaze firing to ensure that all carbons are burned out the first time • Reduce the temperature of the firing for the clay body
Leaching	A mostly invisible phenomenon whereby materials in the glaze migrate to whatever it is in contact with. A leach test (see page 38) may reveal subtle changes in a glaze's color and/or texture. Here you see that the blue glaze has turned black after a leach test with a lemon slice.	• The glaze is underfired or the glaze matrix is not well balanced, leaving some materials unmelted • Some materials, like barium oxide and lead oxide, will leach no matter how well a glaze is formulated	• Fire the kiln hotter for this glaze • Reformulate the glaze matrix for better melt (use UMF) • Do not use glazes containing barium oxide, lead oxide, or any of the toxic metals listed on pages 24–33 in pottery intended for food use
Shivering	Along crack lines in the glaze, it begins to pop off the body in flakes, like old paint—the opposite of crazing	• The glaze has a lower expansion/contraction rate than the clay body	• Adjust the glaze recipe so that it has similar expansion and contraction to your clay body by removing low expansion/contraction oxides or adding high expansion/contraction oxides. • If spodumene is used in your recipe, find a substitute that has a more moderate expansion/contraction rate.

Health and Safety

The ceramics studio should be a safe place where the ability to create is the focus. Being educated about material hazards and the proper use of studio equipment and tools will help you establish safe working habits that benefit everyone, including those who may share the studio space and customers bringing the finished work into their homes. Many health and safety rules are common sense; however, there is much to know about specific ceramic hazards. While testing glazes can be a delight, these materials must be approached responsibly, with an awareness of the implications for your health and the environment.

Breathing Apparatus

A particulate respirator with replacable filters (bottom) is a safer and more efficient protection from dust particles than a disposable variety (below) that will not stop silica dust effectively.

CLEANING UP

Cleaning up should be an integral part of good studio practice. There are times when making a mess is part of the process (and part of the fun!), but it is not always necessary to be covered in clay. Cleaning up right after you have finished working is important not only to keep things organized, but also for your health. Studio aprons and towels should be washed regularly, and all work surfaces should be routinely wiped down with a clean, wet sponge. Keeping yourself and the studio clean will benefit you in the long run.

DUST

Probably the most important safety issue that ceramicists encounter is dust. The silica dust produced by handling dry clay and glaze materials can stay airborne indefinitely; ultimately it accumulates in the lungs and causes chronic damage, including silicosis, which is a progressive, incurable disease. If you will be spending any time in the clay studio, you should minimize this risk by investing in a good-quality particulate respirator that is properly fitted and equipped with the correct replaceable filters. Working in a well-ventilated area with good fresh air exchange is another good option, along with the respirator. Note that the disposable dust masks available at the hardware store are only "nuisance" masks and will not stop silica dust effectively. It is best to have your respirator professionally fitted, which can be done easily at most places they are sold, and be sure that all facial hair is shaved off, as this will ensure an airtight fit.

TOXICITY

While all ceramic materials should be considered potentially dangerous when inhaled as dust, there are other safety precautions that must be taken while handling certain raw materials. The toxicity of a material can range from being a mild skin irritant to being a known cause of very serious diseases, such as cancer. Substances can enter the blood stream through inhalation as well as through the skin or open wounds. Reduce the risk by knowing your materials, and always ask your supplier for a Safety Data Sheet (SDS). Keep the sheets compiled and easily accessible in your studio, and when you acquire any new materials, add the SDS to your collection. See the end of this section on page 39 for a list of toxic materials.

Individuals with sensitive skin and respiratory issues should take special care. Children should never handle toxic materials and should only be allowed in your studio under constant supervision.

FUMES

There are a number of different causes of dangerous fumes in the studio. During the firing, hazardous, carbon-based fumes occur during the burnout cycle, as well as whenever a fuel-burning kiln is put into reduction. When soda (sodium carbonate) and salt (sodium chloride) are

Studio Habits to Minimize Dust

- When mixing clay and glazes, always wear a respirator and work with a good ventilation system.

- Always mop the floor instead of sweeping. If the dust is wet, it is much less likely to become airborne. It is smart to scrape crumbs into a dustpan with a scraper first, then mop. If you must sweep, use generous amounts of "sweeping compound," a specially formulated mixture that "grabs" dust and keeps it from becoming airborne.

- Wipe down tables and work areas with a wet sponge often.

- Wash studio clothes, aprons, and towels often and keep them in the studio instead of wearing them home.

- Avoid clapping boards and hands, shaking out canvas and aprons, and blowing on dry work to clear the surface, all of which can create dust clouds in your studio.

- Use a damp towel to wipe your hands to avoid dry dust being blown into your face. Wash towels regularly and avoid dry, dusty towels.

Studio Habits to Minimize Exposure to Toxins

- Wear a respirator.
- Never eat or drink in the studio.
- Wash your hands well before eating or drinking.
- Wear surgical gloves if you have any cuts or open wounds, or whenever you are handling materials that can cause damage through skin exposure.
- Wear safety glasses to protect the eyes. Clear glasses are used to protect from dust and debris and should be used when using tools such as drills and grinders. Tinted safety goggles protect eyes from extremely bright light from a hot kiln, which can otherwise cause retinal damage when looking through spy holes.

Eye Protection

Safety glasses should be used to protect the eyes while handling toxic materials, using tools, and looking into kilns.

Studio Habits for Kiln Safety

- Practice loading and unloading kiln shelves carefully to avoid back injuries.

- Never place flammable items around the kiln. Keep the habit of never placing or storing combustibles (wareboards, gloves, and the like) on or near your kiln, even when it is not firing.

- Wear closed-toe shoes in the studio, and be aware of long or loose hair, jewelry, and clothing around equipment.

- Wear tinted eye protection when looking through spyholes into the kiln.

- When fumes from firing are present, avoid the area and/or use good ventilation and a chemical respirator.

- Wear a dust mask when unbricking a gas kiln door.

- Regularly replace filters for your respirator and any vents you use. Over time, filters fill up with the particulates they are designed to block and are no longer effective. Read the insert on your filter to find out how often it will need to be replaced.

- Keep water away from electric kilns and their elements.

- Keep open flames away from your fuel source.

- Keep children and pets away from the kiln.

Hand Protection

Latex or rubber surgical gloves (above) protect the skin when handling potentially toxic materials, and should be worn when mixing glazes and performing other procedures in the studio. Heavy-duty gloves (below) should be worn whenever there is the possibility of burning, i.e., lifting still warm wares from the kiln or in the raku firing process.

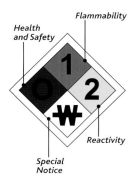

Deciphering and Using SDS Labels

Safety Data Sheets (SDSs) give Hazardous Material Information System (HMIS) ratings that should accompany each material wherever it goes. Materials are given a number code for Health (blue), Flammability (red), Reactivity (yellow), and a letter code for Special Notice (white). Numbers are listed from 0 through 5, with 0 indicating no hazard and 5 indicating extreme danger. When labeling a glaze that contains more than one material, always write the highest number found in each category onto one label. Labels should be visible on the outside of every material in the lab. Be aware of the regulations in your country for labeling, storing, using, and disposing of materials, as they may differ from the description above.

Flammability

Health and Safety

Reactivity

Special Notice

0

1

2

W

Studio Habits to Avoid Noxious Fumes

- Wear a chemical respirator when fumes are present.
- Avoid the kiln area when it is emitting hazardous fumes.

Soda Firing

A mixture of water and soda being sprayed into the kiln at the reduction phase demonstrated by the flame. This will take place several times during the firing.

introduced to a firing, the heat causes a chemical reaction that releases some harmful vapors into the air. In salt firing, the vapor contains hydrochloric acid, and in soda the vapor contains sodium hydroxide, both of which are toxic and corrosive when concentrated. For this reason, it is highly advisable to administer salt and soda quickly while wearing a chemical mask and to leave the kiln area while it is fuming. Smoke and soot from wood and raku kilns should also be avoided.

A chemical mask and gloves should be used in a well-ventilated area for the application of lusters, enamels, and china paints, as they are often mixed with or used in conjunction with hazardous solvents such as mineral spirits, lacquer thinner, turpentine, and exotic oils like lavender and clove, which are

all poisonous to inhale and can easily penetrate the skin. During the firing they are still dangerous, as hazardous fumes escape, and it is highly recommended to only fire in well-ventilated areas or outside to minimize personal exposure to the firing.

EQUIPMENT SAFETY

In general, it is important to read the owner's manual and seek appropriate training before using any piece of equipment in the ceramics studio. Wheels, pugmills, ballmills, and kilns are examples of equipment that can be dangerous if precautions aren't taken. Always wear appropriate eye, hand, and body protection when using these pieces of equipment and see that no loose clothing, jewelry, or hair could put you in danger around moving parts.

KILNS

Kilns are designed to safely produce and contain very high heat when properly installed and used. You'll need to choose the right location; abide by local laws, codes, and permits; and decide whether you need electrical hookup or gas plumbing—so you are strongly recommended to use licensed professionals to ensure your own safety and the safety of those around you. Before every firing you should check to see that no combustibles are located close to the kiln, that all safety shutoffs are fully operational, and that a fire extinguisher is easily accessible.

At-home Leach Tests

There are a few tests you can do at home to check for leaching in both an acid and a base. Two test tiles that have the same glaze on them will be required for these tests. One tile will remain untreated and is used as a control. These at-home tests are most useful in revealing egregious problems in a glaze, and are not as sensitive as lab testing. For definitive results, send your tiles to a reputable lab.

VINEGAR (ACID)

To test for leaching with an acid, fully submerge one test tile in a white vinegar bath for three days. If after three days the glaze has changed color, this is probably not a food-safe glaze.

LEMON (ACID)

In a similar way to the vinegar test, acid-induced leaching can be tested with lemon juice. Place a fresh slice of lemon on the test tile for 24 hours. Any change in the color of the glaze indicates that it is not food safe.

DISHWASHER (BASE)

Put one test tile into the dishwasher and leave it in for every cycle over the course of a month. The dishwashing detergent is alkaline and will show whether the glaze leaches with exposure to a base (as opposed to an acid).

Hazardous Materials in the Lab

The materials in the following table should be handled with caution as some are known carcinogens, and all present health risks. Inhalation is the biggest risk, but many of these materials can also be absorbed through the skin, so always wear safety goggles, a respirator, and latex gloves when handling.

Material	Found in	Material	Found in
Barium oxide	Barium carbonate Strontium carbonate (trace amounts may be present)	Firing fumes	From wax, sulfur, chlorine, fluorine, zinc, chrome, carbon monoxide, carbon dioxide, raku, salt, soda firing fumes
Cadmium pigments	Commercial glazes, particularly bright warm colors	Lead oxide	Lead oxide Lead carbonate Lead chromate Red lead Litharge (lead monoxide) Albany Slip Substitute (lead compound) Some frits, including Frit 3403, Frit 3262, Frit 3304 Zinc oxide (may have trace amounts)
Ceramic fibers	Fiberfax Insulating firebricks Talc		
Chlorides	Hydrochloric acid from salt firing		
Chrome oxide	Chromium oxide Chromate Chrome ore Iron chromate Lead chromate Light, dark, and granular rutile Potassium bichromate	Lithium oxide	Lithium carbonate Spodumene Lepidolite Petalite Some frits
		Nickel oxide	Nickel carbonate Black nickel oxide Black iron oxide (trace amounts of)
Cobalt oxide	Cobalt oxide Cobalt carbonate Cobalt sulfate		
Copper oxide	Copper oxide Copper carbonate Copper sulfate	Manganese oxide	Manganese dioxide Barnard Blackbird and Barnard Substitute
		Vanadium oxide	Vanadium pentoxide

A Note on Safety Guidelines

Safety guidelines are reassessed regularly, and you should err on the side of caution with the handling of materials. For example, barium carbonate is currently added to some earthenware clay bodies to prevent scumming (migration of salts to the surface). Even though it is added in minuscule amounts (0.5 percent) and converts to barium sulfate, a less dangerous form, it is still hazardous. Though it is not widely recommended to use it at all, if you do you should always wear protective gloves when handling it.

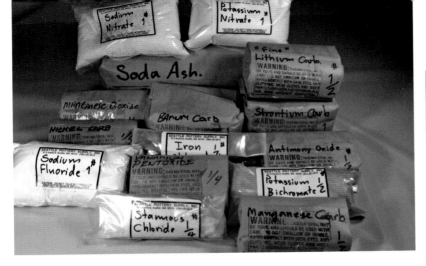

Label Materials

Glaze materials should be clearly and legibly labeled with warning signs where appropriate. Materials do not come from the manufacturer with standardized labels that are easily understood by the artist. Always cross-check information with your supplier, and label accordingly.

KILN SAFETY

While firing, kilns should be carefully managed. They can produce hazardous fumes, high heat, and bright light. You should avoid exposure to fumes by wearing a chemical mask or temporarily vacating the area. Proper ventilation should always be running for the duration of every kiln firing.

The bright light produced during firing can damage eyes with only minimal direct exposure. This risk is greatly reduced if you wear tinted eye protection, with a shade protection of at least 1.73.0, when looking through the spies to check your cones. Regular sunglasses are NOT effective at preventing retinal damage from kilns.

Despite being very well insulated, the outside of the kiln can still be very hot while firing and cooling and can cause third-degree burns. Always wear durable protective leather gloves when handling kiln parts and unloading hot shelves and work. Never touch a kiln with your bare skin while it is firing and cooling.

ENVIRONMENTAL FACTORS

Because ceramic materials are mined from the earth, people often assume they are easy to dispose of safely. However, this is a huge misconception. When materials are mined, they are highly refined, and metal oxides in particular accumulate into highly concentrated forms that are essentially hazardous waste. Most clays and some glazes are not problematic in this regard, and it is fine for them to end up in a landfill, but washing a glaze with toxic materials in it down the sink is putting these harmful chemicals directly into our water supply, which is very unsafe.

DISPOSING SAFELY

The right way to dispose of hazardous glaze materials is to collect them into a "hazardous materials" drum—never wash them down the sink. Begin by using a "glaze trap" or a separate bucket in the sink for rinsing brushes and tools. This bucket can be periodically switched out and left to dry. When the sludge at the bottom has stiffened, it can be transferred to a bag and put in the hazmat drum. Call your local dump to inquire about how to properly dispose of hazardous materials in your area.

An alternative to this is to take the sludge and fire it. Once it is vitrified, the hazardous materials are "trapped" in the glaze and it can be disposed of in the regular trash. You could fill a bowl with it for firing, but be sure that it is strong enough to hold the material, or you may end up with a mess if the bowl cracks and glaze spills onto your shelves. Also, you could use it for some creative project, to "upcycle" the material. Who knows? It may come out as a beautiful glaze.

PURCHASE AND STORAGE OF MATERIALS

All clay and glaze materials should be clearly labeled with their name, and any warning signs should be visible and legible. It is nearly impossible to identify a bin of unlabeled white powder, and unless you know otherwise it should be disposed of as hazardous waste. Keep stored materials well identified.

Materials often come in 50 lb (25 kg) paper bags that can be cumbersome, prone to tearing, and not resistant to moisture. It is important that you do what you can to keep your materials dry and free of contaminants to ensure accuracy when they are used. Whenever you transfer materials to new containers, it is a good idea to keep pertinent information with them by cutting the label from the original packaging and storing it with the materials. SDS labels can be acquired and applied to all raw materials as well as mixed clay and glazes in your studio so that you will always know what they are and what hazards they may present.

BUYING NEW

Purchasing materials secondhand is not recommended because of the risk of mislabeling, which could not only be dangerous, but also could waste precious hours of glaze testing if the materials are unreliable. Be sure your source is trustworthy if you choose to do this, and look for materials that are in their original containers.

In addition, some items, such as plaster, can "expire," having absorbed water over time, rendering it unusable. Most ceramic materials will last forever, though it is a good idea to check for

this before placing large orders of materials that you may not use for a long time.

HOW TO AVOID TOXIC TABLEWARE

If you make work that will come in contact with food, there are considerations to be taken into account. Some glazes are not food safe, meaning they either contain toxic materials that can find their way into food, or they are not hygienic. The latter is not always considered a problem.

The primary concern for keeping functional wares hygienic is the absorption of food and bacteria into the glaze and clay body, which can happen when the porous clay body and faulty glazes are exposed to the food. Crazing, pinholing, and other glaze defects (see pages 34–35) allow food to seep into the cracks and crevices, creating a breeding ground for bacteria. Also, if a glaze is matte with a rich crystalline surface, or if the glaze is not fully vitrified, it may cling onto food particles. Though this isn't a consideration for some, it needn't be a disadvantage; there is a long tradition of purposely allowing this to happen, and there are no documented cases of people being harmed from crazed work. Similar to seasoning a cast-iron pan, one school of thinking is that a teapot, say, gets better with age. Given time to absorb tea from years of use, the vessel imparts a richer flavor with each brew. Most pottery with simple crazing is considered safe to use as long as the glazes themselves are safe and the dishes are washed well.

DEALING WITH DEFECTS

Crazing and other glaze defects really become a problem when a glaze contains toxic materials, because the flaws can allow the toxins to escape from the glaze and contaminate the food. This may happen with glazes that are underfired or contain a large percentage of oxides, which can cause the materials not to be fully fused. In that case, certain oxides can leach, or transfer, from the vessel into a liquid or moist food and then be consumed by the user, poisoning him or her.

It is possible that glazes contain materials (such as lead, chromium, cobalt, copper, manganese, nickel, barium, selenium, cadmium, and lithium) that can leach from a glaze that appears perfectly safe. While the list on page 39 reveals which materials are hazardous, some of them are considered safe once they have been embedded in a glaze matrix. This is the case with many stains and frits that contain hazardous materials, because they have been fired with other materials, chemically bonding to them, and then are ground back down to a fine powder. The idea is that they are fully "trapped" in the glaze. However, even fritted materials can become "undone," depending on the other ingredients in a glaze. For example, copper oxide is known to promote solubility of other dangerous agents. Lead oxide is particularly toxic and should not be trusted even in frits. Barium oxide is also particularly problematic and should never be used for functional wares.

AVOIDING TOXICITY

In order to avoid having to worry about creating toxic tableware, you may choose to discontinue the use of all toxic materials. This may sound like the safest solution—however, many potters find this difficult in practice, as it eliminates so many options from their glaze palette. One possible compromise is to choose a liner glaze to place on all surfaces that come in contact with food. A liner usually has little or no colorant, and is reliable, durable, and designed to fit the clay body to avoid any defects like crazing, creating a truly safe and impervious surface. The more colorful and expressive glazes whose safety may be questionable are then reserved for use on the outside of the pots.

It is possible that most glaze materials can be "trapped" inside a well-formed glaze, but without lab tests you can't be confident that what you are selling isn't putting your customers in danger. If you have a glaze that you suspect may be toxic, you should send samples to be tested in a professional lab before you use it.

Safe Storage

Materials are best stored upright in containers where possible—clearly labeled to show contents and useful information. There are many white powders in ceramics and it is hard to tell one from another without any information.

Storage Containers

Sealable plastic containers come in all shapes and sizes. Always keep materials in well-labeled containers that are easily closable to keep contaminants out and minimize the risk of spillage.

CHAPTER TWO
Color

In this chapter we enter the world of color.
We will touch on the physics and psychology of
color as well as man's historical understanding
and use of color, and the development of the
color wheel. Finally we explore the use of color
in ceramics and specifically in glazes, from
Neolithic pottery through to contemporary,
conceptual ceramic art.

Color in Glaze and Ceramics

From Ancient Egypt's brilliant turquoises and greens to the Tang dynasty's Sancai masterpieces, to the infamous Ming dynasty's blue-and-whites, color is of vital importance in the celebrated history of glazes. Centuries of research and development across continents and cultures have been spent in search of beautiful and colorful glazes. Even into the 21st century, artists continue to discover new ways to create ceramic colors that are unique, prized, and mysterious.

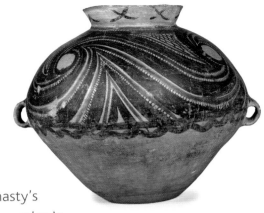

Neolithic Chinese Vessel
This vessel showcases some of the first known ceramic surfaces colored by utilizing oxides that have been mixed with water and brushed onto the dry surface of the clay.

Color was applied to the ceramic surface long before glazes were used. Pigments of red and black were brushed on to create geometric patterns and zoomorphic figures decorating the forms of Chinese pottery during the Neolithic period, between 2,000 and 10,000 years ago. Beyond decorative brushwork, the color of the clay must also be recognized as an integral part of the esthetic of these pieces. The warm earthenware orange of Neolithic Chinese pottery and the neutral tones of Japanese Jomon pottery of the same period, even if by default, add a distinct esthetic value and psychological power to the work. Its influence is still felt today, as artists make a conscious choice to work with "primitive" earthenwares, "pristine" porcelains, or anything in between these two extremes.

THE FIRST GLAZES

The elaborate history of colored glazes is entwined with discoveries of melted ceramic materials. Glazes were developed based on what was available to the people at that time, and what progress they were able to make in their techniques. The first glaze was presumably discovered by the Ancient Egyptians around 5000 BCE. Soon after, the first in-glaze colors were created by the addition of copper into the alkaline base, which enabled brilliant turquoises. Over the next several thousand years, across the ancient Near East and Asia, various colorants were discovered and by the turn of the 1st century CE,

a wide range of brilliant colors were used in glazes: copper, manganese, iron, and cobalt were employed to produce brilliant greens, browns, oranges, and blues in low-fire glazes. Lead became a popular flux in China during the Han dynasty, after the Chinese learned from the Assyrians that it produces bright, saturated colors with glossy surfaces that don't craze like the alkaline bases.

REFINEMENT

Early anagama-style kilns in China around 1500 BCE were built out of more refractory materials, enabling higher-temperature firings. They were fired with wood, which lead to the discovery of ash glazes after people noticed that wood ash melted onto the pot, forming glassy deposits. Areas of green, yellow, brown, and even blue-grays could be achieved, depending on the composition of the clay, the type of wood, and the amount of heat.

From the beginning of the Han dynasty (206 BCE–CE 220) through the six dynasties (CE 220–589), ceramic colors flourished with the use of copper and iron. Low-fire lead greens, amber oranges, and opacified white glazes were used in the very popular Tang dynasty Sancai (or tri-colored) wares, and China's high-fire celadons used iron that mimicked jade to get subtle transparent yellows, greens, grays, and blues. Also at this time, the refinement of materials enabled the creation of porcelain clay bodies. Ultimately refined during the Song dynasty (CE 960–1279), the translucent, vitrified bodies ensured that bright colors were no longer muddied

by iron and other impurities in the clay and had a fine, glasslike quality. The Song dynasty saw the development of even more varied surfaces, including the opalescent sky blue to bright purples of Chun ware, the range of iron saturate glazes like Hare's Fur and Temmoku, as well the very thick celadon, Lung Chuan.

THE SPREAD OF CERAMIC INNOVATIONS

Chinese porcelain began to be exported all across the East. During the Ming dynasty (1368–1644), production boomed as the city of Jindezhen (dubbed the porcelain capital of the world) took on factory production to meet the ever-growing demands. Initially, potters attempted to mimic the whiteness and bright colors of the fine porcelain imports. First in the Islamic world and soon after in Europe, they developed colorfully decorated low-fire white glazes atop earthenware clay, using tin as an opacifier and various oxides for the colorful brushwork. Lusterware was soon developed by firing silver and copper oxides onto the work in a reduction atmosphere.

Meanwhile, when a potent cobalt blue was utilized for decoration in Prussia it was exported to the Far East, and the Chinese artisans produced arguably the most famous style of wares with cobalt blue decoration on their porcelain during the Ming dynasty. The porcelain craze subsequently spread back across the Near East to Europe and inspired the discovery of bone china and soft-paste porcelain, and the proliferation of various tin-glazed earthenware styles of majolica (Italy), delftware (the Netherlands), and faience (northern Italy and France). The wares were colorfully decorated with green from copper, blue from cobalt, purple from manganese, orange from iron, and bright Naples yellow from lead antimonite. The Ming dynasty also saw the development of high-fire copper reds and iron yellows.

In Rhineland, Germany, salt-glazed stoneware was developed in the 15th century, in which a glassy, textured surface was created on the gray and brown pottery, with notes of blue from cobalt decoration. Salt-fired pottery flourished in England and later in the US during colonial times.

The Qing dynasty (1644–1911) saw the development of even more low-fired enamel colors, which again influenced Europeans. Once porcelain production took hold in Europe, it dominated the ceramics landscape as manufacturers like Meissen

in Germany and Sèvres in France utilized a wide range of bold, low-fire enamel colors to decorate their highly ornate functional forms and figurines. Rose pink was made using gold and tin chloride, and yellow and green were made from chrome. In England, after the 18th century, it was discovered that pink could be made from chrome and tin.

MORE RECENT DEVELOPMENTS

Realizing that lead was poisonous, alternative fluxes were explored. Zinc was considered a good flux, which enhanced some colors but turned others an unappealing brown. Borates worked well as a lead substitute and did not alter colors, but tended toward a cooler palette. Adjustments continue to be made to our glaze practices today. As we learn more about the toxicity of various ceramic materials, we work to ensure they are safe to handle not only in their raw state, but also once the fired objects are put to use. An amazing example of a discovery gone wrong was the use of uranium oxide to produce bright yellows in the early 20th century, only for uranium to be found, shortly afterward, to be radioactive and incredibly hazardous to human health.

Between 1845 and the 1940s, several new colorants were discovered. The rare earth elements neodymium, praseodymium, and erbium are used to create bright pastel pinks, purples, and neonlike yellows and greens. It was also discovered that vanadium and zirconium could produce intense yellows, greens, and turquoises, while cadmium and selenium combine to create bright reds, oranges, and yellows at low fire. Vanadium and cadmium are not suitable for pottery and require protective equipment while handling due to their toxicity.

In the last 200 years, many variations on glaze recipes and colorants have been made, and as the world has become increasingly globalized, the sharing of ideas happens faster and more fluidly than ever before. Industry now offers refined ceramic color stains that enable more predictable results in an incredibly wide range of hues. While so much has been discovered about ceramic color, it is amazing to see that even today, industry and artists still make discoveries. The mysterious nature of ceramic materials is endlessly fascinating, color in ceramics continues to astound and inspire.

Celadon Bowl

This bowl was created in the 12th century in China, during the Song dynasty. The decorative carving is revealed and highlighted beautifully with the translucent green glaze.

Bellarmine Jug

This traditional German Bellarmine jug is a good example of salt-glazed stoneware.

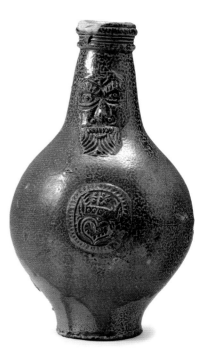

On Color

Color is a powerful tool that affects our emotions, catches our attention, and influences our actions and desires. With such deep psychological effects, color can actually impact our physical health. Over centuries we have struggled to pin down exactly what color is, and how it affects us so. Human understanding of color can most readily be understood by looking at the evolution of the color wheel. The trajectory of the wheel and our developing understanding of color is quite a fascinating story.

> 66 Colors are the deeds and sufferings of light. 99
> Goethe

HISTORY OF THE COLOR WHEEL

One of the first to propose a theory of color was Aristotle (384–322 BCE) of Ancient Greece, who theorized that light was sent down from the heavens by God after observing the way colored light changes throughout the day. He arranged seven colors in a line, beginning with the white light of day and ending with the black of night, and he felt all colors were mixtures of light and dark. Though it seems quite rudimentary nowadays, Aristotle's theory appears to have come full circle in a way: a new theory of physics called the Rainbow Theory, a very abstract concept, proposes that the Big Bang did not happen—instead, it imagines the universe full of wavelengths of color that somehow extend their energy *ad infinitum* (to infinity), with no beginning or end.

But back to the wheel. Following Aristotle, dozens of other color theories were adopted over the centuries, until Sir Isaac Newton's scientific findings came along in the 16th century and revolutionized the way we understand color. After discovering that white light can be broken up into the visible color spectrum, Newton (1642–1726) proposed that the straight band of hues

Aristotle's Color Chart
Aristotle observed changes in colored light and arranged the colors as above. From left to right: white, yellow, red, purple, green, blue, and black.

from his refracted light be arranged in a circle instead, due to the additional discovery that the end of the band could be overlapped to produce a new color. With additive color (using light), red and blue-violet overlapped to create magenta (pink), while with subtractive color (using pigments), red and blue made purple. Pink, interestingly, is a color that does not exist purely within the visible spectrum of refracted light, but can be seen when mixing. Newton's color wheel has undergone several iterations by numerous color theorists, notably, Goethe, Runge, Ostwald, Munsell, and Itten.

German writer Johann Wolfgang van Goethe (1749–1832) opposed Newton's analytical treatment of color and preferred to focus on observing color. He realized that the sensation of color reaching our brain is entirely shaped by our perception, and so color is wildly affective and subjective. He sought to derive laws of color harmony and to characterize the physiological effects of color. Though Newton's scientific theories have prevailed, Goethe's poetic writing about the psychology of color has had a huge impact on generations of artists and philosophers. Meanwhile, Philipp Otto Runge (1777–1819), a painter who lived in Germany at the same time as Goethe, was the first to publish a comprehensive color model in 3D specifically designed for artists. He added dimension to the color wheel, creating a spherical image with tonal shifts, from white at the top axis to pure color at the "equator," and black at the bottom axis. Like Aristotle, he assigned symbolic properties to the colors, with the three primary colors representing the Holy Trinity, white representing good, and black representing evil.

ADVANCES IN COLOR SYSTEMS

At the beginning of the 20th century, American art professor Albert Munsell (1858–1918) created his color system, which also organizes color into a standardized system similar to

Itten's Seven Contrasts

Itten defined seven contrasts that define color relationships and how colors interact.

Hue: This is the most simplistic of the seven contrasts. The contrast of hue is illustrated by three hues in their most saturated state side by side—for example, yellow, red, and blue. The contrast is strongest with primary colors and less so with secondary and tertiary colors.

Value (light/dark): The effects of white and black are opposites, with the range of grays in between adding layers to the contrast. The lightness and darkness of colors side by side creates contrast.

Temperature (cool/warm): The contrast of temperature is based on cool colors (green, blue, and purple) next to warm colors (red, orange, and yellow). The physical effects of a color's temperature are significant (cool green is calming, while warm orange is exciting) and intensify this contrast.

Itten's Color Wheel

Similar to Runge's design, Itten's color "wheel" is actually a color sphere that has been sliced and flattened here so that we can see all parts of the diagram at once.

Complementary: Colors opposite each other on the color wheel create a powerful contrast. Interestingly, when complementary pigments are mixed, they create gray, yet when adjacent they intensify each other's vividness.

Simultaneous contrast: Related to contrast between complements, simultaneous contrast is based on the phenomenon that when any given color is viewed, the eye simultaneously desires its complement. This creates an illusion when a color is placed next to a neutral gray, whereby the gray is perceived to take on the hue of the

color's complement. For example, grey next to orange will look more blue, while the same grey next to green will look more red.

Saturation (chroma): This is the contrast between pure colors of the highest intensity and dull, diluted colors. Desaturation, or dulling, can be achieved in a few ways: by adding white, black, or gray, or by adding the color's complement.

Extension: The contrast of extension has to do with the ratio of colors in combination; the contrast between much of one color and little of another color. Colors with differing luminance may need to have different-sized swatches of color to be "balanced." Adjusting the proportions of colors can activate or pacify the colors.

The largest full ring represents the hues in their most pure, saturated form.

The concentric rings within that show increasing degrees of tint to those hues.

The partial rings or spokes that move outward show increasing degrees of shade to those hues.

Munsell Color System

Organized with equal increments for value, hue, and the intensity of chroma, this "tree" is asymmetrical with certain "branches" reaching out further where the most intense colors occur.

Newton's wheel and is based on hue, value, and saturation or "chroma." His model also affords room for perception of color, and he arranges hue into 100 equal divisions around the color circle, which are numerically labeled. Based on the principle of "perceived equidistance," colors are organized into ten hues divided into ten increments to represent value (amount of white/light to black/dark) with an open scale, allowing for colors that are capable of more distinguishable saturation levels to take up more units of chroma. This resulted in a three-dimensional asymmetrical "tree" model. Munsell's color system, with its precise and equally divided color labels, has been widely used in industry to help standardize the measurements of colors, and is still used widely today. Other popular contemporary color systems used in industry are the Pantone Matching System for pigment-based color, TRUMATCH for graphic design, and the highly precise CIE color system for the international standardization of color.

Along with advances in the color systems during the 1900s, color theory was further explored and celebrated by the art world, most notably by Johannes Itten (1888–1967) and Josef Albers (1888–1976), both of whom spent time as faculty at the Bauhaus

school in Weimar, Germany. Noted as one of the greatest teachers of color in modern times, Itten wrote the book *The Art of Color*, in which he outlines the color categories as well as his Seven Color Contrasts, which are still part of fundamental color theory taught in art schools now. Albers' book *Interaction of Color*, in which he outlines many color experiments with beautiful prints in his minimalist painting style, also continues to be a seminal source for the study of color relationships today. The color experiments of both of these accomplished teacher-artists are as informative as they are artistically stunning.

THE SCIENCE OF COLOR AND THE HUMAN ELEMENT

Through various color theories, humanity has tried to encapsulate the infinite color spectrum into neat categories of wheels and gradients. While these systems are satisfying and intelligently designed, they cannot encompass the true phenomena of all that color offers. However, advancements in the science of color have allowed for much greater understanding of color, which in effect has influenced how color is used and defined in art.

THE PHYSICS OF LIGHT

- **Color comes from light:** The famed physicist and mathematician Sir Isaac Newton discovered in 1676 that a beam of sunlight can be refracted through a glass prism to reveal the colors that can be seen in a rainbow, also known as the "spectral hues." As light is bent, the range of hues is revealed, with each corresponding to a set of wavelengths. Among the range of colors that blend from one to the next, Newton defined seven distinct hues: red, orange, yellow, green, blue, indigo, and violet.

- **Light is energy:** The spectral hues are radiant energies of differing wavelengths that can be measured in nanometers (one billionth of a meter). The visible spectrum (colors that can be distinguished by the human eye) is only a small part of the electromagnetic spectrum, which includes a wide range of radiant energies such as ultraviolet, gamma rays, and X-rays, which are shorter than the waves of the visible spectrum, and infrared, radar, and radio waves, which are longer. It can be assumed that all of these waves are "colored," but because they are beyond the visible spectrum, these wavelengths of radiant energy cannot be perceived by the human eye, adding to the mystery of color.

CONTEMPORARY COLOR THEORY

Color is defined by three main properties: hue, value, and saturation. Hue refers to the quality of a color, which we refer to by naming it—red, orange, etc.—and this name corresponds to a distinctive wavelength of color in the visible spectrum. Saturation, or chroma, refers to the intensity or purity of a color. When a hue is in its most pure form, it is "fully" or "highly" saturated, while a hue that has been partly mixed with other colors that dull it down will be referred to as "low" saturation. To lower the saturation, the color is mixed with its complement (opposite on the wheel). Value, or brightness, refers to the amount of white or black in a color. A color made lighter through the addition of white is referred to as a "tint", while a color made darker through the addition of black is a "shade."

Based on the contemporary 12-point color wheel, the six major hues of the visible spectrum have been categorized in an attempt to bring order to the color spectrum. In this pigment-based wheel,

Color Harmonies

There are endless ways to combine colors to create harmonious as well as discordant color fields. At right are seven starting points for establishing color harmonies.

Complementary: Colors that are opposite each other on the color wheel are said to be harmonious when adjacent to each other, because they are opposites and balance each other out in the mind's eye.

Split complementary: This is a variation on complementary harmonies, whereby one color is chosen on one side of the wheel and two colors are chosen that are directly adjacent to the color opposite. For example, orange would be paired with blue-green and blue-purple.

Double split complementary: This is where the two adjacent colors to a complement are chosen on both sides of the wheel. For example, orange-yellow and orange-red on one side, with blue-green and blue-purple on the other side.

Additive vs Subtractive Color

It is important to understand the basics of how color works for art making, no matter what your medium. However, in ceramics, a unique set of conditions exists. Unlike with paint, colors are achieved through the metamorphic process of firing and do not mix like traditional pigment mixtures, thus often defying the rules of subtractive color. Also, glazes have the additional properties of translucency and luminosity, which can affect the perception of color in the surface. In these cases, rules of additive color may not apply.

Additive color is made with projected light. The more colors are added to each other, the lighter they get. The primary hues of additive light are red, green, and blue. When they are projected and overlapped, they will produce the light secondaries of yellow (from red and green), magenta (from red and blue), and cyan (from blue and green). When all three overlap, they produce white. Black, then, is the absence of light.

Subtractive color is produced using pigment mixtures, and functions very differently. When light reaches an object, certain wavelengths may be absorbed while others are reflected by the pigment. The reflected wavelengths blend to form the color that is "seen" by the human eye. A green leaf, for example, absorbs all wavelengths except for the ones that produce green. A black pigment or object would be one in which all of the colors are absorbed. White, on the other hand, is the reflection of all colors, which blend together as light to produce white.

The more subtractive (pigment-based) colors are added to each other, the darker they get. When the primaries red, yellow, and blue are mixed as pairs, they produce the three secondary colors of orange, green, and purple. When all three primaries are mixed, theoretically they should produce black, though typically they produce more of a dark neutral gray.

there are three primary colors: red, yellow, and blue. A primary color can be mixed to create other hues, but cannot be made by mixing other colors. The three main mixtures that can be produced by the primaries are called secondary colors: orange (from red and yellow), green (yellow and blue), and purple (blue and red). The six tertiary colors are created by mixing the secondary colors, like blue-green and orange-yellow, thus completing the 12 points. The human eye can perceive up to ten million different colors, all of which can be produced using the hues of the color wheel along with white and black.

Colors rarely exist alone. Even if an object is a single color or monochromatic, it exists in an environment made up of additional hues. Colors become dynamic entities when viewed in combination—harmonious or discordant—and there are many specific combinations that can produce optical effects as well.

Triad scheme: This is when three colors are chosen on the wheel that are equidistant from each other. For example yellow, red, and blue.

Monochromatic: Monochromatic harmony is when all of the colors are from the same hue, just in varying tints, shades, and saturations.

Analogous: Analogous colors are those that exist in the same area of the color wheel. Analogous harmonies are when two or more of these colors are arranged together. For example: yellow, yellow-green, and green.

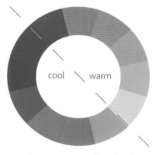

Temperature: Warm and cool colors exist on opposite sides of the wheel in their purest form. Warm colors are red, orange, and yellow, while cool colors are green, blue, and purple. Temperature harmonies are achieved when various colors have similar amounts of warmth or coolness in them. It is interesting to note that when mixing colors, it is possible to achieve a "warm" purple or a "cool" orange.

COLOR EFFECTS AND ILLUSIONS

Josef Albers expertly describes and illuminates various color effects as part of a series of color experiments for students in his book *Interaction of Color*, in which he postulates that color is relative. He begins by illustrating this point using the brilliant example of submerging one hand in cold water and one in hot water. Each hand feels the hot or cold respectively. Then both hands are placed in lukewarm water and the effect is opposite: the hot hand feels cool while the cold hand feels warm. This same effect occurs with our perception of color. What we see is always relative to the other colors around it. Albers utilizes a number of visual-perceptual color exercises to explain these variations, several of which are outlined below.

REVERSED GROUNDS

In this exercise Albers explores how color appears different depending on its background, utilizing the principle of simultaneous contrast (outlined in Itten's seven contrasts, see page 47). Two colors (colors that are complementary and of low saturation work well here) are placed side by side. A new color is mixed that lies somewhere in between the two hues, with similar value and saturation. The result is that the new color is perceptually augmented by the surrounding color ground to appear as the color from the larger adjacent swatch, and vice versa.

SUBTRACTION OF COLOR

The principle here, which is similar to reversed grounds, is that a dominant color will "subtract itself" from a smaller swatch of a less-dominant color, rendering the smaller swatch perceptually altered. For example, a small swatch of light yellow-green on a field of dark blue-green will appear lighter, less green, and more yellow than it actually is, because the green, along with any shading, will get "absorbed" by the dominant darker blue-green background. This can occur in regard to hue, saturation, and value. For example, with grays of varying value, colors or other grays will appear either lighter or darker depending on the value of the color ground behind them. This exercise can also be demonstrated by creating two different colors that look the same due to backgrounds of differing color.

VANISHING BOUNDARIES

This perceptual illusion occurs when two differing hues of the same value are placed side by side. Due to the similarity in their value, the hard edge between the two colors appears to vanish or soften and the colors seem to blend there.

VIBRATING BOUNDARIES

The illusion of vibration, or equiluminance, occurs when two complementary colors of equal luminance (brightness and saturation) are placed adjacent to each other. The human eye has difficulty distinguishing between the colors and they perceptually "vibrate" or pulse.

COLOR IN CERAMICS

Throughout history, scientists, physicists, psychologists, philosophers, theologians, and artists galore have tried to define what color is, what creates it, and how it functions. We now understand that our human color spectrum is relatively small when compared to the spectrum perceived by other living things, and we can recognize through Albers' exercises the limits of our own perceptive abilities. The inconclusive nature of current color theories makes color a mysterious and mesmerizing partner in art making as well as living. We marvel at sunsets, we lust after decorative fabrics, and we plant gardens that bloom rainbows. The

pleasure of color is undeniable, but the meaning of color is most surely subjective.

All artists use color. Whether by default or with intense purpose, it is at the core of what they do. From potters to painters to graphic designers and makers of all kinds, color is an inescapable facet that is integral to and intertwined with their practice. It is used to express emotional content as well as concepts. It helps to clarify designs or make dynamic formal elements in the work, bringing unity, emphasis, balance, contrast, and spatial awareness. Color is a tool that can be used to very effectively manipulate our perception, creating depth when there

THE BEZOLD EFFECT

The Bezold effect, named after the German meteorologist who discovered it, is an optical illusion where separate yet adjacent colors that appear simultaneously are optically mixed, merging into the perception of an entirely new color. This "assimilation effect" is very different from when colors are pushed and pulled by other colors, as in the subtraction of color or simultaneous contrast. Here, they simply mix to create a new color, which can most effortlessly be realized in viewing pointillistic paintings, where small dots of different colors optically blend to create a new color. In the example above left, the red bricks appear a lighter shade because of the white "grout" lines, whereas the red bricks with the black lines (above right) look like a darker shade.

TRANSPARENCE AND SPACE ILLUSION

By adjusting the value of a hue and using tints and shades of colors, swatches can be placed so as to appear like a film atop blocks of color. Depending on how the composition is arranged, this can create layers of depth in an image, establishing an illusion of space or three-dimensionality. In the example at left, the two rectangles in the middle appear as one sheet of transparent paper atop the two background fields of blue.

SUCCESSIVE CONTRAST

Also known as after-imaging, this is the phenomenon whereby a visual sensation occurs after a color stimulus is gone. After staring at a highly saturated image or color design, if you transfer your gaze to a blank white space, the complementary color(s) will appear in the shape of the original image. This wild illusion is theorized to be because the rods responsible for absorbing the original color become exhausted, and when we look to the white page, our eyes create the complementary colors to help balance the color exposure. In this way, it is related directly to simultaneous contrast. Take a moment to look at the example above. After a minute, shift your gaze to the white square below it, or a piece of blank, white paper and there should appear the same red and green in reverse, with green in the middle square and red around it.

is none, rendering a thing invisible, or creating a sense of movement in a static image. Colors interact with each other in such a way as to push our perceptive abilities to their edge—glowing, vibrating, and warping space.

Within each artistic medium there are rules and strategies for creating, controlling, and exploring color. While much of color theory is based on the mixing of pigments and is related to the history of painting, ceramics work offers unique challenges for the mixing and development of color. In addition to hue, saturation, and value, ceramic glazes are endowed with the additional properties of luminosity, transparency, and texture.

While highly processed ceramic pigments (stains) can be used on a white surface in a similarly predictive way to mixing paints, the spectrum of colors achievable in ceramics from raw materials is as varied as it is unpredictable, in part due to the metamorphic process by which oxides impart color on the surface. Ceramic color can be difficult to master. We can study its anatomy, but knowledge does not always generate the desired results. Perhaps it is this elusive nature of ceramic materials that has allowed the ceramic surface to exist *with* color more often than it is dictated by a color vision.

White

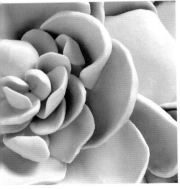

Giselle Hicks, see page 179

White, though it appears as the absence of color, is in fact all of the spectrum combined as light. A white object is one that absorbs all of the wavelengths of color, reflecting none of it back to our eyes. Often perceived as blankness, white can signify emptiness, lack of personality, and even death. However, it is also pervasively used to represent cleanliness, purity, and peace, especially in the Western world. Doctors wear white coats and ceramic fixtures like sinks and toilets are often white so as to exude the perception of sterility. Western brides wear white dresses to represent purity or virginity. Waving a white flag symbolizes a surrender or a truce between opposing parties. In the 20th and 21st centuries, white has been lauded in the art world for allowing the viewer to focus on the form, from the minimalist sculptures of Sol LeWitt to contemporary object design.

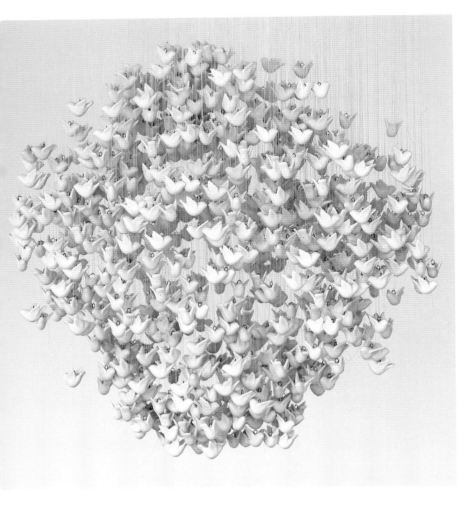

HISTORIC WHITES

The addition of tin oxide to glazes in 9th-century Iran was one of the first attempts to mimic the purity of white porcelains from China. The technique spread rampantly as low-fire clays were being used in many places and this process allowed for a bright white background. (White is often used as a background for decoration.) This can also be achieved by using a white clay body and decorating with either colored slips or glazes and covering in clear glaze for a final sheen, or by applying low-temperature enamels on top of a clear glaze. Italy became famous for its particular style of tin-glazed earthenware called majolica. Japanese shinos that originated during the Momoyama period were comprised of mostly feldspar and a little bit of clay, creating an opaque white glaze.

A Thousand Miles

Jae Won Lee's floating cloud of white and soft celadon blue bird forms exudes softness and fragility. The whiteness of the forms allows them to feel ephemeral, with subtle shadows shaping the space, especially against the blank white background.

> The first of all single colors is white ... We shall set down white for the representative of light, without which no color can be seen; yellow for the earth; green for water; blue for air; red for fire; and black for total darkness.
>
> Leonardo da Vinci

Mieke de Groot, see page 168

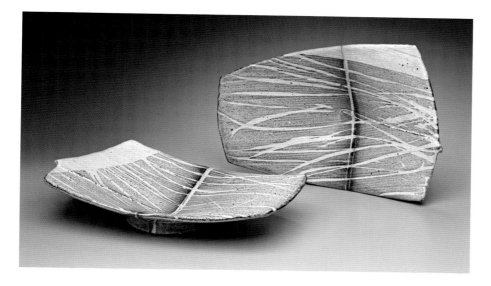

Folded Trays

The iron-rich slip under Randy Johnston's white Nuka glaze seems to singe the outlines of his expressive drips and fluid lines. The whiteness looks like a snowstorm, with the trays framing up windows into the beautifully layered surface.

CREATING WHITES

Today, white is relatively easy to achieve by adding an opacifier to a clear glaze. Tin oxide, titanium dioxide, and zirconium silicates such as Zircopax and Ultrox are typically accessible to the contemporary clay artist. Opaque glazes are achieved by either suspending opaque material in the glaze (see the glaze used by Akiko Hirai Collingwood on page 102, which has a high clay content) or by actually forming crystals in or on the glaze surface, usually during cooling. In contemporary design and industrial objects, white is often achieved by using white or porcelain clay with clear glaze over it. Geoffrey Mann (see page 114) and Bethany Krull (see page 116) are both great examples of this.

Correlations

The fascinating works of Barbro Åberg create an illusionary space, full of white, with shadows that cast upon the ripples, and weblike lines of forms. Structured like coral sponges, the whiteness gives a pure, analytical, and peaceful tone to the work.

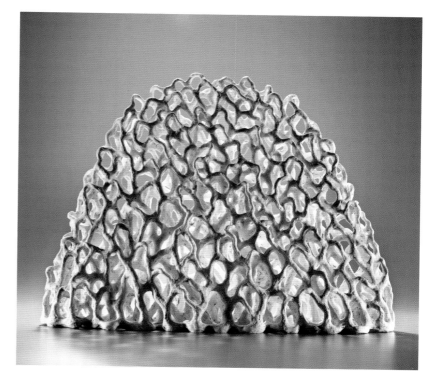

Cristina Córdova, see page 148

Black

Black is a mysterious color. Black is the absence of light and absorbs light. It is also the result of all colored pigments mixed together. Black is the color of mourning in the Western world and is often associated with emptiness, darkness, mystery, and evil. It is often viewed in opposition to white, which can represent purity. However, black also has positive associations, including suggesting depth of emotion. Black is a color of sophistication and is utilized in a judge's robe, for a "black tie" event, and for the suits of clergymen. Black clothes make people look thinner, and so it is considered a cool, classy, and elegant fashion choice. Conversely, though, black can make objects appear heavier than they are. It adds depth to space, while at the same time diminishing readability.

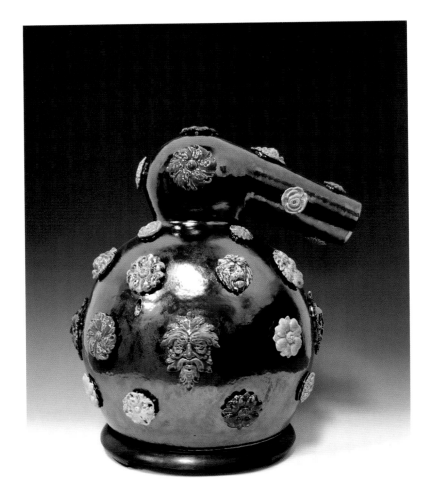

HISTORIC BLACKS

High concentrations of oxides such as manganese were used to brush onto wares to create black linework and imagery, as in Neolithic Chinese pottery, Native American Mimbres pottery, and the pottery of many other cultures throughout history. The highly majestic black-figure amphoras from 700 BCE in Greece were an intensely pure satin black made from terra sigillata. High-iron black and brown glazes from China and Japan, with names like Oilspot, Temmoku, Kaki, and Teadust, are made with high amounts of iron and range from black to brown with streaks of orange. Black seto, a rich black glaze from 16th-century Japan, was achieved by removing pieces with iron glaze from the kiln while still glowing hot. Raku and pit firing have historically transformed clay skins to a dark black color from the heavily reduced atmosphere. This is achieved by post-reduction, whereby the work is smothered in an oxygen-starved environment immediately after removing it from the kiln at peak temperature.

Rock and Rye

A master of seductive objects, Adrian Saxe utilizes a shiny metallic black on his vessel form. The menacing tilt of the vase's neck almost resembles the barrel of a gun with its metal-like sheen. In combination with the opalescent and playful appliqué decorations, Saxe's vessel offers an open-ended critique of society—its indulgences and its dissatisfactions.

CREATING BLACKS

Black glazes can be achieved in many different glaze bases with many different materials. The previously mentioned iron glazes can be quite black. Blacks can be achieved by adding a combination of iron to cobalt oxide, manganese oxide, or chrome oxide, or possibly all three. Black stains are quite reliable but tend to be more expensive than colorants. Both David Eichelberger (see page 146) and Rebecca Catterall (see page 150) take advantage of black stains to create their surfaces. Albany (now difficult to find) and Alberta slips are high-iron clays that produce great blacks at high temperatures when mixed with nepheline syenite in a roughly 70:30 ratio.

Johannes Nagel, see page 286

66 Dark is the basic tone of [Rembrandt's] paintings, and darkness occupies a large area of them ... but how full of life is such darkness! 99

Max Doerner, *The Materials of the Artist*

Basalt Shadows

The stony-matte quality of Halima Cassell's work allows the black hue to absorb light. The shadows cast upon the form reveal and highlight the precise geometric planes that shape the interior.

Intersection VI

While the beaded construction of the surface alludes to basket weaving, Lut Laleman's Intersection VI *is a lovely example of how black can be used to exemplify formality and sophistication. The inner rings form a bridge from one vessel to the other, creating a center between the pair.*

Blue

One of humanity's favorite colors, blue is comfortable, cool, and clean. While blue is often associated with positive qualities such as strength, wisdom, tranquility, and loyalty, it is also used to describe emotional sadness in the term "having the blues," coined in the US. Dark blue in Korea also represents mourning. It can be serene and inspiring when it fills our visual space, as with blue skies and blue water. Furthermore blue is found on more country flags than any other color; blue jeans are commonly worn around the world; and blue is often used to represent the male gender.

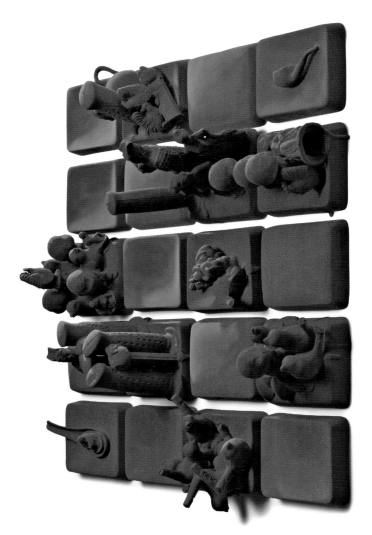

HISTORIC BLUES

Egyptian paste, the first noted ceramic glaze, comes in many shades of turquoise blue—and when cobalt was discovered in Iran around the 9th century, blue began to spread across the East. Blue and white ceramics, now known across many cultures, started in Iran and China around the same time as decoration on earthenware. The esthetic spread around the globe and took many forms, but the most recognized are the Chinese and Iznik floral motifs. Cobalt brushwork is also found on salt-fired stoneware pottery from Germany, England, and later in the US. Celadon blues have been used in China for centuries, and the subtle iron blues on high-fire porcelains are highly prized today as well. Blue pots notoriously sell well, and during the crafts boom in America in the 1960s, 1970s, and 1980s, certain blue glazes acquired nicknames such as "craft-show blue" and "cash blue" for their ability to attract buyers.

Klein Blue Collage

Eleanor Wilson's collage utilizes a high content of cobalt oxide in a matte base, rendering the tile piece so high in saturation and deep in color that light itself seems to be sucked into the forms. The tiles carry suggestive figurine forms, creating an elusive narrative.

" The bluebird carries the sky on his back. "

Henry David Thoreau

CREATING BLUES

Cobalt is what makes the majority of glazes blue (see Annabeth Rosen on page 176 and Johannes Nagel on page 286). Cobalt produces blues easily and will create some color at all temperatures and in most base glazes. It is a strong colorant and recipes often call for 1 percent or less, and commonly as little as 0.25 percent. Barium and copper oxide can produce some of the most vibrant and saturated blues but leaching can be a problem in the wrong base, so a glaze with these materials should be tested before being deemed food-safe. Rutile can create blues combined with tans, browns, and pinks, and results in dynamic, variegated yet runny surfaces. Celadon blues are often created in a reduction atmosphere with the inclusion of small amounts (1–2 percent) of iron, but artists like Andy Shaw (see page 118) and Bryan Hopkins (see page 174) get lovely light blues by drawing out impurities in the clay.

Kristen Kieffer, see page 164

Another Time and Place

As if he is sampling from across time and cultures, Steven Young Lee's Prehistoric series challenges the viewer to explore the context and narrative in each piece, based on one's own perception. Traditional techniques of inlaid cobalt and celadon on voluminous porcelain vases add clues to the cultural underpinnings of the work.

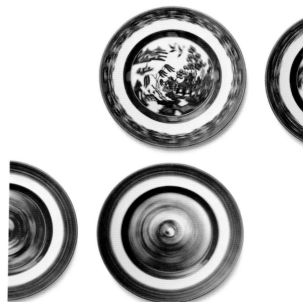

Spin

Robert Dawson's Spin takes a new look at blue-and-white china by recreating and deforming traditional patterns with digital technology. This series of plates displays the stages of a distorted motif in progression from subtly altered to illegibly blurred.

66 Reno Dakota, there's not an iota of kindness in you. You know you enthrall me and yet you don't call me, it's making me blue. Pantone two-ninety-two. 99

The Magnetic Fields

Green

Green, the symbolic color of new growth, springtime, and nature, is often associated with harmony, hope, and calmness. In Western cultures a green shamrock means good luck and around the world a green traffic light signals safe passage. Historically it's had an interesting path. The "green man," a symbol of fertility and growth, can be traced back to many cultures, but was banned by early Christians for its connection to pagan religions.

Matt Wedel, see page 210

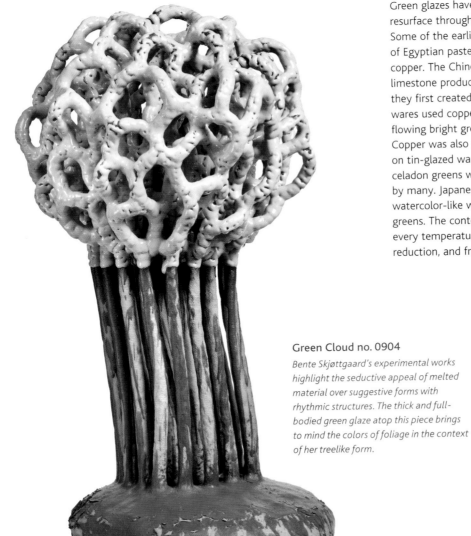

HISTORIC GREENS

Green glazes have been popular in many cultures, and they resurface throughout history at different times as a favorite. Some of the earliest records of green would be from the discovery of Egyptian paste, which is self-glazing clay with the addition of copper. The Chinese discovered that wood ash combined with limestone produced a beautiful green glaze with rivulets when they first created high-fire kilns. During the Tang dynasty, Sancai wares used copper in lead glazes at low temperatures to create flowing bright greens adjacent to white and amber orange. Copper was also used across Persia and Europe to create green on tin-glazed wares. Later, during the Song dynasty, high-fire celadon greens were perfected, emulating jade and revered by many. Japanese oribe's swatches of green vary from thin watercolor-like washes to saturated metallic and opalescent greens. The contemporary clay artist will find green in almost every temperature and atmosphere, from electric to gas reduction, and from raku to cone 12 wood firing.

Green Cloud no. 0904
Bente Skjøttgaard's experimental works highlight the seductive appeal of melted material over suggestive forms with rhythmic structures. The thick and full-bodied green glaze atop this piece brings to mind the colors of foliage in the context of her treelike form.

Wouter Dam, see page 184

CREATING GREENS

Green can be achieved with many colorants, including nickel oxide, chromium oxide (see Claire Hedden on page 200), and iron oxide, but copper (especially as copper carbonate) is a clear favorite (see Anton Reijnders on page 194). Very small amounts of iron oxide in a celadon glaze can create soft light greens (see Jeff Campana on page 188) that really show over white porcelains at high temperatures, while a variety of stains have been made to create almost any shade of green imaginable (see Wouter Dam on page 184).

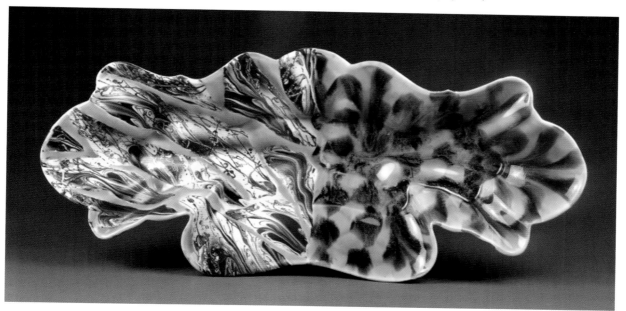

Continental Drift

Patterns melt and drip together across the dynamic form of Andrew Martin's Continental Drift. The two tones of green create a lively and aquatic feel, as their glossy sheens dance in concert with the black and white elements and in contrast to the symmetrical molded form.

Clay Furniture

Constructed by hand forming clay over the top of a metal armature, the clay furniture of Maarten Baas feels both precarious and surreal. The use of a bright, true green hue adds a playful element to this piece.

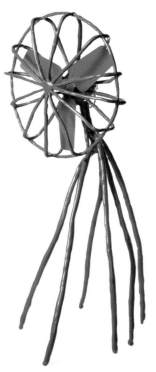

> In ceramics, green is not just green nor is it a particular kind of green, it also has a certain depth, light reflectance, and tactile quality which may cause the same color to look different on two otherwise identical specimens.
>
> Charles Harder

Yellow

Yellow can stir a variety of reactions. Yellow is the most luminous of all colors, and in many religions it is used to depict a deity. Its obvious association with the sun produces a warming effect and stands for cheerfulness. A yellow smiley face means happiness, and yellow roses signify friendship and joy. It is physically the quickest color for the eye to process, which means it always gets attention. Yellow cabs are easy to spot in traffic and warning labels are hard to ignore. It isn't the easiest color for many to wear, and people tend to feel unsettled in yellow spaces.

David Hicks, see page 212

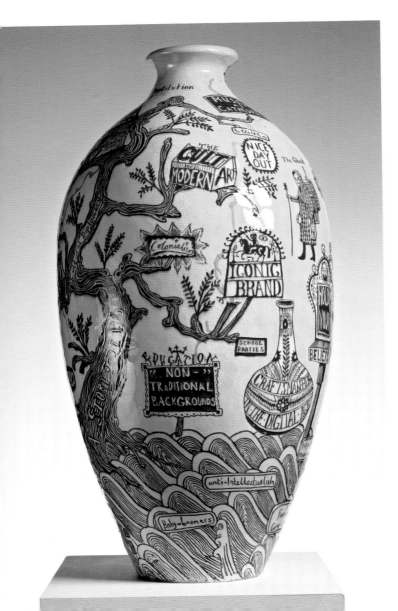

HISTORIC YELLOWS

Historically, yellow was achieved through the addition of iron oxide, as with the imperial Chinese porcelain of the Ming dynasty, with bright, saturated yellow enamels and the soft yellows achieved in high-temperature firings. After imports from the Far East, lead antimonite was used across the Near East to create the famous Naples yellow that was applied to low-fire, tin-glazed wares. In 17th-century Europe, lead slipware glazes utilized iron oxide to produce yellows. In the 18th century in Sèvres, chromium oxide was used to make yellow.

Rosetta Vase

Grayson Perry's vase, whose title draws reference from the Rosetta Stone, is covered in witty and challenging snippets of text in the familiar and exalted ceramic color combination of blue and white. The jarring role of the intensely bright yellow that surrounds the imagery is acknowledged by a caption on the vessel reading "non-traditional backgrounds," which further intensifies the questioning of language, symbolism, and meaning in the work.

CREATING YELLOWS

During the 20th century uranium oxide (yellow cake) was a popular high-temperature colorant, but following the discovery of its radioactivity it is no longer used in glazes. Other oxides, including nickel, rutile, chrome, manganese, vanadium, and titanium, which can all make great yellows, are often used in combination. Many contemporary yellow glazes use iron oxide, but the commercial stains seem to be by far the most popular. Many of the artists in the Directory use stains to achieve bright yellows, including David Hicks (see page 212), Matt Wedel (see page 210), Chandra DeBuse (see page 208), and Taehoon Kim (see page 204). The brightest-possible yellow comes from a stain and is almost unmatchable with oxides, as they tend to produce "earthy" yellows. The exception to this is the rare earth oxide praseodymium, which produces an incredibly vibrant yellow.

Linda Lopez, see page 202

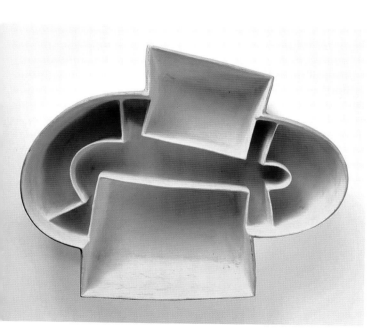

Yellow Spaces

As defined by its title, this architecturally suggestive composition of Daphne Corregan is cloaked in a bright, saturated yellow that seems to glow softly from within. Corregan utilizes a monochromatic palette to focus our eyes on form, with the yellow hue adding a playful, warm, and attention-grabbing element.

Clay Knit 01, Glossy Yellow

Like a minimalist painting in a boisterous yellow hue, Stine Jespersen's wall piece is positioned above a shelf with a vessel form, further alluding to a domestic space. The monochromatic and intense yellow chroma grabs our attention, while the subtle variations in tone pull us deeper into the meticulous and rhythmic knitlike framework.

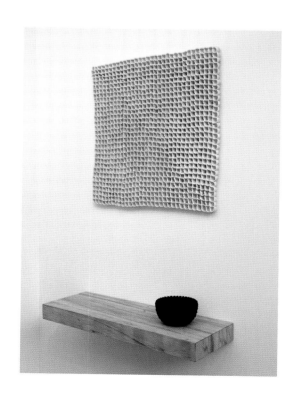

> 66 There are painters who transform the sun into a yellow spot, but there are others who, thanks to their art and their intelligence, transform a yellow spot into the sun. 99
>
> Pablo Picasso

Paul Eshelman, see page 224

Orange

Orange is often characterized as warm, stimulating, and happy. It represents the season of fall, the bountiful harvest, and Halloween. Bright orange is sometimes characterized as aggravating due to its jarring intensity. It stands out against many colors and for this reason it is used for traffic cones, life rafts, police vests, and warning labels. Wearing orange will get attention, which explains why prison uniforms are sometimes orange and hunters wear orange to be visible to other hunters.

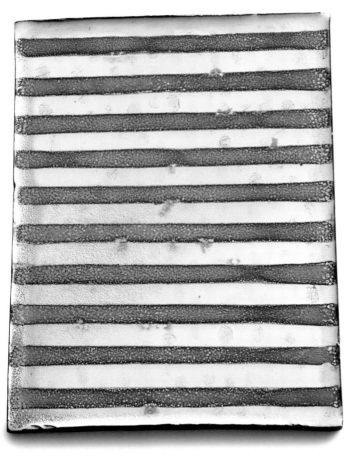

HISTORIC ORANGES

The color of terra-cotta is a pleasant reddish-orange, though it is typically referred to as "brick red" and is known in the history of ceramics at the beginning of almost every culture. The Roman, Etruscan, Native American, Central American, and Peruvian artists are known for their terra sigillata (a fine earthenware slip), which, after being burnished and fired, produced hard and water-resistant surfaces. The first actual orange glazes are found in the Tang dynasty sancai (three-colored) wares, in which a lead-based glaze is used to create white, green, and an amber-orange, which is derived from iron. In 1936, Fiesta ware was offered in an eye-popping, saturated, orangey-red glaze that was very popular. Unfortunately, like many reds and oranges from that time, it was later discovered to be hazardous due to the uranium oxide content.

" Orange is the happiest color. "

Frank Sinatra

Dish

Bright orange lines fade and blur into the white at their edges, decorating and adding depth to the delicate and simple dish by Nina Malterud. Malterud achieves an almost ephemeral effect with her sensitive and intimate works.

CREATING ORANGES

A true orange is not easy to achieve with raw glaze materials. Besides rutile, which can make a muted orange in oxidation, commercial stains and inclusion stains (also known as encapsulated stains) are used. Some glazes that produce several colors can move into the orange range, like shinos and high-iron glazes such as Kaki that break from black to cream and sometimes orange. The atmospheric kilns like salt, soda, and wood can produce amazingly bright oranges, drawing iron and other impurities from the clay and slips. Chris Gustin's work (see page 128) displays some vivid oranges with shino in the wood kiln. Terra-cotta can often be a brilliant orange and terra sigillata made from the same high-iron body can get very close to an orange glazed surface. The use of ferric chloride in low-temperature saggar firing can produce quite a range of oranges as well.

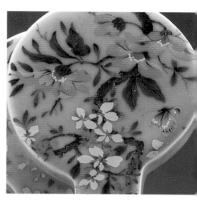

Rain Harris, see page 218

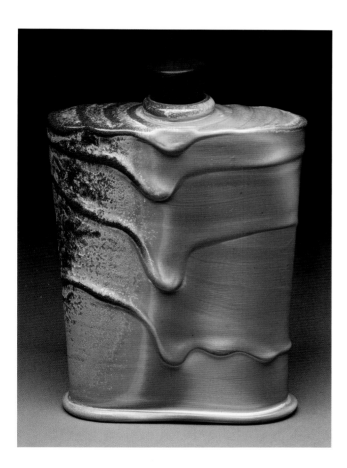

Whiskey Flask

This flask by Matt Long has been brushed with thick, dripping layers of slip that are designed to react with the atmospheric firing of the soda kiln. The surface of the piece documents the unpredictable flame pattern, revealing dramatic and luscious flashes of orange.

Glow Jar

The dynamic composition of two orange glazes and the visible unglazed rim of orange terra-cotta complete the surface of this jar. Holly Walker's playful piece has a large, stepped lid and honest pinched construction that begs to be handled with a bright and carefree energy.

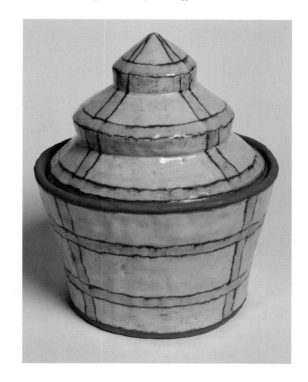

Red

Rebecca Chappell, see page 234

Despite the vast differences in perception, and the staggering plethora of reds that exist, there are some interesting facts about how seeing red affects the human mind. Physiologically, red is a stimulating and emotionally intense color for people. It increases respiration and pulse rates, enhances metabolism, and raises blood pressure. It can encourage action, confidence, and an ability to overcome fear. In conjunction with these physical effects, it then may not be surprising to learn that, for many cultures, red symbolizes the extremes of both death and life: the vitality of love and the heart, the power of passion and fire, and the destruction of anger and bloodshed.

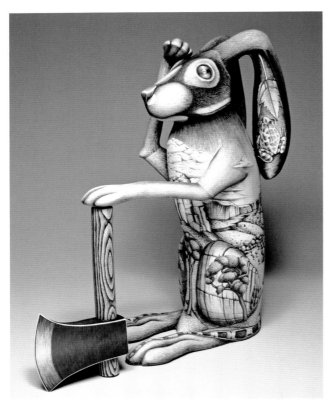

HISTORIC REDS

In many cultures throughout history, pigments of bright, crimson red were difficult to achieve, and were often reserved for the privileged. Originating in the Americas, the brightest red was found in the unassuming cochineal beetle's blood. For centuries its infamous hue was used to create the most exquisite clothes, paintings, and makeup; today, it is still used as a dye in food and drinks. From red ochers, to red lead, to cinnabar, each material that has been used to create red has its story to tell, and the same is true for the reds created in ceramics.

> " If one says 'red'—the name of [the] color—and there are fifty people listening, it can be expected that there will be fifty reds in their minds. And one can be sure that all these reds will be very different. "
>
> Josef Albers

Manifest Destiny

In Jason Walker's piece, Manifest Destiny, *the potent red is used as a powerful accent in contrast to the detailed form and black-and-white imagery. Working with underglaze on porcelain, the red and black appear flat, like ink on newsprint.*

Bean Finneran, see page 230

Red and Black

With layers of clays, slips, and glaze applied and refired several times, Rafael Perez creates wild sculptures with formal elegance. In this piece, the red glaze cracks and splits like old paint on a rusty steel farm tool that has seen many years of wear and sun.

CREATING REDS

Red can be achieved with a variety of oxide combinations in a range of temperatures and atmospheres. Stunning Chinese copper reds were made in the Ming dynasty from the 12th to the 15th centuries, and their allure has endured. They are produced in high-fire reduction atmospheres with copper oxide, as seen on Thomas Bohle's piece on page 228. Variations on copper reds include oxblood (a rich, deep, glossy red), peach blossom (a pale, transparent green with pink to red blushing with green specks), and flambé (a fiery, mottled surface with blue and purple streaks).

Another popular red glaze that originated in Japan is Kaki Red, also known as Tomato Red, Iron Red, Ohata Kaki, or Persimmon. This is a high-iron glaze with bone ash, which typically produces a rich, glossy, mottled reddish-brown.

For low- and mid-range reds in oxidation, artists like Rebecca Chappell (see page 234) and Paul Eshelman (see page 224) use commercial stains. Inclusion stains produce bright, even-toned color. While fritted red stains may produce saturated yet soft bright reds, the toxic reds produced from cadmium-selenium and lead oxide can create rich, flambé-like surfaces.

Red

Robert Silverman's tile is consumed by saturated color with its thick and runny red glaze that streaks around the descriptive text. Vivid and potent, the red hue boldly represents the purest form of the color while also acting as a play on the word itself.

Brenda Quinn, see page 256

Pink/Purple

Pink is a tint of red, but it is often viewed as a distinct color with differing meanings from red. Pink is often characterized as lighthearted, delicate, fun, and youthful, and is often used to represent the female gender. Studies have revealed pink rooms can have a pacifying effect and temper aggression, albeit temporarily. In Japan, pink is considered masculine, and the cherry blossoms that fall from the trees are a metaphor for fallen soldiers, representing the transience of life.

Purple is most notably associated with royalty, but also with creativity, magic, and wisdom. Purple can be calming, especially lavender, which is a tint of purple and whose flowering plant is often used in aromatherapy for its soothing effects. Depending on the temperature of the purple, it can represent nostalgia and romantic feelings (warm) or gloom and frustration.

HISTORIC PINKS AND PURPLES

There aren't a lot of pink or purple glazes in history. During the Yongzheng reign of the Qing dynasty, a rose-pink enamel glaze was created using gold as a coloring agent. In England around the 18th century, it was discovered that pink could be achieved by combining chrome with tin oxide. Sèvres' extremely popular Pink Pompadour was a glaze created for Madame de Pompadour, the mistress of King Louis XV of France. Purples show up in the Chinese copper reds that may have included cobalt in the recipe as well as the famous opalescent Chun blue glazes of the Song dynasty, which were sometimes dominated by the color purple. Manganese oxide was used to create purple on the decorative tin-glazed works across the Near East and Europe.

Life Support

This suggestive yet ambiguous sculpture by Dawn Youll uses the combination of vaguely familiar objects to pose questions about their symbolic roles and meaning. Color is used as a strong signifier, though its purpose, too, is left for the viewer to determine.

" When the silent flamingo dances pink with desire, I'll be there, sipping on owl stares and kitten curls. "

Jarod Kintz,
Whenever You're Gone, I'm Here for You

> **66** Forgiveness is the fragrance the violet sheds on the heel that has crushed it. **99**
>
> Mark Twain

Morten Løbner Espersen, see page 270

CREATING PINKS AND PURPLES

As with many colors, commercial and inclusion stains are capable of making many pinks and purples. Using oxides, matte purples can be created with the addition of cobalt oxide to a dolomite or talc glaze. A typical copper-red glaze can be converted to purple with the addition of cobalt or to pink with the addition of titanium dioxide. Also, purples and pinks can occur in the opalescent glazes that utilize rutile and manganese oxide. Pinks occur in a tin-white glaze that reacts to the presence of chrome oxide. This "fuming" can be seen on the pieces of Emily Schroeder Willis (page 250) and Eva Kwong (page 252).

Contrapposta, Gender

Based on the classical and idealized posture in historic statuary, Jelena Gazivoda's sculpture utilizes blue (male) and pink (female) to create a charged relationship between the two fragmented figurative forms, further deepening the meaning of "counter-posing" suggested in her title.

Dark Blue and Pink Mug with Yellow Prints

A luscious drip of pink flows sideways across the body of Brian Taylor's piece, defying logic. Along with the carefully placed yellow "finger prints," Taylor playfully subverts the esthetics of conventional glazing techniques.

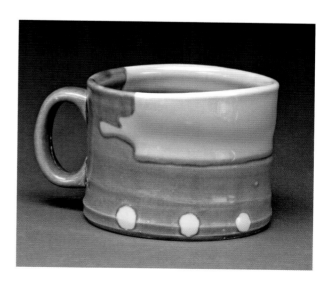

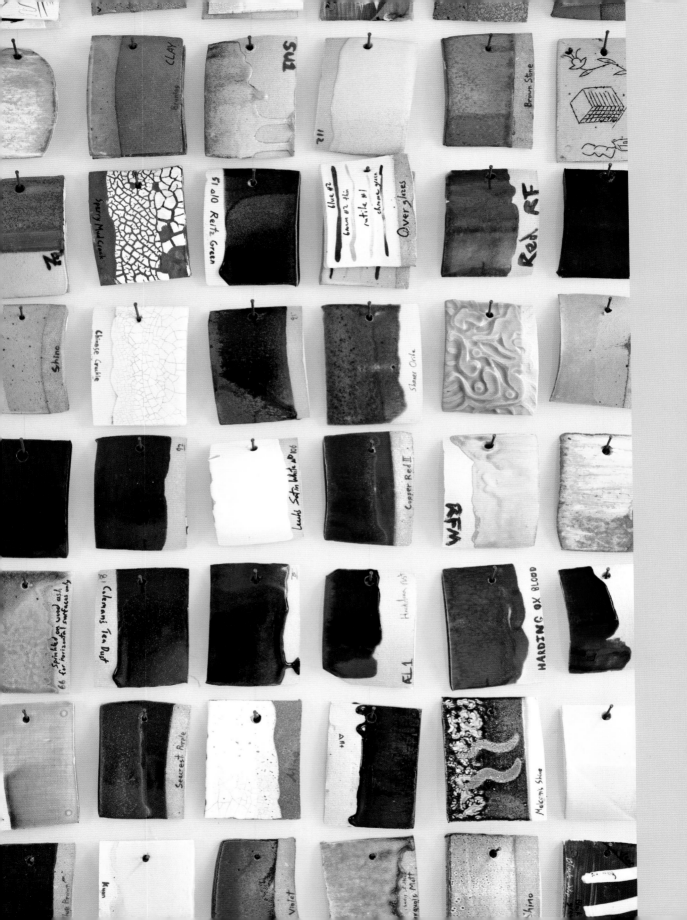

Making and Testing Glazes

Here you will find the information you need to help you take your ideas for the ceramic surface and make them a reality. From the best techniques for mixing a glaze, to how to calculate batches for tests and convert recipes, to utilizing effective record-keeping and techniques for applying glaze and firing, the hands-on strategies in this chapter will give you the confidence to successfully test your glazes.

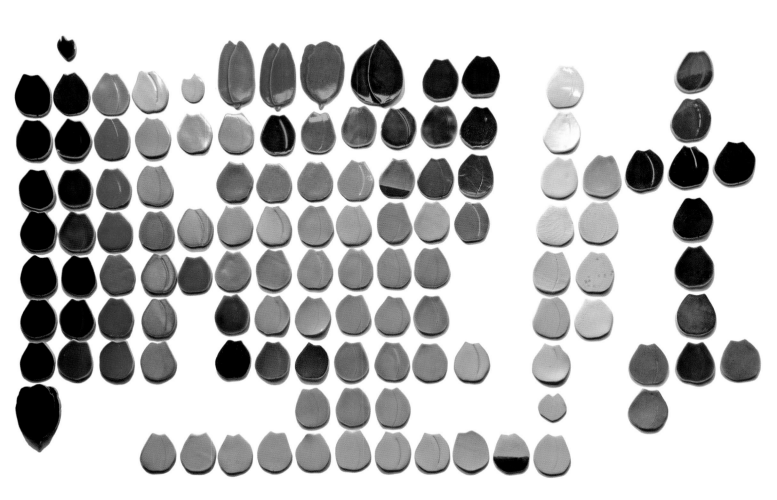

Glaze Testing

Here you will find the information you need to help you take your inspiration and ideas for the ceramic surface and make them a reality in your studio. There are a few points to note before you get started. The first step is testing.

Quick Test Tiles

A useful and quick method of making test samples for glazes is to extrude a shape and then cut it into sections. Here various extruded shapes have been used, each showing evidence of single and double dipping and all clearly labeled with relevant information.

First, it's important to recognize the many factors that can affect a glaze's appearance. The type of clay and the kiln you use, the temperature you fire to and how long it takes to fire and cool, and even the minerals in your water will affect the look of the glaze. In some cases, the same artist, using the same practices and the same glaze, can achieve entirely different results due to the simple fact of the water being hard (full of minerals) on one occasion, which will change the composition of the glaze. What this means is that careful testing is always essential, even when a recipe has had proven success in someone else's studio. Some recipes in this book may not work for you, while others may look even more beautiful—and others still might look exactly as they do in the picture.

While many say emulation is the highest form of flattery, any technique or technology should be "folded into" your unique studio practice. For the beginner especially, it can be very helpful to study master works and attempt to copy techniques in order to develop skill. At a certain point, though, it is important to cultivate your own voice and find a way to "sing" that is entirely particular to you. Often finding your own way comes from piecing together learned strategies, skills, and materials like a carefully woven tapestry of ideas, which become much more than the sum of their parts when they reach fruition. Developing your unique artistic expression in the studio is hard work, but it is an endlessly rewarding pursuit.

STUDIO SYSTEMS

Do recognize the importance of establishing a solid system to work with. Whatever stage you are at in your career, it's essential to keep not only mental tabs but also written notes on how and why you do things; how thick you mix your glaze; how many layers of brushstrokes you use to apply it; how hot and how long you fire for; etc. All of these details may seem minute in and of themselves, but each one plays a very important role in the outcome of your glazed surfaces. Of course, you may pay no attention at all and have beautiful results; however, if the goal is to be able to achieve a color, a surface, and an effect in any specific way, being consistent and precise with your techniques will be crucial. The notes you keep of your glazing adventures will help you keep track of what works and what doesn't, and help you to repeat your greatest glazing successes.

BISQUE TEMPERATURE

Successful glazing begins with the clay. Bisque fire to a temperature that works for your clay body, and stick with it. People usually bisque fire between cone 010 and cone 04, which is an adequate range for most clay bodies to be durable yet porous—two necessities for glaze. Typically, stonewares are bisque fired to cone 08 or even cone 010 for optimal glaze absorption; any lower and you could run into trouble with the pieces being too fragile and breaking in the glazing process. Some potters choose to bisque fire to cone 04 for low-fire clays. One reason this is done is to burn all of the carbon out of the clay, ensuring that it isn't released in the low-fire glaze firing, which could cause blisters and defects on the surface. Others prefer to bisque fire porcelain at the higher end of this range, as this will make the body stronger during the glazing process.

CONTROL AND CONSISTENCY

Whatever temperature you choose, firing for the same length of time and to the same peak temperature is important, as this will affect the porosity of your clay body when glazing, affecting the thickness of the glaze application. Controlling the atmosphere and speed of your kiln is equally important to the glaze firing. In an electric kiln with

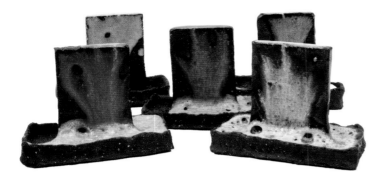

Color and Flow Tests

When testing unpredictable materials, it is useful to make a catch (a dish or similar container) in which to sit/attach your test tile, so that any excessive runs or similar reactions can be contained and thus protect the kiln shelf.

a programming device, this is quite easy. However for, say, a gas kiln in a reduced atmosphere with no meters, a detailed kiln log should accompany each firing, with a record of adjustments made and descriptions of flame color and flue position. Follow the same firing schedule each time, as heat work (the combined effect of temperature and time) can dramatically affect your glaze results. Crystalline glazes, for example, have a very specific kiln schedule, with holds at certain temperatures to promote the formation of crystalline growths.

MIXING THE GLAZE

Be sure to mix your glaze to a consistent thickness, and keep the lid tightly closed when it's not in use so that water does not evaporate from the top, causing it to thicken. It may not be practical to measure the water for your glaze; adding water until a consistency of light to heavy cream is reached will suffice. Becoming familiar with proper glaze thickness for your application purposes will come with experience and may vary between glazes.

APPLICATION

Now that your clay's absorption is set and your glaze is a proper consistency, you can begin the application process. Once again, consistency and record-keeping are key. This is one area where any adjustments to your technique will be most clearly identifiable: applying glazes is a skill, and the marks of your hand in the process will be ever present. Where a glaze is too thick or too thin, it can completely change color, go from glossy to matte, or from stiff to runny. Some glazes are more sensitive to thickness than others—for example, some clear glazes become cloudy when they are too thick. All of these idiosyncrasies will be revealed on your test tile, giving you the information you need to get the results you are looking for.

MAKING DISCOVERIES

After all is said and done, keeping control over the details described will be greatly beneficial in helping you reach your desired outcomes, but don't worry too much if things aren't perfect. Clay can be a very forgiving material, and the process itself leaves room for flexibility. There is a freedom in art making and a beauty in the happenstance of glazing that many ceramic artists are drawn to. There is nothing quite like the feeling of opening a kiln to discover a never-before-seen ceramic surface in your own studio.

Test Tile Wall

These tests show possibilities in layering glazes displayed as a grid. Each row represents one glaze under all other glazes and each column represents one glaze over all other glazes.

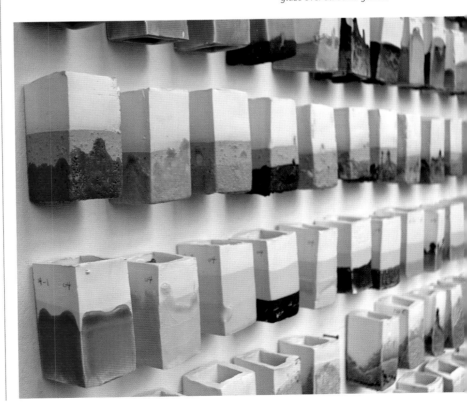

Understanding Recipes and Mixing Glazes

Glaze recipes are very similar in structure to cooking recipes. Most glazes start with a title and the firing temperature noted in cones at the top. The recipe is listed in column form, with ingredients on the left and the ingredient quantities on the right. Often the silica, clays, and feldspars are listed at the top (the base recipe), and additives for color or special effects are listed below a line or with a (+) sign in front of them, showing that they are additions to the base recipe. Most, though not all, recipes will list the base recipe ingredients in quantities that add up to 100. This makes it easier to compare different glazes and treat the quantities as percentages. In the following section, we will describe how using percentages ensures the integrity of a given recipe and makes it easier to increase or decrease the amounts.

CALCULATING A BATCH

When mixing from a glaze recipe, it is easy to increase or decrease the amount, depending on what you need. The term "batch" is used to describe the recipe with quantities calculated for the total desired amount of glaze. To increase the amount of glaze, simply multiply each material quantity by the same number. To do this for a specific amount, see the example below.

To mix a 1,500 gram batch of Brian's FPM, each material quantity needs to be multiplied by 15. To get the proper number to multiply by, move the decimal point twice to the left from the amount (in grams) that you want to make. (For 5,000 grams, multiply by 50; for only 250 grams, multiply by 2.5.)

Brian's FPM

Frit 3124	40 × 15 = 600	
Wollastonite	25 × 15 = 375	
EPK	20 × 15 = 300	
Flint	15 × 15 = 225	
Total	100	*1,500

*To double-check the math, be sure that all of the weights add up to 1,500.

CONVERTING PARTS BY WEIGHT TO PERCENTAGE

Occasionally a glaze is listed in parts, not by weight. In this instance the parts typically don't add up to 100, which can make it difficult to compare to other glazes. However, it is possible to change a parts recipe into a percentage recipe by weighing one part and substituting.

Matte base:
3 parts EPK
2 parts feldspar
1 part silica

First, weigh $1/4$ teaspoon (one part) of EPK and record. Do the same for feldspar and silica.

Example:
$1/4$ teaspoon EPK = 1.1 g
$1/4$ teaspoon feldspar = 1.3 g
$1/4$ teaspoon silica = 1.6 g

Now, multiply by the number of parts:
3 parts EPK = 3.3 g
2 parts feldspar = 2.6 g
1 part silica = 1.6 g

Add the weights to get 7.5 g total weight. Now divide each material weight by 7.5 and multiply by 100 to get the percentage:

3.3 EPK ÷ 7.5 = 0.44 × 100 = 44.0
2.6 feldspar ÷ 7.5 = 0.347 × 100 = 34.7
1.6 silica ÷ 7.5 = 0.213 × 100 = 21.3
 100

The parts recipe has been turned into percentages and can now easily be used.

Mixing a Glaze

Before you get started, make sure you have the following things at hand:

- **Recipe:** It is wise to transfer the recipe onto a clean piece of paper and make batch adjustments there so that the original is not altered.

- **Safety equipment:** Respirator, gloves, safety glasses, apron, and ventilation. See Health and Safety on page 36.

- **Dry materials:** Check your recipe first and be sure that you have more than enough of each material you need before you start.

- **Clean scoops:** Metal or plastic scoops in varying sizes for transferring materials to the scale.

- **Two clean buckets:** You need one to mix in and one to catch the glaze as you pour it through the sieve. Choose buckets that are larger than you think you need. When measuring your dry materials into the first bucket, they may have more volume than when your glaze is mixed with water. Once your glaze is mixed, you can downsize to a bucket that better fits your glaze.

- **Scale and measuring container:** You can use either a digital or a triple-beam scale, but make sure it has a tare option so you can zero out the weight of the measuring container. You'll want a scale that can accurately measure your smallest materials but can also weigh most of your larger materials.

- **Whisk or blunger:** You'll need something to mix the glaze to ensure proper distribution of materials through the water. This could be a clean stick, a metal whisk, or a mixing attachment on an electric drill. All will work, but you might find you have a preference once you mix a few glazes.

- **60-mesh sieve:** The sieve helps catch foreign materials from the glaze and also greatly assists in the distribution of materials in the water. Mesh size is a number that expresses what size of materials will pass through and what won't. 60-mesh is adequate for glazes. Sieves come in different forms. Some fit securely into a 5-gallon bucket and some are sized for test cups. Choose the appropriate size for the amount of glaze you have.

- **Water:** Clean, room-temperature tap water should be fine for glaze mixing. If you know that your water is high in minerals, you may want to purchase distilled water to eliminate potential contamination factors.

Mixing Glazes

When mixing glazes, be patient and meticulous. Mistakes will produce inaccurate results that might be exciting but will not be reproducible. Once all of your safety equipment is put on and the ventilation is working, begin by weighing the materials.

1. Place the measuring container on the scale and then zero the balance. Starting at the top of the recipe, accurately weigh the first material. Pour the measured material into one of the buckets and make a small check mark next to the material name to note that it is done. Do the same thing for each ingredient. Measure it, pour it into the bucket, and make a check mark next to the name. Once all the materials are combined in one bucket, minimize clumping by gently stirring them together until they look fairly cohesive.

2. Add water. Start by adding what looks like a third of the volume of dry materials. Mix vigorously, and slowly continue to add water until the mixture looks like heavy cream. Be sure to scrape all materials stuck to the bucket into the glaze and mix well. Know that the ratio of water to dry material is measured by eye, so err on the side of too thick because it's easier to add water than to take it away.

3. Once the glaze is thoroughly mixed, it will need to be sieved. Place the 60-mesh sieve on top of a clean bucket and pour the mixed glaze through. Depending on the materials in the glaze, it might fall smoothly through the sieve or it might clog up quickly. If it does clog the sieve, a rubber rib or a plastic bristle brush are great tools for pushing all the materials that can fit through the sieve.

4. Check the consistency of the glaze. The glaze is ready to use right away; alternatively, put an airtight lid on it for storage.

The perfect test tile allows space for you to record the name of the recipe.

Test Tiles

A well-designed test tile is your key to successfully revealing a glaze's potential before applying it to your work. It may save your pieces from the shard pile by taking out the guesswork, saving you time and money, and may reward you with glorious glaze surprises without risking your work.

There are almost as many different test tile designs as there are ceramic artists. Each artist tailors his tiles to suit his specific needs. Sometimes an artist makes test tiles that are fast and simple; other times they are as detailed and complex as their works of art. In any case, tiles are a great way to establish an understanding of a glaze and its application.

Similar to paint swatches, test tiles give you a snapshot of what a glaze can do. A collection of tiles can be used to formulate your palette for a body of work, and can be a fast and easy testing ground for application techniques. For specific results, make a tile that replicates the surface details of your work. Tiles that are uniform in size and surface treatment will aid in the analysis and comparison of various base glazes or color tests.

LABELING YOUR TILES

There are a number of ways to label your tiles, but however you do it, labels should go where there will be no glaze application and there is little risk of the glaze running over the top of them in the firing.

Many ceramicists use red iron oxide, chosen for its deep, nontoxic, and non-reactive coloring, mixed with a little water, to brush the label on. It is important to use a very fine brush and not to pick up too much material, which could drop a blob of iron onto your tile, obliterating your label. Some choose to add a little gum to make the label less susceptible to smudging. To add a gum (such as veegum), first mix thoroughly in hot water, and let it stand for several hours. You may wish to prepare some gum for this purpose ahead of time and store it in a lidded jar, thinning the mixture with some water as you need it for labeling, but this is not essential.

Choosing a Design

There are many different reasons for testing, and your tile design should cater to your specific needs. Outlined below are five basic test tile designs, their distinguishing properties, and guidelines for reproducing them yourself.

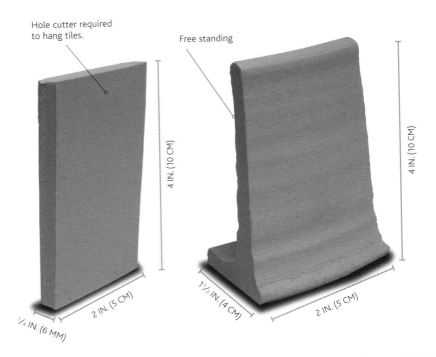

FLAT SLAB TILE

Roll a slab ¼ in. (6 mm) thick and use a fettling knife and ruler to cut tiles. This flexible process offers ample space for labeling work and adding a variety of textures. The tiles store neatly and can be easily hung with the addition of a hole. They can be fired flat or propped to show vertical flow.

THROWN TILE

Throw a bottomless cylinder that is 4 in. (10 cm) high and 12 in. (30 cm) in diameter, leaving a flange at the bottom for stability. Using a fettling knife, slice the walls vertically from rim to base at 2-in. (5-cm) intervals. These uniform, stand-alone tiles are ideal for testing glazes for thrown work.

BASICS

- Design the form of your tile so that the glaze will behave the same as on your work: flat for tiles, vertical for pottery, and so on.

- Use the same clay body as you do for your work, and make the tile the same thickness.

- Make your tile big enough to reveal plenty of information about your glaze. A standard test tile size is roughly 1½–2 in. × 3–4 in. (4–5 × 8–10 cm).

- How will your tile be displayed or stored after firing? Try cutting a hole for hanging and making tiles uniform and stackable for organized storage.

ADDITIONAL LAYERS AND TEXTURES

- Add ridge lines and gouges to the clay to see how the glaze "breaks" and "pools."

- Leave some areas flat to see how the glaze acts when undisturbed by textures.

- You may want to add a swatch of white slip to your tile to observe how the glaze looks without the "impurities" of your clay body.

- For specific results, prepare the tile's surface as you would your work to see how the glaze interacts with various textures, decorations, slips, and washes.

LABELING

- Designate an area on the tile that will be left unglazed for clear and legible labeling.

- Create a shorthand system or code that corresponds with your glaze recipe notes.

- Stamp the tile when wet, or, when bisqued mark it with either underglaze pencil or red iron oxide wash.

- Leave space on the tile to use a permanent felt-tip marker to write the recipe on after firing.

GLAZE APPLICATION

- Apply glaze to your test tile the way you would with your work (dipped, brushed, or sprayed).

- Leave room for the glaze to run (for a vertical tile, usually ½–1 in./1.3–2.5 cm is plenty) and consider firing on sand for runny recipes.

- Test for glaze thickness by applying more than one layer in sections.

Glaze pools here in ridges.

1½ IN. (4 CM)
2 IN. (5 CM)
4 IN. (10 CM)

Organic shapes aid an interesting surface texture.

1½ IN. (4 CM)
4 IN. (10 CM)

1½ IN. (4 CM)
1½ IN. (4 CM)
4 IN. (10 CM)

SOFT SLAB TILE

Cut a 6 × 2-in. (15 × 5-cm) flat tile out of a soft slab. Lift the tile vertically and fold the bottom 2 in. (5 cm) onto a flat work surface, forming a stable base. This vertical variation on the flat slab allows for the tile to stand alone, provides an area for glazes to pool, and is ideal for testing texture on hand-built work.

PINCHED TILE

By squeezing a 1½ × 4-in. (4 × 10-cm) coil in your hand and pressing the extra clay flat against the work surface, you get a quick pinched tile. These no-fuss tiles offer good surface variation but have minimal space for labeling, and can be cumbersome for storage and display.

EXTRUDED TILE

Extrude clay using any hollow form die. Once leather-hard, cut 4-in. (10-cm) lengths and stand them vertically. Extruded tiles have more surface area, they stand up well, and can be strung easily for display. This is an easy process for making many tiles quickly.

Glazing and Labeling Test Tiles

(TOP) Dipping a test tile in glaze. Be diligent about applying your test glazes as you would apply the glaze to your work.

(ABOVE) Using a mixture of manganese and iron oxide to paint a reference number on the back of a test tile. Whether you brush or use an underglaze pencil to label your tiles, make it simple and legible.

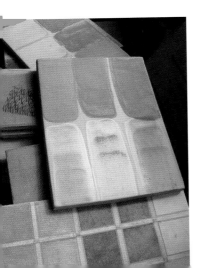

Testing Color and Temperature

A collection of test tiles from Regina Heinz showing examples of a brushed lithium glaze fired at different temperatures and with different colors.

Another labeling option is to use a black underglaze pencil. For this, you will want the surface that you write on to be as smooth as possible. When the tile has variations in the surface, such as canvas texture from a slab roller, it makes the pencil mark messy and difficult to read. On a smooth surface, however, a pencil can be much easier to control and more legible than a brush.

Marking test tiles before bisque firing by carving them with a pin tool or by stamping is another way of adding a shorthand code (see page 95). Or, simply add a number to the tile that corresponds to your journal notes when you apply the glaze.

Labeling tiles with a fine fibertip pen after firing is a good way to add important information that may have been too cumbersome to put on the tile before. For example, you might record cone temperature and atmosphere immediately after the firing, or write out the colorants for easier reference. Some ceramicists write the whole recipe on their tile after firing. This makes it easy to understand the tile immediately without sifting through notes. Choose the material and process that works best for you, and keep your labeling simple.

APPLYING GLAZE TO TEST TILES

When applying glaze to your tiles, it is best to apply the glaze as you would to your actual work. This means dipping if you normally dip, spraying if you normally spray, and so on. Beyond that, it is smart to incorporate some variations. For example, try one thin layer and another thicker layer so that the test reveals the variations that are possible. You may also wish to test what happens if the glaze is applied smoothly rather than in lumps. Some glazes may surprise you by leveling out nicely during the firing, while others may leave very noticeable variations in the surface where brush marks were messy, drips added another layer, or scratches through the glaze left a blemish. If pinholes show up after applying the glaze, try smoothing them out (by rubbing gently with your finger) only over part of the tile to see what difference it makes.

Leave extra room (1/2 in./1.3 cm to 1 in./2.5 cm is plenty) at the bottom of vertically fired tiles to account for running glazes. Depending on how you will fire the tile, choose a place for your labeling that will be unaffected by glaze (on the back for flat tiles; at the very bottom for vertically fired tiles).

FIRING YOUR TEST TILES

It may sound redundant at this point, but in order to achieve accurate results it is very important to test your glazes in the same way as you plan to fire your work. Ideally, a test would be fired along with a typical kiln load, using the firing schedule that you generally use. Small test kilns can be great for quick results, but oftentimes the actual temperature and cooling rates vary greatly between different kilns, resulting in inconclusive results.

When loading your test tiles, those that are designed to be freestanding can simply be placed on the kiln shelf and fired. Flat tiles without bases that are meant to be fired vertically can be leaned against something stable in the kiln, pressed into a ball of wadding, or set in a tile tray. Tile trays can be either store-bought or homemade, and are very helpful tools for firing many test tiles at once. In addition to vertical firing trays, some are designed to stack flat-fired tiles for efficient use of kiln space.

It is wise to use kiln wash on all your shelves to protect them from everyday glaze mishaps. A good kiln wash recipe is 50% alumina hydrate, 25% EPK, and 25% calcined EPK mixed with water. Apply it to your shelves in an even layer, using a large (4-in./10-cm) brush, and wipe shelf edges with a damp sponge to clean up any drips. When the shelves are fired the refractory wash will be dry, and if clumps are left hanging over the edges of the shelf, they may chip off and fall onto your work in the next firing.

If you suspect that a glaze test may run, take extra precautions and add an extra layer of wash to your shelves or, better yet, fire runny glaze tests on scrap pieces of bisqueware or kiln shelf bits. Another very effective way to avoid glaze disasters is leveling out a 1/4-in. (6-mm) bed of sand underneath the tiles. However, do be careful not to let sand slip through shelf cracks and onto the work below.

STORING AND DISPLAYING TEST TILES

Considerations for storing and displaying test tiles should be part of the design of your tiles. Each storage and display option has benefits and drawbacks. Here are a few options:

STRUNG TOGETHER

Stringing test tiles together is a great way of keeping a set of tiles grouped—for example, if you had the same glaze tested in oxidation and reduction, the glaze on different clay bodies, or if you tested a base and several colorants. Stringing the test tiles for a glaze to the bucket that contains the mixture is a great way to have an easy reminder of what that particular glaze looks like as you're working. The drawback is that the tiles need to be durable enough to withstand any banging around from working with the bucket. Also, the tiles may get glaze spilled on them, which can be messy to clean up. Tiles can also be strung on the wall in groups. In this fashion, they are still grouped, but are also on display with other groupings, acting like a rack of clothes ready to be sifted through. Square- or circle-shaped extruded tiles can be strung without a hole being made in the wet clay, which is a fun and useful design solution.

BOARD GRID

Arranging tiles on a board grid is a terrific way to see a range of glaze surfaces all at once, making it easy to compare them and to get a feel for the overall palette that is available. This is a seductive approach to display, as it is often quite tantalizing to be faced with many beautiful glazes at once. It is best suited to situations in which the results are examples to pull from, or a learning tool for a series of tests, as opposed to a set of stray experiments. Oftentimes, tiles in a grid are hung on a nail or hook. This allows the tiles to be pulled down and inspected, and for a selection of tiles to be compared on the table to aid in designing a palette for a piece. As tactile people, most potters appreciate this aspect of the hanging tile. However, some may prefer the tiles to be mounted with glue for permanent display, which is great for keeping them from disappearing in a school environment,

though it does makes them more difficult to inspect. The board grid approach to display takes up a considerable amount of wall space and can also be quite labor intensive, with preparing the board and nails. Be sure to put the nails and hooks in at an angle so that the tiles can't slide off once mounted. The color of the board should also be considered, as a neutral background will help with observation of the colors. White, black, or gray paints are most often used.

RECIPE BOX

Using the recipe box method is an easy and efficient way to store tiles, and is great for when you are engaged in a lot of testing. Use shoeboxes or other small cardboard boxes to compile and catalog your collections, as a large box will get too heavy very quickly. You can also make a slab box that is used for firing the tiles. The slab box creates both a way to store the tiles and to protect the shelves from dripping glazes. The ideal is to have tiles that are flat and uniform in shape, so that they stack nicely in a vertical arrangement, like files in a drawer. Paper or sticker tabs can be added to the tiles themselves, or labels can be stuck to the boxes. This method is great for saving space, and also allows for tiles to be pulled out easily and arranged on a table for observation and handling. The main drawback is that it is difficult to see the big picture, and if you don't know quite what you're looking for, rifling through boxes can get tedious.

Unique Test Tiles

(ABOVE) Rebekah Myers and Tim Berg glaze tests. Use an object that is identical to the finished piece as a test sample, as it gives a true indication of how the surface will look on the finished work.

Testing Tips

(BELOW LEFT) Placing stoneware samples with a typical kiln load wherever there is a small space is the best way of testing a glaze for repeatable outcomes in a firing schedule you will usually use.

(BELOW RIGHT) Stoneware and porcelain test tiles after firing on washed shelves to prevent items from adhering to the surface.

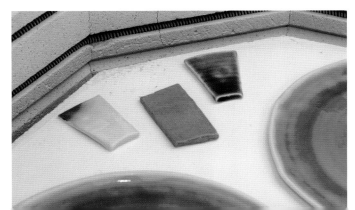

Glaze Testing Methods

In almost any glaze calculation, the first thing to do is to take each raw material, fire it to a variety of temperatures, and be amazed at the transformation that takes place. Place a small pile of powder on a slab with a divot, or in a small bowl, and fire it, preparing to be enlightened by seeing the dramatic differences between each material and how heat affects them. This simple and exciting exercise is a great hands-on way of familiarizing yourself with the materials in your lab.

> " In his first experience with ceramic color the artist often experiences a feeling of hopeless frustration because of his inability to achieve and control the exact color quality he may have in mind. This is because his experience with ceramics is not yet extensive enough to make it possible for him to think of color in terms of ceramic materials and processes. "

Charles Harder, 1955

Stoneware Glaze Tests

The tiles above show the effect of using two glazes, one on top of the other (glaze on glaze). Each tile has a single-dipped application of each glaze on each end. Changing which you apply first will affect the color response.

As materials are combined, however, things become more complicated. Each material interacts with and affects others in a variety of ways. Combinations of ceramic materials catalyzed by heat can create more aggressive melts. Scientifically, these effects are known as eutectic phenomena. A eutectic is the lowest possible melting point of two or more oxides. For example, EPK and whiting (calcium carbonate) melt at different temperatures. When combined in specific proportions, one would intuit that they would melt in between; however, a eutectic is formed and they begin to melt at a lower temperature than each material alone.

Despite the substantial amounts of scientific data on the subject, testing glazes doesn't have to be an overwhelming experiment in math, chemistry, or physics. Some artists have no interest in learning to properly use UMF and prefer to use only commercial glazes, while others may dabble with minor alterations, and others still will experiment with pushing a glaze to its limits. There are perhaps as many ways to approach glaze testing as there are ways of making. However you choose to work with glaze, it is always wise to run tests before

committing your bisqueware piece to an unknown and permanent surface. The following section will explain some simple ways to experiment and accurately document your testing process. The options inherent to each test are explained, and any strategy you choose will offer unique benefits and insights to your practice.

BASE TESTS

An acquired glaze recipe or premade commercial glaze is a great place to start if you are looking for new surfaces. As mentioned previously in this book, every glaze has a broad range of possibilities, and many factors contribute to what you consider to be "good results." For this reason, performing a test is a necessary prerequisite to mixing up a large batch of any glaze that you are not already familiar with. Testing a glaze with your materials, on your clay, with your surface texture, in your kiln, is the best way to see if it works for you.

Any glaze in this book can be tested easily by mixing up a small batch of the recipe, applying it to a tile, and popping it into a kiln. Be sure to choose glazes that fire to the temperature you are working

with, and take into consideration the differences in the way the artist and you may be treating your pieces.

STRATEGIES FOR BASE GLAZE TESTING

Beyond the most basic approach of mixing up and testing a found recipe, the real discoveries begin with making alterations. To convert any given recipe to a "base" recipe, calculate the ingredients to add up to 100 (see page 72). Have colorants and additives in addition to 100 when you calculate. It may make sense to test several base glazes to enable you to choose a few that have qualities you like, from their tactile character, to their sheen, to their degree of transparency.

From these bases, you can test any number of variables. Usually potters choose to test for color development and opacity, and by testing many variables you can achieve a well-rounded understanding of the potential of a certain base glaze. Executing a series of relatively simple tests will reveal a tremendous amount of potential. With the right base glaze, you could theoretically establish your entire glaze palette. Using the same percentages of colorants/opacifiers on different bases will reveal how the materials that compose a glaze may have dramatically different effects.

For the following test, a list of oxides is offered with particular percentages that suit their properties, as each colorant and opacifying oxide has a range within which color development and opacity are optimal. Some oxides such as rutile and red iron oxide have such a wide range that it may be useful to try two tests of those particular materials. This may be a good foundation to start with, but of course can be altered to suit your particular tastes. It is wise to always include a test of just the base glaze as a control for your experiments.

TEST PROCEDURE
- Mix up your base as a dry batch (mix it well).
- Divide evenly into 4 oz. (100 g) or 8 oz. (200 g) cups.
- Add colorant (or other additives) to each cup.
- Mix with water and sieve each batch.
- Dip/brush onto your test tile.
- Don't forget to label the tiles and mark your journal.

Testing suggestions:

A. Base glaze
(For the rest, base glaze plus the following)
B. 2% Red iron oxide
C. 10% Red iron oxide
D. 2% Rutile
E. 10% Rutile
F. 0.5% Cobalt carbonate
G. 3% Copper carbonate
H. 2% Manganese dioxide

I. 1% Nickel oxide
J. 0.5% Chrome oxide
K. 4% Illmenite
L. 7% Stain
(Opacifiers)
M. 4% Tin oxide
N. 4% Titanium dioxide
O. 8% Zircopax

SOME NOTES ON BASE TESTS

Batches of 4 oz. (100 g) are most often used for batch tests because of the simple conversions from percentages to grams, as well as this being a sensible amount of materials. However, some choose to use slightly larger batches, as this will keep any minor measuring discrepancies from having a large impact on the overall proportions of the mixture. (For example, it can be difficult to accurately measure 0.25 percent chrome oxide.) If you choose to try all of the variations listed here, that is a total of 15 tests, so 4 oz. (100 g) batch tests would mean mixing 60 oz. (1,500 g) of your base glaze. If you choose 8 oz. (200 g) batch tests, you would mix up 120 oz. (3,000 g) of your base.

Base Colorant Test

In this test, the base glaze was tested with a variety of colorants. Each tile is clearly labeled with a shorthand system (for identifying the colorants in the tester's notes) including cone temperature, and is dipped twice to reveal variations in thickness. The first tile on the left (A10) is the base without any colorants. This glaze happens to not only take color very well, but makes a beautiful opaque and glossy white glaze also.

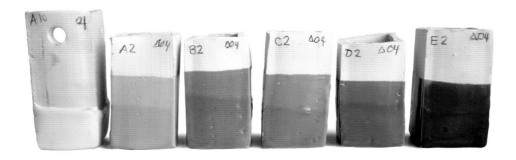

Cobalt Oxide Line Blend

This test shows a cobalt oxide progression line blend tested on two clay bodies. Always test on the clays that you actually use, as results can vary depending on different clay qualities.

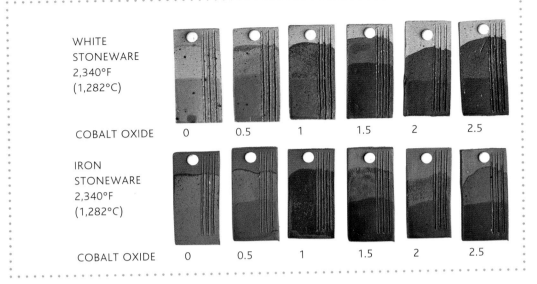

WHITE STONEWARE 2,340°F (1,282°C)

COBALT OXIDE 0 0.5 1 1.5 2 2.5

IRON STONEWARE 2,340°F (1,282°C)

COBALT OXIDE 0 0.5 1 1.5 2 2.5

LINE BLENDS

By testing materials in increments, line blends are an excellent way to test the variable effects of glaze materials and are the basis of more complex testing strategies like triaxial and quadraxial blends. In their most basic form, line blends are a great way to illustrate the eutectic relationship between two materials—for example, silica and a flux. Like viewing stop-motion animation pages, this test is visually satisfying as you can see the progression of melt from one tile to the next. Similar to the singular melt tests, this is the natural next step in the progression of understanding glaze-material melt and is an excellent tool in understanding the nature of eutectics.

USEFUL STRATEGIES FOR LINE BLEND TESTING

When bringing this technique into your studio practice, there are a few things to consider to make the time and effort of all that mixing worth while. Regular increments may be informative, but may also be unnecessary. Oftentimes, the most useful or most interesting relationship between the materials occurs across only a few of the tests, in which case it may be beneficial to do another line blend, focusing just on that section. For example, one could do a test of 5 percent increments between the 80/20 and 40/60 mark. Alternatively, making a line blend of only five tests may be all you need. Keep in mind that the point of all this

is to see the results you are interested in, so once you have the hang of the line blend techniques that are outlined on these pages, see how you can modify and apply them best to your practice. While a line blend is, in its most basic form, used as a way to test the relationship between two specific materials, it is also a great tool for testing color. In the following descriptions, specific notes are included about how color testing can be achieved with each technique.

BASIC LINE BLENDS

In a basic line blend, materials are mixed in ascending and descending proportions. The standard format has 11 total tests, with each test in 10-percent intervals. 100 percent of each material is at each end of the "line," then 90 percent of one and 10 percent of the other and so on, until the blend is complete. Fired results will reveal a progression or change in properties depending on what was tested: melt, color, opacity, crystalization, etc.

Possible variables to test (as material A and material B) could be:

• Singular materials, such as silica and flux.

• A glaze and a singular material. (In this case, the singular material would be used to test for variation to a base glaze's properties, like a flux, an opacifier, or texturizer.)

• A glaze and another glaze.

Line Blends

Test#	1	2	3	4	5	6	7	8	9	10	11	
Mat. A	100	90	80	70	60	50	40	30	20	10	0	STANDARD LINE BLEND FORMAT
Mat. B	0	10	20	30	40	50	60	70	80	90	100	
Total	100	100	100	100	100	100	100	100	100	100	100	

Test#	1	2	3	4	5	6	7	8	9	10	11	
Base	100	100	100	100	100	100	100	100	100	100	100	PROGRESSION TEST FORMAT
Mat. A	0	1	2	3	4	5	6	7	8	9	10	

Test#	1	2	3	4	5	6	7	8	9	10	11	
Base	100	100	100	100	100	100	100	100	100	100	100	MODIFIED LINE BLEND FORMAT
Mat. A	10	9	8	7	6	5	4	3	2	1	0	
Mat. B	0	1	2	3	4	5	6	7	8	9	10	
Total	110	110	110	110	110	110	110	110	110	110	110	

TEST PROCEDURE

- Dry mix 19½ oz. (550 g) of material A.
- Label your cups 1–11. Add 100 g to cup 1, 90 g to cup 2, 80 g to cup 3, and so on. Cup 11 will not have any of material A.
- Dry mix well 19½ oz. (550 g) of material B.
- Add 100 g to cup 11, 90 g to cup 10, 80 g to cup 9, and so on. Cup 1 will not have any of material B.
- Mix each batch with water, sieve, and apply to labeled test tiles.

PROGRESSION BLENDS

This test is a variation on the line blend and is not a true "blend," but rather a simple test for a base with the addition of one variable. It is an ideal format for testing one opacifier or colorant with a base glaze, and allows you to see how a material can affect a base (at what point opacification occurs or at what point the desired color saturation is achieved), without the material altering the proportions of the base recipe. Though the chart above shows 11 tests in increments of 1 percent, it can be modified to suit the effective range of the material added. For example, tin may be tested in 2-percent increments between 2 and 14 percent, resulting in seven tests, while chrome may be tested in increments of 0.25 percent from 0.25 to 2 percent, resulting in eight tests. Additionally, regular increments may not be necessary and you may wish to test red iron oxide, for example, at 0.5, 1, 2, 4, 6, 9, and 12 percent.

TEST PROCEDURE

This test can be done by dry mixing a large batch and portioning it out into separate cups, but an easier way to do a progression test is as follows:
- Mix one small batch of the desired base glaze and sieve. Dip the test tile and label properly.
- Add 1% of material A (a colorant, perhaps) to the cup. Mix well, sieve the glaze, dip a new test tile, and label.
- Add another 1% of material A so the total is 2% in the cup. Continue to mix, sieve, and dip a new test tile for each increment up to 10%.
- When finished, you will have a gradation from no color to 10% color in 1% increments.

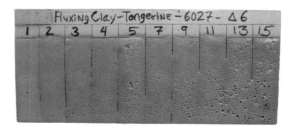

Line Blends

Daniel Bare's progression line blend shows additions of a colorant to a base. Note that he has altered the increments (as marked on the tile) to suit his needs.

MODIFIED LINE BLEND FORMAT

This test allows you to see how two materials can blend together in addition to a base recipe, often creating exciting results. This test can be used to test two colorants or a colorant and an opacifier, or other additives as well. It is a natural next step after doing one colorant progression test on a base. Testing in 1-percent increments up to 10 percent is an effective way to test the addition of stains, which tend to achieve optimal saturation at around 7 percent. For testing colorant oxides, the amounts added do not need to be in 1-percent increments and could be more effective if the amounts better reflect the nuances of each oxide's behavior. Some oxides have a wide range of effectiveness, while others change dramatically in very small increments. See the testing suggestions on page 79 for some idea of the optimal oxide amounts.

Try these oxide combinations:
- Iron + rutile
- Iron + cobalt
- Cobalt + nickel
- Cobalt + chrome
- Cobalt + manganese
- Manganese + copper
- Copper + rutile
- Copper + chrome

TEST PROCEDURE

- Dry mix 39 oz. (1,100 g) of base glaze and divide evenly (100 g each) into cups labeled 1–11.
- Add 10% of material A (colorant) to cup 1.
- Add 9% of A and 1% of material B (colorant) to cup 2.
- Add 8% of A and 2% of B to cup 3 and continue this pattern for all 11 batches.
- Mix each cup with water, sieve, and apply to labeled tiles.

HOW TO USE YOUR RESULTS

Once you achieve the desired results from your tests, it is time to do the math to figure out what exactly went into the mixture on your chosen test tile. Deciphering percentages on your mixtures will depend on what kind of test you did. Review the following examples to get an idea of how to mathematically determine the recipe of your favorite results.

BASIC LINE BLEND

To translate the amount of each of your materials in a particular line blend test to a 100% batch, the original amount of each material needs to be divided by the percent mixed. To do this, take the percent of each material, move the decimal point two spaces to the left, and multiply by that amount. For example, if you like test 3, which was 80 percent material A and 20 percent material B, you would multiply the original material A (and all of its ingredients individually if it was a recipe) by 0.80. Then multiply material B by 0.20. The materials then would add up to 100.

PROGRESSION TEST AND MODIFIED LINE BLEND

In the case of colorant tests, you do not need to do any math because colorants are always listed in addition to 100. However, if for some reason you wanted to have the total equal 100, you would take the total and move the decimal point two spaces to the left, and then divide each material by it. For example, If you liked test 7 from the modified blend, the total would be 110, so to determine what percentage each part is, divide each by 1.10. So, the 6 g of material B would become 5.45 percent of the test, and 7.4 g of material A would become 3.63 percent. Do this to all materials and the total will add up to 100.

The final step would be to mix up a new batch of the recipe based on your calculations and test it again to confirm the results.

TRIAXIAL BLENDS

Triaxial blends look intimidating but are actually quite simple. They offer unique benefits to the diligent tester and are a worthwhile pursuit, despite being quite time-consuming to execute. Essentially, they are line blends with a third point, which opens up many more possible combinations. In a traditional triaxial chart, each point would be assigned to a material, labeled A, B, or C. From each point the 100-percent pure material would be blended sequentially with the others in even increments.

For glaze calculation purposes, a conventional approach would be to have the three components of a glaze—glass former, stabilizer, and flux—on each point. The test should reveal in what proportions a proper glaze melt is achieved. From here you may wish to further refine a particular area, or take one tile and put in at point "A," then add other oxides to points "B" and "C," creating a more complex mixture. This is a great way to develop glazes from scratch and is a tool often employed by ceramic engineers.

Flux Variations

This example shows the same glaze with adjustments to the flux. Triaxial and quadraxial blends can help you locate which materials affect which parts of the results.

A 21-point grid is most common; however, 66-point may be more appropriate for very thorough testing. Many choose the more practical approach of a 21-point grid, but only actually mix and test the inner blends of the chart, since that is where the more interesting results may lie.

USEFUL AND APPROACHABLE STRATEGIES FOR TRIAXIAL BLEND TESTING

Triaxial blends allow you to see how, with three different colorants added to a base, more nuanced and inventive color options are possible. They also show that new glazes can be discovered through base tests. Experiment with the following options:

Use the same base glaze throughout:
- Add a colorant to each point and blend.
- Try taking a successful line blend and adding in a third colorant.
- Try two colorants with an opacifier on the third point.
- Try adding a texturizer to one point, such as silicon carbide.

Use three distinctly different glazes:
- Run a triaxial blend of their bases.
- Leave colorants in to see what interesting combinations arise.
- Add new colorants to each base for different combinations.

Use triaxial blends to find new base glazes:
- Clearly identify overall qualities.
- Colorants can then be added as a base test, a line blend, or a triaxial blend to find your favorite results.

Point A 100%

1	
A - 100	
B - 0	
C - 0	

2	3
A - 80	A - 80
B - 20	B - 0
C - 0	C - 20

4	5	6
A - 60	A - 60	A - 60
B - 40	B - 20	B - 0
C - 0	C - 20	C - 40

7	8	9	10
A - 40	A - 40	A - 40	A - 40
B - 60	B - 40	B - 20	B - 0
C - 0	C - 20	C - 40	C - 60

11	12	13	14	15
A - 20	A - 20	A - 20	A - 20	A - 20
B - 80	B - 60	B - 40	B - 20	B - 0
C - 0	C - 20	C - 40	C - 60	C - 80

16	17	18	19	20	21
A - 0	A - 0	A - 0	A - 0	A - 0	A - 0
B - 100	B - 80	B - 60	B - 40	B - 20	B - 0
C - 0	C - 20	C - 40	C - 60	C - 80	C - 100
Point B 100%					**Point C 100%**

21-point Triaxial Blend

Here is a chart of the basic format for a 21-point triaxial blend. Each corner is labeled with a letter to represent the chosen material. Each box is numbered and lists the percentage of each material that goes into each test.

QUADRAXIAL BLENDS

Quadraxial blends are a more complex grid of tests than triaxial blends, and utilize a fourth point. Quadraxial blends can be designed as 16-, 32-, or 122-point grids, and beyond.

CURRIE METHOD

A variation on this format is the "Grid Method" described in Ian Currie's book, *Stoneware Glazes*, which offers a systematic approach to understanding all of the factors that can affect a glaze matrix. These formats are rarely necessary for the less complicated color testing advocated in this book, but would be very useful to the artist interested in developing glazes from scratch.

SEQUENTIAL MIXING METHOD

Using the seven most common colorant oxides, the possible combinations in a base are overwhelming, and when you throw in other modifiers such as opacifiers, there are virtually endless possibilities. The sequential mixing method is an exciting and fruitful test designed to achieve as many color combinations as possible with a given set of oxides. Its basic format has been used and refined by the best in the world of ceramic testing, with great results. Go ahead and modify this basic structure to fit what works best for you.

First, choose a base glaze. For an excellent color range, use the seven most common oxides. Choose a percentage of each to test in addition to the base. Mix a 140-oz. (3,500-g) batch of your base and divide into seven 20-oz. (500-g) batches. Measure the amount of water needed to mix one batch to the desired thickness, then add this same amount of water to each batch for consistency. Add the oxide percentages to each batch, then wet mix and sieve. Using small cups, measure and combine tablespoons of glaze to dip your test tile into one at a time. For example, for your first cup, add a tablespoon from batch A and a tablespoon from batch B. Mix together and dip your tile. For the next test, combine a tablespoon from batch A with a tablespoon from batch C, and so on. By following the combinations listed here, you will have 27 tests, covering each oxide in combination with all the others. In addition, by testing three together (A, B, and C), you will end up with an additional 32 combinations, making a total of 59 different glaze tests out of only seven batches of glaze.

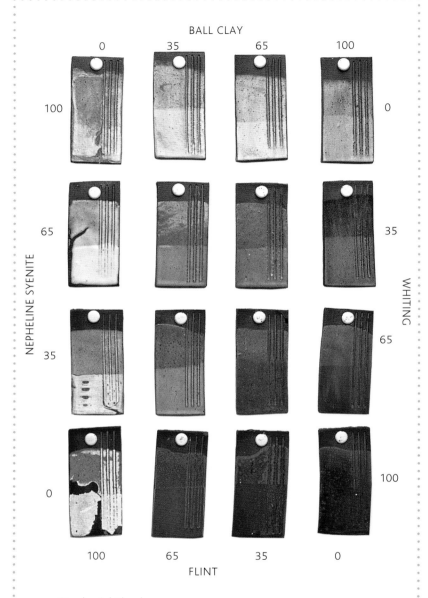

Quadraxial Blends

A more detailed method of understanding materials is to use a quadraxial blend of four materials. Here, ball clay, nepheline syenite, flint, and whiting have been used. Each side of the square represents one of the materials in various quantities. For example, top left is 100% nepheline syenite, and as the tiles progress along the top row, increasing amounts of ball clay are added to the mix. Each tile has been double dipped in the mixture to see how a single coat differs from a double coat. The results vary considerably, being shiny at top left and very dry at bottom left where there is only 100% flint, a glass former. Somewhere on the board, there will be a satisfactory glaze finish.

Sequential Mixing Method

Outlined here is a basic sequential mixing chart utilizing the seven major oxide colorants in common percentages. The base glaze is evenly portioned into seven containers labeled A through G, and the corresponding colorants are added (wet sieve each batch). In small batches, using a teaspoon, glaze combinations are mixed using the sequences at right. Tiles may be dipped or brushed if there is not enough material for dipping.

OXIDE	%
A: Iron oxide (red)	4%
B: Rutile	3%
C: Manganese dioxide	2%
D: Copper carbonate	2%
E: Cobalt carbonate	1%
F: Chrome oxide	0.5%
G: Nickel	0.5%

MIX RECIPES

A, AB, AC, AD, AE, AF, AG

B, BC, BD, BE, BF, BG

C, CD, CE, CF, CG

D, DE, DF, DG

E, EF, EG

F, FG

G

ABC, ABD, ABE, ABF, ABG

ACD, ACE, ACF, ACG

ADE, ADF, ADG

AEF, AEG

AFG

BCD, BCE, BCF, BCG, BDE, BDF, BDG, BEF, BEG, BFG

CDE, CDF, CDG, CEF, CEG, CFG

DEF, DEG, DFG

EFG

A few important notes:

- When calculating the oxide percentages for the test results, remember that in the tests with two oxides, the combined batch effectively cuts your oxide percentage in half. So, for test AE, if red iron oxide (RIO) is 4 percent and cobalt is 1 percent, the combined batch would be RIO 2 percent and cobalt 0.5 percent. For the tests that combine three, the percentage should be divided by three.
- This test uses a relatively rudimentary measurement: a wet batch by volume. Keeping the added water as consistent as possible will yield more accurate results. The results should be viewed as a guide for further testing, and any combination that is really successful can be tested again with more accurate measuring.
- After the test is complete, you will have some glaze left over. From here, try some experimental combinations, such as adding three tablespoons of one batch and one tablespoon of another (AAAC), or try adding many together (BDCEF).

Try some variations on this test:
- Add other oxides besides the seven most common.
- Add more of the same common oxides in different percentages.
- Add stains.
- Add opacifiers: tin oxide, titanium oxide, zirconium oxide.
- Add additional materials that adjust the surface, such as wood ash or silicon carbide.

OVER/UNDER GRID TEST

In this test you'll be testing what two glazes look like together, one over and one under. To run the test below you'll need five glazes, but you'll end up with 25 results.

Begin by labeling 25 test tiles, each corresponding to a set of numbers separated by a backslash, as in the chart below. Label your five "Glazes 1–5," and mix them thoroughly. Now dip all the tiles that have a 1 first (the whole top row) into glaze 1. Try to dip all tiles for the same amount of time for consistency. Dip the second row in glaze 2, the third row in glaze 3, the fourth in glaze 4, and the fifth in glaze 5. Now begin dipping the tiles as labeled in the columns using the second number. Again, try to be consistent in how long you dip each tile. You'll end up with 25 tiles displaying what each of the five glazes look like over and under each other. The tiles 1\1 and 2\2, etc. will only show a second dip of the same glaze. These tiles act as a guide for comparison purposes. Expand the experiment to include as many glazes as you would like.

1\1, 1\2, 1\3, 1\4, 1\5
2\1, 2\2, 2\3, 2\4, 2\5
3\1, 3\2, 3\3, 3\4, 3\5
4\1, 4\2, 4\3, 4\4, 4\5
5\1, 5\2, 5\3, 5\4, 5\5

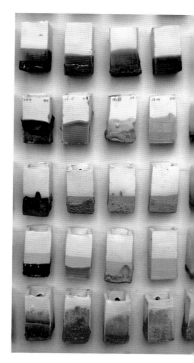

Grid Test
Five glazes were dipped onto tiles in various combinations. The tiles located at 1/1 (blue), 2/2 (flesh), 3/3 (green), 4/4 (yellow), and 5/5 (gray) show each glaze on its own, with a second dip to reveal surface variations due to thickness.

Alterations:
TESTING FOR CHARACTERISTICS

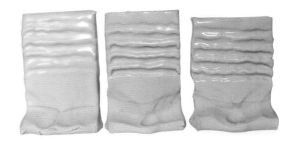

As you become more familiar with and empowered by your knowledge of ceramic materials, glaze testing will take on a whole new level of expertise and intrigue. Not satisfied with simply giving up when a glaze doesn't work for you? As with any great achievement, finding your own way to a unique result is incredibly rewarding. Testing for specific results can be a challenge, but if you follow these simple tips, it should be more accessible.

Variations of White

Here is an example of different variations within the same color. The tests listed here can be used to explore surface texture and opacity as well as colors.

ADJUSTING THE MELTING POINT

Adjusting a glaze's melting point may seem simple (add a flux to melt, add a refractory to stiffen)—however, the magic of eutectics makes it quite unpredictable. Raising the melting point of a glaze can be done by adding refractory materials in increments of 5 percent. The most common refractory additive is a kaolin, but perusing the Directory of Ceramic Materials (pages 308–311) will offer a more extensive list of possibilities. Be aware that adding refractories will affect color development as well. For example, kaolin (alumina) will make the color more dull, while magnesium will make pastels and barium can produce bright mattes.

Lowering the melting point of a glaze by adding a flux in increments of 2–5 percent, depending on how many cones you are shifting the recipe by, can be a little more tricky. Fluxes are much less predictable and interact in very different ways, depending on their proportions. Boron fluxes (e.g., colemanite, Gerstley borate) are a good choice because of their wide range of melting actions and relatively stable effects. Lithium carbonate is another predictably powerful flux, and additions of up to 5 percent can alter a glaze's melt from cone 10 to cone 6; however, it will also affect glaze fit and color development, so beware! See pages 25–27 for a thorough explanation of how the fluxing oxides affect color development.

ADJUSTING SURFACE QUALITY

To make a glaze more matte, you can add a refractory, but this effectively alters the firing temperature, rendering the glaze "underfired." A better solution would be to add in some of the fluxes that have matting effects, such as the alkali earth oxides. In high amounts calcium oxide, magnesium oxide, barium oxide, and strontium oxide all have matting properties while maintaining glaze melt. To make a glaze more glossy, lowering or replacing the alkali earths is a good place to start. Also, the addition of other fluxes, particularly ones that melt very smoothly, may be a good idea. Try boron fluxes, such as Gerstely borate and some frits, as well as the alkaline fluxes—sodium oxide, lithium oxide, and potassium oxide. Other materials such as silicon carbide and illmenite can be added for more unique textural effects.

ALTERING BY SIMPLIFYING

Often a glaze recipe has been developed using precise glaze calculation methods, with the quantity of each material given to a decimal point, as in the recipe on the following page. Many artists simplify a recipe to minimize clutter and sometimes alter the order in which materials are listed for streamlined measuring. In most cases, minor alterations such as rounding out the decimal point will have a negligible effect on the glaze's overall character, but any alteration may, in fact, change the behavior of the glaze. Alterations should be seen as experimental and should always be tested against the original recipe. Simplifying colorants and additives is not recommended, as they can play dramatic roles in glaze color and surface, even in tiny percentages.

IMPROVING GLAZE APPLICATION

Some glazes have very desirable characteristics once fired, but may have terrible working properties. Handling an unruly glaze can be very frustrating. From sticking steadfastly to the bottom of the bucket, to drying so fast that the brush sticks to the pot, to cracking and flaking off before firing, these kinds of glaze flaws can be easily remedied with simple additions. To read more about how glaze additives can improve the working characteristics of glaze application, see page 33.

Here is an example of a glaze from John Britt's excellent book, *The Complete Guide to High-Fire Glazes*.

RECIPE:		ALTERATION 1:		ALTERATION 2:	
Custer feldspar	30%	Custer feldspar	30%	Custer feldspar	30%
Whiting	11.1%	Whiting	11%	Silica	26%
*Calcium carbonate		Silica	26%	Kaolin	17%
Silica	26.3%	Kaolin	17%	Dolomite	27%
Kaolin	16.8%	Dolomite	16%		
Dolomite	15.8%			Total:	100%
*Calcium magnesium carbonate		Total:	100%		
Total:	100%				

Alteration 1: Rounding out the decimal points. This will almost certainly have a negligible effect on the glaze's outcome.

Alteration 2: Combining dolomite (calcium magnesium carbonate) and whiting (calcium carbonate). Though these similar materials were previously almost equal parts, using only dolomite may impact the glaze as it will now have a greater overall quantity of magnesium carbonate.

The only way to know how different the glaze will be for sure is to test it. Even if it turns out slightly differently than expected, you may have discovered a glaze you like even better, that now has the added bonus of being more user friendly.

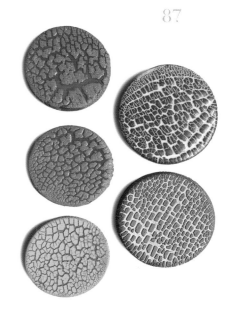

Crawling Test Tiles

The above are glaze tests by Karin Östberg, showcasing the difference in glaze color and behavior that can be achieved when the same glaze is fired at a different height and location in the kiln.

SUSPENSION

Glazes are like salad dressings, with the various ingredients sinking and settling out into layers over time. Both need to be mixed immediately before use to ensure proper dispersal of all materials. Some glazes seem to settle very quickly to the bottom of the bucket in an unmixable, rock-hard slab. This often happens with glazes that have little to no clay in them, or that have very high amounts of fritted material, which is heavy. Adding suspension agents like bentonite or flocculants to the glaze helps keep all particles in suspension. Some additives will alter the look of the finished glaze, but only a little is needed to make a big difference to the suspension. See page 33 for a description of the various additives and instructions on how to use them.

COAT ADHESION/DURABILITY

Have you ever labored over the delicate application of a glaze, only to find that when you go to load it into the kiln, it lies in flakes around the base of your pot, or chips off as you go to pick it up? Glaze flaking may be blamed on recipes with little to no clay in them, but conversely on glazes extremely high in clay content as well. The main problem with too little clay is that the dry skin of the glaze is so fragile, with nothing binding it together and sticking it to the pot. With too much clay, the issue is one of shrinkage—the glaze shrinks too much as it dries,

essentially flaking off the pot. Adding clay to a glaze that is fragile due to low clay content or removing clay from a glaze that shrinks and cracks due to high clay content can help solve this problem; however, it may also alter the way the fired glaze acts. Adding gum or suspension agents can solve the problem without affecting the glaze-fired look. Sometimes a glaze is fragile and flakes off simply because there is too much on the pot, as can happen when layering. Also, when a glaze still needs to be a working surface, as in the case of majolica, it requires added strength. Spraying the glazed piece with a spray starch or a watery solution of a gum such as CMC gum is very effective in this case. It stiffens and toughens the surface pre-firing, but burns off, leaving no trace. Alternatives to spray starch include hairspray, as well as mixing and brushing on a watery solution of cornstarch, or even sugar or honey.

ROT

Sometimes when a glaze has been mixed up for a while, the organic matter in it (from gums and carbon-based matter) will actually begin to decompose and ferment, giving the glaze a truly nasty aroma. This rotting does not affect the firing behavior of the glaze, and is only an issue because it is unpleasant. Drying the glaze out completely and then remixing it can eliminate the growth of bacteria. A few drops of your favorite essential oil can also help mask the smell.

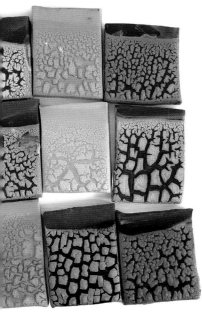

Pushing the Limits

"Everything in moderation," they say... Well, this is true for glaze in some respects: There is a range within which a glaze will "act appropriately." Then there is the space beyond that. Undoubtedly, many of the glazes in this book would fail the ever-valuable UMF test, but when making works for sculptural pieces, the ideal melt is not the most important thing. Seeing what happens when you push a glaze beyond the conventional suggestions may yield surprising and revolutionary discoveries. Ceramic materials are mysterious in many ways. So much has been done before, yet there remain endless combinations and proportions of materials to work with. What discoveries are waiting for you in the studio?

Shrinking and Crawling

Above are examples of crawling glaze by Karin Östberg. This glaze is high in magnesium carbonate, which causes the surface to shrink, while the other materials in the glaze cause it to melt and adhere.

ADDING TEXTURE

There are a number of materials that can be added to a glaze to create either a visual or a physical texture. Glazes can have dramatic and wonderful effects on textured clay surfaces, but let's focus on creating texture within the glaze itself. Here are some interesting experiments to run for glaze texture:

- Granular rutile and illmenite will add speckles to the surface.
- Silicon carbide can create wild, foamy surfaces, often referred to as volcanic/lava glazes; try adding 3–5 percent silicon carbide.
- Try adding ashes such as bone ash and wood ash to add rivulets to a glaze.
- Try tossing on powdered materials to the surface of wet glaze, such as zinc for crystal development.
- For crawling, beading, and lichen glazes, try adding magnesium carbonate.
- Use feldspars in a slip trail bottle to create a beaded line on clay.

- Use powdered clay or a wet slip brushed on top of a glaze to create a crackle or crawling effect.
- Add small piles of colored glass beads or broken glass to pockets where they will melt for a dramatic pooled effect.
- Use metals such as copper wire, nails, metal flashing, or found objects to leave marks on the clay; wire can be spun around the piece, and depending on the composition of the metals you choose, it may burn off, flash, or fuse.
- Organic materials and food products that are high in certain ceramic oxides, such as banana peel, pet food, and Pepto-Bismol, may also have interesting effects on the surface after burning off in the firing.

Note: Good ventilation is very important when firing organic and metal materials. Smoke and fumes will occur and may be extremely toxic.

Over-the-Top Additives
- Try adding excessive amounts of a colorant. For example, some gold metallic glazes utilize 50 percent manganese.
- Try adding excessive amounts of textural additives. We know that materials such as wood ash and silicon carbide will dramatically affect a glaze's surface quality. But see what happens if they are used in excess ...

Note: When testing materials that may run off your tile, it is wise to protect your kiln shelves by placing tests in simple drip trays, on clay slabs that have been bisque fired, or on sand beds. See page 76.

Flora Pool

Hand built in terra-cotta, layers of commercial and studio glazes have been applied along with fluxes, frits, and colored glaze frits to achieve this luscious, fluid-looking surface, serendipitous in its outcome as none of the materials is measured before application.

Textured Forms

These hand-built but heavily grogged stoneware forms are covered in multiple layers of glaze that are each fired on individually in an electric kiln, slowly building up the desired surface effect. Each firing adds to the crawling and dripping appearance to give the works a visually unique and tactile quality.

TESTING EXTREMES IN THE FIRING CYCLE

Crystalline glazes are formed by precise, slow cooling, while a matte glaze may be rendered transparent if it is crash cooled. Most glazes will run if held at peak temperature. What might happen to your glaze as you dramatically alter your firing cycle?

- Try using a controlled cooling cycle on your kiln.
- Try crash cooling. (Crash cooling typically involves opening a hot kiln, which is extremely dangerous! Take appropriate safety precautions and consider possible implications for kiln damage.) Raku pieces are always pulled from a kiln at peak temperature. What might happen to your glaze?
- Try a hold in temperature, either at peak temperature or at any other point.

FIRING GLAZE TO THE "WRONG" TEMPERATURE

Sometimes this happens by mistake. But what if you did it on purpose?

- Try the glaze a cone or two hotter or colder.
- Put it in a different atmosphere.
- Be bold: What does that cone 06 microcrystalline matte look like at cone 10? How does that cone 04 opaque satin yellow look at cone 06? (Hint: it will probably melt more, so put down some sand.)

BUILDING THE GLAZE BACKWARD

What would happen if in your glaze testing you started with a colorant and added frit, then silica, then clay? By switching the glaze-building process around, you could discover a new glaze form.

GLAZE THICKNESS

Conventional glazing strategies include applying glaze the thickness of a credit card for accurate results. But what happens if you push glaze thickness in either direction?

- Try a coat of your glaze super thin.
- Try applying the glaze super thick, like thick frosting.
- Try adding piles of glaze to small bowls to test volatility as well as to observe how the extremely thick puddle of glaze affects the form. Does it crack under the pressure or hold its shape? Does it reveal some new surface quality not previously achieved with a typical application? (Make sure you plan appropriately for glaze run.)

Glaze Application

Glaze is a thin application of ceramic material on top of a clay body. It fuses during the firing to form a glassy surface. The ceramic materials that make up a glaze are mixed with water to allow for their particles to be held in suspension—this helps in the application process. When applied to bisqueware, the water in the creamy glaze mixture is sucked up by the porous clay body, which acts like a sponge, leaving a smooth and even skin of glaze material on the surface. As a result of this sponging action and the dry air, glazes typically dry to the touch within minutes, if not within seconds.

Japanese Hake Brush

This is used specifically for decorating and generally to layer on large areas of slip, glaze, or color.

Mop Brush

Traditionally used to apply glaze, these brushes are also good for slip and underglaze color application.

There are as many ways of applying and working with glaze as there are of making the initial form. Each technique has its own nuances in finish and quality, depending on the tools, materials, and processes used. Your preferences and the desired results for a particular piece should be the two driving factors in choosing the proper glaze application technique. Some pieces may need just a quick dip, while others require delicate brushwork, areas masked by wax, and multiple glazes and firings. Be attentive and curious, because this is an essential step in determining the finish of the final piece.

PREPARING FOR GLAZING

There are several things to consider once you have selected your piece and the glaze(s) you'll be using.

- Make a plan, and take your time. This is the final step in creating your piece, so don't rush and risk losing hours of work. Prepare with notes and sketches to minimize mistakes, and also to use as a reference when the pieces come out of the kiln.
- Ensure that the surface you are applying glaze to is dry and free from dust. Use a clean, damp sponge to minimize the inevitable (and hard to see) studio dust. Dust or oil spots from dirty hands can act as a resist, which hinders glaze adherence to the body. A wet piece will be difficult to glaze because the body absorption will be dramatically reduced, resulting in a very thin coat.

- Use a soft pencil to sketch on the piece to show where you'd like to apply glaze. Labeling which glaze goes where, and even in which order, can be very helpful. The pencil lines will burn off in the firing.
- Determine how the piece will sit in the kiln, and do not put glaze where the piece will touch the shelf. Glaze will melt and stick to anything it touches while firing. Keep the bottom of the piece free from glaze by wiping it well with a wet sponge. Wax can be used on the bottom to keep most glaze from adhering. Any glaze left on top of the wax will still melt in the kiln and stick to anything it is touching, so be sure to clean it off.

Achieving Proper Thickness

Glaze results can vary dramatically depending on the thickness of application in whichever application process you choose. Test tiles can be a great place to experiment with a specific glaze's potential. Some say the glaze should be the thickness of a credit card—or less than $1/32$ in. (1 mm)—but measuring can be difficult. Using a needle tool to scrape through the glaze in a discreet spot can be a good way to see the thickness. To the experienced ceramicist, a little finger swish in a well-mixed glaze will provide enough information to assess proper consistency for glazing.

Dipping

Dipping is probably the simplest and most common way of applying glaze. You'll need just enough glaze to completely submerge your piece. Be smooth but swift when submerging and removing your piece from the glaze to eliminate inconsistencies. Any wavering once the piece touches the glaze can result in lines, drips, and thick or thin applications.

You'll need to consider how to hold the piece during the process, and what potential marks (glaze drips and bare spots) this will make. Glaze tongs can be very helpful, but small marks and drips can still happen. Dipping a piece halfway, allowing it to dry, then dipping the other half is another option to consider—but where the halves meet can be obvious in the finished piece. The size and shape of pieces will often inform dipping strategies.

Tip: *Having different-shaped containers in your studio can be very helpful for dipping large, flat items such as platters, or tall, narrow things like vases.*

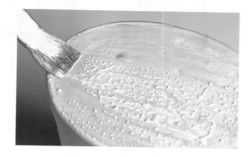

1. The base of this pot is coated in brush wax to repel the glaze where it is not required. (Glazing the base is only possible if the pot is to be fired on stilts, and these are not commonly used at stoneware temperatures.)

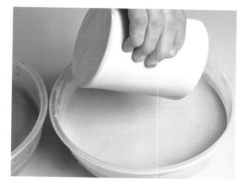

2. Now that the wax is dry, the pot is dipped sideways into a bowl of glaze which is sufficiently wide and deep to accommodate it.

3. When the glaze is dry enough to touch, the pot is held and dipped the other way, overlapping the first glaze in the middle.

Pouring

Pouring glaze is a good strategy for certain forms such as large bowls, or for decorative purposes. A good way to evenly glaze the interior of a pot is to pour glaze into it and then pour it out. It might need a little wipe along the rim to correct some drips, but this technique is used by many potters. Glaze can also be poured strategically to create decorative effects, especially when used over another glaze.

Grip the bowl between the thumb and spread fingers, with the thumb gripping the base. Fill a small jug with glaze and pour it slowly and evenly over the outside surface. Any fingermarks can be cleaned up afterward. If the pot is too big to hold in your hand, place sticks across the bucket to support the rim of the pot while pouring the glaze.

Spraying

Spraying can be very helpful for pieces that are difficult to dip or pour glaze onto because of their complicated forms, large scale, or fragility. It is also useful for specific decorative purposes such as glaze fading. Spraying glaze from about a foot (30 cm) away will ensure that you get an even coating and that it does not go on too wet (spray too close and it will drip) or too dry (spray too far away and it won't stick). Two types of sprayers are widely used in the ceramic studio: A paint sprayer attached to an air compressor, and a glaze atomizer. The air compressor attachment is great because it usually holds more glaze and there is constant pressure coming from the gun when you hold the trigger. A glaze atomizer is perfect for small jobs, and is controlled simply by you blowing, rather than compressed air. It's cheap and you don't need any additional equipment. When using either of these devices you should work in a glaze spray booth with proper ventilation, and wear goggles and a respirator. While spraying, move the piece constantly so as to not build up too much glaze in any one spot. Turntables can be very useful for this.

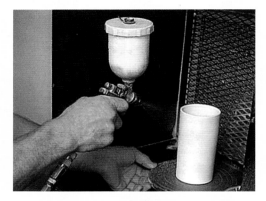

1. A white glaze is sprayed over the entire pot. Spraying should be as methodical as possible to ensure even application. It is important that runs don't develop—as soon as the glaze appears wet, move on to the next area.

2. A second glaze (in appearance gray, but actually green) is sprayed over the first. Do not spray too close to the pot or the application will be too concentrated in one place: 12 in. (30 cm) is about the right distance, but this depends to some extent on the power of your spray gun and the effect desired.

3. The colored glaze merges from top to bottom—thick to thin. All glazes are likely to appear differently depending on the thickness of application, and this is a matter for experimentation.

Spraying is also a good way to cover stencils evenly and quickly.

BRUSHING

Pieces can be glazed entirely with brushes, or brushes may be used only for decorative purposes and applying fine detail. Brushing is ideal for touching up little mistakes and for smaller swatches of glaze. Achieving proper glaze thickness can be challenging, because the manual application is relatively difficult to control and some glazes dry very quickly when applied to bisqueware. If you'll be decorating quite a bit, you might want to consider a glaze additive for smooth application, such as CMC gum. Commercial glazes are full of these additives and are designed for brushing, but also spray well.

RESIST METHODS

Resists are used to keep a glaze from sticking where you don't want it. Wax can be brushed on to mask off sections or to create decorative patterning in layered glazes. It is not removable unless it is burned off in a kiln, so watch out for drips. Often the bottom of a piece is waxed to keep glaze off, which could otherwise melt onto the kiln shelf. There are many types of wax that can be used, but most studios are equipped with a cold wax emulsion that can be thinned with water—this is very effective and easy to use. Latex is also brushed on, and once it dries it can be peeled off, revealing porous, glazeable ware underneath.

Two or more resist methods can be used together to create elaborate patterns. Tape is a useful and inexpensive material to experiment with, which easily creates sharp, straight lines. Masking tape and blue painter's tape are both recommended, as they are easily removed from bisqueware and tend not to leave adhesive residue as many other tapes do. Stencils cut out of various materials such as newsprint can be very useful for flat or cylindrical work—wet the cutouts and stick them to the piece, then remove them after glaze has been applied. This process works better on wet clay with slip than during glazing, and may not withstand more than light brushwork or spraying.

PRINTING ON CLAY

There are almost as many processes for printing on clay as there are for printing on paper. A good reference when printing on clay is Paul Scott's book, *Ceramics and Print*, as well as Paul Andrew Wandless's book, *Image Transfer on Clay*. Screen printing is a very popular way to apply images to ceramics; this involves sealing an image into a mesh screen and pushing ceramic materials (such as an underglaze or stain) through the portions of open mesh, transferring them to clay, and revealing an image. An accessible method for you to try is monoprinting, which involves creating an image using slip or underglaze on a slab of plaster, then pressing a slab of clay onto that, transferring the image to the clay. Direct printing methods include using stencils, stamps, and sponges filled with glaze. Sponging can create a mottled texture all over, or a specific pattern by using finer sponges cut into shapes.

ADDITIVE DECORATION TECHNIQUES

Additive techniques for glaze decoration include stippling, spattering, sponging, and trailing. Stippling can be done using a stiff or flat-tipped brush and applying glaze with a blotting motion to create a unique texture. Spattering is done with a similar brush, but instead the glaze-covered bristles are flicked at the work, applying a directional "splat" of glaze to the surface in the style of a Jackson Pollock painting. To create linear decoration with glaze, you can use a trailer. These come in many shapes and sizes, but the kind of fine-tipped trailer you can find in ceramic supplies stores will allow for the most intricate linework. Unlike when trailing with slip, glaze trails may run and bleed when fired.

REDUCTIVE DECORATION TECHNIQUES

Sgraffito is the process by which a pin tool or special sgraffito loop tool is used to scrape away a surface to reveal what is beneath. This process can be carried out at all stages, from wet clay to glazing. When done on glaze, the line can be scraped through to the bisqueware, or wax can be applied first and another glaze inlaid where the scraped lines are made. With sponge removal, a wet sponge can be used to blot away an even coating of glaze—effectively mottling it—or it can be used to wipe away glaze from masked-off sections. Finger wiping or combing is done when the glaze is still wet, just after application. By swiping fingers through the glaze, the thickness is disrupted, leaving behind a fluid mark. Combing is similar, and can be done with any number of tools including a rib, card, stiff brush, or actual rubber comb.

Keeping a Glaze Journal

Whatever stage you are at in your career, it's essential to not only keep mental tabs but also written notes on how and why you do things: how thick you mix your glaze, how many layers of brush strokes you use to apply it, how hot and how long you fire for, and any other details that are important to your process. All of these details may seem minute in and of themselves, but each one plays a very important role in the outcome of your glazed surfaces.

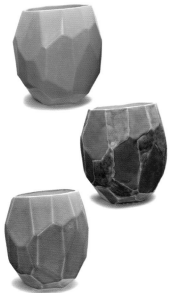

From Pad to Pots

A good sketchpad should record ideas and inspiration so that the basics of an idea quickly drawn can then be developed and outcomes can be repeated. Here, ideas for form, proportion, color, and surface treatment can clearly be seen to have translated from the sketchpad to the finished pots.

Of course, you may pay no attention at all and still have beautiful results; however, if the goal is to achieve any specific color, surface, or effect, being consistent and precise with your techniques will be crucial. It has happened to so many potters that the most beautiful results have led to frustration as a result of losing notes scribbled on scrap paper, or simply forgetting a process after not writing down at all what has been done. The notes you keep of your glazing adventures are extremely valuable, and will help you keep track of what works and what doesn't so that you can replicate your greatest glazing successes.

An artist's glaze journal should be a well-organized working reference book. It is a repository in which to record and keep track of the glazes that have been used, tested, or collected for use tomorrow or far into the future. Do not assume you will be able to remember every detail or sometimes even the most basic elements of a test. At the time, it may seem obvious, but years (or for some busy people even days) later, the decisions that were at the forefront of your mind at the time will fade—and if they are not written down, you will have no way to access that information when you need it. Establishing accurate and consistent journal habits will benefit you for years to come.

Beyond the most fundamental information about your testing, such as the base recipe, added colorants, and cone temperature of your glazes, there is a lot of other information worth adding. While you are applying glaze to your tiles, record the behavior of your glaze and how you treat the tile:

- Does the glaze settle badly?
- Does it seem to be mixed thinly/thickly?
- Do dramatic pinholes appear after dipping?
- Record the number of layers applied and any surface techniques employed.
- How long/thickly did you dip/brush?
- Did the glaze dry and clump while brushing?
- Did you mark the glaze in any way?
- You may find it helpful to draw a simple diagram of your test tile showing exactly what you did and where.

Notes like these can help you assess results and identify issues to fix.

Once your tiles are pulled from the kiln, record your results, including the conditions of the firing:

- Was there heavy or mild reduction?
- Was it hot on the top or even cones all throughout?
- Was there a hold at peak temperature?
- Did the kiln cool slowly or did you crash cool?

Good Journal-Keeping Habits

- Write legibly and clearly, and double-check all recipes for accuracy when transferring between sources.

- Develop a numbering system for corresponding recipes in your notes with test tiles.

- Take care of your journal! Keep your journal in a safe place so that you can find it, and keep it away from water.

- Be sure to keep all the relevant important information with each recipe, i.e., cone temperature/atmosphere/additives.

- Some artists find it helpful to date the recipes and also date any changes made.

- Try to organize your journal into categories such as "cone temps" or "firing styles" for quick reference.

- Record all your results!

- If there are surprises, inspect your tiles to find out why—was there a chrome-glazed pot near your white tin base that flashed pink?

SHORTHAND LABELING

It is impossible to compile all the pertinent information onto a test tile—there would be no room for the glaze. The solution is to establish a shorthand system of numbers and letters that corresponds with your notes. If simply designed and diligently followed, this makes an easy way to keep track of your recipes and results.

The most important information to label is the recipe and any variations added (for color, opacity, texture, and so on). Other factors to label include the cone temperature and atmosphere of the firing, as well as toxicity. Depending on your unique studio practice, these other variables may not be as necessary to include on your tile. For example, if you only own an electric kiln, then there is no need to label for atmosphere, because reduction is not an option for you.

Abbreviations for the base glaze recipe can use initials, with colorant additions represented by lower-case letters or numbers. Depending on the type of testing you are doing, you may wish to

establish codes for your tests that you use through several rounds of testing. For example "B" can be used for "base glaze," and "V" for "variation to the base."

For the tile example below, Mamo White Matte would be "MWM." "MWMV1" could correspond with a variation including the addition of 2 percent lithium, while "MWMV2a" could represent a variation replacing whiting with dolomite, with the additional lower-case letter "a" representing colorant additions. You may use these suggestions as a starting point, but most important is to find a system of shorthand that makes sense for you, and use it every time.

Leave Nothing to Chance

Natasha Daintry's journal records all relevant information for each glaze trial in both written and picture format, all essential for repeatable outcomes. There cannot be too much information recorded; every detail is important.

Shorthand Notes

Create a shorthand code for your testing system to make reading results easier. It allows you to fit a large amount of information onto a small test tile.

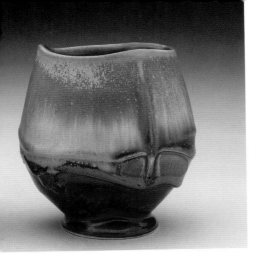

Beyond Glaze

Though the focus of this book is on color development in glazes, there are many other ceramic—and nonceramic—materials that can be used to carry color in a work. The following pages show a variety of ways in which color can be added to the ceramic surface in addition to glaze.

Thick Slips

Using slip in a very thick state (like Greek yogurt) can yield interesting textural results, as in the work of Steven Hill, with luscious drips in the form.

Terra Sigillata Shovel

This work by Joseph Pintz does not show any of the characteristic qualities of smoothness and sheen associated with terra sigillata, but Pintz uses the terra sigillata along with slip and glaze to complement the texture created during the forming process. A muted color palette creates a subtle, weathered surface and suggests a history of use.

LIQUID CLAY

Slip, terra sigillata, underglaze, and engobe are all liquid mixtures of clay and glaze materials that are typically applied to ceramic work at various stages of greenware, from wet to dry, and sometimes even bisqueware. Each offers a wide range of textural possibilities as well as the option of adding the same colorant oxides and stains that are used in glazes, making them capable of almost infinite modification. A clear or translucent glaze will enhance the embedded colors, making them brighter and richer.

Some potters choose to leave these surfaces unglazed, particularly the terra sigillatas. "Liquid clays" fire to a dry to a satin surface. Engobes and underglazes may vitrify (begin to melt) depending on their particular formulation and final firing temperature. The form and color of all these materials are fixed to the surface of the clay, and they do not run or blur when fired to the proper temperature, even when coated with a glaze.

SLIP

Slip is essentially a clay body liquefied by the addition of water. It is most commonly mixed to the consistency of heavy cream (like glaze, or slightly thicker). It can be applied to greenware by dipping, spraying, or with a brush or slip-trailing tool, but it can also be used as a thin wash for dipping, or in a thick, yogurtlike consistency for application with a trowel. Colored slips are typically made using white base recipes with the addition of colorants. Flashing slips typically have a high clay content (70–90 percent); however, if they go thin, oftentimes they will adhere to bisqueware as well.

CASTING SLIP

Casting slip is a clay body that has been deflocculated for making forms by slip casting into molds. Casting slip can be an effective decorative medium as well, especially for slip trailing. Any slip recipe can be mixed as a casting slip, by using less water and adding a tiny amount of Darvan 7 or sodium silicate.

TERRA SIGILLATA

Also known as colloidal slips, terra sigillatas are prepared by refining clays to procure the smallest particles for a fine, smooth, and dense surface. This process includes mixing the slip with ample amounts of water and a few drops of a deflocculant, which helps the clay particles settle into layers. After resting for several days the finest particles, which settle as the top layer of material, are siphoned into a separate bucket, while the rest is discarded. For best results this process can be repeated, and the mixture should be sieved at least once through a 150-mesh screen before use.

It is common for red clays such Redart to be used for sigillatas, producing warm, rich, orange-reds. White clays such as OM#4 (a ball clay) with colorants added before sieving the refined slip can produce a wide range of colors. Terra sigillatas are often burnished (rubbed with a stone, spoon, or chamois) to compress the surface particles together, producing a dense surface with a delicate sheen. If done properly, this can render the surface watertight.

UNDERGLAZE AND ENGOBE

Underglazes and engobes are both types of slip, and because of their similarities to slips there is often confusion over the differences. Both typically have less clay in their recipe and can be applied to bisqueware as well as to greenware. Engobes are vitreous slips that contain more flux than a typical underglaze. Both underglazes and engobes can

be applied similarly, but the fired results will have differing levels of vitrification. "Underglaze" most often refers to commercially prepared mixtures with additives that make them especially useful for fine decorative work.

STAINED CLAY

You can choose to use oxides and stains to color a clay body, though this tends to produce paler versions of the color, as it is diluted by the clay.

WATERCOLORS AND WASHES

An oxide wash is simply any colorant oxide mixed with water, with the most common ones being iron, manganese, copper, cobalt, rutile, and chrome, but stains can be used as well. You may add up to 50 percent of Gerstley borate to help the oxide fuse to the surface of the clay. Using oxide as a wash is an easy way to create linear brushstroke marks with sharp definition, and is a terrific way to highlight textural surfaces. By brushing the wash over textured bisque clay and then wiping it away from the surface with a sponge, textures are enhanced. If a glaze is applied on top of the wash, depending on the glaze matrix and how thick it is, many of the very thin layers of oxide will absorb into the glaze and dissipate, leaving behind only the darkest spots in the deepest crevices. Ceramic watercolors are more like a ceramic pencil or chalk recipe, but are thinned out with water and applied in a traditional watercolor style to the bisqueware.

DRAWING WITH CERAMICS

Though we tend to think of ceramic color as a liquid that we can apply to the surface, ceramic color may also take the form of drawing tools such as pencils, crayons, chalks, and pens, affording the artist the ability to mark the clay with graphic precision. Ceramic pencils are widely available. They can fire up to cone 10 and, while they look like regular pencils, they are composed of ceramic materials, including up to 15 percent stains or oxides. Pencils, along with pastels, crayons, and pens, can be made in the home studio as well. The primary difference is how they are prepared in addition to the base recipe: Pencils are fired to a low temperature to provide durability, while chalks and crayons are used unfired. Crayons are mixed with wax, making them act as resist agents when applied to bisqueware, which can have a unique effect. Pens make use of very fine slip trailers, as their recipes are mixed in

such a way that they remain in liquid form. You can find such recipes from a variety of sources, or simply experiment yourself, starting with a slip or underglaze recipe as a base and adding just enough water to roll out coils. Leave them to dry and try them out on bisqued test tiles. Robin Hopper's book, *Making Marks: Discovering the Ceramic Surface,* is a good resource for ideas.

EXTREMELY LOW-FIRE COLOR

China paints, lusters, and decals are applied to work that has already been glaze fired. The glaze does not re-melt completely at the very low temperatures, meaning it provides a stable canvas for the materials to adhere to without being absorbed into the glaze matrix and losing definition. They are typically fired to between cone 022 and 015, and while they are fully melted and fused at this temperature, they remain relatively fragile; the surfaces can scratch or wear down over time if subjected to heavy use (they are not dishwasher safe).

CHINA PAINTS

China paints, also known as enamels or overglazes, are fritted ceramic materials, typically composed of silica, lead, or boric acid, and the oxide colorants. They are painted onto already fired glaze surfaces (glossy glazes work best) to create very detailed, crisp, and brightly colored imagery, and fired to cone 019–018. They can be purchased as premade paints or in powder form, and can be mixed like paints to achieve a practically unlimited color range. Most artists prefer the powdered form because it is less expensive, has a longer shelf life, and most importantly allows for more artistic control. In powder form, China paints can be mixed with water or oil. Many oils will work, including lavender, clove, linseed, and even olive oil. When using oil, china paints can be thinned using turpentine, allowing for more flexibility in application. These "glazes" are fired to extremely low temperatures and, unlike most ceramic colors, look almost the same before and after firing. Many artists find the characteristics of china paints appealing because they can be controlled and predicted like regular paint, but are in fact ceramic surfaces.

LUSTER

There are two types of lustrous surfaces in ceramics: Lusters (on-glazes) and luster glazes (inglazes). The latter are applied to bisqueware and

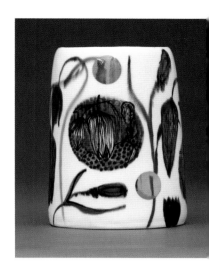

Using Luster

Anat Shiftan uses luster here to add another element of ornamentation. The crisp edges and highly reflective qualities make luster a dynamic addition to the glazed surface.

Wax and Graphite

Clay has great working properties, but it doesn't always demand a glazed surface. Jeffrey Mongrain has discovered many incredible results using nonceramic materials such as the layers of wax and graphite seen here.

Paint and Luster Safety

The hazardous nature of lusters and china paints means that they should not be used on the inside of functional work. Lusters and china paints release toxic fumes, both when being applied and when they are fired. Proper protective equipment, including a chemical respirator (not just a dust mask), gloves, and ample ventilation, should be used at all times. Waste should be disposed of in hazardous material bins and not in the regular trash or down the drain. Decals are fixed materials and do not pose a health risk in handling.

Dramatic Decals

The use of strategically positioned decals on wares that have a traditional quality and which are fired in a rigorous and unpredictable process successfully crosses the boundary into contemporary practice while maintaining the distinction from the more traditional use of decals, as in this vase by Justin Rothshank.

fired to cone 010–04. Typically used in raku, these glazes are heavily reduced to produce pearlescent, opaque, and metallic surfaces. Though both are high in metal content, on-glaze lusters are very different.

Almost exclusively used in commercially premixed form, lusters are metallic salts (gold, platinum, and palladium) in solution. They are painted directly onto fired glazed pieces and then fired to between cone 022 and 018 to produce brilliantly bright, mirrorlike, metallic skins that fuse to the glazed surface. Lusters work best on smooth, glossy glazes to achieve the highest shine. They will take on the quality of the glaze, so if a glaze is glossy but has crazing, that will tend to show. If a glaze is matte, the luster will not look like shiny metal and will be matte as well. Lead-alkaline base glazes are recommended for superb luster results.

DECALS

Decals are images made from ceramic-based materials (usually oil-based china paints) that are printed onto decal paper with a water-soluble film on it. The image is then coated with a clear layer of shellac or a similar substance, which can be removed from the paper much like a sticker. Then it can be manipulated and affixed to a ceramic surface and fired to fuse it on. Commercial decals retain all of the color and graphic qualities present once they are fired, which is very appealing for those interested in a flat, graphic, and detailed image quality. Decal printers are available so you can print one-of-a-kind decals. It is expensive to buy a printer like this, but there are companies that offer this printing service to artists.

There are two types of decals:

- Oil-based overglaze decals are premade images that can be purchased from a variety of commercial sources. These often kitschy images are inspirational fodder for many artists. You could make them from scratch by screen printing china paints onto decal paper, though this is an in-depth technical endeavor of its own. These decals are typically fired somewhere between cone 019 and 015. Another way to get an original image is to design your own decal and have it made for you by a decal company. This may be more costly, but will allow you to get exactly what you want, in any color you desire.

- Laser toner decals are a special type of decal that you can make yourself. The toner in a laser printer has iron in it, which is why these printed images fire onto the work, leaving behind the characteristic reddish-brown images. These decals have a much wider firing range, which is dependent on the temperature at which the base glaze begins to flux, thus adhering the iron to it. When using laser toner decals, it is best to do a test on the glaze you plan to adhere the decal to before committing to a piece. To make these, you will need to purchase blank decal paper and be able to print your own images using a laser printer with the iron in the toner. Choose images that are graphic black and white or grayscale, as gradients do not transfer well.

To use a decal, submerge it in warm water and wait just long enough (about a minute) for the film to release from the backing paper. Then apply the skin of the image onto the ceramic object. Be delicate, as the image can tear easily. Use a rubber rib to gently press all water and air bubbles out from between the image and the piece. Let dry, then fire to between cone 019 and 015.

Sources for decals:

o *www.ceramicdecalprinting.com*
o *www.beldecal.com*
o *www.ebay.com*
o *www.lazertran.com*

ACHIEVING COLOR BEYOND GLAZE

Many ceramic purists cringe at the thought of substituting a real ceramic glaze with something like paint; however some of the greatest ceramic works in history—the Terra-Cotta Warriors of Xian, China, for example—were made in precisely that way. However, the use of nonceramics should be thoughtfully considered, if only because ceramics

come in so many forms these days that almost anything is possible with this material! Each material choice the artist makes has an impact on the meaning of his work.

PAINTING AND DRAWING

Paint, or "room temperature glaze" as some jokingly refer to it, has been used in all its forms to coat the ceramic surface. Of course, what it lacks in depth and luminosity it makes up for in convenience and predictability. Any and all kinds of paint will affix to ceramics. Automobile paint can provide a super-slick, glazelike quality that some enjoy. Drawing implements such as pencils, pens, pastels, and the like may be used on ceramics as well, but their effectiveness will be determined by the quality of the surface they are being applied to. For example, pencil and pastel will not mark hard glaze, but could be applied to a softer or more texturized surface.

FLOCKING

Flocking is a process of coating a surface with tiny fiber particles, creating a soft, velvety surface. A special glue is used to coat the object first. While the glue is still wet, the fiber particles are applied with a flocking "gun"—usually two nested cardboard tubes with holes on one end that make use of internal air pressure to pump the fibers out in airy puffs. After the fibers are evenly applied and settled into the glue, it cures, giving the surface a slightly raised and fuzzy feel.

METALLIC LEAF

Leafing is a process by which extremely thin metallic foils are affixed to a surface with an adhesive. First, the surface is prepared by cleaning and then applying the adhesive. When it has reached the desired amount of tackiness, the leaf is carefully placed, either with a brush or tweezers, and smoothed out. After the adhesive is completely set (which may take as long as two days), the surface can be gently burnished with some soft fabric. Leaf can be made from many different metals, including gold, silver, platinum, and various alloys, as well as imitation metals. This is a delicate process that requires practice. Anything treated with metal leaf can be for sculptural purposes only.

ENCAUSTIC, COLD WAX, NONCERAMIC SEALER

Encaustic is a form of painting with hot wax that can carry a wide range of colors. When applied to ceramics, encaustic lends a soft sheen and depth of surface similar to a semitranslucent satin-matte glaze. Because the wax is translucent, the color of clay or glaze beneath will affect the final surface color. Natural beeswax as well as petroleum-based wax can be melted for this purpose. Cold waxes that are used for polishing, such as bowling alley wax, can also be used to seal a porous ceramic surface. It can be buffed into the clay, leaving a warm, soft sheen. Other sealants typically used on wood, concrete, or even plastic can also be applied to ceramics. These items, such as spray shellac or resin, may make an object watertight, but it should not be considered food safe.

SURFACE-REMOVAL PROCESSES

Sandblasting is a process whereby the surface material is chipped away to reveal what is beneath. It is done in an enclosed booth in which a hose is attached to an air compressor that sprays an abrasive material at the piece. The pressure of the spray forces the sand to pick away, piece by piece, at the surface. It can be applied subtly to reveal what is just below the surface, or quite aggressively to deteriorate the form. It can also be done to bisqueware or glazed pieces, and can be used to remove the sheen from a glossy glaze, or create patterns from tape resists applied to the form.

Acid etching is a toxic process in which glass etching medium (hydrochloric or hydrofluoric acid) is applied to a glazed surface. It eats away at the glaze and, when washed away, reveals a matte surface quality. Wax can be used to create a resist pattern and later removed with turpentine. You should always wear a chemical mask and gloves and use ventilation when carrying out acid etching.

Drill engraving is done with a small drill such as a Dremel tool that can be fitted with a variety of abrasive bits that pick away at the ceramic surface. This process offers many possibilities, including the application of detailed, three-dimensional, and permanent drawings to the glazed surface.

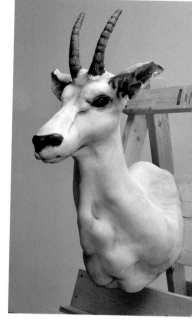

Using Paint

Paint is applied to the surface of this hand-built piece by Alanna DeRocchi in several layers and rubbed in to remove brush marks. Wood stains, shellac, graphite, or charcoal are used to draw in detail, which is then sealed with a fixative.

Sandblasting

Caroline Slotte reworks found ceramic wares as the foundation of her work. She carefully sandblasts the surfaces to simultaneously erase and reveal, allowing the secondhand materials to take on a new and poetic narrative.

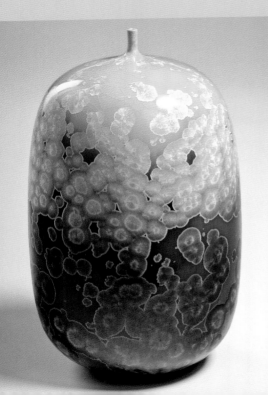
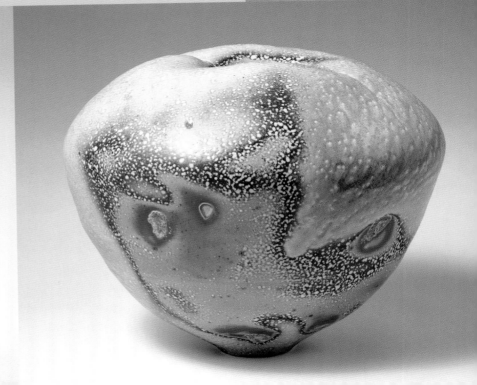

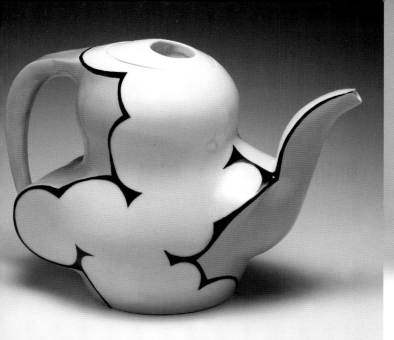

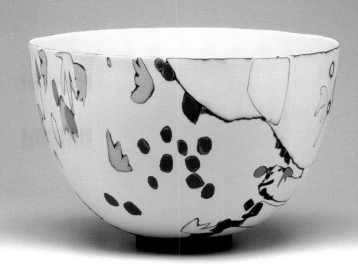

CHAPTER FOUR
Directory

One hundred of the best contemporary ceramicists share their works, their technical processes, and the fascinating ways they use glaze and color. See pages 8–9 for details on how the directory is organized.

Akiko Hirai Collingwood

The modest and pure form of the moon jar is Akiko Hirai Collingwood's muse. Hirai Collingwood recreates this traditional Korean form as a vessel that can express time, simulating years of wear and celebrating imperfections with chips and stains in the surfaces and bringing crater textures into sharp focus. Deeply layered with various slips, glazes, and wood ash containing bits of stone and metal, Hirai Collingwood pays homage to the raw honesty of ceramic materials while the void within the vessel carries a simple quietness.

White Moon Jar *(detail)*
Looking closely at Hirai Collingwood's vessel, the surface appears infinitely deep. SEE GLAZE DETAILS, BELOW.

Technical Description

Hirai Collingwood begins by layering thick black, red, and porcelain slips by hand onto greenware, then applies a thinner slip to add a crackle effect. After bisque firing, the pieces are thinly sprayed or brushed with wood ash, then thick white glaze is poured on the upper part of the pot, allowing the glaze to run to the lower part of the pot during firing. Wood ash and black stain are then sprayed in some areas and layers of flint, nepheline syenite, and wood ash are added to produce the dry white sections. Finally, leftover ash is applied on top of the white glaze. Work is reduced lightly in a gas kiln to between cone 9 and 10, with the fourth burner left off to create a cooler section in the kiln, producing a matte surface.

GLAZE DETAILS

WHITE GLAZE, *cone 9–10*

Potash feldspar	35
Dolomite	20
Whiting	5
Kaolin	20
Quartz	20

Note: This glaze gets bluish-transparent when reduced. If fired to cone 9, it becomes textured semi-matte/satin.

ADDITIONAL MATERIALS
Raw materials are applied directly to the surface
Ash tree wood ash
Flint
Nepheline syenite
Contem UG42 Jet Black stain

❝ Ceramic materials and raw minerals can replicate the beauty of nature in a short period of time in the extreme heat. ❞

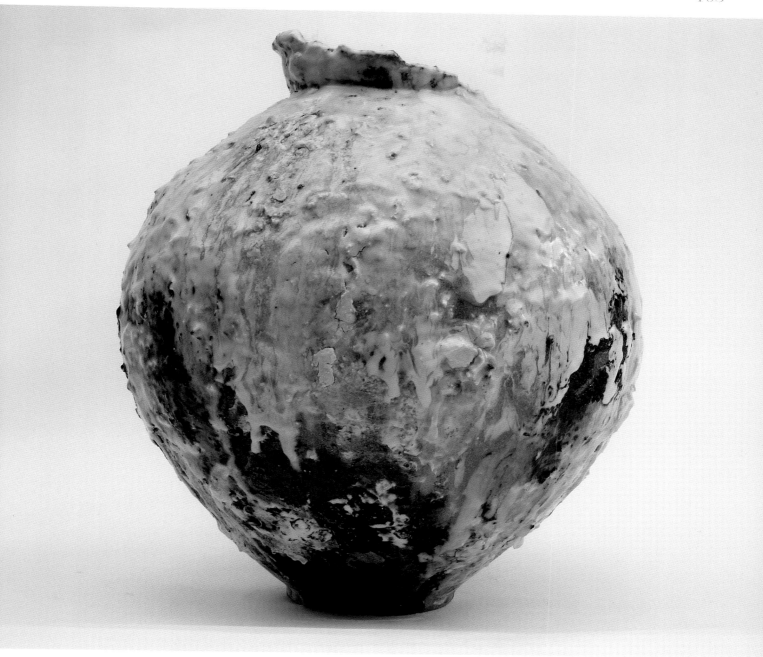

White Moon Jar *24 × 20 × 20 in. (60 × 50 × 50 cm), thrown stoneware, slips, thick white glaze, wood ash, fired in uneven reduction atmosphere to cone 10. The cooler part of the pot is matte white, the reduced, hotter part is blue-ish, the less reduced part is slightly yellow. All are from the same glaze. SEE GLAZE DETAILS, LEFT.*

● Layers of icy whites look glacier-like as they flow across the geological surface.

● Deep, maroon red adds a rich, earthy undertone to the frosty landscape of the vessel.

Claire Loder

Vacillating between the impenetrable façade of the petal-encrusted face and outward-gazing eyes, Claire Loder toys with narrative in her demure figurative sculptures. With unapologetic pinches of clay and washes of glaze, her pieces reveal their materiality with delicate and expressive marks that feel like metaphors for human mortality and imperfection. Loder proposes a balance between internal and external expression, with the soft, pasty white of the skin that exudes vulnerability and the bold cobalt ornamental mask.

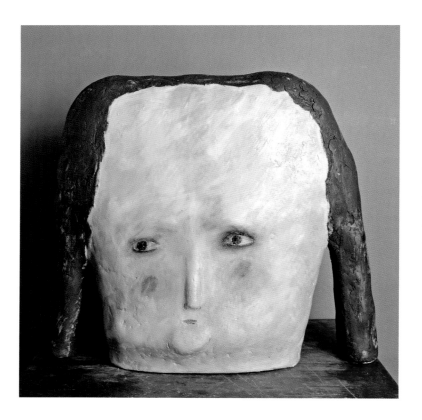

Technical Description

A combination of slips and underglazes is used to apply the details of the face to the wet, greenware pieces. Next, the matte glaze is applied across the face with free, sweeping strokes using a wide, flat brush. Layers are built up more precisely across the hair and neck. This glaze goes from shiny to matte, transparent to opaque, depending on the application. In the case of *Bloom*, the blue glaze was built up in layers using a small brush. The pieces are once fired to cone 3, between 1,975 and 2,010°F (1,079 and 1,099°C).

What Do I Stand For?
16 × 18 × 6 in. (40 × 45 × 15 cm), hand-built, grogged white clay with slip, underglazes, and oxides, matte earthenware glaze applied, single fired to cone 03. SEE GLAZE DETAILS, BELOW LEFT.

GLAZE DETAILS

MATTE EARTHENWARE GLAZE, cone 03

Lead bisilicate	40
Feldspar	20
Alkaline frit	15
Whiting	5
Zinc oxide	5
Kaolin	15

BLUE EARTHENWARE SATIN-GLAZE, cone 05–04
Mauritius satin-glossy (Botz 9590, lead free)

> The eyes play a central role in my work, to communicate the interior world of the subject. I used a non-reflective glaze surface so the eyes communicate and engage with the viewer without being obscured by reflection.

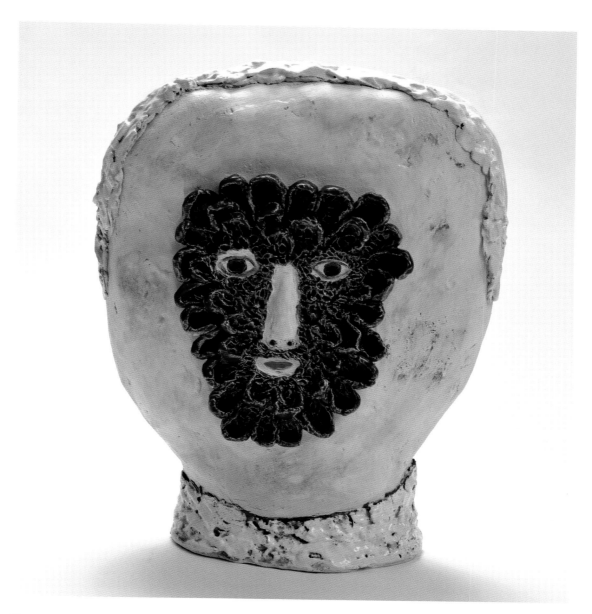

Bloom *14¹/₂ × 12 × 5 in.*
(37 × 30 × 12 cm), hand-built,
grogged white and terra-cotta clay
with slip and underglazes, brushed-
on matte glaze and commercial
blue glaze. Single fired to cone 03.
SEE GLAZE DETAILS, LEFT.

● *Bright blue appears*
electric against the
pale white.

● *Matte white reads*
almost like powdered
makeup.

Steen Ipsen

The sleek organic form is in stark contrast to the clean, tight, flat black lines that wrap around the work of Steen Ipsen's *Organic Works* series. This mathematical language cuts through the curves, isolating the sections of the form like a topographical map. Working with repetition, modularity, and geometry, Ipsen creates stunning objects that can be connected to modern design and architecture, and the shapes and expressions of Danish and Scandinavian design. With forms that are both amoebic and geometric, Ipsen's practice is grounded in a formal language but inspired by an intuitive approach. The form's voluptuous yet prim volume looks as if something is writhing and pushing out against the shrink-wrapped skin of white glaze, only to be further bound and defined by black lines. The implied tension is engaging as the form sits weightlessly on the ground, appearing as if it could come to life and roll itself away across the floor.

Technical Description

After bisque firing, glaze is poured over Ipsen's hand-built forms. The next day the entire piece is sprayed with a second layer of the same glaze and then fired to cone 04 (1,958°F/1,070°C). The process is repeated up to four times to ensure a perfectly consistent coat. For the *Organic Works*, thin strips of opal black decal paper are meticulously cut and applied and the pieces are fired again to cone 015 (1,472°F/800°C).

Organic 5 *10 × 9 × 9 in. (25 × 22 × 22 cm), hand-built stoneware clay, commercial white glaze, fired to cone 04, black decal paper. SEE GLAZE DETAILS, BELOW LEFT.*

GLAZE DETAILS

WHITE GLOSSY GLAZE, *cone 04*
Cerama Stoneware S-Glaze 1302

- *The white is crisp and uniform, with black decal lines adding a sharp graphic element that defines the curves.*
- *White references cleanliness, purity, and perfection.*
- *The sharp black and white contrast brings a heightened focus to both the form and the way the curves are defined by the black lines.*

66 In my works you can see the relationship with the geometry and from the beginning of my career I have had a keen eye for the ornamental potential in the universe of geometric form. 99

Organic 3 *16¹/₂ × 10 × 10 in. (42 × 26 × 26 cm), hand-built stoneware clay, commercial white glaze, fired to cone 04, black decal paper. SEE GLAZE DETAILS, LEFT.*

Jennifer Brazelton

Inspired by maps of countries distorted to reflect population, Jennifer Brazelton created her *Constructed Cartogram* series. In her pieces *Oman* and *Tunisia*, she sculpted cryptic objects engulfed in abstracted markings that reference both manmade and organic micro- and macro-structures. Working with layers of textured clay, slip, and glaze, the surfaces appear dense, busy, and confusing with a whimsical and exploratory feel, despite the provocative subject matter. Brazelton uses color as a signifier to both repel and attract. For example, in *Tunisia* the brilliant colors were chosen to reference the poignant moment in 2010 when a protester set himself on fire, bringing a political charge to her abstract work.

GLAZE DETAILS

UNDERGLAZES
Pink (Leslie Ceramics U-13)
Jet Black (Amaco Velvet V-361)
Turquoise Blue (Amaco Velvet V-327)
Zinnia Orange (Amaco Sun Strokes SS-205)
Ivory Beige (Amaco Velvet V-301)
Light Pink (Amaco Velvet V-316)
Iceberg Blue (Amaco Velvet V-328)
Flame Orange (Amaco Velvet V-389)
Antique Ivory (Amaco Velvet V-368)
Electric Blue (Amaco Velvet V-386)

COMMERCIAL GLAZES, *cone 06*
Carnation Matte (Laguna EM-1248)
Black Cobblestone (Mayco SG-201)
White Cobblestone (Mayco SG-202)
Clear (Duncan Envision IN 1001)
Neon Red (Duncan Envision IN 1206)

BURNISHED GOLD LUSTER, *cone 018*
Engelhard Hanovia

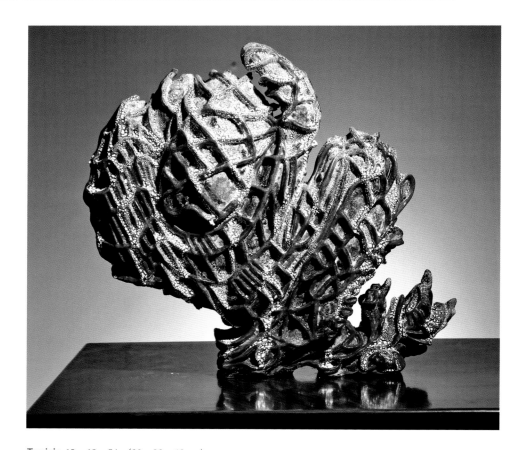

Tunisia *12 × 13 × 5 in. (30 × 33 × 13 cm), multi-fired stoneware clay, layered colored underglazes, commercial glazes, and White Cobblestone glaze. Fired to cone 05.* SEE GLAZE DETAILS, LEFT.

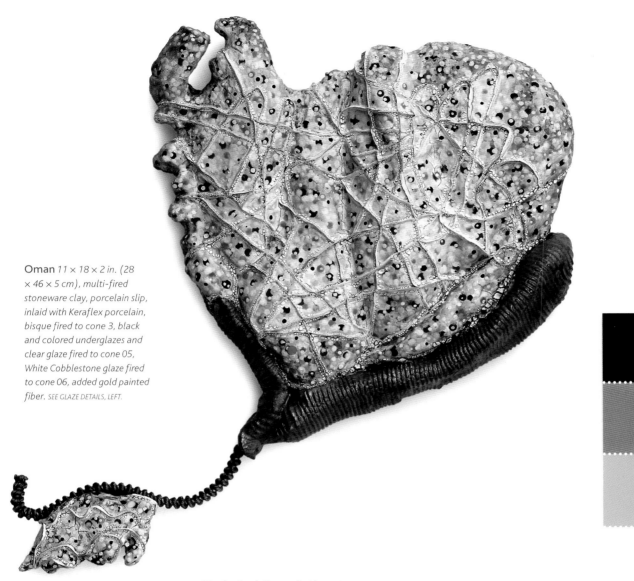

Oman *11 × 18 × 2 in. (28 × 46 × 5 cm), multi-fired stoneware clay, porcelain slip, inlaid with Keraflex porcelain, bisque fired to cone 3, black and colored underglazes and clear glaze fired to cone 05, White Cobblestone glaze fired to cone 06, added gold painted fiber.* SEE GLAZE DETAILS, LEFT.

Technical Description △

Oman was first built from a sculptural stoneware body and then covered in a deflocculated porcelain slip at the leather-hard stage. After bisque firing to cone 3, a thin coat of black underglaze coated the piece and then was wiped off with a sponge. Next, polka dots of various colored underglazes were applied with a stipple brush and the head of a pin, and selective places were coated with clear glaze. Once fired to cone 05, the lines were brushed with white glaze (also used on *Tunisia*) and fired again to cone 06. One additional firing to cone 018 was needed for the burnished gold luster. The curly line between the pieces is an actual hair tie painted gold.

● *The frenzied polka dots of color that cover the surface of* Oman *allude to a busy city full of bustling people, as well as mottled biomorphic skin.*

● *Crackling white lines criss-cross the form like wiry veins or a network of streets or tunnels.*

Paul Kotula

Paul Kotula's sleekly designed tableware harks back to his upbringing in the US during the 1960s in both presentation and color palette. The table settings incorporate laminate wood trays and glassware, providing a context for the dishes steeped in personal history, but also thoughtfully articulated for the contemporary user. Composed of crisp, clean lines, the often asymmetrical forms are offset by Kotula's remarkable sense of coloration. His combinations of muddy-pale tones with accents of bright colors are curiously compelling and the experimental application of Temmoku brings a freshness to the familiar. With a background in painting, Kotula's compositions have the added intrigue of variegated luminosities, textures, and opacities that are inherent to the ceramic surface.

Plate *11¹/₄ × 10 × 1 in. (28.5 × 25 × 2.5 cm), white stoneware, silver and pink Mason/F9M and Shu glaze, fired to cone 10, laminated wood. SEE GLAZE DETAILS, BELOW.*

GLAZE DETAILS

MASON/F9M, *cone 10*
This recipe is from A M Martens

Potash feldspar	35
Whiting	12
Frit 3124	17
EPK	12
OM#4 ball clay	17
Silica	7

Silver
+ 10% Silver Gray stain (Mason 6530 CrFeCoSiNi)

Pink
+ 10% Deep Salmon stain (Mason 6031 CrFeSn)

F5G BASE, *cone 10*
This recipe is from Robin Hopper

Potash feldspar	35
Talc	17
Whiting	12
OM#4 ball clay	17
Silica	19
+ Manganese dioxide	0.5

SHU BASE, *cone 10*

F-4 feldspar	40
Whiting	20
Talc	10
Barium carbonate	3
EPK	2
Silica	25
+ Lithium carbonate	5
+ Tin oxide	0.5
+ Bentonite	3
+ Copper carbonate	0.5

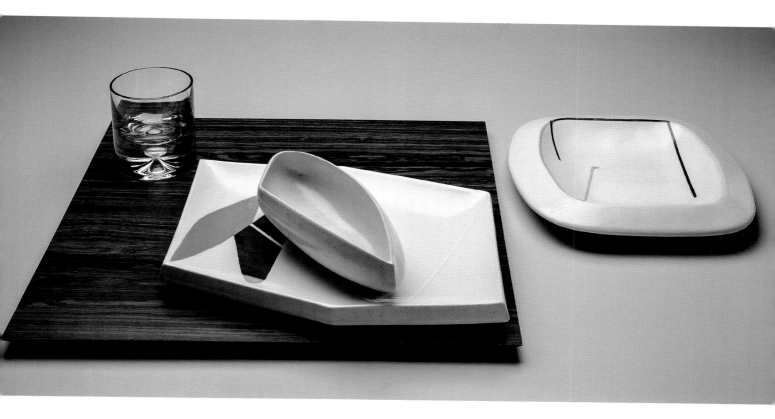

Technical Description

Patterns are first drawn onto the form with a graphite pencil, and then masking tape is used to block areas and lines where glaze is poured or brushed on. After sponging or scraping with a metal rib to remove any excess, the dried glaze is brushed with cold wax to the edge of the tape, and then the tape is removed. The process is repeated for additional shapes and colors. Kotula uses a white stoneware clay body and fires his work in an electric kiln to cone 10.

Setting For One *27 × 22 × 4¹/₂ in. (68.5 × 56 × 11.5 cm), white stoneware, silver and pink Mason/ F9M, F5G, and Shu glazes, fired to cone 10, glassware, laminated wood tray. SEE GLAZE DETAILS, LEFT.*

> I enjoy building monochromatic color palettes so the texture and opacity of the glazes play a vitally subtle role in the compositions I create.

● Fine geometric lines and crisply masked slices of gray, black, and brown add a unique vitality to the curious compositions on each of Kotula's pieces.

● Kotula references contemporary design and, by using varying shades of white and gray, adds a dynamic intrigue that challenges the standard dress for "whiteware."

Carl Richard Söderström

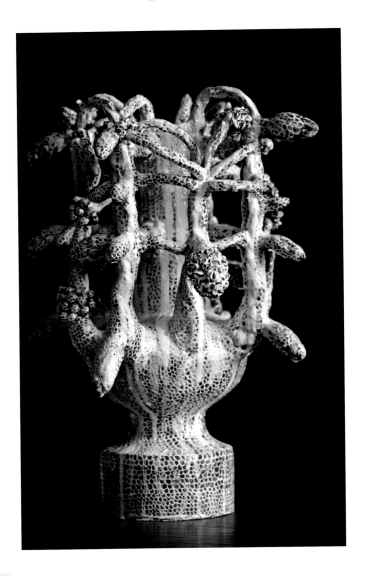

Swedish artist Carl Richard Söderström creates ominous vessels expressively coated in various sugary, pasty, and glossy whites that drizzle down the forms like frosting, or wax drips smothering a candlestick. The starkly contrasting whiteness pushes the dark clay farther into the shadows, with the meticulous lattice brushwork adding even more depth to the layered surface. The iconic vase forms and Queen Anne-style feet are elements that allude to opulence, only to be defaced by the growths of branches and leaves that seem to consume the forms like an abandoned lot overgrown by foliage. The complex combination of ornamentation and abandonment gives the melancholic forms an emotional potency.

Technical Description

Söderström works with a dark clay body full of impurities that break through to spot and stain his white glazes, so he first brushes and pours on white slip, which helps to control the impurities, and bisque fires to cone 08 (1,760°F/960°C). The white opaque matte glaze is mixed thicker than recommended and applied randomly over the bisque-fired form, and fired to cone 8 (2,300°F/1,260°C). After the initial glaze firing, another low-fire white gloss glaze is applied using a syringe to achieve the decorative patterning, and the work is fired to cone 04 (1,940°F/1,060°C).

GLAZE DETAILS

WHITE OPAQUE MATTE GLAZE,
cone 8
CEBEX 5548

WHITE GLOSSY GLAZE, *cone 05*
CEBEX 1019

Vase with Branches and Fruits *25 × 12¹/₂ × 12¹/₂ in. (64 × 32 × 32 cm), stoneware decorated with slip and glaze, fired to cone 04. SEE GLAZE DETAILS, LEFT.*

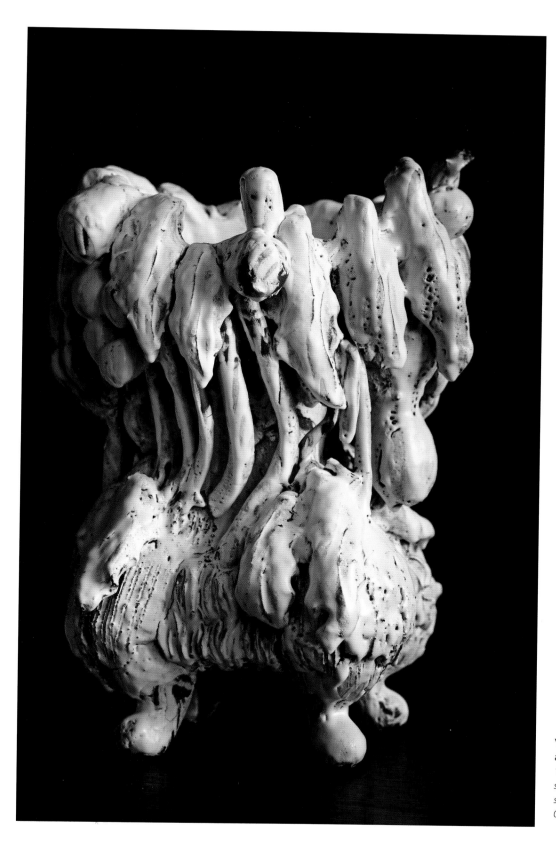

● The black of the clay
allows the viewer to focus
on the form.

● The white is used to mask
the form as well as to break
up the surface.

**Vessel with Branches
and Leaves** *15 × 11 ×
11 in. (38 × 28 × 28 cm),
stoneware decorated with
slip and glaze, fired to cone
04.* SEE GLAZE DETAILS, LEFT.

Geoffrey Mann

Geoffrey Mann's exquisitely crisp yet playful cup and saucer sculptures integrate traditional and digital practices. Using animation software, Mann orchestrated an environment in which a ceramic cup could have the material properties of water. The habitual mannerism of blowing to cool the hot coffee now alters the form itself. The objects' implied motion reminds us of the impacts of our actions, and encapsulates the ephemeral wildness that exists beyond the material world. The pristine white of the bone china highlights the inventive forms.

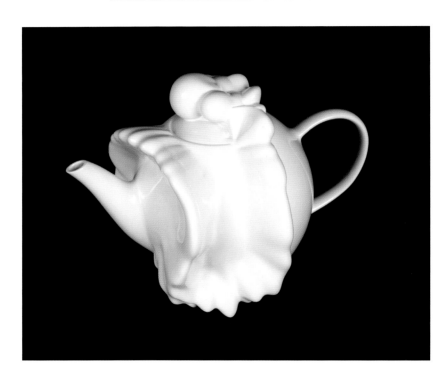

Technical Description

These pieces are made using rapid prototyping technology. The prototypes are used to make plaster molds and the pieces are cast using fine bone china clay. After bisque firing, they are brushed with two coats of a commercially available clear glaze. The pieces are fired to cone 05 (1,900°F/1,040°C) at 210°F (100°C) per hour with a 15-minute hold. The clear glaze provides a sure-fitting sheen that accentuates the purity of the bone china.

Cross-Fire Teapot (Natural Occurrence Series) *8 × 11 × 9 in. (20.5 × 27 × 22 cm), bone china, slip-cast, commercial clear glaze, 3D-printed model, Animated Audio generated form, fired to cone 05. SEE GLAZE DETAILS, BELOW LEFT.*

66 Blown forces craft to be less monumental and more of an occurrence. Rather than a distinct piece, Blown is an approach that invites viewers to create their own digital pieces by using the simple action of blowing a cup of tea. Blown is a dynamic and democratic craft. 99

Blown Application

In addition to the physical objects produced, Mann has extended his interest in capturing the ephemeral into an interactive project. He has produced an application called Blown (which can be downloaded via iTunes for free) in which the user can, in real time, alter a cup by blowing onto their screen. The captured images are collected and displayed, creating a critical mass of custom-made blown animations.

Blown Cup and Saucer (Natural Occurrence Series) *Cup: 3 × 5 × 4 in. (7.5 × 13.5 × 10.5 cm); saucer: 8 × 8 × ¾ in. (20.5 × 20.5 × 2 cm). Slip-cast bone china, 3D-printed model from iPad-app-generated form, bisque fired to cone 8, commercial clear glaze applied, fired to cone 05. SEE GLAZE DETAILS, LEFT.*

● *Stark white keeps attention on the form.*

● *Clear gloss adds a reflective quality that contributes to the "water" effect.*

Bethany Krull

The sad, hairless cat with a disapproving scowl and an overly eager-to-please poodle are part of Bethany Krull's *Dominance and Affection* series, which explores the contradictory phenomenon of pet ownership. Once wild animals, pets have been relegated to the role of dependents, whose needs are often cast aside by the very people who perpetrated their condition. The ghostlike white porcelain forms are impeccably sculpted and styled, with vivid colors highlighting their absurd accoutrements, bringing a sense of satire to the dark subject matter.

Sweatered Sphinx *17 × 10 × 8 in. (43 × 25 × 20 cm), hand-built porcelain, clear glaze, once fired to cone 6 in oxidation, altered sweater. SEE GLAZE DETAILS, BELOW.*

Technical Description

These pieces are sculpted with vitrifying porcelain clay. While most of the form is left unglazed, clear glaze is brushed onto selected areas, like the eyes, nose, and tongue, to "wet" them. Glaze is applied to greenware and the pieces are fired extremely slowly to cone 6, with a controlled cool to avoid cracking the fragile porcelain. The cat's sweater is an altered knit sweater, while the purple texture on the poodle is made of papier mâché. The paper is soaked overnight in hot water, then after boiling the mixture to break down the glue, it is blunged with a drill to fully disperse the fibers. Next, the slurry is pressed through a sieve (Krull uses a stocking) and mixed with a cement bonder (any strong white glue). The mixture is applied in a thin layer and allowed to dry, curing in place.

66 Wild animals have been genetically sculpted into sweeter, cuter, less dangerous versions of themselves, permanently altered by man's effort to fulfill our own need for relentless love, assistance, amusement, and companionship. 99

GLAZE DETAILS

WOLLASTONITE CLEAR, cone 6	
Nephyline syenite	30
Gerstley borate	21
EPK	10
Flint	31
Wollastonite	8

Pretty Please *22 × 9 × 14 in. (56 × 23 × 35.5 cm), hand-built porcelain, clear glaze, once fired to cone 6 in oxidation, papier mâché, nail polish.*
SEE GLAZE DETAILS, LEFT.

● *The white of the porcelain exemplifies purity, fragility, and preciousness.*

● *The glossy eyes and tips of nose bring a lifelike feel to these characters.*

● *The use of nonceramic materials to achieve the purple color adds a unique dynamic to this work, whereby the papier mâché "crafting" of the form becomes metaphorical.*

Andy Shaw

Andy Shaw creates approachable, durable, and beautiful tableware that comfortably finds its place in the landscape of the home. His geometric decorations reference what Shaw calls "incidental domestic patterns" such as the lines of floorboards, the grids of window frames, or the circle motif that connects both the pattern and form. The pale blue tone has a clean and soft appearance, acting as a neutral and versatile accompaniment to the home and a flattering frame for the foods being served upon it.

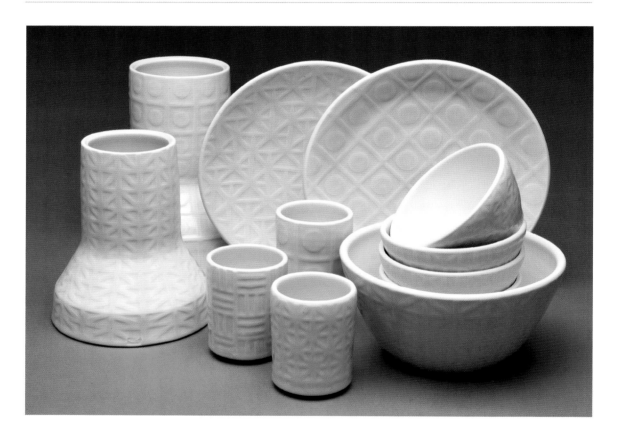

GLAZE DETAILS

TODD WAHLSTROM MATTE WHITE, *cone 9–10*
Note: Needs to be fired to cone 10 down.

Cornwall stone	36.7
Whiting	27.5
EPK	18.3
Flint	12.9
Magnesium carbonate	4.6

Technical Description

In these pieces, Shaw employs a decorative technique called water carving to create the patterns on his forms. At the bone-dry state, the pattern is brushed on with wax and the piece is gently wiped with a damp sponge, slightly eroding the surface of the unmasked clay. Once bisque fired, the wares are glazed by dipping by hand or with tongs for 4–5 seconds in white glaze. Shaw notes that this glaze melts evenly and most drips and tong marks disappear. Pieces are glaze fired in reduction to cone 10.

Tableware *height 4–10 in. (10–25 cm), wheel-thrown porcelain, water carved using wax resist, fired to cone 10 in reduction. SEE GLAZE DETAILS, LEFT.*

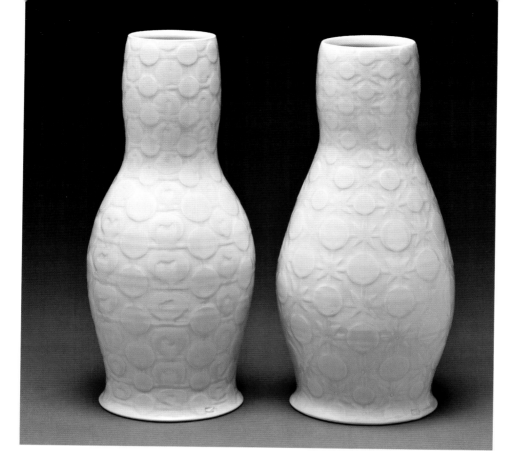

● *This delicate, pale glaze is fine and soft, with a satin matte surface that allows for the gently embossed patterns to show through.*

● *The monochromatic nature of the work creates an unassuming sense of serenity and continuity.*

Two Vases *left: 17 × 6¹/₂ × 6¹/₂ in. (43 × 16.5 × 16.5 cm), right: 17 × 9 × 9 in. (43 × 23 × 23 cm), wheel-thrown porcelain, water carved using wax resist, fired to cone 10 in reduction. SEE GLAZE DETAILS, LEFT.*

Dinner Plate *10¹/₂ × 10¹/₂ × 1 in. (27 × 27 × 2.5 cm), wheel-thrown porcelain, water carved using wax resist, fired to cone 10 in reduction. SEE GLAZE DETAILS, LEFT.*

Joseph Pintz

Joseph Pintz's pieces exude bucolic simplicity, with surfaces that appear worn from years of use lending a sense of familiarity and nostalgia to the forms. Rusty, washed over, and pocked, the surface reveals dense objects that look as if they have been pounded out or carved from a massive block. The neutral tones of brown and cream suggest reverence for their materiality, and an unapologetic, rugged rawness. As functional objects, they propose a lifestyle of workmanship, harking back to a romanticized past when spending time preparing a meal was a practice of patience, both meditative and purposeful.

Cream Separators
14¹/₂ × 16¹/₂ × 9 in. (37 × 42 × 23 cm), hand-built earthenware, terra sigillata and washes, fired to cone 04. SEE TERRA SIGILLATA DETAILS, BELOW.

Technical Description

Once the pieces are bone dry, three layers of terra sigillata are brushed on. After bisque firing, a thin black copper oxide and water wash is applied and then sponged off, leaving only some highlights and traces in the pitted surface texture. Next, a simple wash of 1 part borax to 4 parts tepid water is brushed on to assist with the surface variegation. Some of the borax doesn't dissolve, creating an interesting freckled effect on the surface (lithium carbonate or soda ash work well too). Pieces are glaze fired in an electric kiln to cone 04 (1,945°F/1,063°C).

TERRA SIGILLATA DETAILS

TERRA SIGILLATA FOR CREAM SEPARATORS, *cone 04*
1 cup XX Sagger terra sig base (see Making the Terra Sigillata Base, right)
+ ¹/₂ tbsp titanium dioxide
+ ¹/₂ tbsp Victoria Green stain (Mason 6263 CrCaSiZr)

TERRA SIGILLATA FOR BREAD PAN, *cone 04*
²/₃ cup XX Sagger terra sig base (see Making the Terra Sigillata Base, right)
¹/₃ cup Newman Red sig base
+ 1 tsp crocus martis
+ 1 tsp chromium oxide

TERRA SIGILLATA FOR ABACUS, *cone 04*
1 cup XX Sagger terra sig base (see Making the Terra Sigillata Base, right)
+ 1¹/₂ tsp iron chromate

Note: These recipes are not food safe.

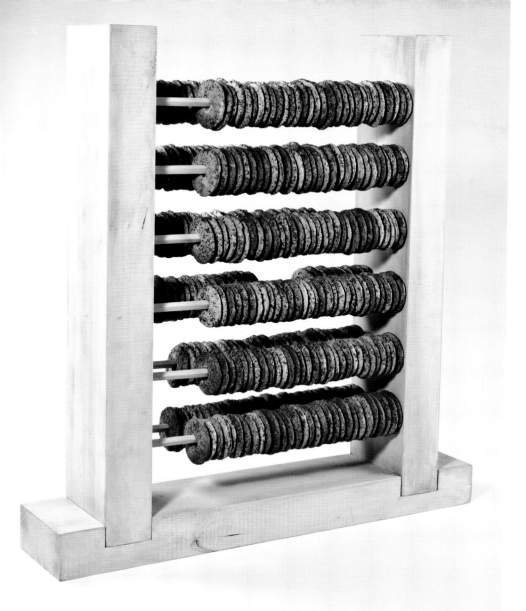

● *Neutrals bring an earthiness to the raw surfaces.*

● *Subtle monochromatic colors with matte surfaces don't distract from other forms.*

> I embrace irregularities as a part of the character of my work. They are not covered up, but become an integral part of the whole.

Making the Terra Sigillata Base

Pintz makes the terra sigillata by blunging 2 parts water to 1 part clay, plus deflocculant (approximately 0.25%) for a thin slip. After settling overnight, the top layer of sediment is siphoned off. This "terra sig base" can be used as is, or in the case of these pieces, colorants can be added, and various bases can be blended for subtle color variations. Pintz recommends not adding more than 1 tbsp colorant per cup of terra sigillata, or flaking may occur.

Abacus *31 × 29 × 6 in. (79 × 74 × 15 cm), hand-built earthenware, terra sigillata and washes, wooden frame, fired to cone 04. SEE TERRA SIGILLATA DETAILS, LEFT.*

Breadpan *18 × 12 × 2¹/₂ in. (46 × 30 × 6 cm), hand-built earthenware, terra sigillata and washes, fired to cone 04. SEE TERRA SIGILLATA DETAILS, LEFT.*

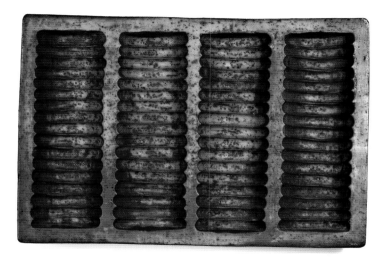

Gail Nichols

The lush surfaces and bulbous vessels made by Gail Nichols reflect the environment in which she lives and works: at the western foot of Mount Budawang near Braidwood in New South Wales, Australia. The dynamic push–pull between the valley within which her studio nestles and the massive mountains she can call her neighbors informs her work. Each vessel embodies this narrative. Nichols' Soda Ice Glaze produces a luscious, crystalline, semi-matte white that flows across the surface. Coarse quartz particles in her clay create dimples in the vessels as heat works on them in the firing. Red, yellow, blue-green, mauve, gray, and black are all developed in concert with the organic forms through artfully orchestrating the firing atmosphere.

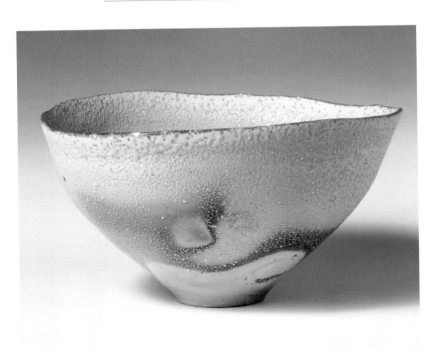

Technical Description

Nichols' pieces are made from a high-alumina low-iron stoneware, and single fired in a soda kiln to cone 11. There is no glaze applied prior to kiln loading. Instead, the soda mixture is added to the kiln during the firing, which vaporizes and reacts with the clay in extreme heat, resulting in the finished surface. The dry materials for Soda Ice mix are mixed well before adding water. The mixture warms and sets, similar to plaster. The solid mass is broken into pieces and introduced into the firebox between cone 9 and 10. To further enhance the coloring and surface results, the kiln atmosphere is manipulated during firing, and cooling is controlled to achieve the desired effects.

Descending Cloud *7 × 13 × 12 in. (18 × 34 × 31 cm), soda-vapor glazed stoneware. The glaze is created through interaction of flame and soda vapor with alumina and silica in the clay body. Soda is introduced into the kiln at cone 9–10. Reduction fired to cone 11.* SEE SODA MIX DETAILS, LEFT.

SODA MIX DETAILS

SODA ICE MIX, *cone 9–11*
Introduce into kiln during sodium vapor firing.

Sodium bicarbonate	28.5
Light soda ash	28.5
Whiting	43.0

Add 34 fl. oz. (1 liter) of water per 4.4 pounds (2kg) of dry material

Note: See Technical Description for mixing instructions. Wear rubber gloves and a respirator when mixing the materials.

The Story of Gail Nichols' Glaze

Gail Nichols has spent many years researching and practicing to develop her signature surfaces. A leader in the field of atmospheric firing, she has shared the story of her research in her book *Soda Clay and Fire*, published in 2006 by the American Ceramic Society.

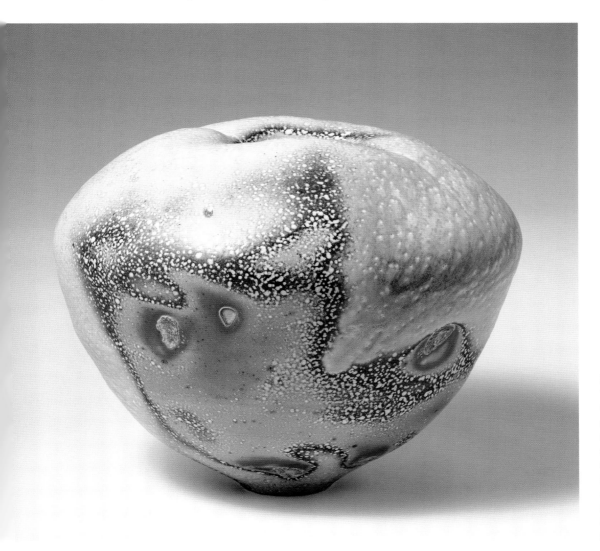

● *Warm colors against cool colors add dynamism and balance to the work.*

● *Warm peach, orange, and red trace the flame pattern from the soda atmosphere.*

● *Cool whites, grays, and blues happen from receiving more soda and reduction.*

Storm on the Mountain
13 × 17 × 17 in. (33 × 43 × 43 cm), soda-vapor glazed stoneware. The glaze is created through the interaction of flame and soda vapor with alumina and silica in the clay body. Soda is introduced into the kiln at cone 9–10. Gas fired to cone 11. Reduction during the first three hours of cooling. SEE SODA MIX DETAILS, LEFT.

❝ These works are vehicles on which the glaze can form, flow, and reveal the dynamics of exposure to flame and soda vapor. They celebrate my close involvement with materials and process. ❞

Kala Stein

Kala Stein creates still lifes composed of various functional vase forms—soft, muted vessels that are unified by the monochromatic palette; the bright white clay illuminates the glaze as it breaks delicately along the edges, highlighting the pieces' silhouettes. Referencing the paintings of Giorgio Morandi, Stein's forms look as if they have been extruded from a flat plane, and the foggy, melancholic mood in Morandi's works is translated beautifully in the gradients of warm, satiny grays shaped by the light cast on the empty forms.

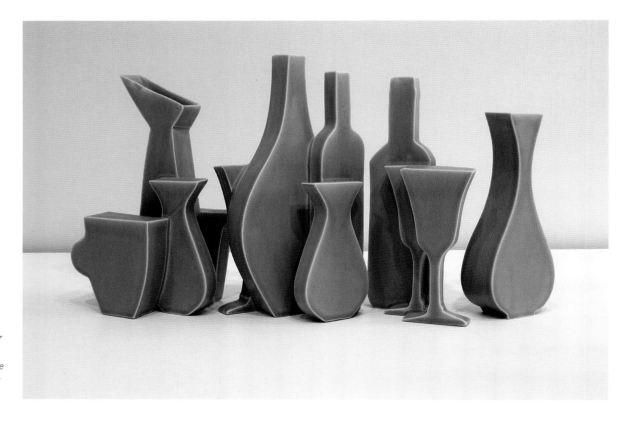

Form and Plenty in Gray *15 × 24 × 6 in. (38 × 61 × 15 cm), slip cast using modular mold system, matte gray glaze fired to cone 4 in oxidation. SEE GLAZE DETAILS, BELOW.*

GLAZE DETAILS

STEIN MATTE BASE, *cone 4–5*

Nepheline syenite	42
EPK	2
Flint	18
Wollastonite	20
Zinc oxide	18

Stein Matte Gray
+ 0.25% Iron chromate
+ 0.5% Naples Yellow stain (Mason 6405 FePrZrSi)
+ 0.15% Best Black stain (Mason 6600 CrFeCoNi)

Stein Satin Matte Blue
+ 1% Silver Gray stain (Mason 6530 CrFeCoSiNi)

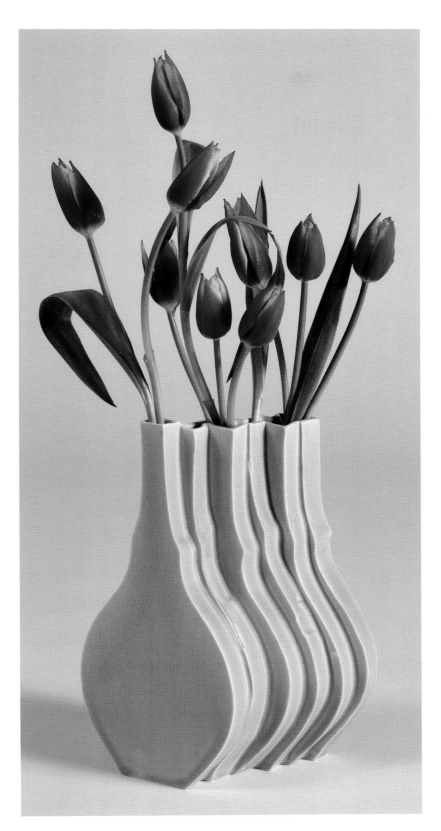

Promenade *11 × 8 × 6 in. (28 × 20 × 15 cm), slip cast using modular mold system, satin matte blue glaze fired to cone 4 in oxidation.* SEE GLAZE DETAILS, BELOW LEFT.

Technical Description

Stein prepares her glaze by mixing on the thin side and sieving several times. Colorants are also ball milled to keep them from speckling in the glaze. After bisque firing the work to cone 06, the pieces are dipped in a quick, fluid fashion. Any drips are removed with a metal rib. If the piece requires glaze inside and outside in two separate steps, Stein will glaze the inside first, then wait 24 hours before dipping the outside. This allows the thin cast form to dry completely, allowing for better absorption of the glaze. The pieces are glaze fired in an electric kiln to cone 4–5 with a simple program.

● *Keeping the attention on shapes and forms, the matte surface helps to flatten the planes.*
● *Satin grays are warm due to the slight inclusion of yellow stain in Stein's Matte Gray glaze.*

" Monochromatic glazing gives attention to the shape, line, and volumes in the forms I make. The color is a unifying force for the variety of forms and I am interested in how this plays into the idea of synchronicity. "

Matt Kelleher

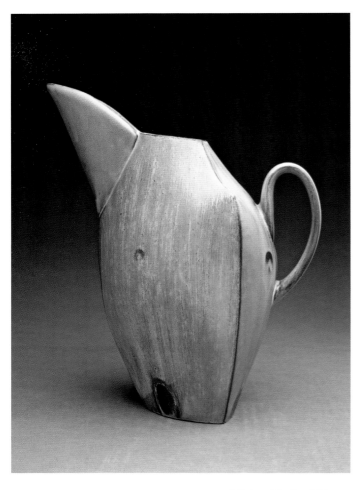

Pitcher *13 × 9 × 6¹/₂ in. (33 × 23 × 17 cm), slab built, cone 3 soda-fired red clay with flashing slip.* SEE SLIP DETAILS, BELOW LEFT.

Inspired by the way in which serving pieces can excite the space they occupy during use, Matt Kelleher creates beautifully altered platters, with wide expanses allowing for variations in the surface to be accentuated and celebrated. A sweeping parabolic curve frames the form of the *Triangle Bowl*, which pivots into a border of partial scallops, adding curiosity to the familiar format of the platter without sacrificing functionality or comfort. Kelleher chooses to employ flashing slips for their ability to develop layers of information while also allowing the qualities of the clay to show through. With neutrals ranging from warm burnt umbers to cool charcoal grays, he creates abstract landscapes across his asymmetrical platters.

Technical Description

Kelleher's atmospheric surfaces are created with layers of flashing slip on terra-cotta clay fired in a soda kiln. First, flashing slip is poured over the piece. Then, a second coating of a more watered-down slip is poured on, slightly removing some of the first layer. This process is continued until a desirable surface is achieved. The kiln is fired in oxidation up to cone 3, with 15 minutes of reduction at the end, and pieces are sprayed directly with soda ash.

66 I pay a lot of attention to the clay surface and its play with light and shadow. I find glazes cover these details up and create their own surface. 99

SLIP DETAILS

GOLDART FLASHING SLIP, *cone 3*
Goldart (screened at 200 mesh) 80
Frit 3124 20

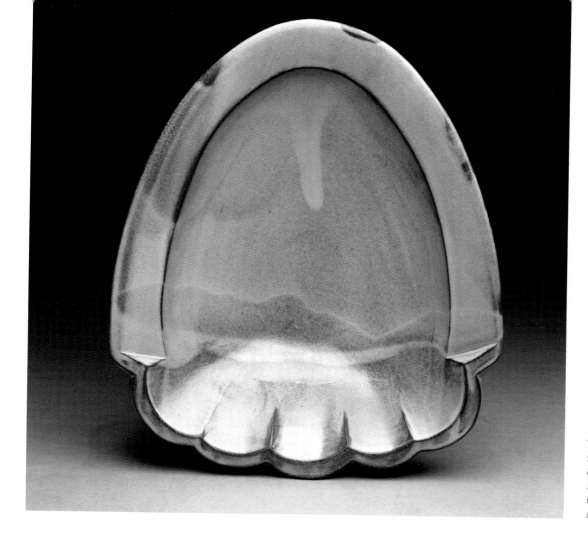

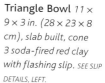

● *The light slip on the red clay shows sensitivity to thickness, allowing for a range of colors.*

● *The softness from the pastel colors is dynamic against the crisp edges of the pieces.*

Triangle Bowl *11 × 9 × 3 in. (28 × 23 × 8 cm), slab built, cone 3 soda-fired red clay with flashing slip. SEE SLIP DETAILS, LEFT.*

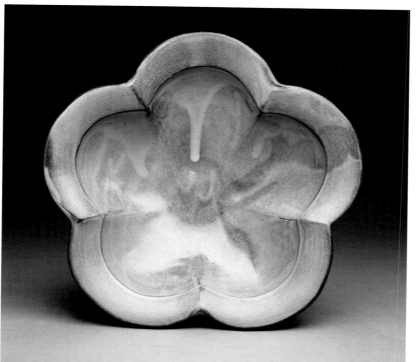

5 Petal Bowl *12 × 12 × 3 in. (30 × 30 × 8 cm), slab built, cone 3 soda-fired red clay with flashing slip. SEE SLIP DETAILS, LEFT.*

Chris Gustin

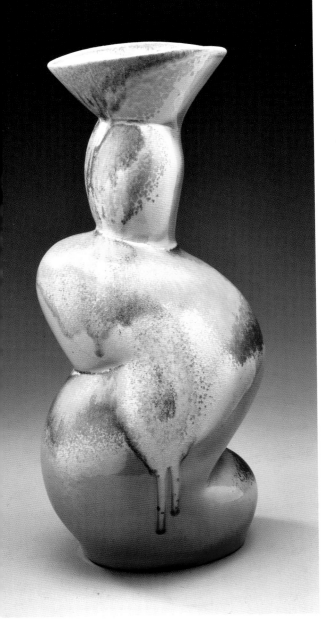

Alcobaça Vase *21 × 8 × 9 in. (53 × 20 × 23 cm), slip-cast porcelain, Gustin Shino glaze, anagama wood fired to cone 11. SEE GLAZE DETAILS, BELOW.*

The masterfully sculpted vessels of Chris Gustin command our attention with their monolithic stature. Softened by their vulnerable, visceral reference, the voluptuous forms are intended to mimic the gestures of the human body, and their large scale aids in that interpretation, with each life-size curve, dip, and bulge offering an emotive presence. Gustin's work is coated entirely in one glaze, providing uniformity and visual support for the form, and is fired in an anagama kiln for several days, imparting a sense of time across the work. This controlled yet ultimately unpredictable process yields variety in the luscious surface, with the flow of the flame and melt of the ash defining the form's curves and allowing for subtle shifts in color on the earthy skin of shino.

Technical Description ▷

Built from a buff stoneware with 5 percent grog, this piece is bisque fired and then sprayed with the shino glaze. Fired for five days in an anagama wood kiln to cone 11, ash is deposited on the form throughout the firing. Collected ash and flame patterns dramatically alter the glazed surface, from light pink and orange blushes to dark pools and runs.

❝ Color is very important in my work. I use it as a way of supporting the form, rather than dominating the form. That's why most of my work is monochromatic in nature, using glazes that allow nuance and color shifts to happen that are determined by flame, pattern, and ash. ❞

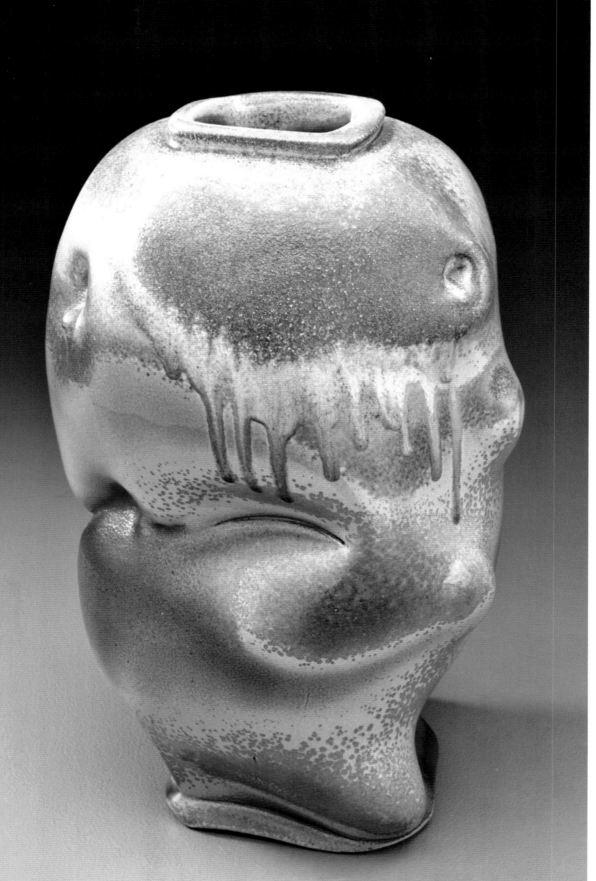

● The subtle, neutral tone of the shino glaze creates a smooth surface for the ash to collect and run into during firing.

● Skin tones emphasize references to the body in the work.

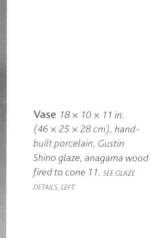

Vase *18 × 10 × 11 in. (46 × 25 × 28 cm), hand-built porcelain, Gustin Shino glaze, anagama wood fired to cone 11.* SEE GLAZE DETAILS, LEFT.

Adrian Arleo

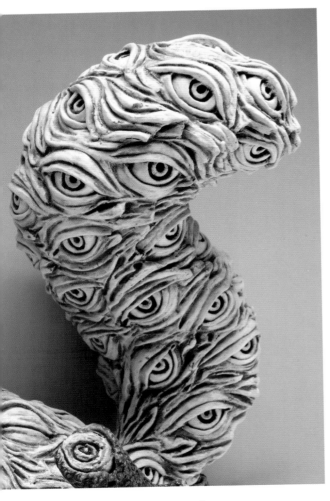

Adrian Arleo feels that her uncanny sculpture *Vigilance* resonates with a quote by the 11th-century Ch'an monk, Yuan-Wu, who said, "Throughout the body are hands and eyes." Eyes peer out from every fold of fur in the sculpted squirrel's tail and body, inciting introspection in the viewer, as they grapple with being outnumbered by the pervasive, penetrating gazes. Within a surreal (or, in Arleo's view, mythological) framework, her powerful yet subdued work suggests that our actions are constantly under observation. Her use of color is purposely understated and neutral. In contrast to the dry, black branch, the squirrel is highlighted with soft encaustic wax, which draws our focus. The enhanced texture of the surface adds a richness to the quiet nature of the color palette, creating a serene backdrop for the unsettling effect of the eyes.

Technical Description

After slowly bisque firing the piece, the Sand Dry glaze is applied as a wash, then wiped off the top surface to enhance the texture. Next, the Stony Lithium glaze is applied lightly to the top of the texture with a fan brush adding highlights to the squirrel, then the piece is glaze fired in an electric kiln to cone 05–04. The encaustic recipe is melted in a double boiler on an electric burner and, while still hot, applied to the squirrel very lightly with a brush. Then Arleo uses a heat gun to help the encaustic melt into and adhere to the surface.

GLAZE AND WAX ENCAUSTIC DETAILS

SAND DRY GLAZE, *cone 05*

Gerstley borate	50
Alumina hydrate	33
Nepheline syenite	17

Subdued brown
+ 12% Iron chromate (FeCr)

Brighter brown
+ 16% Hazelnut stain (Mason 6126 CrFeZnAl)

Black
+ 18% Best Black stain (Mason 6600 CrFeCoNi)

STONY LITHIUM GLAZE, *cone 05*

Lithium carbonate	16
EPK	22
Flint	45
Bentonite	3
Frit 3110	14

For opacifier
+ 8–10% Superpax or zircopax

GENERAL WAX ENCAUSTIC

This is a general recipe from Dana Lynne Louis, as used by the artist.
1 cup melted bleached or unbleached beeswax
¼ cup (approx.) Damar varnish
1 tbsp–⅛ cup mineral spirits (to thin to desired consistency)

Note: to add color, use a small amount of oil paint or dry pigment.

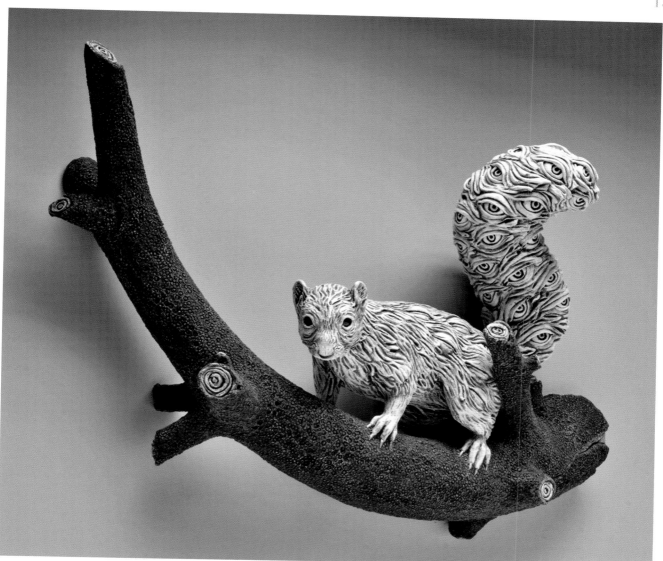

Vigilance, Awareness Series *24 × 16 × 6 in. (61 × 41 × 15 cm), hand-built earthenware, brown Sand Dry glaze, Stony Lithium glaze, fired to cone 05–04, wax encaustic.* SEE GLAZE AND WAX ENCAUSTIC DETAILS, LEFT.

● Using the natural brown and black colors on a matte surface helps the piece feel realistic, while bringing light and shadow to the form. The color palette was chosen specifically to relate to the real colors of a squirrel and branch.

● Dark colors applied as a wash to the texture and wiped away from raised surfaces add depth to the highly textured and modeled surface.

Justin Rothshank

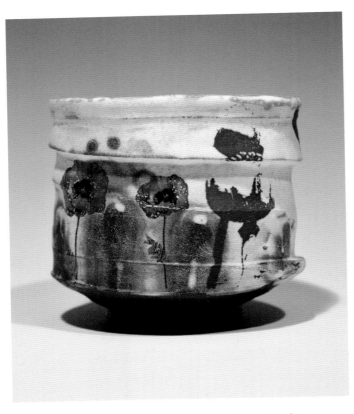

Poppy Bowl *4 × 4 × 4 in. (10 × 10 × 10 cm), wood-fired earthenware fired to cone 2, liner glaze, porcelain slip, decals fired to cone 017. SEE SLIP AND GLAZE DETAILS, BELOW LEFT.*

Justin Rothshank builds functional objects with unapologetic, deep, throwing lines and tool gouges. With an affinity for colors that mimic nature, Rothshank utilizes earthy clay bodies and atmospheric firing effects to produce rich surface "decorations" that add depth to his applied accent glazes and decals. Brighter colors are used sparingly in order to create focal points and encourage exploration of all sides of his fluid vessels. The surfaces are conceived with decals in mind, strategically placing white backgrounds, glossy skins, and visual and textural breaks between the clay and glaze, bringing out a dynamic color contrast that activates the composition. The unique combination of the rigorous and unpredictable atmospheric firing process and the manufactured decal imagery creates pieces, which honor the enigmatic materiality of ceramics, which has been lauded for centuries, while also embracing contemporary practices.

Technical Description

Thrown from cone 6 dark stoneware, pieces are first coated in flashing slip. Iron-toner decals are applied to the raw clay, and the shino glaze is applied to the inside. Pieces are then fired in a wood kiln with a soda ash mixture sprayed into the kiln when the temperature reaches cone 6. This soda solution, combined with the wood ash from the fuel, is what leads to the flashing colors on the pieces. Temperatures in the large kiln vary significantly during a single firing—ranging from cone 2–10. Rothshank places clay bodies in specific places to take advantage of these temperature discrepancies. The commercial red poppy decals are added after the wood/soda firing and refired to cone 017 in an electric kiln.

> I use color often in small quantities. It is my hope that the color will draw attention to specific areas of each piece to encourage the user to rotate the piece, explore all sides of it, and explore the surface.

FLASHING SLIP #1, *cone 04–10*

Grolleg	50
Tile#6 kaolin	20
EPK	20
Flint	10

SHINO TYPE F LINER GLAZE, *cone 7–10*
Also works well when fired hotter

Nepheline syenite	50.3
OM#4 ball clay	16.2
F-4 feldspar	14.7
Spodumene	12.6
Soda ash	3.4
EPK	2.9

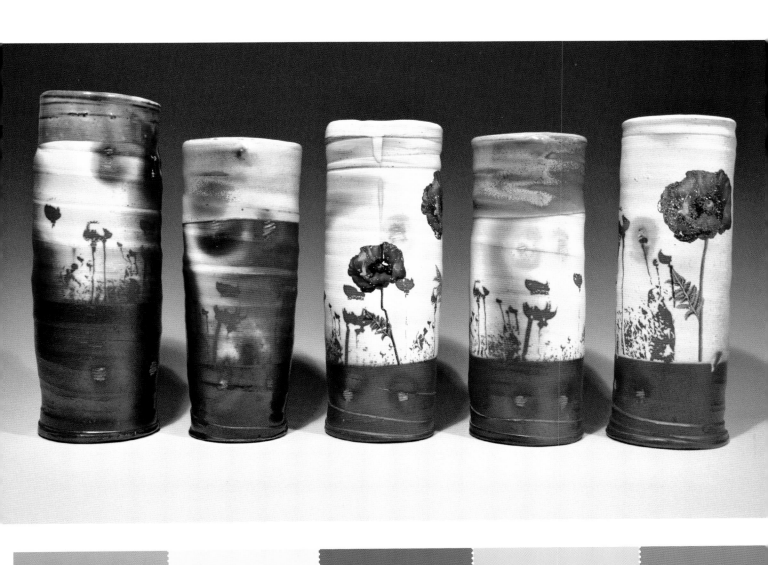

● Earth tones are punctuated with vivid reds from the colored decals.

● Iron-transfer decals blend into the slips and flashing that occur in the atmospheric kiln.

Poppy Vases *10 × 4 × 4 in. (25 × 10 × 10 cm) each, approximate, wood/soda-fired stoneware, Shino liner glaze fired to cone 6, porcelain slip, decals fired to cone 017. SEE SLIP AND GLAZE DETAILS, LEFT.*

Meredith Knapp Brickell

A day spent along the shore of Lake Michigan inspired American artist Meredith Knapp Brickell to create her *Tanks* series as part of a two-person exhibition entitled *When I Go Swimming*. Brickell constructed the forms, elevated on pier-like scaffolding, to reflect the presence and sensations of pooling water. While water blue is part of the color palette, red, gray, and cream are used to punctuate the stillness, expressing the range of hues that water can encapsulate and reflect. Each wide cylinder is marked by layers of seductive sigillata, patina, glaze, wash, and luster—variegating the smooth surface and adding a weathered feel to the forms. While the tanks themselves contain emptiness, with their quiet presence they fill the gallery with a minimalist landscape of almost contemplative, cogent objects.

Technical Description

At the bone-dry stage, Brickell brushes two to three coats of the colored terra sigillata onto her terra-cotta pieces. After a cone 04 bisque firing, the piece is brushed with the patina, allowed to dry, and then wiped off, leaving only traces in the faintly textured surface. Next two to three coats of MereKari clear glaze are brushed onto the desired areas, and the borax/soda ash wash is applied. After a cone 03 glaze firing, luster is applied and the piece is then fired to cone 018.

Tanks *largest: 32 × 22 × 22 in. (81 × 56 × 56 cm), coil-built earthenware forms with terra sigillata, patina, wood, milk paint, clear glaze, soda wash fired to cone 03, and luster fired to cone 018. SEE TERRA SIGILLATA AND GLAZE DETAILS, BELOW.*

TERRA SIGILLATA AND GLAZE DETAILS

OM#4 TERRA SIGILLATA BASE, *cone 04*
This base recipe is from Pete Pinnell
20 lb (9 l) water
10 lb (4.5 kg) OM#4 ball clay
0.5% (22.7 g) sodium silicate

PEWTER TERRA SIGILLATA, *cone 04*
1 cup OM#4 Terra Sigillata base
+ 1½ tsp titanium dioxide
+ ⅜ tsp manganese dioxide
+ 1/16 tsp cobalt carbonate

BLACK PATINA
This is modified from a recipe by Silvie Granatelli
1 tsp black copper oxide
1 tsp EPK
1 tsp Gerstley borate
Mix with 1–1½ cups water

MEREKARI CLEAR, *cone 04*
Originally Satin White Opaque by Val Cushing, modified by Meredith Knapp Brickell and Kari Radasch

Frit 3124	59
Frit P-626	14
Nepheline syenite	11
Silica	10
EPK	6
+ Veegum	1.6
+ CMC gum	0.6

SODA/BORAX WASH
1 tsp borax
1 tsp soda ash
Mix with ¼ cup water

WHITE GOLD LUSTER, *cone 018*
Duncan OG 802

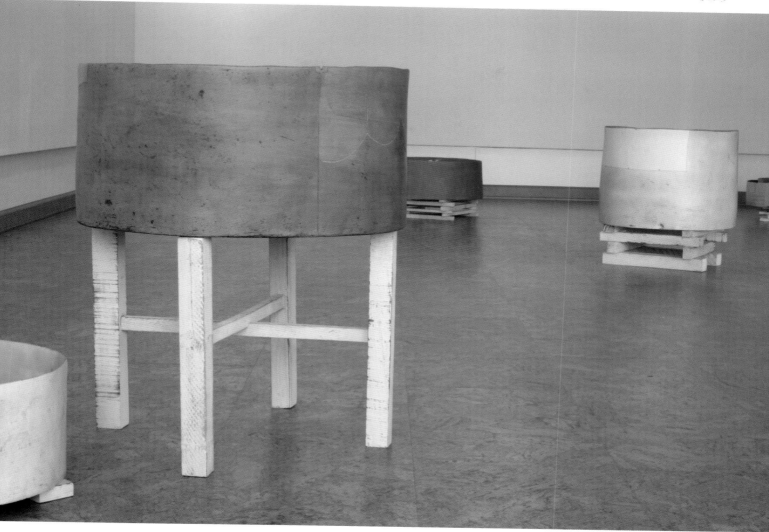

66 Each tank in the series is glazed in just one color. No one tank is meant to dominate the series—so the colors are slightly muted but strong enough to keep the viewer's eye moving from tank to tank, or color to color. 99

● A range of colors is used to capture the array of reflective hues that can be seen in rippling water.

● These soft yet matte surfaces have a "raw clay" feel, adding visual weight to the pieces, which is contradicted by the thin walls.

● The color palette helps us imagine a gray day with water carrying the image of an overcast, cloudy sky or industrial structures along the water's edge.

Colby Parsons

Colby Parsons creates ceramic works designed to act as a screen upon which he can project images. The play between the three-dimensional physicality of form and the ephemeral waves of light creates a fascinating illusion that warps space as the clay's rich surface pushes back into the projection, creating a mesmerizing dance of curving and dipping lines of light. Parsons worked tirelessly to formulate this microcrystalline glaze that provides true color projections, sparkles delightfully in bright light, and has a strong material identity.

GLAZE DETAILS

COLBY'S VIDEO GLAZE, *cone 08*

Lithium carbonate	22.7
Gerstley borate	14.4
Dolomite	9.3
Magnesium carbonate	7.6
Silica	3.0
Frit 3134	24.6
EPK	6.5
Talc	11.9
+ Black stain (Mason 6600 CrFeCoNi)	0.3
+ Tin oxide	10
+ Zircopax	3
+ Titanium dioxide	0.3

Note: The color of the glaze is variable, and looks slightly different depending on the type of light shining on it. It can range from light gray to pale blue, and sometimes a darker blue-gray where it pools.

Materiality of Light **(#3)** *23 × 15 × 4 in. (58 × 38 × 10 cm), video projection onto textured light gray stoneware with high-fire bisque, microcrystalline glaze, fired to cone 08. SEE GLAZE DETAILS, LEFT.*

Technical Description

As a result of the glaze's propensity to become over-thick after mixing, Parsons chooses to dry mix a large batch, and wet mix only the amount that he needs at the time. He brushes the glaze on in three to five coats, allowing for drying in between coats. The clay type can affect the quality of the gray, and Parsons finds that a light stoneware produces the "truest" gray, ideal for his projections. Pieces are first bisque fired between cones 5 and 10 so that they can be propped on their edges for the low-fire glaze firing. The microcrystalline Colby's Video glaze is fired to cone 08, with a controlled cooling cycle between cone 010 and cone 011 as slow as 10° per hour for crystal development. Parsons will refire up to three times to get the results he's looking for.

- The blue color comes from digital projection.
- Colors read like reflected light from a TV.

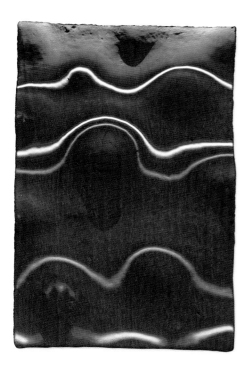
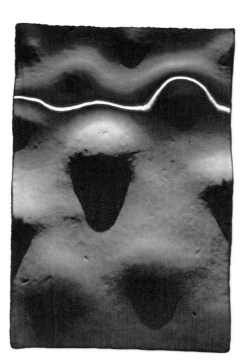
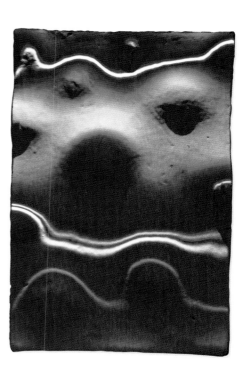

> I became aware of a kind of "materiality" or texture to the projected light, particularly when shone on uneven surfaces, because of the way the pattern of pixels spreads out or bunches up depending on the shape. I wanted to create forms that would bring that quality to the forefront.

Adam Field

With precise and intricate hand carving, each unique vessel of Adam Field's combines the language of patterning with approachable forms that celebrate utility as well as the history of decorative motifs on craft objects. Informed by the patterns found in indigenous fiber arts such as Hawaiian tapa, Inca cordage, and Zulu basketry, Field's carvings dynamically wrap around his forms, expanding around their bellies and tightening around their necks, giving them a sense of volume and liveliness. While valuing historical works such as the antique Far East pottery enveloped in patterns and the atmospheric firings of colonial American pots, Field embraces his role as a contemporary potter by extending the lineage of these traditional techniques and bringing a fresh and welcome perspective on them.

Cup 4¹/₂ × 3¹/₂ × 3¹/₂ in. (11 × 9 × 9 cm), soda-fired porcelain with carved patten, Amber Celadon glaze, liner glaze, and flashing slip, fired to cone 10 in reduction. SEE GLAZE AND SLIP DETAILS, BELOW.

Technical Description

Pieces are first thrown from a pure grolleg porcelain, whose whiteness displays colors vividly. After the surface decoration is carved, the pieces are bisque fired. Glazes are dipped and poured for application. Pieces are then fired to cone 10 in a soda kiln. A soda ash and water solution is sprayed into the kiln at the top temperature while simultaneously holding the kiln in heavy reduction. The results are slight carbon trapping within the glazed surface.

" I prefer a translucent runny glaze for my carved surfaces. The glazes help to highlight the carved areas and create an organized drip pattern as the glaze is channeled through the carved lines. "

GLAZE AND SLIP DETAILS

AMBER CELADON, *cone 10*

Custer feldspar	21.74
Wollastonite	14.13
Whiting	7.60
Gerstley borate	3.26
Alberta slip	35.87
EPK	3.26
Silica	14.13
+ Yellow ocher	8

BAUER ORANGE FLASHING SLIP, *cone 10*

OM#4 ball clay	41.9
EPK	41.9
Zircopax	10.5
Borax	5.7
+ Bentonite	2

SHANER CLEAR, *cone 10*
Note: This is the liner glaze.

F-4 feldspar	30
Whiting	16
Dolomite	5
EPK	14
Flint	30
Zinc oxide	5

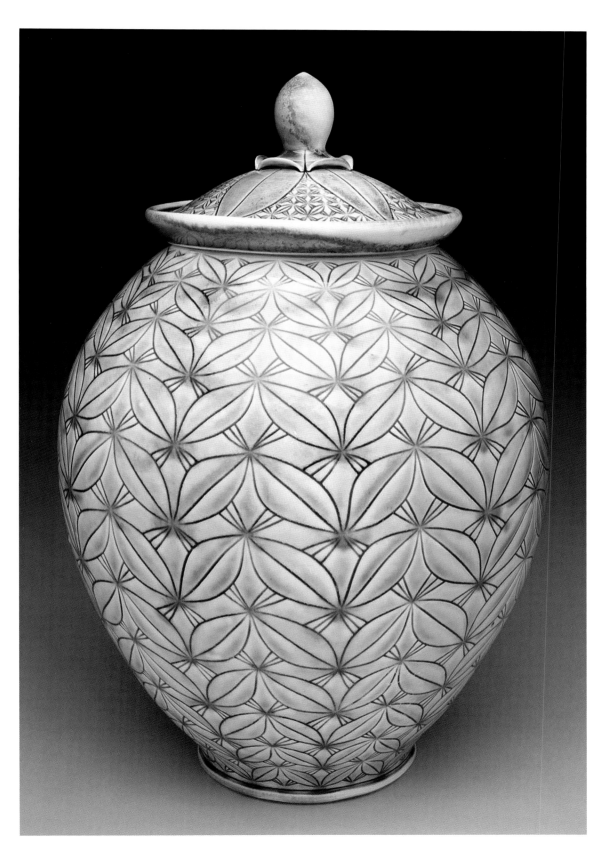

● Where the glaze pools in the carving, it becomes darker, enhancing the decorative pattern and creating two distinct shades of color in the glaze.

● The traditional amber celadon has a color and quality that is both familiar and luscious.

Covered Jar 16 × 10½ × 10½ in. (41 × 27 × 27 cm), soda-fired porcelain with carved pattern, liner glaze, and Amber Celadon glaze, fired to cone 10 in reduction. *SEE GLAZE AND SLIP DETAILS, BELOW LEFT.*

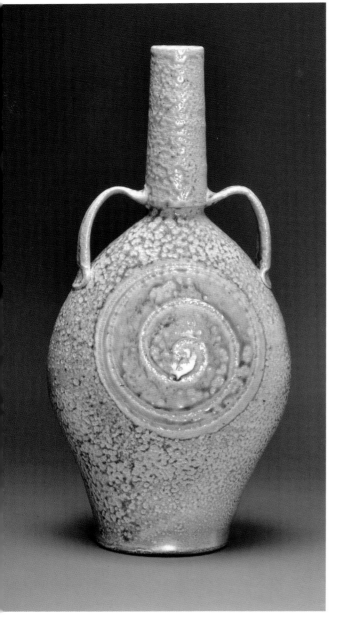

Mark Shapiro

With an admirable reverence for the ceramic medium and its dynamic history, potter Mark Shapiro embraces the creation of his work with a sophistication that speaks equally to our sensory desires to handle the clay object and our intellectual desires to engage with the world more deeply. With diligent attention paid to the life of the object—from lump, to form, to fired and used—Shapiro expresses sincerity in his workmanship, captured by his visible tooling and the throwing lines of his approachable forms. The maker's mark becomes a way of connecting the various hands that have held and will hold the piece, while abstract and gestural textlike markings allude to the relationship that ceramics has with storytelling. The formal contrast of light versus dark, soft versus hard, shiny versus matte, brings the work to life in a range of warm orangey browns, with the gentle marks of atmospheric firing creating one-of-a-kind pieces.

Technical Description ▷

At the leather-hard stage, the teapot is coated in the Tile#6 slip and then brushed with an iron oxide wash. Everything except the spout, handle top, and the top of the knob is then coated with Forbes wax. Once the wax is dry, Shapiro uses a stick to carve through the surface of the wax, iron wash, and slip into the clay below. Then the Moveable Feast glaze (which works on greenware) is applied, adhering to all areas without wax. The glaze beads up a little on areas covered in wax, leaving tiny spots of glaze. Pieces are wood- and salt-fired to cone 10 in a cross-draft kiln, using 80 percent pine and 20 percent hard wood. At the end temperature salt is added in 15-minute intervals, closing the damper almost completely after salting.

SLIP AND GLAZE DETAILS

MOVEABLE FEAST, *cone 10*
This recipe is from Andrew Martin

Frit 3110	13.0
Nepheline syenite	14.0
Gerstley borate	2.5
Strontium carbonate	9.5
Barium carbonate	9.0
Lithium carbonate	2.5
Grolleg kaolin	11.5
Silica	37.0
Bentonite	2.0
+ Copper carbonate	2.5

TILE#6 SLIP

Tile#6 slip	94
Bentonite	6

AVERY KAOLIN SLIP

Avery kaolin	70
Nepheline syenite	30
+ Bentonite	2

Tall Flask With Handles
15 × 7 × 4 in. (38 × 18 × 10 cm), stoneware, sprayed Avery kaolin slip, amber glaze circle, fired to cone 10 with wood and salt. SEE SLIP AND GLAZE DETAILS, LEFT.

Teapot *5¹/₂ × 8 × 8 in. (14 × 20 × 20 cm), stoneware, carved through Tile#6 slip and iron oxide wash. Moveable Feast glaze applied and fired to cone 10 with wood and salt. SEE SLIP AND GLAZE DETAILS, LEFT.*

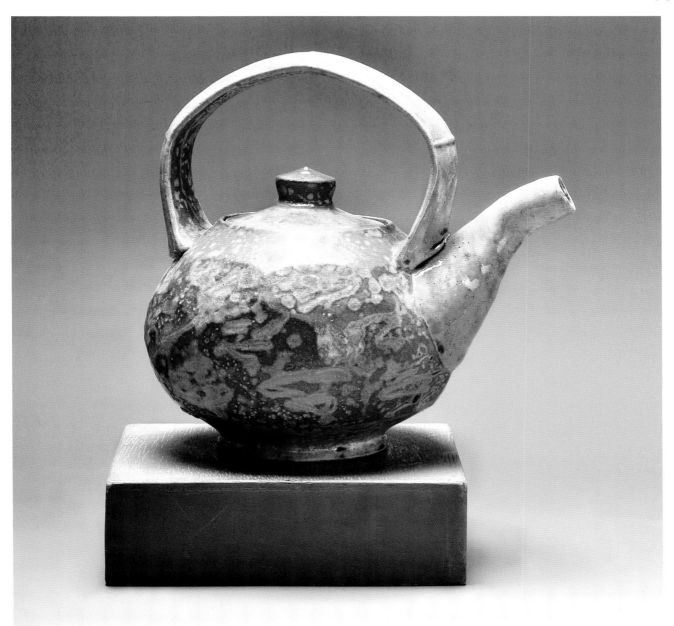

66 I love the wet trout-like quality of these surfaces when the ash, salt, glaze, and marks all meld into something beyond their individual roles. 99

● *The color is a direct byproduct of the process, with glaze and slip color developing in a complex and varied earth-toned surface in the wood- and salt-firing.*

● *Oranges, browns, and yellows emit a warm and comfortable feeling.*

Paul McMullan

Chance, intuition, collecting, and time are all important elements in the creative work of Paul McMullan. His narrative sculptures suggest nonsensical, playful scenarios, with dark underpinnings that draw reference from the found and constructed objects utilized in their creation. With each part carrying its own memories of use and meaning, McMullan's decisive use of color highlights and defines sections of his pieces, leaving a clue for the viewer as to where the story might begin or end.

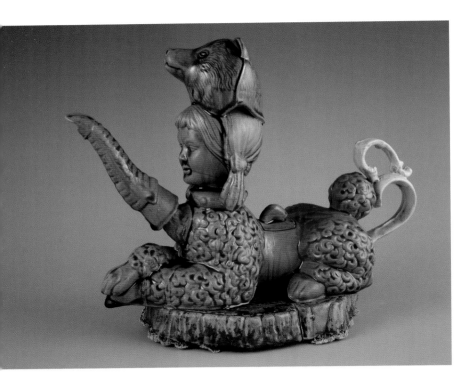

Technical Description ▷

Terra-cotta is used in both hand building and slip casting forms, and bisque fired to cone 04. Masking some sections with tape, glazes are applied thickly by spraying in a well-ventilated booth. In *Woody*, first a thick coat of Forbes Black is applied, and then Metallic Bronze is built up until it beads. Pieces are glaze fired to cone 04 in a slow-cooling electric kiln, helping the development of the matte surface.

Poodle Teapot
10 × 13 × 6 in. (25 × 33 × 15 cm), slip-cast and hand-built terra-cotta with Jacquie's Base with red iron oxide, Wilson's Chartreuse Moss, and Erickson's Peeling Paint, fired to cone 04.
SEE GLAZE DETAILS, BELOW.

GLAZE DETAILS

METALLIC BRONZE, *cone 04*	
Manganese dioxide	35
Redart	46
Ball clay	4
Flint	4
Copper oxide	4
Cobalt oxide	2
Red iron oxide	2
Rutile	3

FORBES BLACK, *cone 04*	
G-200 Feldspar	20
Frit 3124	24
Whiting	11
Gerstley borate	20
EPK	10
Barium carbonate	10
Zinc oxide	5
+ Manganese oxide	10
+ Copper carbonate	10
+ Red iron oxide	10
+ Chrome oxide	1

JACQUIE'S BASE WITH RED IRON OXIDE, *cone 04*	
Used over a thin coat of copper wash:	
50/50 of Frit 3124 and copper carbonate	
Gerstley borate	38
Lithium carbonate	10
Nepheline syenite	5
EPK	5
Flint	42
+ Red iron oxide	5

WILSON'S CHARTREUSE MOSS, *cone 04*	
This recipe is from Lana Wilson	
Lithium carbonate	80
Gerstley borate	5
Silica	15
+ Bentonite	2
+ Chrome oxide	3
+ Tin oxide	7

ERICKSON'S PEELING PAINT, *cone 04*	
Gerstley borate	80
Titanium dioxide	20

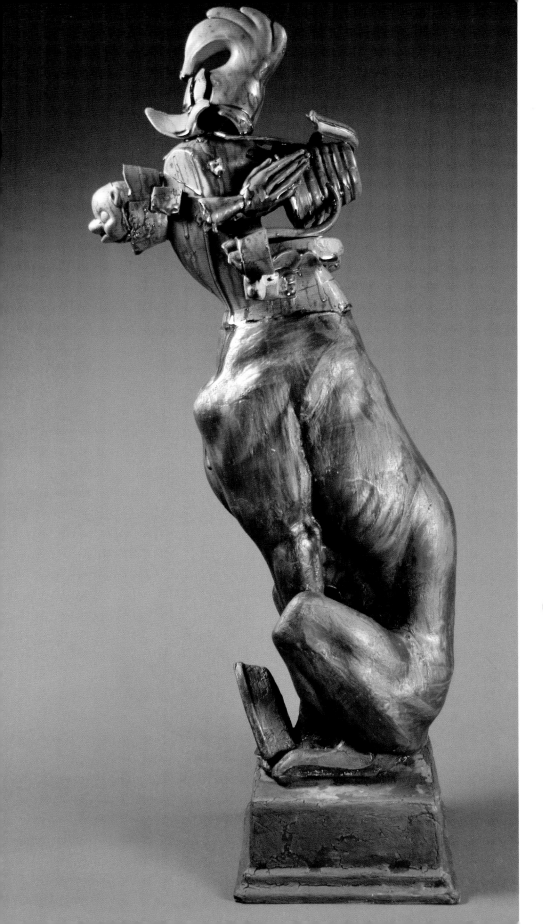

● *Color is used to bring out the narrative.*
● *McMullan recognizes that lack of color also carries a lot of content.*
● *The black surface references pewter statuary.*
● *The amber glaze highlights the "head" of the figure.*

" I look at my work as a collage/narrative based on the confusion and angst I see in life. "

Woody *34 × 9 × 14 in. (86 × 23 × 36 cm), slip-cast and hand-built terra-cotta, brushed on Forbes Black glaze, Metallic Bronze glaze and Jacquie's Base with red iron oxide, fired to cone 04 in oxidation. SEE GLAZE DETAILS, LEFT.*

Sean O'Connell

Inspired by a wide range of sources including abstract painting, historical ceramics, contemporary design, textile patterns, and poetry, Sean O'Connell melds intuitive forms and decorations to create his sensual and crisp functional tableware. These "accessories to service," as he calls them, are beautifully designed not only for ease of use, but also to be visually compelling. The surfaces of the sleek forms are decorated with black, graphic patterns that boldly wrap around and define the voluptuous curves. These abstract geometric patterns blur and bleed with the fluid glaze, creating a perceptive displacement that inspires visual and tactile stimulation.

Technical Description

Working in mid-range porcelain, decoration is done with underglaze at the bone-dry stage. Often diluted with water or mixed with other underglazes, it is applied freehand with a brush or by inlay (mishima) techniques. Once the piece is bisque fired to cone 04, it is then glazed and fired in an electric kiln to cone 7. O'Connell fires with a slow program that ensures glaze maturity and movement, dragging and streaking the underglaze. O'Connell ball mills the entire glaze for 25 minutes to minimize clumping of materials and then pours the glaze through an 80-mesh screen. If it has been sitting for more than a week, it is screened again, as the lithium (spodumene) can crystallize into small hard "beads."

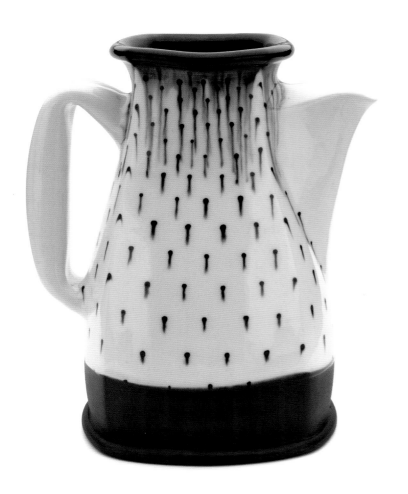

Cocktail Pitcher *11 × 7 × 9 in. (28 × 18 × 23 cm), wheel-thrown and altered porcelain, brushed commercial underglaze, Campana Clear glaze, fired to cone 7 in an electric kiln. SEE GLAZE DETAILS, BELOW.*

GLAZE DETAILS

CAMPANA CLEAR, cone 6–8
This recipe is from Jeff Campana

Spodumene	13
Frit 3134	21
Wollastonite	20
EPK	20
Silica	18
Zinc oxide	8

VELOUR BLACK UNDERGLAZE
Amaco Velvet V-370

> In making each piece I am just as concerned with how a hand might touch the surface as how the eye might travel its contours or indulge in a moment of decoration.

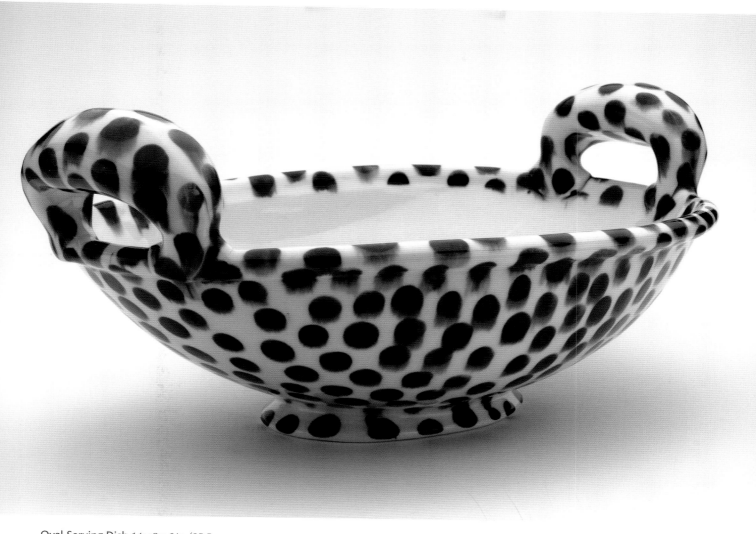

Oval Serving Dish *14 × 8 × 6 in. (35.5 × 20 × 15 cm), hand-built porcelain, brushed commercial underglaze, Campana Clear glaze, fired to cone 7 in an electric kiln.*
SEE GLAZE DETAILS, LEFT.

• *The black, graphic patterns both define and blur the curves of the sleek forms.*

• *The black color, which appears so stable and deep where it is placed, runs when in contact with the clear glaze, allowing for streaks of a bluish-black to cascade off the dots like a shadow being cast on the forms.*

David Eichelberger

The scalloped edges and rhythmic curves of David Eichelberger's work carry our gaze around the form, begetting a visual exploration, while the delicate pinches of clay reveal the hand and process of making, inviting our own touch. His decisive and alluring forms imply a subtly mysterious function, tempting the viewer to engage with them. The matte and glossy black surfaces contrast with crisp patterning, creating a sleek dynamic reminiscent of Native American black-on-black wares. Punctuated by a sharp red line, the sumptuous, reflective black exudes refinement, while the softer, yet equally chic matte black gives our eyes a place to rest and move into the work.

Serving Box *8 × 7¹/₂ × 4¹/₂ in. (20 × 19 × 11 cm), hand-built red earthenware, matte and gloss black glazes, fired to cone 04. SEE GLAZE DETAILS, BELOW.*

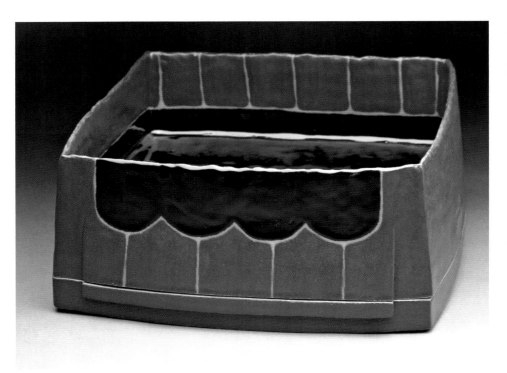

Technical Description

After pieces are constructed from terra-cotta with various hand-building techniques, they are bisque fired to cone 04. Guidelines are drawn with a pencil onto the bisqueware and one of the black glazes is brushed on, stopping just shy of the line. The other black glaze is then brushed on the other side of the line, leaving a millimeter-wide gap between the two glazes. The pieces are then fired to cone 04 (sometimes a little hotter), and this gap turns to a brighter red with a light sheen as the glazes fume onto the exposed terra-cotta.

GLAZE DETAILS

SIMPLE MATTE BLACK, cone 04	
Gerstley borate	36
Albany slip	36
PV clay (plastic vitrox)	7
Nepheline syenite	21
+ Best Black stain (Mason 6600 CrFeCoNi)	8

SIMPLE GLOSS BLACK, cone 04	
Frit 3124	45
Frit 3289	45
OM#4 ball clay	10
+ Bentonite	2
+ Best Black stain (Mason 6600 CrFeCoNi)	10

66 The objects I make are both an anthropological study and an artistic endeavor, and incorporate an attempt to understand the world we live in, through making. 99

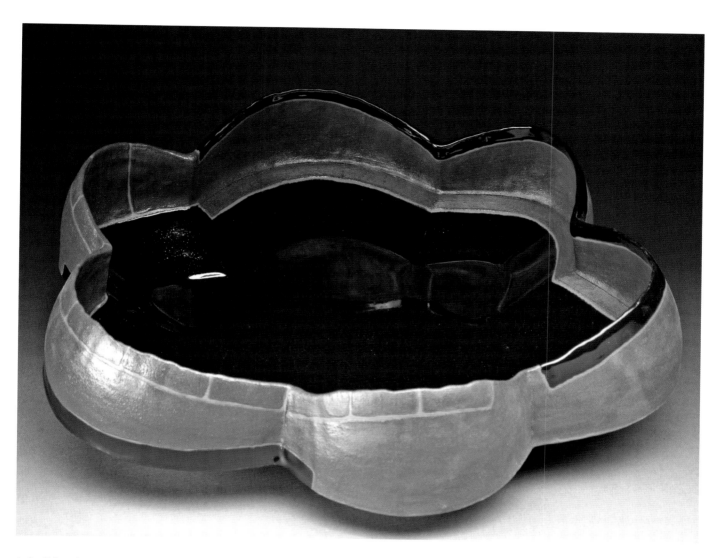

Lobed Vessel *21 × 21 × 6¹/₂ in. (53 × 53 × 16.5 cm), hand-built red earthenware, matte and gloss black glazes, fired to cone 04. SEE GLAZE DETAILS, LEFT.*

• *Matte black against shiny black creates a sharp contrast that helps lead the eye around the form.*

• *The bright red of the terra-cotta is revealed in unglazed lines that add structure to the forms.*

Cristina Córdova

With a gaping mouth and listless gaze, Cristina Córdova's figure is both haunting and utterly vulnerable. The black-and-white color palette creates a stark formal contrast, while also imbuing the work with an emotionally charged duality. Disembodied and suspended, it's as if consciousness itself is trapped behind the veil of a hyperrealistic yet ambiguous identity. Heavily textured matte black coats the entire surface, swallowing the light cast on the figure and negating the softness of the skin. Pure white porcelain fragments of fruits and flowers orbit the figure, a metaphor for swirling thoughts or memories.

Technical Description

At the leather-hard stage, high-temperature wire is pressed into the clay to later support the porcelain parts. The eyes are painted with Amaco underglazes, then protected with wax. The piece is then sprayed several times with a white casting slip stained by eye with black (cobalt-free) Mason stain to get a rich gray color and build up the texture. After a cone 06 bisque firing the eyes are covered with tape and a thin wash of black underglaze is brushed on, followed by several light sprays of the same underglaze. Next the eyes are glazed with the clear glaze and the piece is fired to cone 04. After the final firing, the porcelain pieces are attached to the wire with PC-11, a strong epoxy.

Vestigos 12 × 9 × 6 in. (30 × 23 × 15 cm), white mid-range stoneware, porcelain, slip and black cobalt-free stain, black underglaze, fired to cone 04. SEE GLAZE DETAILS, BELOW LEFT.

GLAZE DETAILS

Commercial mid-range casting slip stained with Cobalt-free Black stain (Mason 6666 CrFeMn)

JET BLACK UNDERGLAZE
Amaco Velvet V-361

CLEAR TRANSPARENT GLAZE,
cone 05
Amaco F-10

" Often I gravitate to black or white when the sculpting is busy and needs to be quieted or unified. Black is a color of dynamic thought and realizations. while white is more serene and passive. "

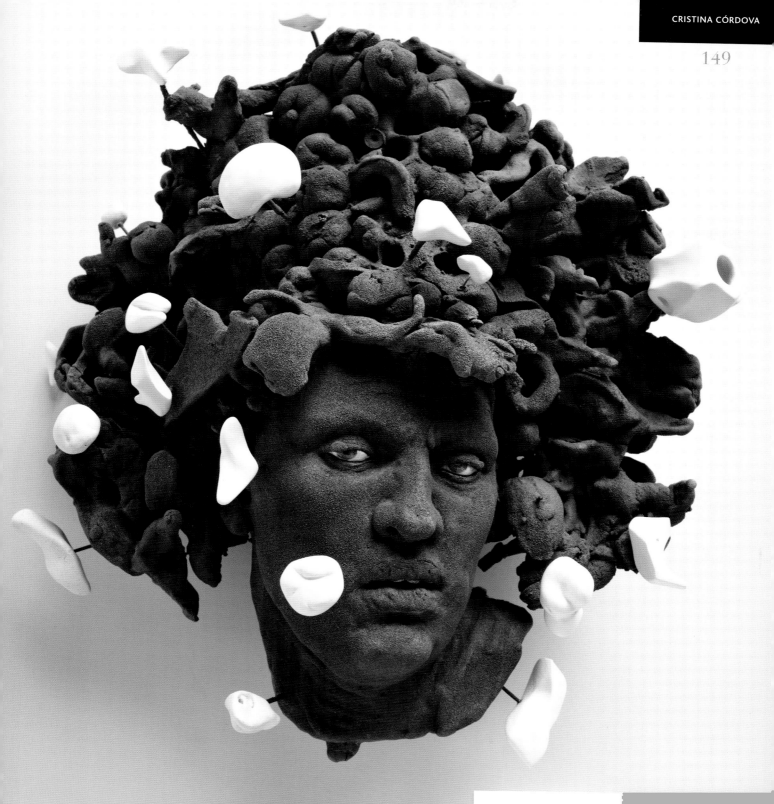

● White porcelain fragments feel pure and calm as they orbit the figure.

● Textured matte black absorbs light, making the surface feel endlessly deep.

● The monochrome black feels dynamic, serious, and emotionally intense.

Rebecca Catterall

Uninterrupted, saturated color allows for light to define the planes and edges of Rebecca Catterall's dense, architectonic forms. The subdued and somber black surface grounds the work and places the emphasis on form—its pattern, system, and order in relation to space. Inspired by the methodology of streamlined manufacturing, Catterall begins with a logical sequence of familiar geometric components. She constructs complex, cantilevered arrangements whose precarious balance resembles modernist architectural structures. The well-founded and precisely tailored beams present with great resolve, yet evoke more questions than answers.

Shallow Eaves (detail). Catterall's slip-covered blocks are arranged in a modern, architectural structure. SEE SLIP DETAILS, BELOW LEFT.

Technical Description

To provide a base coat, the slip is first poured on, while the piece is turned several times to ensure full coverage on the internal parts of the form. Uneven spots on the outside are cleaned up with a sponge and slip is then brushed on. Catterall sprays the pieces with several thin layers to achieve the desired coverage, sanding between spraying to even out any inconsistencies. The application process defines the texture—too quick and thick and it will have a sheen; too loose and too many layers and it will crumble. The piece is fired to cone 4 oxidation in an electric kiln. Catterall will warm, respray, and refire a piece if it shows inconsistencies after the first firing.

SLIP DETAILS

SLIP, *cone 4*

Kaolin	80
Nepheline syenite	20
+ Stains (50:50 mix of Mason Chrome-free Black 6616 CoFeMn and Mason Shadow Gray 6527 CrFeAlSiSnZr)	10
+ CMC gum	1

> 66 My work holds many conflicts: recognizable shapes interrupted, order without orientation, surfaces evoking other material qualities—in-between places where monotony and familiarity are manufactured into obstructions. I am interested in the capacity of objects to be a thing and space: an obstacle to negotiate, classify, and touch. 99

● *The matte gray is cool and analytical.*

● *Monochromatic color allows the eyes to focus on the form, with light and shadow adding definition.*

● *The color combined with the crisp, straight lines allude to a material other than clay.*

Shallow Eaves *5 × 10 × 12 in. (12 × 26.5 × 30 cm), extruded stoneware clay blocks cut into asymmetrical forms. Slip and commercial stains sprayed onto bisque, then fired to cone 4 in oxidation.* SEE SLIP DETAILS, LEFT.

Elsa Sahal

Elsa Sahal's *Acrobate* is part of the *Equilibres* series, which investigates the harmony of form and space through the lens of the body. This balance of the form, whose impulse is frozen in material, becomes a metaphor for finding equilibrium. The tenuous posture of the leggy figure imbues a sense of humanity, and helps the viewer empathize with the performer. With the visceral bulges piled atop and frizzy hair extensions flowing from follicles in the clay skin, the perplexing, grotesque form marries with the flat, black palette to project an ominous presence.

Technical Description

Sahal uses a heavily grogged stoneware to give her large-scale sculptures strength, as well as to add an interesting texture to the surface, which her glaze choice accentuates. The engobe is applied to bone-dry greenware. Using a layer of sand as miniature ball bearings, Sahal "rolls," or slides, her pieces off drywall boards and into the electric kiln and fires them slowly to cone 1.

> I manipulate vast sheets of clay whose thickness is conditioned by the needs that this material holds, in order to be one with itself. Without balance of the forces — the ligaments, the muscles, and the thought of the artist on one side and the weight, the density, the texture of the stoneware, on the other side — the nothingness settles again at the primitive center of the acting creation.

ENGOBE DETAILS

SINTER ENGOBE SE10, *cone 04–1*

Nepheline syenite	32
Whiting	15
Lithium carbonate	5
Zinc oxide	3
Kaolin	23
Quartz	22
+ Black stain (Cerdac PCM 716 CrFe)	10

● Deep, saturated black unifies the form, including various textures and materials, into one ominous whole.
● A monochrome palette brings focus to the form.
● Satin black keeps highlights down, allowing the viewer to read all surfaces.

Acrobate 63 × 26 × 26 in. (160 × 66 × 66 cm), grogged stoneware, sprayed black glaze fired to cone 1 in oxidation, synthetic hair. SEE ENGOBE DETAILS, LEFT.

Virginia Scotchie

Inspired by everyday objects, simple forms from other cultures, and utilitarian shapes, Virginia Scotchie constructs ambiguous geometrical vessels. Her *Turquoise and Bronze Ball Bowl* is based on a visual exploration of a bowl form expressing the figure 8. With spheres for handles and a ballooning volume contained by a succinct form, the vessel feels playful and serious at once. Scotchie notes that all colors can be found in nature and she uses that as a source of inspiration for her works. The intense turquoise blue and metallic black are equally deep and vivid, but contrast each other in texture and tone. The metallic feels machined while the texture of the turquoise glaze feels decidedly organic, as they define the contours of the form and provide a basis for visual interpretation.

White and Bronze Bowls *7 × 10 × 6 in. (18 × 25 × 15 cm) each, stoneware, textured glaze and bronze glaze, fired to cone 5–6 in oxidation. SEE GLAZE DETAILS, BELOW LEFT.*

Turquoise and Bronze Ball Bowl *20 × 14 × 10 in. (51 × 35.5 × 25 cm), stoneware, textured turquoise glaze and bronze glaze, fired to cone 5–6 in oxidation. SEE GLAZE DETAILS, BELOW LEFT.*

GLAZE DETAILS

BRONZE GLAZE, *cone 2–6*	
Redart	48
OM#4 ball clay	4
Silica	4
Manganese dioxide	36
Copper carbonate	4
Cobalt carbonate	4

TEXTURED GLAZE, *cone 4–6*	
Bone ash	77.3
Cyrolite	13.7
Barium carbonate	0.4
F-4 feldspar	8.6

Turquoise
+ 3% Copper carbonate

66 When working on a piece I may not know its final outcome but it is the act of making that leads me to new forms and concepts for my work. I do not work from a blueprint but I have notebooks full of sketches and drawings that find their way into the work I create. 99

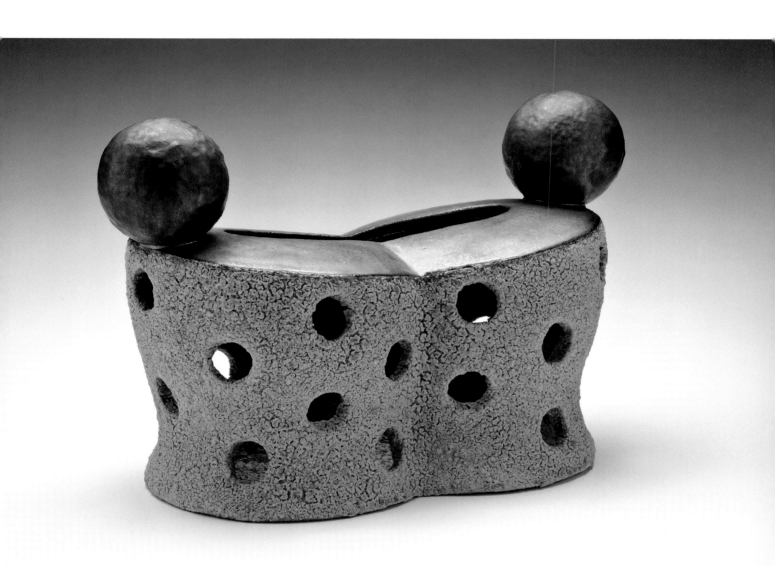

Technical Description

After bisque firing, the bronze glaze is sieved and brushed on in three layers. The textured glaze is mixed with a hand blender to a stucco consistency and dabbed onto the piece with a brush. Finished pieces are glaze fired to cone 5 or 6 in oxidation.

● Bright, textured turquoise has a light feel against the heavy, solid metallic surface.

● The bronze glaze has a warm and intensely metallic sheen that shifts from a copper tone to a matte black depending on its thickness.

Steven Montgomery

In Steven Montgomery's *trompe l'oeil* sculptures, the artist exploits the clay with astonishing virtuosity to create hyperrealistic machine parts and industrial detritus. The elegant yet cold, heavy object titled *Liquid Fuel Nozzle* remains ambiguous, despite its incredible realism, as a fragment of some larger apparatus. Its ominous function is yet to be seen, though the waning polish suggests it has already been used. While the menacing object projects strength, the falseness of its materiality brings the illusion to the forefront as a metaphor. What other deceits might be hiding beneath the surface?

Technical Description

Montgomery works with a white earthenware talc clay body that is bisque fired to cone 04, glazed in commercial clear glaze, and fired again to cone 04. Before the luster is applied, the glazed pieces are cleaned with denatured alcohol, then the brushes, glaze containers, and the piece are sprayed with compressed air to remove all of the dust and minute fibers that can cause pinholes. Wearing the appropriate vapor mask and latex gloves, Montgomery carefully but swiftly brushes on the luster, avoiding drips and pooling, then the piece is fired to cone 016. Pieces are finished with various paints to achieve a wide range of realistic textures, patinas, and colors.

Zero Sum Game *65 × 17 × 17 in. (165 × 43 × 43 cm), clear-glazed earthenware, fired to cone 04, luster fired to cone 016, finished with paints.* SEE GLAZE DETAILS, LEFT.

GLAZE DETAILS

CLEAR GLAZE, *cone 04*
Duncan Envision IN 1001

PLATINUM LUSTER GLAZE, *cone 016*
Engelhard Hanovia

Note: Montgomery uses an OSHA-approved vapor respirator and latex gloves when handling the highly toxic luster, and he avoids exposure to the noxious exhaust fumes by firing in an enclosed kiln room with an industrial-strength ventilation system.

❝ While expedience and immediacy are not irrelevant, I believe that the use of unconventional, nonfired surfaces on fired ceramics should be approached from a technically and conceptually informed point of view. ❞

Liquid Fuel Nozzle
31 × 16 × 16 in. (79 × 41 × 41 cm), clear-glazed earthenware, fired to cone 04, platinum luster fired to cone 016, finished with paints. SEE GLAZE DETAILS, BELOW LEFT.

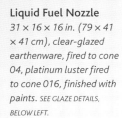

● *The black and yellow zigzags communicate caution, as they resemble the labeling on hazardous materials.*

● *The chrome "plating" is slightly worn, subtly denoting a sense of time and use.*

● *The bright yellow and glaring mirrored surface demands attention.*

François Ruegg

In these pieces titled *Contre Nature Morte*, which translates as "against still life," Swiss artist François Ruegg creates ambiguous objects that both tantalize and confuse with their sensual surfaces and their allusion to ambiguous bodily bulges. The globular forms, directly taken from vegetal shapes, are wrapped in a reflective sheath. The vacuous interiors are coated in the lively colors of fruit and vegetable skins, and as the mirrored armor gives way to openings, cuts, and punctures, the glow emitted draws the viewer's gaze. Still, upon investigating, we are faced with the reflections of ourselves in the objects as Ruegg plays with internal and external, self and other.

Contre Nature Morte 1
12 × 12¹/₂ × 11 in. (30 × 32 × 28 cm), slip-cast porcelain, bisque fired to cone 7, interior sprayed with neon green underglaze and frit, exterior transparent glazed, fired to cone 05, and platinum luster fired to cone 017. SEE GLAZE DETAILS, BELOW.

GLAZE DETAILS

SHINY TRANSPARENT GLAZE,
cone 05
Bodmer Ton 82.210

UNDERGLAZES, *cone 05*
Neon Yellow underglaze
(Duncan Concepts CN 501)
Neon Orange underglaze
(Duncan Concepts CN 504)
Neon Green underglaze
(Duncan Concepts CN 505)

LUSTER, *cone 017*
Commercial Platinum Luster

Technical Description

Ruegg's slip-cast porcelain forms are first bisque fired
to cone 08 (1,760°F/960°C). The interiors are sprayed
with colored underglaze and fired again to cone 7
(2,260°F/1,238°C). Next, the pieces are slightly warmed
and the exterior is sprayed with the transparent glaze that
is mixed with a bit of glue for adherence and the piece is
refired to cone 05 (1,904°F/1,040°C). To finish, the piece is
sprayed with the commercial platinum luster and fired to
cone 017 (1,360°F/738°C).

Contre Nature Morte 2

*29½ × 12 × 11 in. (75 × 30
× 28 cm), slip-cast porcelain,
bisque fired to cone 7, interior
sprayed with neon yellow
and neon orange underglazes
and frit, exterior transparent
glazed, fired to cone 05 and
platinum luster fired to cone
017.* SEE GLAZE DETAILS, LEFT.

● *The platinum luster on
the smooth glaze reflects
like a mirror.*

● *The reflection is
extremely vivid because
there is no glaze or glass
over the actual luster.*

● *The soft, matte interior
hues sometimes mimic the
fruits and vegetables from
which they were cast.*

Karin Östberg

Karin Östberg's proliferation of multiples allows her the opportunity to discover making possibilities by remaining open to what new insights her material may reveal. Contrasting colored glazes help to feature the crackled surfaces, creating a dynamic composition of jagged lines and perfect curves from her spherical and buoyant "plupps." The multiples are not defined by a specific purpose, and can exist singularly, or in piles, lines, or grids, on the wall or on the floor. Östberg offers the viewer the freedom to be in charge of color combinations and compositional arrangements.

Blue and Green Balls
earthenware clay balls, 3 in. (7 cm) in diameter each, layered colored earthenware glazes, crackle glazes, fired 3–4 times, last firing to cone 04. SEE GLAZE DETAILS, BELOW.

Technical Description

Östberg first applies her commercial earthenware glazes to bisqueware and fires the pieces to between cone 017 and cone 016 (1,400–1,454°F/760–790°C). Next she applies the crackle glazes and refires the pieces to cone 04 (1,958°F/1,070°C), with no hold at the end. The earthenware glaze acts as a layer of color that is revealed beneath the crackle, but it also adheres the crackle in place by fusing it to the piece. She makes small clay shelves coated with an alumina hydroxide and kaolin mixture that she uses to protect her kiln shelves, and as trays to transport the work without handling the delicate crackle glaze. Östberg describes her technique as memory based—working in proportions, the way the glaze looks as it coats, the weight of the form in her hands, etc. She experiments with variations of glaze thickness and clay body color, as well as placement in the kiln, which offers a fluctuating temperature, to obtain a wide range of results.

GLAZE DETAILS

COMMERCIAL GLAZES
Turquoise Glossy (CEBEX E-Glaze 5126)
Copper Green (CEBEX E-Glaze 5119)
Cobalt Blue Glossy (CEBEX E-Glaze 1976)
Transparent Glossy (CEBEX E-Glaze 1031)

MIXTURE A
20 fl. oz. (600 ml) mixed Transparent Glossy Glaze (see left)
14 oz. (400 g) Tin oxide

MIXTURE B
Nepheline syenite (20%) and Gerstley borate (80%) mixed with water as a glaze 50
Magnesium carbonate 50
(also mixed with water to a similar thickness)

CRACKLE GLAZE C, *cone 04*
Mixture A (see left) 50
Mixture B (see left) 50

CRACKLE GLAZE D, *cone 04*
Borax frit 45
Tin oxide 55

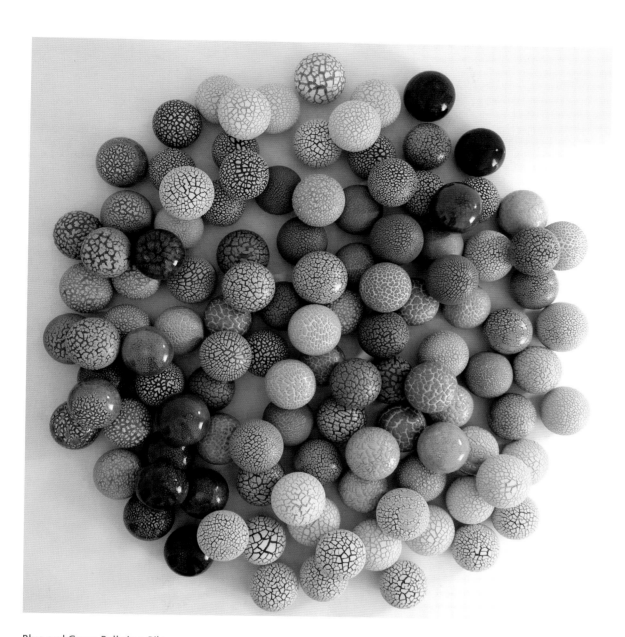

- The multiple hues of blue, from light turquoise to aqua and deeper blue, meld together across the piece, creating an overall feeling, with moments of glossy darkness and crisp, pale blue crackles.

- Upon closer inspection, the cracked blue skin reveals contrasting red and peach clay backgrounds, adding interest and variation to the uniform spheres.

- Subtle variation in color from piece to piece keeps with the organic feeling of the texture.

Blue and Green Balls in a Pile
31 × 31 in. (80 × 80 cm), approximately 120 earthenware clay balls, 3 in. (7 cm) in diameter each, layered colored earthenware glazes, crackle glazes, fired 3–4 times, last firing to cone 04. SEE GLAZE DETAILS, LEFT.

66 I seek rhythm and matter of course. Space between, clay and glaze, patterns in layers on layer. It takes time and goes slow. 99

Sin-ying Ho

Sin-ying Ho's seven-foot tall vase titled *One World, Many Peoples* is part of a series of works called *Eden*, which explores cross-cultural identities in the format of historic Chinese porcelain practices. Originally from Hong Kong, Ho now lives in North America, and she draws on this personal history to inform her work. Paying homage to her Chinese heritage, she paints the traditional Chinese hundred flowers in cobalt blue as the background on the vases. In contrast, cutouts of human silhouettes are consumed in text from 46 different languages, symbolizing how cultural systems affect personhood but also reveal a collective relationship with syntax and an ever-present gap in communication.

Temptation—Life of Goods No. 1 and No. 2
69 × 23¹/₂ in., 68 × 23¹/₂ in. (175 × 60 cm, 173 × 60 cm), thrown middle-white porcelain, sprayed super white slip, hand-painted cobalt underglaze, red underglaze silk-screen on cotton paper decal transfers, light celadon glaze, once fired to cone 12. SEE GLAZE DETAILS, BELOW.

Technical Description

Pieces are created using a middle-white porcelain that has a lower chance of warping. After forming, the pieces are sprayed with a thin layer of super white casting slip to create a bright background to enable the colors to show vividly. The figure silhouettes are then cut from paper, traced onto the form with pencil, and the shapes are filled by brushing on liquid latex. Using a projector, the flower images are traced with a pencil and then painted with a cobalt underglaze pigment in a style called Qing Hua, or Blue and White. Next, the entire piece is sprayed with the light celadon glaze and, once dry, the latex figures are peeled off, exposing the bare surface. Latex is brushed around the figures and underglaze silk-screen cotton paper decals are applied inside the silhouettes. Pieces are then fired once to cone 12 (2,419°F/1,326°C).

GLAZE DETAILS

LIGHT CELADON GLAZE, *cone 12*
Pui Yin Tang

COBALT BLUE UNDERGLAZE
Pui Yin Tang, Kan Qian No. 1

> My work invites viewers to contemplate the questions of whether there are meanings or discernible patterns of human endeavors.

One World, Many Peoples No. 1 *69 × 20³/₄ × 20³/₄ in. (175 × 53 × 53 cm), thrown middle-white porcelain, sprayed super white slip, hand-painted cobalt underglaze, yellow, red, and green underglaze silk-screen on cotton paper decal transfers, light celadon glaze, decals, once fired to cone 12. SEE GLAZE DETAILS, LEFT.*

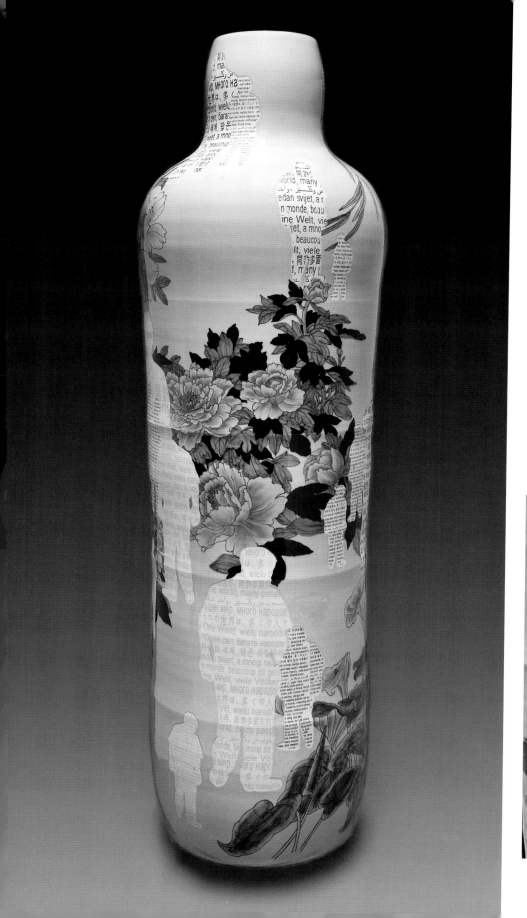

● *The traditional cobalt blue decoration is juxtaposed against the flat silhouettes, filled in with vibrant red, green, and yellow.*
● *The colored text draws out more cultural references.*

Kristen Kieffer

Kristen Kieffer is a full-time studio potter residing in Massachusetts. Her elegant, lively, and inviting pots are crafted with the utmost attention paid to their utility, as well as to their beauty. Inspired by a range of historically significant decorative styles, from 18th-century silver service pieces to couture clothing, and from Art Nouveau illustrations to cake fondant, Kieffer's work embraces the synergistic potential between function and ornamentation, with silky glazes and sensual forms.

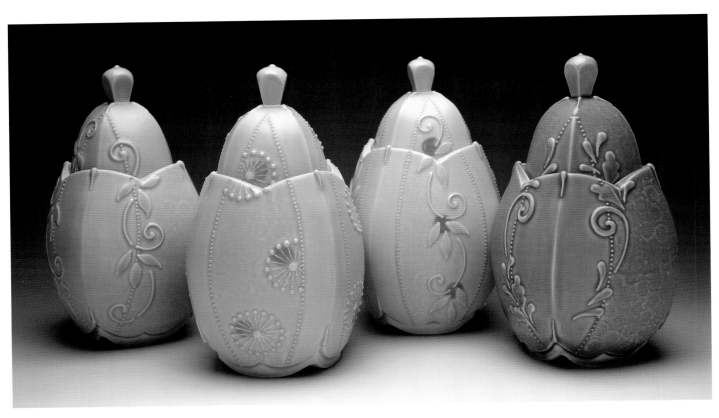

Small Covered Jars *10 × 5 × 5 in. (25 × 13 × 13 cm) each, porcelain with trailed slip and underglaze.*

GLAZE DETAILS

DIXON SATIN REVISED, *cone 5–6*
This recipe is from George Bowes

Nepheline syenite	22.65
Whiting	22.35
Frit 3124	8.82
EPK	20.30
Flint	20
Gerstley borate	2.94
Magnesium carbonate	2.94

Kieffer Aqua
+ 5% Turquoise stain (Mason 6364 SiZrV)

> *Even though I know how to do glaze calculation, I've always preferred to utilize the myriad of glaze bases already out in the world, and tweak them for my needs, spending more of my time on color testing.*

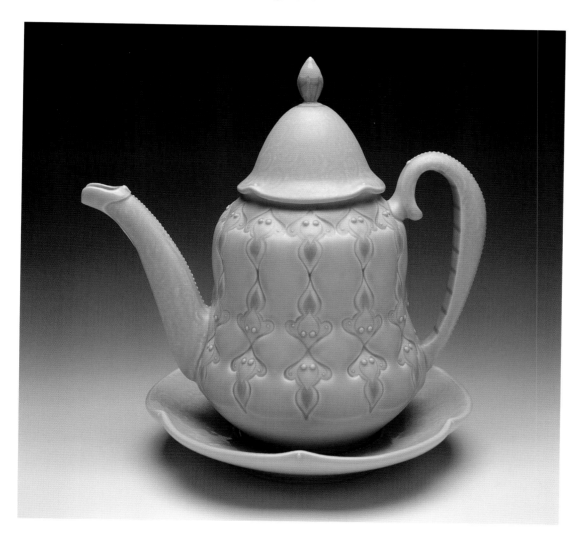

- *Color is used to complement the style, vision, and content of Kieffer's work.*
- *Individual colors are used to create a pleasing palette when grouped together.*
- *Consideration is always paid to keeping a balance between light and dark, soft and bright, and the colors of the wheel.*
- *Color is not necessarily function specific, but consideration is paid to how it can complement the function of a piece.*

Technical Description

Kristen's work is mostly wheel thrown, altered, and built with additional decoration using stamping, slip-sponging, and slip-trailing techniques on Standard Clay's mid-range porcelain #213. Underglaze, applied with a brush on greenware, adds accents of color to enhance the decoration. The pieces are then dipped in glaze and fired to cone 7 in oxidation. She uses a 15+ hour glaze-firing cycle, including a seven-minute hold at peak temperature and a programmed ramp down.

Aqua Teapot and Saucer
12 × 12 × 8 in. (30 × 30 × 20 cm), mid-range porcelain with stamping, trailed slip, underglaze, and Aqua glaze, fired to cone 7 in oxidation.
SEE GLAZE DETAILS, LEFT.

Sidsel Hanum

The tenuously shaped, abstract constructions of Norwegian artist Sidsel Hanum appear to be somewhere between the edge of collapse and weightlessly floating. The incredibly meticulous work relies on Hanum's meditative labors of creation, but also speaks to the vast expansiveness of time itself. Inspired by coral reefs, the vessel-like forms reference organic as well as geological structures, with their topographical layers wound around a network of plantlike webbing. She bathes her pieces in chloride washes that reveal every tiny detail and undulation in the surface, radiating a kind of subtle glow.

Star Alliance *8 × 5¹/₂ × 3 in. (21 × 14 × 7 cm), porcelain dipped in sulfuric acid hydrate of titanium and copper chloride dihydrate, fired to cone 02–03 in reduction.* SEE SOLUTION DETAILS, BELOW.

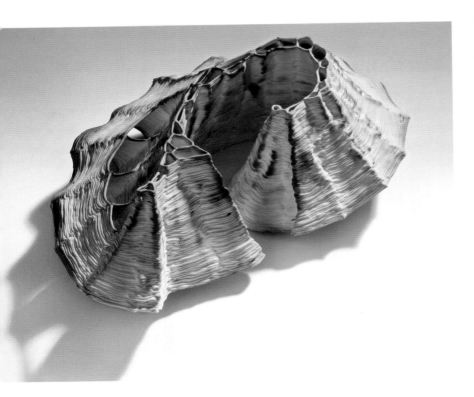

Technical Description

Hanum's pieces are constructed by "drawing" with fluid porcelain, building up layer by layer, into plaster molds she has made. In order to retain the detailed layering of the construction process, Hanum avoids glazes in favor of chloride solutions (highly toxic water-soluble metal salts). After bisque firing, the pieces are first submerged in water to slow the absorption rate of the chlorides. Dried slightly with a hair-dryer, the piece is then set into a bath of the chloride solution, allowing it to penetrate. Sometimes the piece is dried again and dipped into a different solution or it is brushed onto the surface. Hanum's pieces are fired in reduction, beginning around cone 07 (1,795°F/980°C) up to cone 02–03 (2,065°F/1,130°C) in a paraffin-fueled kiln.

SOLUTION DETAILS

STAR ALLIANCE
First dip:
Clean water
Second dip:
20% solution of titanium (IV) oxysulfate hydrate (sulfuric acid hydrate)
Third dip:
20% solution of copper (II) chloride dihydrate
The 20% solutions are created using the ratio of ³/₄ oz. (20 g) material to 3¹/₄ fl. oz (100 ml) water.

THE ROSE OF ABEL
Whole piece:
dipped in clean water
Bottom:
dipped into cobalt (II) chloride
Walls:
brushed with copper (II) chloride

SEAWEED
First dip:
Clean water
Second dip:
cobalt (II) chloride
Outside walls:
brushed with copper (II) chloride

Note: These materials (water-soluble metal salts) are extremely toxic and can be easily absorbed through the skin. Wear latex gloves, eye protection, and a proper respirator. Refer to manufacturers' instructions when handling, storing, and disposing of hazardous materials.

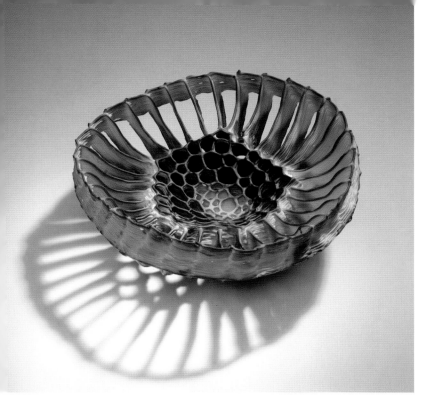

66 I did not want to close down the surface with a thick glaze, because the construction is a very important part of the whole piece. 99

The Rose of Abel *5¹/₂ × 5¹/₂ × 2 in. (14 × 14 × 5 cm), porcelain brushed and dipped with different chlorides including cobalt and copper, fired to cone 02–03 in reduction. SEE SOLUTION DETAILS, BELOW LEFT.*

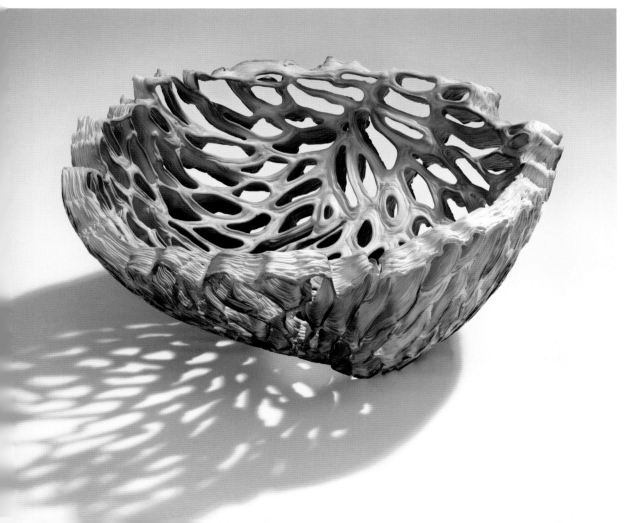

● *The soft, saturated blues in* Seaweed *look as if the piece were immersed in the ocean, with light delicately refracted across the form.*

● *In* Star Alliance *the color fades from earthy browns to cream, revealing a weathered, timeworn surface.*

Seaweed *8 × 7 × 4 in. (21 × 19 × 9¹/₂ cm), porcelain dipped and brushed with different chlorides including cobalt and copper, fired upside down to cone 02–03 in reduction. SEE SOLUTION DETAILS, LEFT.*

Mieke de Groot

Suggestive of the underlying mathematical structures found in nature, Mieke de Groot's geometric volumes are astonishingly refined. De Groot's hand-carved grid precisely wraps around the robust objects, defining them with a harmonious rhythm that stretches to contain their lively forms. The solid mass appears buoyant, creating the illusion of floating on the ground. The saturated blue color and soft, matte surface of *2010.11* are designed to support the form and allow for light to play an important role in defining the pattern, with the edges of lines crisply highlighted and shadows sucked deeply into the concave carvings.

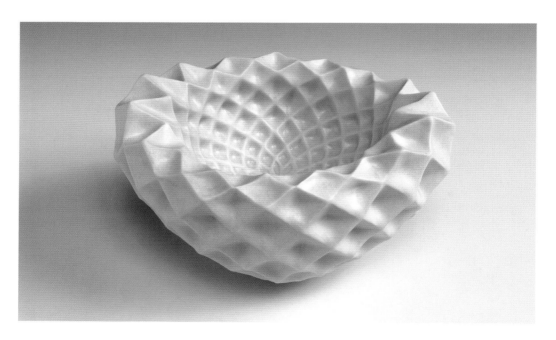

BLUE SINTERING SLIP, *cone 4*

White casting clay	80
Calcined kaolin	20
+ Frit 1510 (alkaline frit, similar to Ferro frit 3110)*	15
+ Cobalt carbonate	2
+ Copper oxide	4
+ Turquoise stain (Keramikos PM245b ZrSiV)	8

Note: Frit 1510:
$0.62\ Na_2O\ 0.06\ Al_2O_3\ 2.1\ SiO_2$
$0.06\ K_2O$
$0.10\ CaO$
$0.22\ ZnO$

WHITE HIGH-ALUMINA MATTE GLAZE, *cone 6*

Potash feldspar	10.1
Nepheline syenite	56.4
Dolomite	14.8
Whiting	7.7
Kaolin	9.9
Quartz	1.1

Note: You can enhance the matte appearance by adding 3–5% aluminum oxide.

2012.8 *10 × 8 × 6 in. (25 × 20 × 15 cm), slip-cast porcelain, fired to cone 12, sprayed with white glaze with added CMC gum and fired in a gas kiln to cone 6 in oxidation. SEE GLAZE AND SLIP DETAILS, LEFT.*

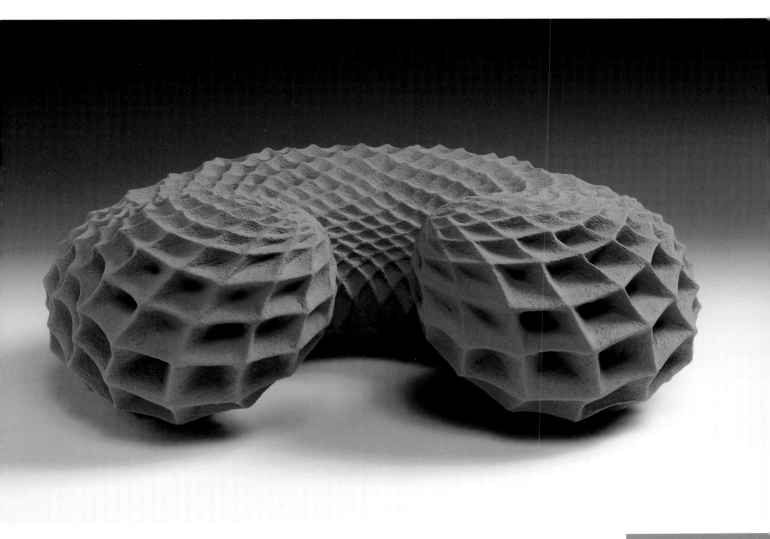

Technical Description △

De Groot sprays thick layers of the blue sintering slip over the entire form. The mixture is carefully sieved through a 100-mesh sieve prior to spraying in order to keep the calcined kaolin from leaving a speckled surface. The piece is fired on a bed of sand in a gas kiln in oxidation to cone 4 (2,155°F/1,180°C).

2010.11 *16¹/₂ × 12¹/₂ × 6 in. (42 × 32 × 15 cm), hand-built stoneware, sprayed with blue sintering slip, fired in a gas kiln to cone 4 in oxidation. SEE GLAZE AND SLIP DETAILS, LEFT.*

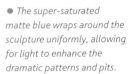

● *The super-saturated matte blue wraps around the sculpture uniformly, allowing for light to enhance the dramatic patterns and pits.*

● *The monochromatic work allows for color to play a symbolic role, giving each piece an emotive presence.*

● *The blue color references water, like light reflecting off overlapping ripples.*

Julia Galloway

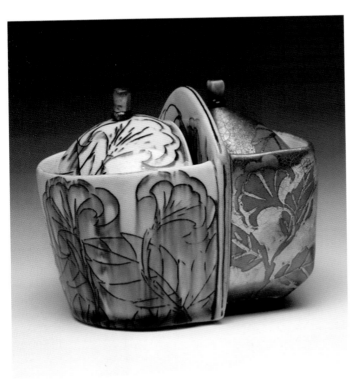

Inspired by the famed watercolors and prints of James Audubon, Julia Galloway spent several years working on a series of functional objects upon which she drew specific birds with gorgeous line quality and expert craftsmanship. On her *Scissor-Tailed Flycatcher Pitcher*, Galloway takes advantage of the greatest assets her ceramic materials afford, exemplifying the elegantly seductive forms with luscious and ornate decoration. With an impeccably fastidious hand, she brings the bird's character to life, situating it among a field of flowing botanical motifs and paired with a romantic lattice pattern that references a gate or fence, providing an environment for the bird to rest in. Galloway produces beautiful objects that carry a sense of lyricism and engender joyous and pleasurable experiences in their use.

Salt and Pepper Pot *5 × 3 × 4 in. (13 × 8 × 10 cm), porcelain, interior: white liner glaze; left: clear chartreuse base over inlaid blue slip; right: Some Bright Green, soda fired to cone 5, gold luster, fired to cone 018.* SEE SLIP AND GLAZE DETAILS, BELOW.

SLIP AND GLAZE DETAILS

KOKE WHITE LINER GLAZE, *cone 5–6*
Leslie Ceramics Koke 1105

BLUE SLIP, *cone 5*
Porcelain slip made from her clay body +10% Mazerine Blue stain (Mason 6388 CoSi)

FLASHING SLIP (parts), *cone 5*

Tile#6 kaolin	8
Grolleg	1
Whiting	1

SOME BRIGHT GREEN, *cone 5*
This recipe is from Jeff Oestreich

Custer feldspar	42
Whiting	7
Strontium carbonate	33
Zinc oxide	8
Ball clay	10
+ Copper carbonate	3
+ Red iron oxide	2
+ Rutile	2

CLEAR CHARTREUSE BASE, *cone 2–5*

Nepheline syenite	23
Lithium carbonate	11
Whiting	23
Frit 3124	9
Ball clay	3
Flint	31

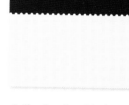

● *Blue lines from inlaid cobalt blue give crisp imagery with historical references.*

◁ **Technical Description**

In the greenware state, the image of the bird and foliage are carved into the clay with an X-Acto knife. A blue slip is brushed into the lines and the excess is wiped off with a sponge. That area is covered with wax and the rest of the piece is dipped into the flashing slip. The inside is glazed with Koke White liner glaze. Pieces are fired in a soda kiln to cone 5.

Scissor-Tailed Flycatcher Pitcher *7 × 5 × 16 in. (18 × 13 × 41 cm), porcelain, commercial liner glaze, inlaid blue slip, flashing slip, clear glaze, soda fired to cone 5.* SEE SLIP AND GLAZE DETAILS, LEFT.

Adam Frew

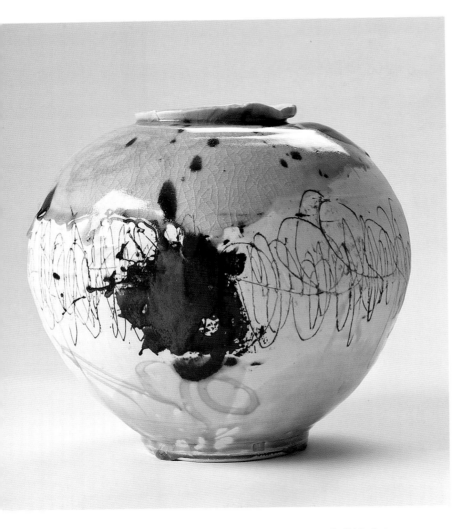

Adam Frew's fluid porcelain pottery takes inspiration from traditional Eastern ceramics. Frew's practice is driven by process and an intimate responsiveness to the material. On the wheel, his work is pushed to the limits of form holding. He marks the clay with spontaneous scribbles and drips, bringing an emotional charge to the work. The mark making is coated in a viscous celadon glaze, with a drippy translucency that enhances the idiosyncratic expressions.

Technical Description

Frew decorates his wheel-thrown porcelain pieces using colored slips that are brushed on and inlaid in the greenware state. After bisque firing, the celadon glaze is thickly applied. A long and hot glaze firing up to cone 10 (2,370°F/1,300°C) is important to achieve the thick and drippy surface effects. Frew has experimented with a variety of firing conditions, with each affecting the color and quality of the glaze. It is important to fire in reduction in order to achieve the cool blue tone on these pieces.

GLAZE DETAILS

BLUE CELADON, *cone 10*

Potash feldspar	42
Whiting	10
Zinc oxide	6
Dolomite	5
Talc	2
Kaolin	2
Bentonite	1
Flint	30
Red iron oxide	1–2

Note: The glaze used on the Small Bowl contains 1% red iron oxide; the glaze used on the Scribble Pot contains 2% red iron oxide.

Scribble Pot
20 × 20 × 20 in. (50 × 50 × 50 cm), thrown porcelain, inlaid drawing with cobalt and red slip, thick celadon glaze with copper red splash, fired in reduction to cone 10.
SEE GLAZE DETAILS, LEFT.

> I am fairly restrained in my color palette. I want to create simple, bold pieces that are expressive.

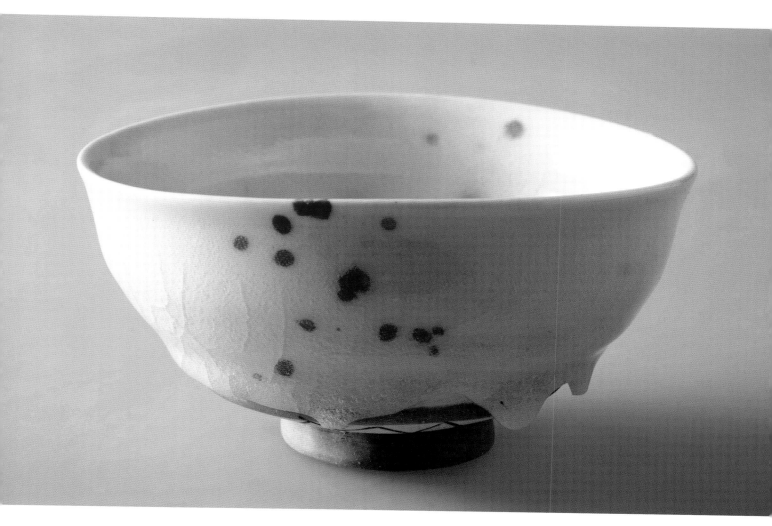

Small Bowl *4 × 6 × 6 in. (10 × 15 × 15 cm), white porcelain and cobalt slip with red slip splash under blue celadon glaze, fired in reduction to cone 10. SEE GLAZE DETAILS, LEFT.*

● *The celedon glaze is luscious and drippy, like icicles or frosting.*

● *The blue is interrupted and punctuated by drips of intense red, adding a complementary color relationship that accentuates the provocative marks.*

● *Scribbles of color contrast with the fluid and soft forms.*

Bryan Hopkins

Bryan Hopkins' sleek utilitarian vessels combine the refined whites of porcelain and crisp celadon blues, to exemplify simple beauty in form and surface. With ready-made textures from particleboard, concrete, and weathered machine structures, Hopkins creates a calculated comingling between the raw, industrial impressions and the precise, clean craftsmanship of the hand in each piece. With a nod to the austere history of prized Song dynasty celadons and Ding ware, his works combine relevance in the contemporary landscape with the beauty of celadon traditions.

Toast Rack *7¹/₂ × 3 × 3¹/₂ in. (19 × 8 × 9 cm), wheel-thrown and altered porcelain, Hopkins Clear #13 glaze, fired to cone 11 in reduction. SEE GLAZE DETAILS, BELOW.*

HOPKINS CLEAR #13, *cone 11*	
Custer feldspar	43
Silica	32
Grolleg kaolin	15
Whiting	10
+ Bentonite	2

HOPKINS CLEAR #7, *cone 11*	
Custer feldspar	45
Silica	25
Grolleg kaolin	15
Whiting	15
+ Bentonite	3

Note: These glazes are to be used with #257 Porcelain made by Standard Ceramic Supply in the U.S.A.

> ❝ My approach to research for these glazes was fairly intuitive. My current glaze palette was arrived at after many years of stripping away color. ❞

Vase *14 × 8 × 5¹/₂ in. (35.5 × 20 × 14 cm), wheel-thrown and altered porcelain, Hopkins Clear #7 glaze, fired to cone 11 in reduction.* SEE GLAZE DETAILS, LEFT.

Technical Description

Hopkins mixes his glazes to the consistency of whole milk (slightly thinner than average) with very hot water and then ball mills them for an hour to achieve a smooth fired surface. If a ball mill is not available, screening three times with a 120-mesh screen will suffice. Wax is used to mask off unglazed areas, and pieces are glazed by dipping. Hopkins utilizes a meticulous firing process, which involves using an oxyprobe to achieve a long, rising body reduction as well as a later glaze reduction. While most celadons have small additions of iron to achieve blue in a reduction atmosphere, this cycle is designed to draw out the slightest impurities in his body and glaze, creating delicate, pale blues.

● *Celadon blue is derived from the slightest impurities of iron in Hopkins' clay and glaze.*

● *The white of the porcelain is cool and crisp.*

● *The simple coloration in white and pale blue accentuates the minimalist approach.*

Annabeth Rosen

Like all of Annabeth Rosen's work, the precarious and powerful sculpture *Wave* astounds with its unapologetic materiality and energetic expression. The sensation of a rolling wave of water is created by the accumulation of abstract shapes, densely and flowingly stacked into a bulbous arc. The forms appear to be hurtling through space, threatening collapse as their combined mass juts outward. However, the tension is tempered by a kind of playful exuberance and sense of wonderment, as they also seem to defy gravity, floating like a cloud of swirling blue and white——or a porcelain factory caught in the whorl of a tornado. Each object carries an expressive spiral of deep cobalt blue, bringing to mind the history of its valuable and prolific use, while emphasizing the passionate mark making of the artist. The rhythmic momentum of the work feels frozen in time, much like the cascading swirls that are captured in the glassy matrix.

Technical Description

In the greenware state, a thick layer of clear glaze is applied to each individual piece with a hake brush. When the glaze dries, a wash of cobalt carbonate mixed with a small amount of fritted cobalt and CMC gum solution is brushed in a spiral pattern around the piece. Fired to cone 5, pieces are then reglazed and refired two more times. Multiple firings achieve a more fluid surface. Each object is placed on stilts on kiln shelves lightly sprinkled with silica to catch drips. After firing, pieces are assembled with baling wire onto a steel frame.

> After a lifetime of ceramics, the things I know about glaze and glazing are sub-cellular. It is difficult to differentiate between educated, experimental, and intuitive knowledge. Glaze work must be convincing and contemporary, organic and true.

GLAZE DETAILS

CLEAR GLAZE, *cone 5*

Base glaze mix (see below)	80
Lead silica frit	10
Silica	10
+ CMC gum (added as needed)	

BASE GLAZE
This recipe is from Cathleen Elliot. Rosen mixes it dry and uses it as the base of all her glazes.

Gerstley borate	75
EPK	25

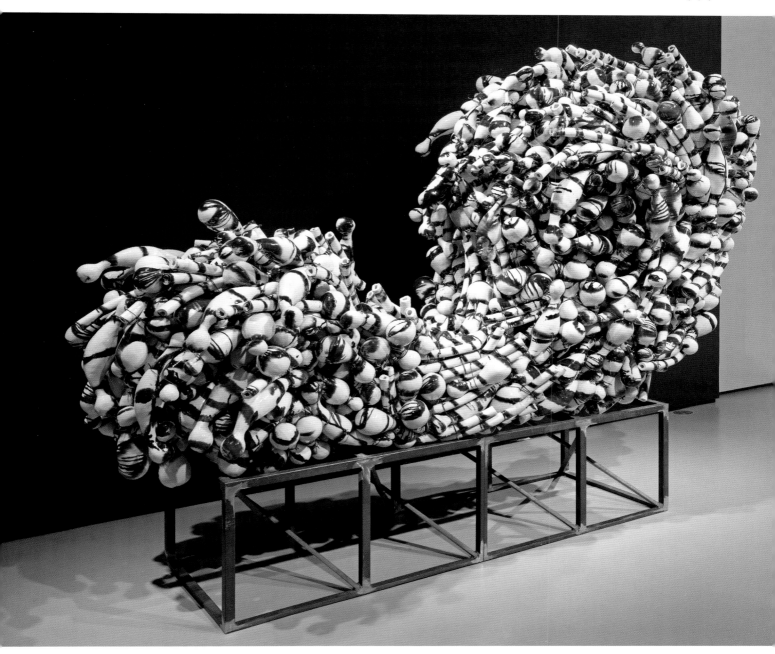

Wave *72 × 90 × 59 in.*
(183 × 229 × 150 cm),
white mid-range clay body,
glazed, cobalt wash, fired
to cone 5, steel base, baling
wire. SEE GLAZE DETAILS, LEFT.

● *Cobalt blue carries vast historical*
significance and reminds us of the
proliferation of blue-and-white wares
originating in China.

Giselle Hicks

American-born Giselle Hicks creates elegant tile vignettes with delicate inlaid decorations that reference the rich traditions of Western ornamentation and textile design. While the cobalt blue and porcelain combination is inevitably associated with the history of blue and white in ceramics, Giselle's interests lie more in the subtle softness of her pale color palette. The muted blue tones and sensual whites have an emotional presence, and her pillowy tile forms, like folded linens, speak to a domestic landscape. With a captivating tactile quality, the sugary glaze moves and blurs the meticulously crafted decoration, suggesting foggy memories of "home," just out of reach.

Technical Description

These pieces are created using molding techniques, with pinched floral elements added later. The surface decoration is crafted using a technique called mishima, which involves inlaying a blue underglaze into leather-hard to bone-dry clay. The Sugar Crackle glaze is dipped or poured onto bisqueware, with close attention paid to thickness (thicker applications cause more distortion of the decoration). The pieces are then electric fired to cone 1 (2,110°F/1,154°C) with a 10-minute hold and a slow cool cycle (200°F/93°C per hour to 1,950°F/1,066°C, then 110°F/43°C per hour to 1,600°F/870°C) to encourage crystalline growth in the glaze. If fast fired, the glaze will be glossy. Hicks uses a cone 4 white clay body and has had success with this glaze on a cone 6 commercial porcelain as well.

Horizontal Tiles with Flowers
31 × 16 × 2¹/₂ in. (79 × 41 × 6 cm), white mid-range clay, inlaid blue underglaze, Sugar Crackle glaze, fired to cone 1 with slow cool. SEE GLAZE DETAILS, BELOW.

GLAZE DETAILS

SUGAR CRACKLE GLAZE, cone 3–4	
Frit 3124	25.7
Frit 3134	5.0
Whiting	20.2
Spodumene	15.0
Soda ash	9.5
Zinc oxide	3.7
EPK	20.2
Flint	0.6

BLUE UNDERGLAZE	
Delft Blue stain (Mason 6320 CoAlSiSnZn)	64
EPK	32
Gerstley borate	4

Note: This recipe is approximate and Hicks adds ingredients by eye.

> **I wanted a glaze that distorted the pattern some to create a depth of surface and perhaps make the surface look old and worn. I am inspired by textiles and wanted to make the ceramic tiles look soft and aged.**

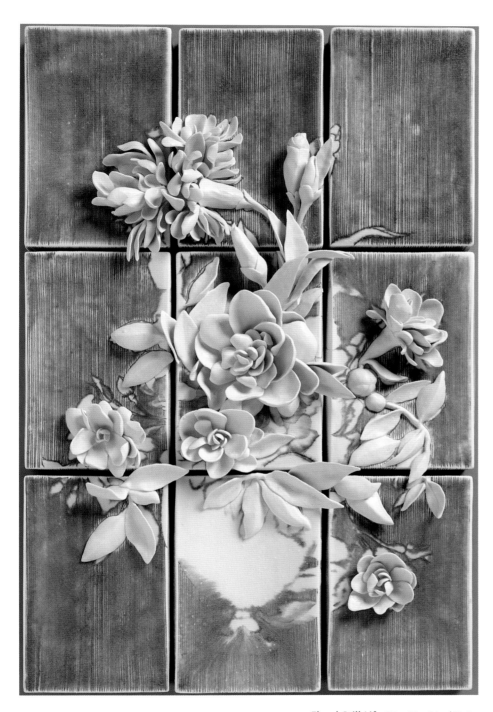

- Bright blue is softened under the sugary glaze, adding depth and a sense of age to the surface.
- The blue lines bleed and blend to varying degrees based on the thickness of the glaze.
- The color combination feels classic and elegant.

Floral Still Life *27 × 18 × 3 in. (68.5 × 46 × 8 cm), white mid-range clay, inlaid blue underglaze, modeled flowers, Sugar Crackle glaze, fired to cone 1 with slow cool. SEE GLAZE DETAILS, LEFT.*

Erin Furimsky

Erin Furimsky is an American artist whose intimate, amorphous forms invite the touch. With a skin of soft, satin glaze, familiar curves of the body are abstracted and nestled together, while layered swatches of floral motifs pattern the surface, creating a delicate patchwork moving into and around the bulbous shapes. The cool blue color palette and the prim decoration temper the fleshy sensuality, evoking a sense of innocence and sweetness in the abstractions.

Technical Description

Colored shapes are silhouetted onto the leather-hard clay using underglaze and paper stencils, and the underglazed areas are painted over with a thin layer of clear satin glaze. The blue satin matte glaze is applied either with a brush or sprayed on in three layers and then fired to cone 5½ in a slow firing with a slow ramp down. To determine the proper thickness of the sprayed glaze, food coloring is added to the glaze for the second coat and then a different color added to the third. The food coloring works as a visual reference to identify where you have glazed and does not alter the glaze results. After the glaze firing, decals are applied and the piece is fired again to cone 018.

> “ Flowers, newborn clothing, decadent pastries, and Mentos candies: grandmother's china placed on doilies, My Little Ponies, and beautifully designed couture dresses—all revel in soft and sometimes sedately saturated pastels. The colors that cover my work become a flirtatious whisper that beckons you to come closer. ”

GLAZE DETAILS

UNDERGLAZES
Chocolate Brown (Amaco Velvet V-314)
Medium Blue (Amaco Velvet V-326)

CLEAR SATIN GLAZE, *cone 5–6*
Amaco High Fire HF-12

LOW-EXPANSION SATIN MATTE GLAZE 1 (LESM1), *cone 5¹/₂*

Nepheline syenite	31
Frit 3124	16
Kaolin	32
Dolomite	18
Zinc oxide	1
Quartz	2
+ Willow Blue stain (Mason 6360 CoAlSiCrSn)	0.5
+ Bentonite	2

Adding 2% Bentonite will help with any setting of the materials.

Note: This recipe is from Mike Bailey's book, Glazes Cone 5–6. Furimsky used Frit 3124 as an adaptation, when it was suggested to use a low-expansion frit. It is a high-alumina satin matte glaze. In addition to a dense stoneware clay body, this glaze fits a porcelain body well, and would be a brighter shade of blue.

● *Baby blue adds to the softness of the gentle shapes.*

● *Various shades of blues in decals keep decoration cohesive through several processes.*

● *Brown adds depth and focus to the center, while linear links of blue decoration lead the eye around the piece.*

Equate *18 × 8 × 6 in. (46 × 20 × 15 cm), hand-built stoneware, stenciled underglaze, sprayed and trailed glazes, fired in oxidation to cone 5½, decals fired to cone 018.*
SEE GLAZE DETAILS, LEFT.

Shoko Teruyama

The decorative floral surface of soft greens, yellows, and baby blues reveals peeks of the warm red clay through the tiny sgraffito markings, bringing a gentle quietness to the functional pieces of Shoko Teruyama. Her *Turtle Candleholders* are intended to represent the nature of turtles carrying something with them, be it their homes, a candle, or, as in some mythologies, the weight of the world. In the format of traditional Dutch tulipieres, Teruyama's lyrical flower vase is topped with a sweet and unassuming turtle and playful bird forms. The statuesque animals have a stylized, childlike innocence, with soft round edges making the objects comforting and approachable.

Turtle Candleholders
5 × 7 × 4 in. (13 × 18 × 10 cm) each, hand-built red earthenware, white slip, sgraffito decoration, fired to cone 04. Glaze fired to cone 05. SEE GLAZE DETAILS, BELOW.

Tulipiere *15 × 10 × 10 in. (38 × 25 × 25 cm), hand-built red earthenware, white slip, sgraffito decoration, fired to cone 04. Glaze fired to cone 05. SEE GLAZE DETAILS, BELOW.*

GLAZE DETAILS

GLOSS CLEAR BASE GLAZE, *cone 04*

Gerstley borate	55
EPK	30
Flint	15

Yellow Green
+ 4% Copper carbonate
+ 3% Rutile

Blue
+ 1% Cobalt carbonate

Light blue
+ 4% Turquoise in-glaze color (Cerdec 741 series 127416)

Red/pink
+ 4% Intense Red inclusion stain (Cerdec-Degussa 279646)

Purple
+ 4% Violet stain (Mason 6304 CrSnSi)

JACQUIE'S MATTE PALE GREEN, *cone 04*

Gerstley borate	38
Lithium carbonate	10
Nepheline syenite	5
EPK	5
Flint	42
+ Bentonite	1
+ Chrome oxide	0.25

● *Pastel colors add a sense of softness and delicacy to the pieces.*

● *Analogous tones of blues, greens, and yellows flatten the contrast so no area draws more attention, allowing the eyes to keep moving.*

● *The scrolling floral decoration wraps around the forms, revealing the red clay beneath and accents of soft pinks on the flowers. This adds a sense of comfort, along with hints of warmth to complement the soft, cool hues.*

Technical Description

At the leather-hard stage, Teruyama's red earthenware pieces are brushed with white slip. Once bone dry, the imagery is carefully scratched through the slip with an X-Acto knife and then bisque fired to cone 04. Using a gloss or a matte base, different colors are achieved by mixing 3–7 percent of different Mason stains. Glazes are mixed to the consistency of yogurt for the more saturated colors and watered down when lighter tones are needed. A watery layer of clear glaze is applied over the entire piece before any colors are added, which helps keep the glaze from crawling away from the scratched design. Pieces are then fired to cone 05 in an electric kiln.

Wouter Dam

Retaining the fluidity of the wheel, Wouter Dam's paper-thin vessel forms are altered and collaged to gently curve in and around each other, as if making tangible the sweeping lines of a dancing figure. Although several weeks are needed to finish each piece, the speed and ease of the initial assembly can happen in as little as 15 minutes, bringing vitality to the form with a freshness and lightness that pervades the space. The soft, suede-like surfaces seem to abandon their materiality, creating a floating sensation as if the forms were made of color itself. Weightless and spirited, the color resonates with a vibrancy that is the soul of the work.

Light Blue Sculpture
12 × 11¹/₂ × 12¹/₂ in. (30 × 29 × 32 cm), thrown and assembled stoneware, colored engobe, fired to cone 5 in oxidation. SEE ENGOBE DETAILS, BELOW.

Technical Description

Dam's delicately thrown and altered sculptures are bisque fired and then sprayed with a thin layer of colored engobe. Carefully leaving a few spots bare for handling, the piece is placed in the electric kiln and fired to cone 5. While still warm from the firing process, the pieces are sprayed again with the engobe and fired once more to cone 5. Dam says that each piece is always fired at least twice and sometimes three times to achieve the preferred outcome.

ENGOBE DETAILS

LIGHT BLUE ENGOBE/SLIP, *cone 5*	
Kaolin	62.5
SG1800 alkaline transparent glaze	22.5
Turquoise glaze stain (Johnson Matthey 14N144)	10.0
Tin oxide	5.0

GREEN ENGOBE/SLIP, *cone 5*	
Westerwald semibold ball clay	40
SG1800 alkaline transparent glaze	25
Green body stain (Rhenania F-4049)	32
Blue body stain (Johnson Matthey 10BS510.A)	3

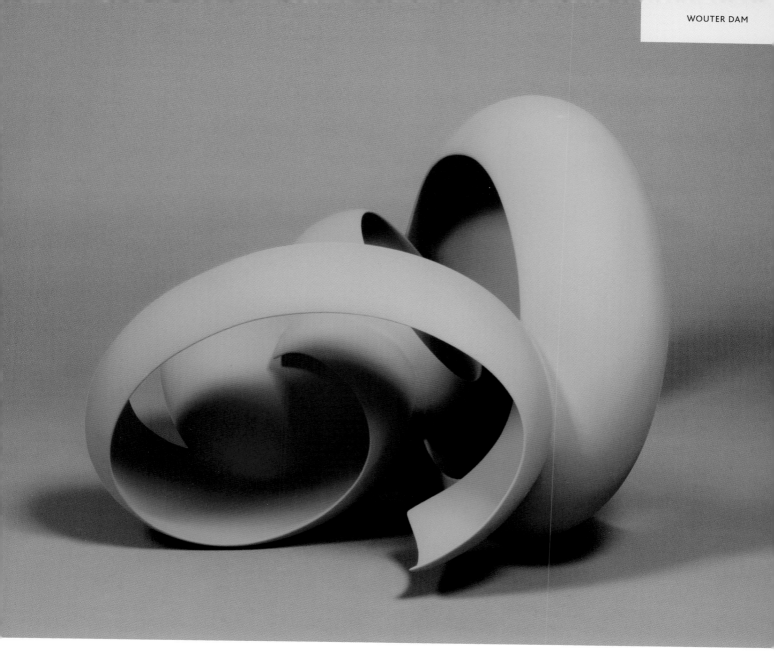

Green Sculpture *10½ × 11 × 12 in. (27 × 28 × 30 cm), thrown and assembled stoneware, colored engobe, fired to cone 5 in oxidation.* SEE ENGOBE DETAILS, LEFT.

❝ My work has developed over time from vases and bowls to fully sculptural shapes: in a sense they are deconstructed ceramic shapes with the classical shapes they originated from still tangible. ❞

● *The soft, matte surfaces allow shadows to play a role in these dynamic pieces.*

● *Dam's use of solid, uniform colors deliberately focuses our attention on the form.*

Timothy Berg and Rebekah Myers

Whether painted or glazed, ceramic or not, the works of Timothy Berg and Rebekah Myers are intended to look as if the color on the surface is not just a skin, but the material throughout the object. Utilizing familiar icons, this tongue-in-cheek *trompe l'oeil* effect is not intended to create realistic-looking objects, but rather to provoke a critique of our standards of value by rendering the materiality of the toys and souvenirs with trickery. In their piece *For All It's Worth,* the playful sculpture looks at the multifaceted ways in which humans value nature. From the actual, yet humorously oversized, wooden caliper, to the ceramic bonsai tree tchotchke, to the plasticky toy firewood stack, the way in which these "wooden" items are valued psychologically is brought into question.

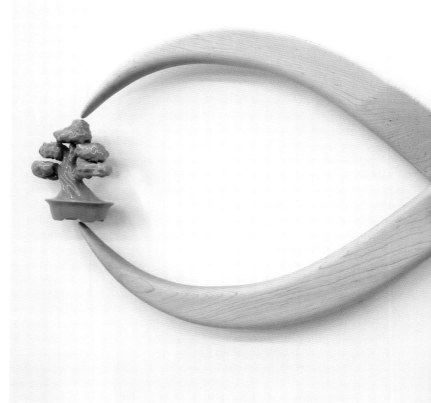

GREEN GLAZE, *cone 06*
Mayco Foundations Opaque
FN-007

Technical Description

After bisque firing, the slip-cast earthenware pieces are glazed with two poured coats and glaze fired to cone 06. To assure an opaque surface, the pieces are glazed once more and refired to cone 06.

> ❝ Oftentimes in our work it is difficult to distinguish between a fiberglass painted object, a ceramic painted object, and a ceramic glazed object. We like the play between the inherent and perceived value of those materials. ❞

- *Color here is used as a distinct signifier of the identity of the object.*
- *Green signifies the live tree, while brown signifies chopped wood.*
- *The glossy, commercial green glaze references manufactured token figurines, not only in origin but also in esthetic.*

For All It's Worth *52 × 24 × 5 in. (132 × 61 × 13 cm), Maple, slip-cast earthenware tree, glaze fired to cone 06, slip-cast, colored cone 6 porcelain logs, cast iron hardware.* SEE GLAZE DETAILS, LEFT.

Jeff Campana

Jeff Campana's subdued yet luscious glazes underscore the exacting and delicate attention given during the construction of each piece. The sweeping, crisp seam lines created by dissecting and reassembling the form act as decoration, but also imply structural fragility. Once the translucent glaze relaxes in the firing, it coats the sleek forms with a smooth, almost opalescent sheen and pools in the seams, highlighting them esthetically and reinforcing them structurally. Campana's unique process adds intrigue to the carefully crafted vessels without sacrificing their well-designed functionality.

Green Lotus Bowl *6 × 6 × 4 in. (15 × 15 × 10 cm), thrown, dissected, and reassembled mid-range porcelain, green glazes, fired to cone 6 in an electric kiln. SEE GLAZE DETAILS, BELOW.*

Green Leaf Planter *8 × 8 × 5 in. (20 × 20 × 13 cm), thrown, dissected, and reassembled mid-range porcelain, green glazes, fired to cone 6 in an electric kiln. SEE GLAZE DETAILS, BELOW.*

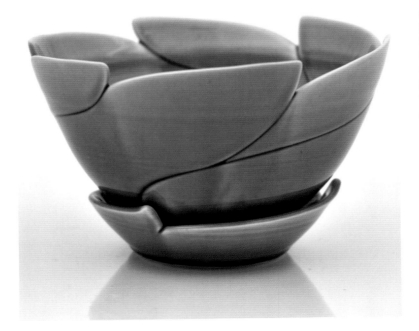

Technical Description

After bisque firing, interiors are first poured with clear base glaze which is then quickly dumped out. Immediately after, the piece is dipped upside down until three-quarters of the piece is glazed in the bright green glaze. Once the glaze dries, wax is brushed onto the glazed area, tracing closely to visible seam lines in the form. Once the wax dries the exposed glaze is sponged off and the piece is left to dry for a day. The final step is to dip the bottom of the piece into the drab green glaze (same base glaze) and clean the foot. Pieces are then fired to cone 6 (2,214°F/1,212°C) with no hold.

GLAZE DETAILS

CAMPANA CLEAR BASE, cone 6	
Spodumene	13
Frit 3134	21
Wollastonite	20
EPK	20
Silica	18
Zinc oxide	8

Bright Green
+ 1.6% Copper carbonate
+ 1% Red iron oxide

Drab Green
+ 1% Red iron oxide
+ 1.4% Copper carbonate
+ 0.05% Cobalt carbonate

Lines on the exterior coincide with lines found inside, as each line is in fact a seam, a scar where it was once severed. Though these seams imply fragility, pooling glazes seal and strengthen the ware.

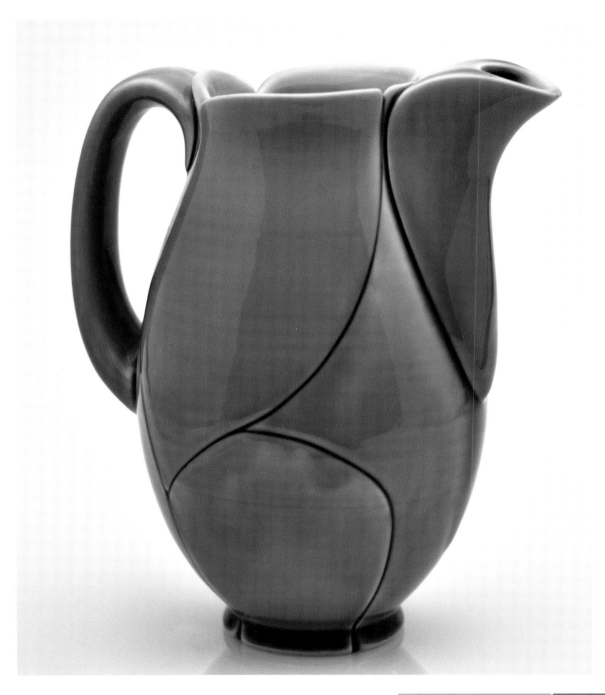

Green Leaf Pitcher *6 × 6 × 9 in. (15 × 15 × 23 cm), thrown, dissected, and reassembled mid-range porcelain, green glazes, fired to cone 6 in an electric kiln. SEE GLAZE DETAILS, LEFT.*

● *Crisp and translucent, the bright green subtly fading into drab green adds to the feeling of fluidity in the piece.*

● *Simple, smooth glazes that pool into the seams highlight the lines of the form, allowing their structure to become the focus.*

Jason Green

Jason Green generates precise, geometric tiles that reference the passage of time, from their fragmented architectural structure, to the layering of historically sourced patterns, to the phenomenon of moving glaze that is captured during the firing. His expert use of running and crazing glazes adds a sense of chance to the systematic patterns, fracturing and pulling the graphic black lines. Like optical illusions that blur the boundaries between 2D and 3D, Green's tiles evoke an awakening of our perceptive sensibilities and challenge us to reconsider our relationship with place and time.

Persistence of Illusion: Penrose on Cairo *14³/₄ × 29¹/₄ × 3 in. (37 × 74 × 8 cm), watershed terra-cotta, slip, Light Green, Cobalt Blue, Dark Cobalt Blue, and Water Blue glazes, fired to cone 04. SEE SLIP AND GLAZE DETAILS, BELOW.*

Technical Description

Green's terra-cotta press-molded tiles are intricately layered with patterns of slip and glaze. Using an image projected onto the greenware tiles, layers of white slip and then white and black underglazes are brushed on. Pieces are bisque fired to cone 06 and glazes are applied with a brush in three coats. His tiles are fired vertically with a program that encourages the glazes to move and drag colors from the layered slips and glazes (holding at the peak temperature, 1,926°F/1,052°C for 30 minutes and down-firing at 150°F/65°C per hour to 1,828°F/998°C).

Persistence of Illusion: Cubed

No. 2 *14³/₄ × 29¹/₄ × 3 in. (36 × 74 × 8 cm), terra-cotta, slip, Iron Yellow, Cobalt Blue, Water Blue, and Light Green glazes, fired vertically to cone 04. SEE SLIP AND GLAZE DETAILS, BELOW.*

SLIP AND GLAZE DETAILS

WALTER OSTROM BASIC WHITE SLIP, *cone 04*
For wet to leather-hard application

Talc	30
OM#4 ball clay	45
Calcined kaolin	15
Frit 3124	10

UNDERGLAZES
White (Amaco LUG-10)
Black (Amaco LUG-1)

PARSONS GLOSSY BASE, *cone 04*

Gerstley borate	26
Nepheline syenite	20
Frit 3124	30
Lithium carbonate	4
EPK	10
Flint	10
+ Veegum	2
+ CMC gum	1

A-23 Iron Yellow
+ 4% Red iron oxide
+ 2% Praseodymium Yellow stain (Mason 6450 PrZrSi)

A-22 Water Blue
+ 2% Copper carbonate
+ 2% Praseodymium Yellow stain (Mason 6450 PrZrSi)

PG E Light Green
+ 4% Victoria Green stain (Mason 6263 CrCaSiZr)

PG F Dark Cobalt Blue
+ 2% Cobalt carbonate

PG G Cobalt Blue
+ 0.5% Cobalt carbonate

Note: Veegum (for brushability) and CMC gum (to harden the glaze surface before firing) need to be added to the glaze after first being blunged in hot water. To keep his measurements accurate, Green uses a ratio of 1 g CMC gum or Veegum to 19 g water, so for every gram needed in his glaze, he measures out 20 g of the mixed solution.

66 The glaze phenomena that emerge during the firing process—such as the mixing of color, the drips and runs, and the crazing—allow a certain amount of chance into the process while also having a reference to time. 99

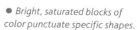

● Bright, saturated blocks of color punctuate specific shapes.
● Graphic black and white slip creates striking visual patterns.

● Glaze movement activates color blending, creating more color variations.
● Analogous colors (yellow, green, and blue) create a harmonious palette.

Daniel Bare

Precarious stacks of discarded commercial dishware, tchotchkes, and the like, are defaced and bonded together with thick layers of molten glaze, in the politically charged works of American artist Daniel Bare. Collected from thrift stores, landfills, and abandoned kiln sites, Bare compiles objects that are no longer valued into monumental symbols of waste that expose the gluttonous tendencies of our consumer culture. In the kiln, Bare prompts the material itself to reclaim the ubiquitous objects, bringing them to the brink of collapse, as they shift, slump, and melt under the extreme heat. The colorful clay and glazes ooze, cascade, and pool around the forms. Thus, the habitual process of disposal is successfully intercepted, and the resulting works have a renewed sense of purpose.

Technical Description

Bare begins by stacking ceramic saggars inside the kiln, designed to contain parts of his sculpture and also protect the kiln from toppling pieces during the firing. He puts a layer of sand or kaolin inside the bottom of the saggar, which helps stabilize the work and also catches the running glaze before it reaches the kiln floor or shelves. The parts are carefully stacked inside the saggar and held together with nichrome wire, which withstands the firing and becomes a linear element in the finished piece. Casting slip is then dripped over the top of the work and glazes are applied. Watery glaze is dripped or squirted with a glaze bulb to reach difficult places, while extremely thick glazes are applied using his "glopping" technique with a spatula or gloved hand. Once the glaze application is complete, the piece is fired to cone 6 with a standard 6–8-hour firing. Bare cools the kiln very slowly and is careful to not open the kiln too early.

> " I chose this glaze for its ability to physically add dimension to surface as well as alter the overall form. The physical glazing process is like a decaying house returning to the earth. "

GLAZE DETAILS

FLUXING CLAY MATTE GLAZE,
cone 5–6

Nepheline syenite	41.7
EPK	16.7
Wollastonite	16.7
Talc	16.7
Gerstley borate	4.2
Lithium carbonate	4.0

White
+ 10% Zircopax Plus

Light Blueish-greens
+ 0.25–0.75% Copper carbonate

Chartreuse
+ 5–10% Chartreuse stain (Mason 6236 ZrVSnTi)

Light Greens
+ 5–10% Victoria Green stain (Mason 6263 CrCaSiZr)

Blues
+ 0.25–3% Cobalt carbonate

Oranges
+ 5–8% Tangerine stain (Mason 6027 ZrSeCdSi)

Note: Adding 5–10% Zircopax Plus will turn the glaze matte. For a shinier surface, add less or no Zircopax Plus; for a more matte surface, add more Zircopax Plus. Increased Zircopax Plus means the glaze will be whiter and more opaque. When colorants are added, increasing the Zircopax Plus will make the colors more pastel and matte.

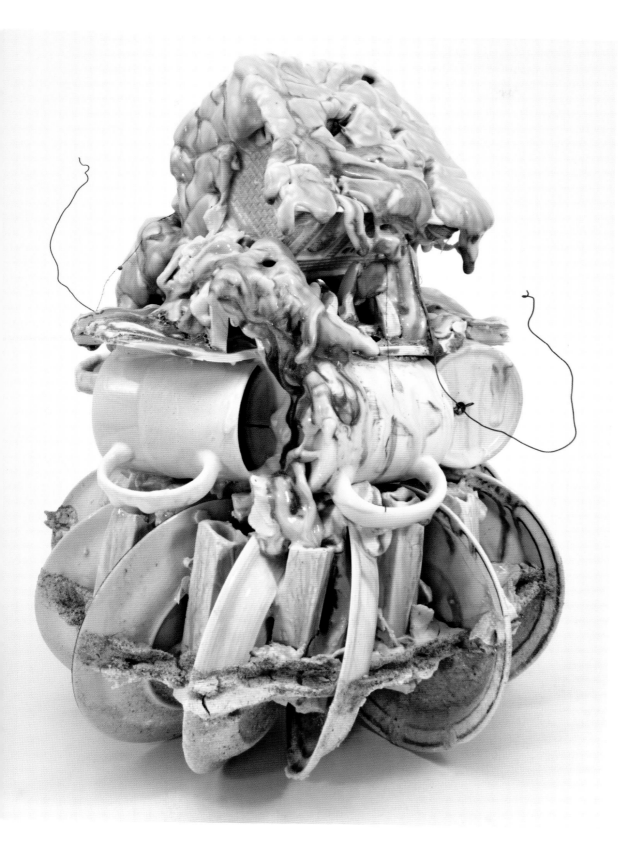

• *The cloaking green-to-blue glaze material looks like moss, mold, or algae oozing over the form.*

• *Color becomes deeper and more rich as the glaze pools and forms drips.*

• *Multiple colors keep the viewer's eyes moving around the piece.*

Envelop (Re/Claim Series) *16 × 14 × 14 in. (41 × 35.5 × 35.5 cm), post-consumer ceramic objects, porcelain, coarse grog, kyanite, nichrome wire, and glazes. SEE GLAZE DETAILS, LEFT.*

Anton Reijnders

In his series entitled *Nomen Nescio*, Latin for "I do not know the name," Anton Reijnders poetically combines familiar, symbolic forms. In a world that can be criticized for its misguided emphasis on efficiency and instant gratification, Reijnders offers viewers the opportunity to be astounded, and for their curiosity to carve a path to a deeper introspection. His use of color is deliberate; it is applied only when it adds to the content of the work. In the case of *Nomen Nescio 146*, the surface of the "tree" has a fleshy connotation, shifting the perception of the work's meaning.

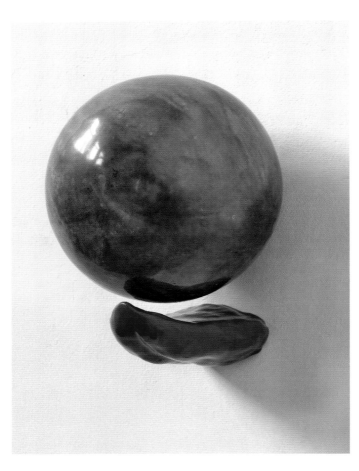

Sphere and Tongue *9¹/₂ × 7 × 7 in. (24 × 17 × 17 cm), press-modeled (sphere) and slip-cast (tongue) stoneware, once fired to cone 7 in oxidation. SEE GLAZE DETAILS, BELOW.*

66 I hope to create opportunities for reflection, concentration, and stillness. 99

GLAZE DETAILS

SPHERE GLAZE, *cone 7*

Frit 2495	25
Quartz	38
Aluminous ball clay	18
Whiting	9
Zinc oxide	4
Lithium carbonate	6

First glaze layer (three coats)
+ 11.5% Copper carbonate

Second glaze layer (two coats)
+ 7% Tin oxide

Note: To adhere to unfired clay works, add 1% CMC gum and 0.5% bentone EW or 2% bentonite. Water content approximately 50–60%.

TONGUE GLAZE, *cone 7*

Aluminous ball clay	30
Whiting	15
Quartz	30
Frit 2495	25
+ Pink glaze stain (Cerglas 113 CaSnSiCr)	30

Note: To adhere to unfired clay works, add 1% CMC gum (no bentone or bentonite is needed due to high clay content). Water content approximately 50–60%.

TREE GLAZE, *cone 7*

Kaolin	17.5
Whiting	40
Quartz	19
Nepheline syenite	17
Zinc oxide	4
Frit 3221	2.5
+ Rutile	2.5
+ Gray glaze stain (Cerglas 478 SnSbV)	4

Note: To adhere to high-bisque works, add 0.3% CMC gum and 0.2% bentone EW or 1% bentonite. Do not add more than 40–50% water.

● *Color is used decisively in order to add content to the work.*

● *The intense reflectiveness of the glossy green glaze brings a mirror-ball effect to the sphere form.*

● *The flesh-toned glaze on the branch form shifts the identity of the piece.*

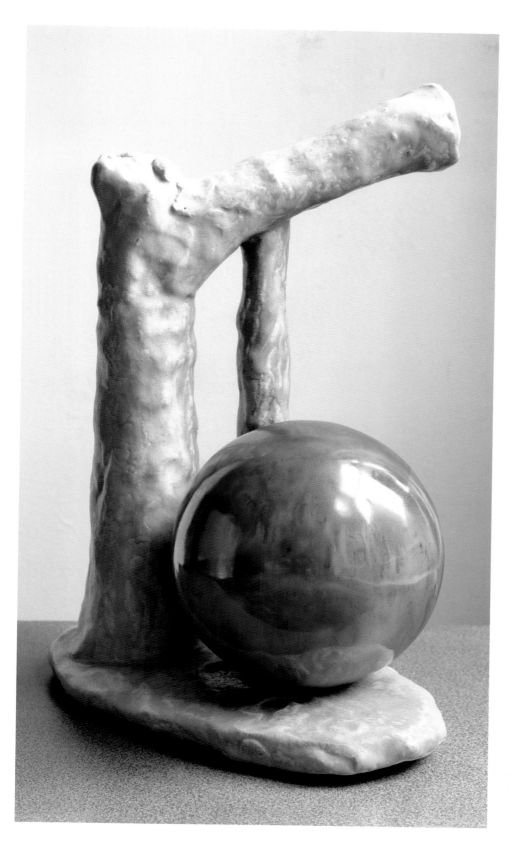

◁ **Technical Description**

For *Nomen Nescio 146*, Reijnders first fired the tree-shaped piece to cone 7, then added a very thin layer of black stain to the tree section, which turned the glaze atop a pink-red. Next the glaze was brushed on thickly, allowing for drips and unevenness. With the sphere, five coats of the glaze were applied, the first three using copper carbonate as a colorant and the last two using tin oxide as a colorant, with uneven coats allowing for greater color variations. The Tree glaze and Sphere glaze were fired to cone 7 with a slow ramp toward the end (140°F/60°C per hour). The Sphere glaze was once fired.

Nomen Nescio 146
13 × 10 × 6 in. (33 × 26 × 15 cm), modeled (tree) and press-molded (sphere). Tree high bisque fired; sphere once fired to cone 7 in oxidation. SEE GLAZE DETAILS, LEFT.

Susan Beiner

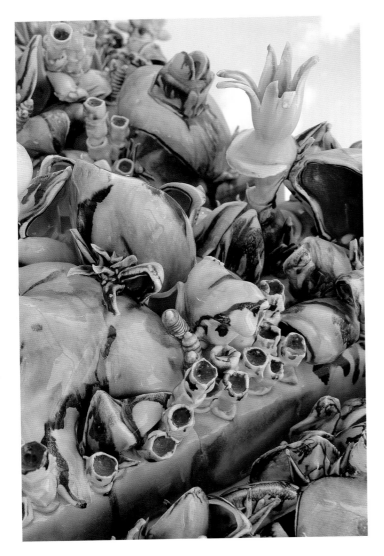

Susan Beiner's large wall installation is bursting with densely packed foliage and budding botanical forms. This piece, entitled *Synthetic Reality*, deals with the uncertain ramifications of biotechnology by inundating the viewer with indistinguishable hybrid flowers and unfurling plant growth. Glossy, translucent glazes in greens and yellows, with pops of pink, red, and black, bleed over a matte white background, creating contrasting textures and lavishly vivid colors that lead the eyes around the piece in a dizzying frenzy.

Technical Description

First, the cone 8 white glaze was sprayed over the entire piece. Next, Beiner utilized her palette of various high-fluxing colored glazes to layer on top by spraying, brushing, and using a bulb syringe for linework as well as getting into crevices. Wax is used to mask and additional matte glazes are used in other areas to add depth to the texture. The work was fired to cone 6 in a gas kiln with light reduction, which left the cone 8 base glaze dry and capable of absorbing the drippy layers of glaze on top, keeping them from running off the form.

Synthetic Reality

(*detail*). *SEE GLAZE DETAILS, BELOW.*

GLAZE DETAILS

CLEAR BASE, *cone 5–6*

Nepheline syenite	39
Gerstley borate	27
Whiting	8
EPK	8
Flint	18

COLORANT ADDITIONS

To achieve the myriad shades of green in her piece, Beiner uses variations from a line blend of greens, including:
Bermuda Green (Mason 6242 ZrVPrSi)
Chartreuse (Mason 6236 ZrVSnTi)
Victoria Green (Mason 6204 CrCaSiZr)
Turquoise (Mason 6288 ZrVCrCaSi)
Praseodymium Yellow (Mason 6450 PrZrSi)

WHITE GLAZE, *cone 8*

Soda feldspar	55
Gerstley borate	10
Whiting	8
Ultrox	15
EPK	6
Flint	6
+ Bentonite	3

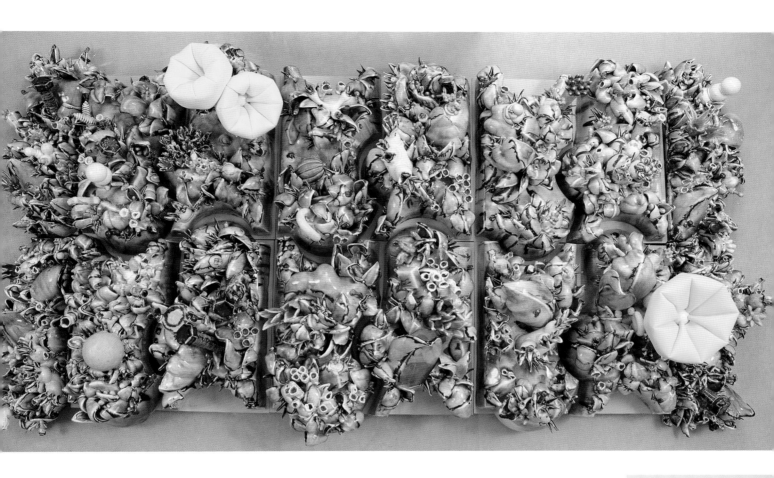

Synthetic Reality *74 × 48 × 8 in. (188 × 122 × 20 cm), porcelain, slip cast and assembled wet, foam, polyfil, multiple glazes. Gas fired to cone 6, mounted on wooden panels. SEE GLAZE DETAILS, LEFT.*

● *Beiner's glaze palette is drawn from nature with soft greens and yellows.*

● *The foliage is accented with pops of bright red that resemble blooming flowers or tentacles.*

Ashley Howard

Ashley Howard's eloquent works express reverence for tradition while allowing for intimate gestures and spontaneity to guide the forms and surfaces of his vessels. Steered by the spiritual and contemplative elements of ceremonial objects and the ways and spaces in which they can be placed, Howard views the pot as a theatrical object, imbued with life and meaning. The soft white dolomite glazes are the backdrop for rivulets of pearlescent yellows, while muted stains of blues and greens appear to emanate from far deeper than the material allows.

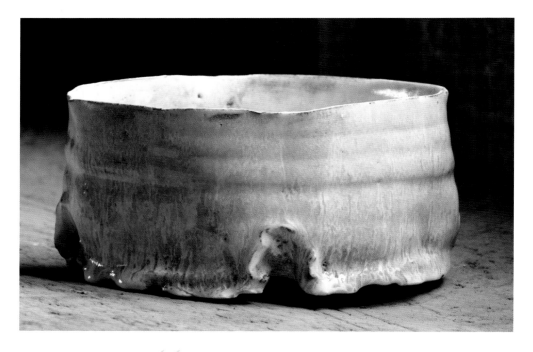

Stoneware Bowl *6 × 6 × 5 in. (15 × 15 × 13 cm), thrown and altered stoneware, porcelain slips, brushed-on dolomite matte glazes, fired to cone 9.*
SEE GLAZE DETAILS, BELOW.

66 The glazes give a sense of flow to the color. Colors respond to these glazes by highlighting their natural tendency to flow and give movement to the piece. 99

DOLOMITE MATTE, *cone 9*

Potash feldspar	60
Dolomite	20
Kaolin	20

DOLOMITE SATIN MATTE, *cone 9*
This recipe is from Lucie Rie

Potash feldspar	62
Whiting	13
Dolomite	13
Kaolin	13

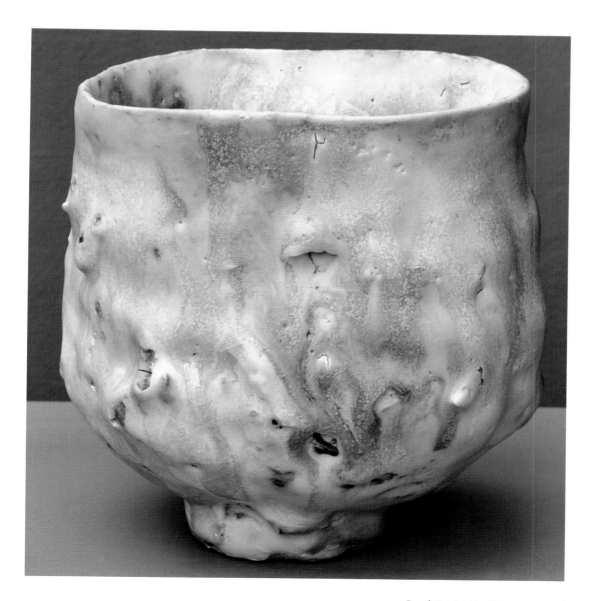

● *Hues of foliage create rivers of green across the landscape of the pots.*

● *A bright pop of yellow bleeds into the runs, while maintaining intensity, creating a focal point on the piece.*

● *Soft, creamy dolomite white acts as a carrier for the runny colors on the vessel.*

Technical Description △

At the leather-hard stage, Howard liberally brushes the form with one coat of porcelain slip, then a second coat that contains 3 percent copper carbonate is applied. After bisque firing, both dolomite glazes are applied with a large soft brush in a random manner, and fired to cone 9 (2,300°F/1,260°C) in an electric kiln. A second glaze firing to cone 017 (1,380°F/750°C) is required for the yellow on-glaze enamel.

Bowl *5 × 4 × 4 in. (13 × 10 × 10 cm), thrown and altered stoneware, copper carbonate porcelain slip, brushed-on dolomite matte glazes, fired to cone 9. Yellow on-glaze enamel rubbed into the surface and refired. SEE GLAZE DETAILS, LEFT.*

Claire Hedden

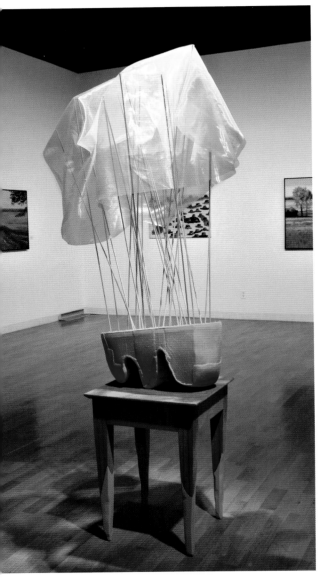

In her piece *Grazing*, which was inspired by bucolic landscapes, Claire Hedden explores the codependence of animals and the land by coupling ambiguous forms with familiar signifiers. The skin of the anthropomorphic form is soft and lush, alluding to moss or lichen that would grow atop a rock or a patch of green pasture, thus allowing color to play a primary role in defining the referential charge of the piece. The placement of the form in relation to the exquisitely crafted woodwork and fabric alludes to a domestic setting, further deepening the narrative. Though Hedden's sculptures are non-representational, they animate the space with an emotive charge and beget an empathetic response.

Technical Description ▷

Hedden sprays this vitreous slip on bisqueware in many layers, to build up texture and drips. Because the slip doesn't get very glassy, it can be applied to all sides of the piece, as it won't stick to the kiln shelf. After the desired coating is applied, the pieces are fired to cone 04 and assembled with wooden structures and fabric.

Fair *35 × 18 × 76 in. (89 × 46 × 193 cm), slab-built earthenware, sprayed with vitreous slip, tinted with Dark Red Mason stain, fired to cone 04, wood and fabric. SEE SLIP DETAILS, BELOW.*

SLIP DETAILS

VITREOUS SLIP, *cone 04*

OM#4 ball clay	25
EPK	25
Frit 3110/3124	20
Silica	20
Talc	10
+ CMC gum	0.5

Green
+ 2% Chromium oxide

Red
+ 6% Dark Red stain (Mason 6088 ZrSeCdSi)

66 The ceramic form is just one of the components of this piece... I find that each material, color, surface, and texture plays a role in creating a complex sculpture that is not complicated but rather straightforward and familiar. 99

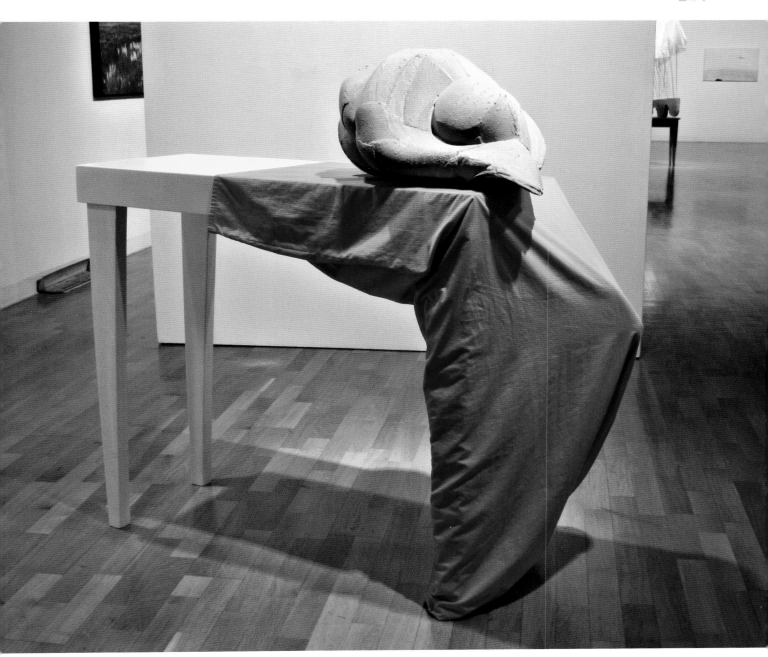

Grazing *49 × 18 × 46 in. (124 × 46 × 117 cm), slab-built earthenware, sprayed with vitreous slip tinted with chromium oxide, fired to cone 04, wood, fabric.* SEE SLIP DETAILS, LEFT.

● *The solid colors and matte surfaces add cohesiveness to the objects and allow the viewer to focus on form.*

● *The green alludes in a literal sense to bucolic pasture lands, as well as being an emotive signifier.*

Linda Lopez

Tangled, skeleton-like lines and a pile of drooping petals are arranged to create Linda Lopez's symbiotic still-life arrangements that feel both analytical and absurd. In her piece *And To Think It All Started With That*, Lopez uses color specifically for its ability to impart a personality to the clay objects. The carefully staged pair of objects is imbued with pale white and brilliant chartreuse, which helps direct the conversation that the forms have with one another, creating an open-ended storyline. Using a wooden shelf enhances the context by suggesting the domestic setting, while Lopez's highly unique and unfamiliar clay forms defy classification.

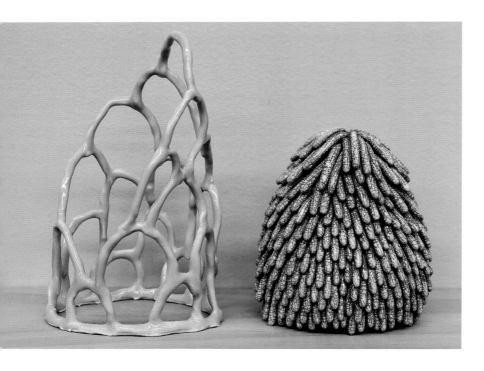

Technical Description

When making her linear sculptures, Lopez coats the entire piece with white slip during the greenware stage using a soft round brush, which helps to create a smooth surface and covers up any creases or joints. Lopez then brushes on three flowing coats of glaze to her cleaned bisque surfaces, allowing the glaze to dry completely between each coat. The works are glaze fired in an electric kiln to cone 04.

From One Pile to Another
13 × 11 × 5 in. (33 × 28 × 13 cm), low-fire earthenware, white slip, glazes, fired to cone 04, overfired luster. SEE GLAZE DETAILS, BELOW.

GLAZE DETAILS

BABY MATTE BLUE GLAZE, *cone 04*

Frit 3124	45
Laguna borate	10
Whiting	5
Silica	15
EPK	5
Nepheline syenite	15
Talc	5
+ Zircopax	5
+ Turquoise stain (Mason 6364 SiVZr)	2

CLEAR GLAZE, *cone 04*
Duncan Satin SN 351

LIQUID BRIGHT GOLD LUSTER
Duncan OG 801

Note: The pink surface on From One Pile to Another *was a happy accident. Lopez originally wanted the piece to be all gold luster, but after a failed attempt, she decided to burn out the* luster *by firing to cone 04. The results of the burn-out left fantastic red veins in the crazed surface of the clear white.*

NEON CHARTREUSE GLAZE, *cone 04*
Duncan Satin SN 378

SNOW WHITE GLAZE, *cone 04*
Spectrum 701

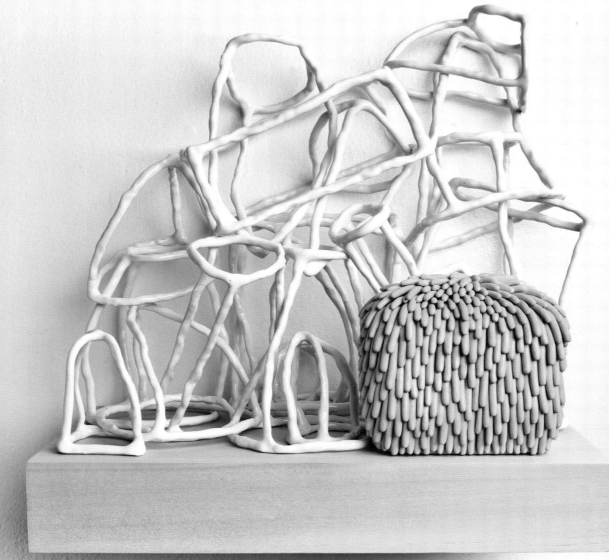

● *Bright green highlights the object as a focal point*
● *White gives a ghostly, skeletal feel to the linear sculpture*

66 I utilize color as a form of expression to construct a presence that the objects communicate. Some objects tend to be cheerfully bright, while others are dark and moody. 99

And To Think It All Started With That
14 × 13 × 5 in. (35.5 × 33 × 8 cm), low-fire earthenware, white slip, commercial glazes, fired to cone 04. SEE GLAZE DETAILS, LEFT.

Taehoon Kim

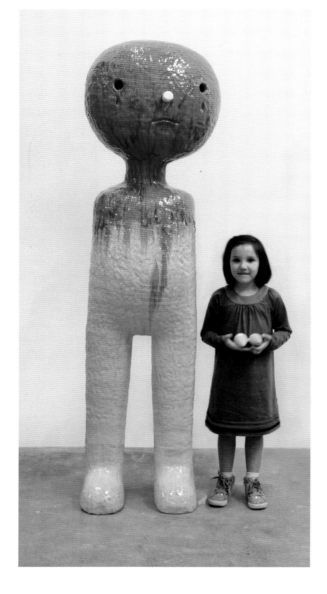

Proposing a more empathetic relationship with other sentient beings, Taehoon Kim's life-size cartoonish figures invite interaction. Although clearly not human in their proportions, the scale and features of Kim's works incite curiosity in the potential of other creatures to have emotional personas that seek to be understood. The brightly colored and playful figures are engaging, and give the viewer the opportunity to explore the space of the gallery as if it were a playground for social experimentation.

Technical Description

Kim applies the yellow and red glazes thickly, so that the glazes run enough to cover the yellowish clay body. A "proper" application of three coats thick would produce an opaque bright yellow or red. Although the glaze recipes listed are for cone 05–04, these pieces were fired hotter—to cone 02— so the glazes ran and streaked.

Son of Trapeze Artist
73 × 19 × 19 in. (185 × 48 × 48 cm), fired clay brushed with colored glazes, fired to cone 02. SEE GLAZE DETAILS, BELOW.

GLAZE DETAILS

LISA ORR, *cone 05–04*
This is used on the yellow and red heads and legs

Frit 3110	63
Gerstley borate	9.5
Soda ash	16
EPK	4.5
Flint	7

Yellow
+ 6–8% Lemon Yellow inclusion stain (US Pigment 1352-Y ZrSiCdSe)

Red
+ 6–8% Bright Red inclusion stain (US Pigment 50672 ZrSiCdSe)

FAT WHITE, *cone 05–04*
This is used on the blue stem

Nepheline syenite	36.5
Whiting	24.5
Lithium carbonate	12
EPK	2.5
Flint	24.5
+ Copper carbonate	1–2

WATER BLUE, *cone 04*
This glaze reacts with the yellowish clay body to produce the color on the green leaves

Frit 3110	72.5
Gerstley borate	4.5
Soda ash	4.5
EPK	7
Silica	9.5
Bentonite	2
+ Copper carbonate	4.5

T.S. MAJOLICA, *cone 04*
This is used on the white base

Frit 3124	69.5
Flint	9.5
EPK	11.5
Zircopax	9.5

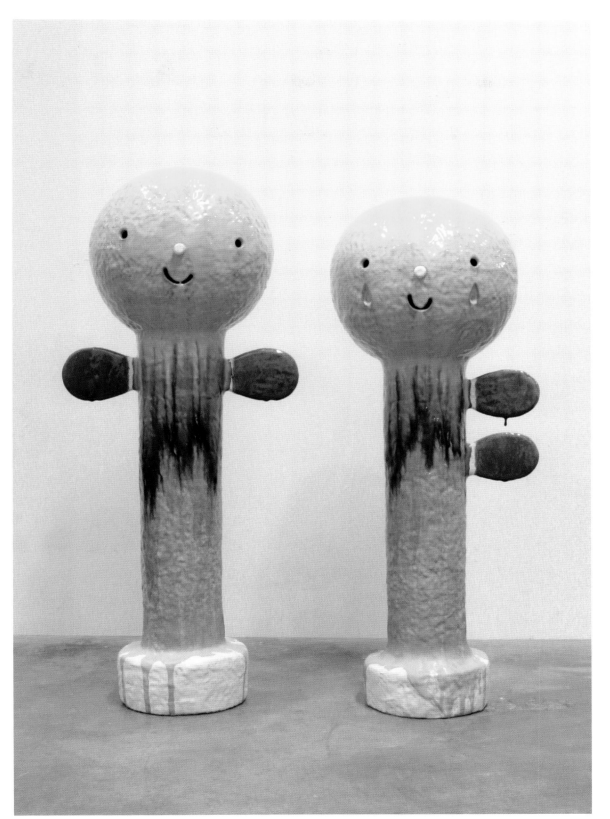

● *Kim's color palette is decidedly playful and harmonious, with the bright primary colors, yellow, red, and blue, and the analogous green.*

● *The yellow becomes a bit ominous as it bleeds into the blue, creating a black halo around it.*

Romance of Flowers
left: 55 × 21 × 18 in. (140 × 53 × 46 cm), right: 54 × 24 × 18 in. (137 × 61 × 46 cm), fired clay brushed with colored glazes, fired to cone 02.
SEE GLAZE DETAILS, LEFT.

Robert Silverman

Robert Silverman's large-scale wall tiles carry the esthetics of minimalist paintings with the added dynamism of a ceramic surface's depth, luminosity, and flow. With color as his starting point, Silverman seduces the viewer with luscious, hypersaturated glazes that have a radioactive intensity. Inspired by "demon pots" from the 6th to the 8th century in Iran and Iraq, and the epigraphic pottery of medieval Islam, Silverman's semiotic investigations question how the legibility and purpose of linguistic marks influence our perception of meaning. His training as a social geographer further informs his exploration of our relationship with systems of communication.

Diamond Backs Graph *36 × 28 in. (91 × 71 cm), large, handmade tile, glazed to cone 6 for Amanda's Black base glaze, reglazed and fired to cone 04 for red, yellow, and orange glaze stripes. Fired vertically. Charting the win-loss record of the Arizona Diamond Backs.* SEE GLAZE DETAILS, BELOW.

GLAZE DETAILS

AMANDA'S BLACK, *cone 6*

F-4 feldspar	35
Whiting	30
Flint	20
EPK	15
+ Black Stain (Mason 6657 CrFeCo)	10

REXRODE BLUE, *cone 6*

Nepheline syenite	45.6
Barium carbonate	36.6
Ball clay	7.2
Flint	9.5
Lithium carbonate	1.1
+ Cobalt carbonate	0.1

RED GLAZE, *cone 04*
Johnson Matthey 89290

YELLOW GLAZE, *cone 04*
Johnson Matthey 89291

OVERGLAZE, *cone 04*
Johnson Matthey 2451 with added stains for color

Note: Silverman deflocculates the glazes to aid in application by brushing and spraying.

Technical Description

Silverman's large tiles are sprayed with his own glazes and fired to cone 6 with the tiles flat in the kiln. They are then reglazed using a spray gun, and refired vertically to cone 04. Finally, the tiles are reglazed using stencils or a brush to apply the text. The tiles are propped up vertically again to encourage glaze run during the final cone 04 firing. Sometimes Silverman refires pieces multiple times to achieve the desired effects.

Degas/Yeats *36 × 28 in. (91 × 71 cm), large, handmade tile, glazed to cone 6 for Rexrode Blue base glaze, reglazed and fired to cone 04 for yellow glaze, reglazed and fired to cone 04 for translation of quotes by Degas and Yeats. Fired vertically.* SEE GLAZE DETAILS, LEFT.

“ Color and glaze characteristics have always been the starting point for my work. They set the conceptual framework from which the work goes forward. ”

- Yellow is used not only as a color but as a symbol that carries meaning.
- The bleeding together of the glazes both heightens and hides the marks.
- Luscious drips of yellow are emphasized by breaking greenish-black.

Chandra DeBuse

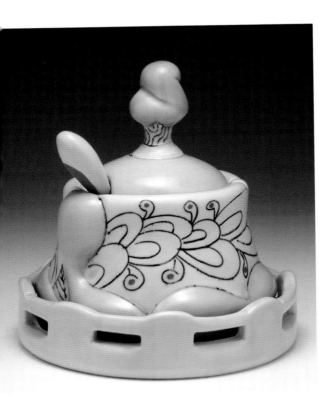

The playful service wares of Chandra DeBuse delight with their soft, bulbous forms and jovial decorations. The narrative elements of her *Yellow Treat Server with Snail* tell the heartwarming and enchanting story of "desire, determination, and achievement" through the three tiers. Referencing the candy-like pastels of childhood, DeBuse utilizes the soft and seductive yellow glaze to reinforce the purpose of the form—holding treats, as well as to esthetically balance the bouncing patterns and anthropomorphic decorations. These decorative spaces on the works become "playscapes," as she calls them, where floral and animal motifs dance and amuse, proposing open-ended narratives that stimulate the imagination and provoke a sense of play in the user.

Technical Description ▷

In the greenware state, lines are inlaid with black underglaze. After bisque firing, the lines are lightly sanded to ensure crispness and then the piece is washed in water and allowed to dry. Blue painter's tape is used to mask off designated areas and then the EM Satin yellow glaze is sprayed on. The tape is then removed and various colored underglazes are brushed on, sometimes quite diluted in water for a "washy watercolor" look. Once finished, the entire piece is sprayed with the EM Satin glaze without any colorants for a clear coat. Small areas are brushed with the lithium wash to encourage running, which is especially interesting over the black underglaze. After the piece is fired to cone 6, the spoon handles are brushed with gold luster and fired again.

> ❝ My work, in practice and product, reflects my approach to make-believe, which I identify through worlds of imagination with determined characters and landscapes of leisure. ❞

GLAZE AND UNDERGLAZE DETAILS

EM SATIN GLAZE, *cone 6*
This recipe is from Eric Mirabito

Silica	20.8
Nepheline syenite	19.8
Whiting	19.8
EPK	19.8
Frit 3124	19.8
+ Bentonite	2

Yellow
+ 5% Vanadium Yellow stain
(Mason 6404 AlSnV)

Blue
+ 5% Zirconium Vanadium Blue
stain (Mason 6315 SiVZr)

Green
+ 5% Victoria Green stain (Mason
6264 CrCaSiZr)

UNDERGLAZES, *cone 6*
Chartreuse (Amaco Velvet V-343)
Bright Red (Amaco Velvet V-387)
Velour Black (Amaco Velvet V-370)

White (Amaco Velvet V-360) *(White is
mixed with Bright Red to make pink and
mixed with Velour Black and watered
down to make gray.)*
Squash Yellow (Mayco UG-203)

CRAZY LITHIUM RUNNY WASH

Lithium carbonate	95
Bentonite	5

GOLD LUSTER GLAZE, *cone 019*
Engelhard Hanovia

**Honey Jar with Dribble
Tray** *7 × 6 × 6 in. (18 ×
15 × 15 cm) mid-range
white stoneware, inlaid
black underglaze, colored
underglazes, dipped yellow,
blue, green, and clear satin
glazes, fired to cone 6.*
*SEE GLAZE AND UNDERGLAZE
DETAILS, LEFT.*

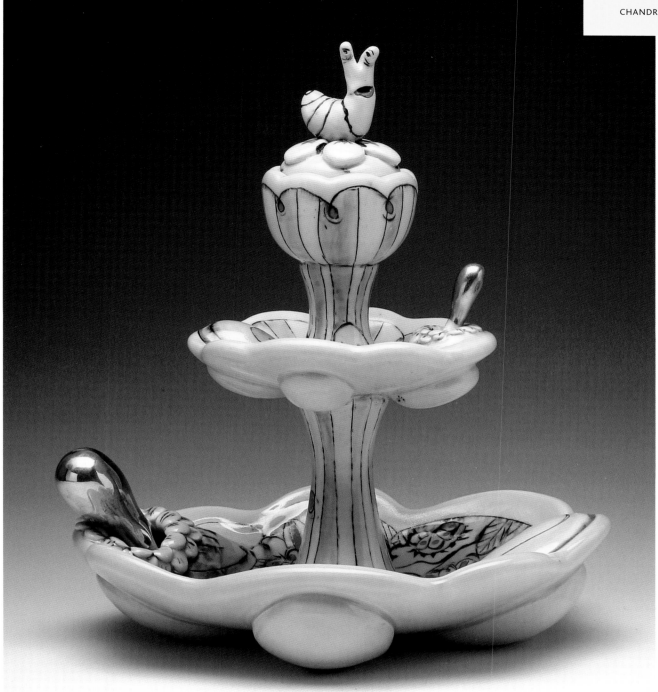

Yellow Treat Server with Snail
11 × 10 × 7¹/₂ in. (28 × 25 × 19 cm), mid-range white stoneware, inlaid black underglaze, yellow satin glaze, colored underglazes, clear satin glaze, fired to cone 6. Gold luster fired to cone 019. SEE GLAZE AND UNDERGLAZE DETAILS, LEFT.

● *Reflective gold handles punctuate the delicate nature of the piece.*

● *Soft, pale yellow continues the approachable and playful nature of the work.*

Matt Wedel

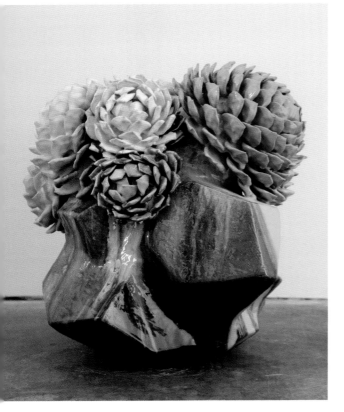

In Matt Wedel's pieces entitled *Flower Tree*, simple pinches of clay are repeated to form enormous blooms that resemble artichokes or gigantic cactus flowers. Placed atop thick stalks protruding from faceted, geological forms, they carry the rhythm of concentric spirals, lending a kind of melodic current to the large sculptures. Based on ideas of landscape, the study of forms has evolved into elaborate formal compositions guided by the emotional presence of the color. Rivers of glaze overflow from the floral elements, as if they were faucets spewing the essence of color itself. Wedel embraces the unpredictability of his glazing process. The tension between familiarity and uncertainty in the forms and their luscious surfaces provides a subtle allegorical framework within which to view the work.

Flower Tree *19 × 18 × 15 in. (48 × 46 × 38 cm), hand-built paper clay, layered Fat White, Lisa Orr, and commercial glazes, fired to cone 04.* SEE GLAZE DETAILS, BELOW.

Technical Description

Wedel often uses up to four base glazes with various colorant mixtures each time he glazes his pieces. He is sure to mix Fat White immediately before application, due to its tendency to settle quickly. First he coats the faceted portion of his sculpture with Fat White with some copper carbonate, giving it a baby-blue quality, then coats it again with Laguna yellow glaze, creating a mottled surface. On the flower stalks, he uses the Lisa Orr glaze with Bermuda stain. Next he uses a tube syringe to squirt various colored glazes into the crevices of his petal structures. The commercial glazes are mixed together and altered by the addition of various stains and colorants to create the color palette. He holds a bowl beneath to catch the glaze that pours off the form. During this process he sometimes builds glaze up to 1 in. (2.5 cm) thick. Stains are often added by eye instead of measuring.

GLAZE DETAILS

FAT WHITE, cone 06–03
This recipe is from Tony Marsh

Nepheline syenite	36.4
Whiting	24.5
Lithium carbonate	11.8
EPK	2.8
Flint	24.5

Baby blue
+ Copper carbonate, added by eye

Lavender
+ Pansy Purple stain (Mason 6385 CrSnCoCaSi), added by eye

LISA ORR, cone 06–04

Frit 3110	63.0
Gerstley borate	9.5
Soda ash	15.1
EPK	4.8
Flint	7.6
+ Bentonite	1.8

Green/blue
+ 10% Bermuda Green stain (Mason 6242 ZrVPrSi)

COMMERCIAL GLAZES, cone 06–04
Holly Red (Laguna 0-1748)
Ripe Banana (Laguna G-01764)

COLOR ADDITIONS
The following commercial stains and colorants are added to the Ripe Banana dry mix to alter the color:

Shell Pink (Mason 6000 CrSnCaSi)	10%
Lavender (Mason 6333 CrSnCoAlSi)	10%
Zirconium Yellow (Mason 6464 ZrVTi)	10%
Orange (Mason 6024 ZrSeCdSi)	10%
Vanadium Pentoxide	10%

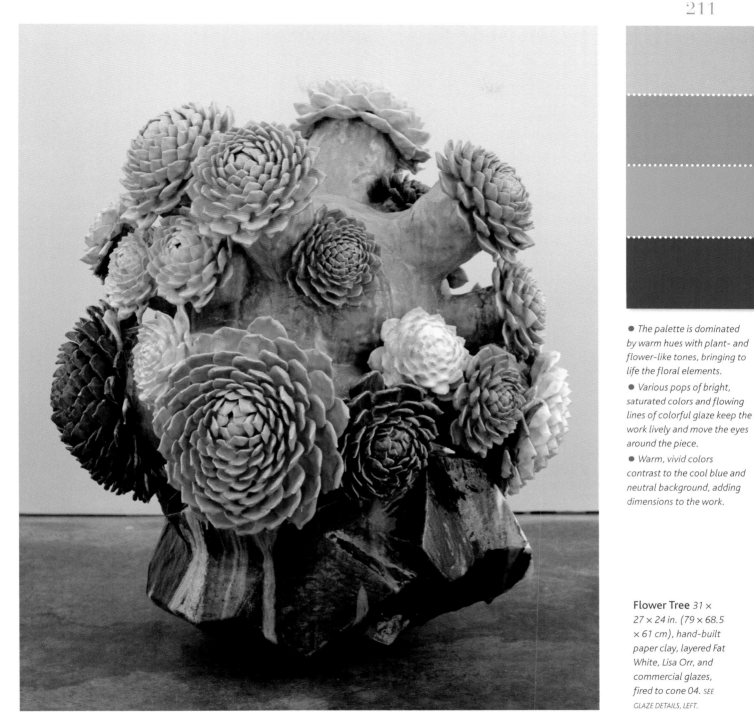

● *The palette is dominated by warm hues with plant- and flower-like tones, bringing to life the floral elements.*

● *Various pops of bright, saturated colors and flowing lines of colorful glaze keep the work lively and move the eyes around the piece.*

● *Warm, vivid colors contrast to the cool blue and neutral background, adding dimensions to the work.*

Flower Tree *31 × 27 × 24 in. (79 × 68.5 × 61 cm), hand-built paper clay, layered Fat White, Lisa Orr, and commercial glazes, fired to cone 04. SEE GLAZE DETAILS, LEFT.*

❝ Color creates emotion, directs the eye. It can highlight a form or undermine a form. I like to be surprised by color and let it tell me where my work is going. ❞

David Hicks

David Hicks creates unrepeatable surfaces that pool and flow over his dendritic forms, creating biomorphic-inspired curiosities with alchemistic rigor. He relinquishes predictability and reliability in favor of loose, immediate gestures and a lengthy yet liberating firing process. He collaborates with the heat to make something remarkable out of the many layers of fluxing materials and colors, as saturated pigments are melted, blended, dripped, and sometimes obliterated, revealing the clay beneath and bringing the massive mycological florets to life.

Flora (Yellow Melt)
(detail). *SEE GLAZE AND FLUX DETAILS, BELOW.*

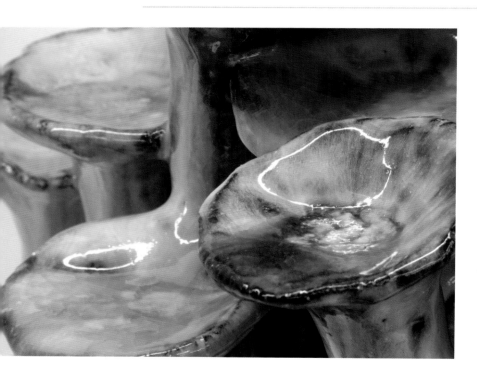

Technical Description

Hicks first sprays his bisque-fired terra-cotta with a thick layer of majolica. Next, simple flux washes of unmeasured soda ash and frit are brushed on, followed by heavy layers of numerous colored commercial glazes. One more layer of flux wash is added, and occasionally Hicks sprinkles colored glass frits for specks of colors. Pieces are fired to cone 01, assessed, reglazed, and refired numerous times until an optimal surface is achieved. Each refire is set to a slightly lower temperature to avoid complete glaze shift. For the firing, pieces are placed on soft bricks cut to match the shape of the foot, coated in kiln wash. The shelf beneath is covered in a layer of silica sand to catch the anticipated pools of dripping glaze. The final piece is polished with a diamond flat lap disk to clean up glaze runoff.

> 66 I'd rather say that the form plays a role in my glaze than the other way around. I engineer runs and pools. I try to destroy glaze with frit and flux. I want to break down the commercial genericness of ceramic glazes and create a unique, one-off surface. 99

GLAZE AND FLUX DETAILS

MAJOLICA BASE GLAZE, cone 04–10	
Frit 3124	53
Barium carbonate	6
EPK	16
Silica	8
Bentonite	1
Zircopax	14

COMMERICAL YELLOW GLAZES
Cornmeal glaze (Duncan Envision IN 1030)
Sun Yellow glaze (Duncan Envision IN 1003)

FLUXES
Soda ash
Frit 3124
Lead monosilicate

Note: Lead and soda ash require caution when handling—wear a respirator and latex gloves.

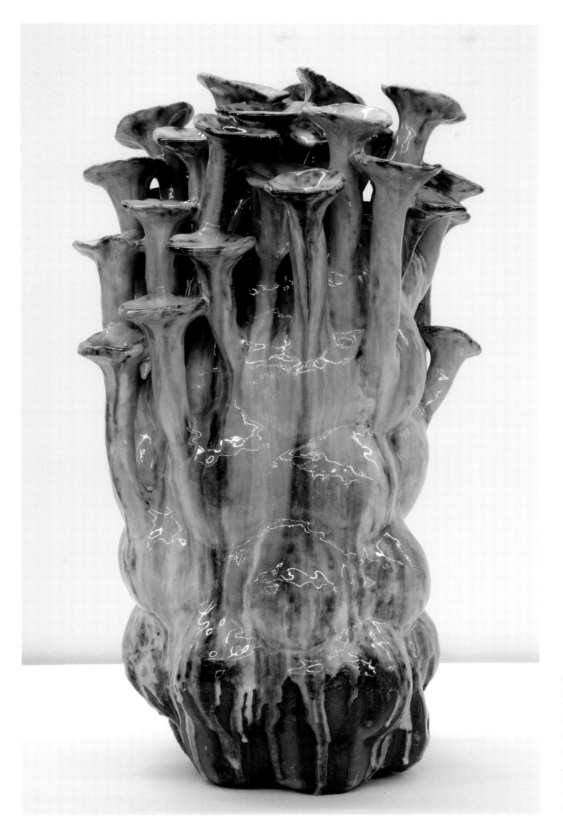

- *White majolica is used as a canvas to enhance brighter colors over the dark clay.*
- *Glossy bright yellow looks like oozing organic fluids.*
- *The colored drips document the firing process.*

Flora (Yellow Melt)

24 × 14 × 14 in. (61 × 35.5 × 35.5 cm), hand-built terra-cotta, multi-fired glazes layered with fluxes and frits. Additions of colored glass frits and commercial and studio glazes. Firing range cone 04–01. SEE GLAZE AND FLUX DETAILS, LEFT.

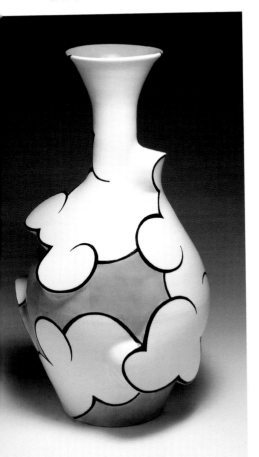

Sam Chung

Originally inspired by graphic examples of cloud motifs in Korean art, Sam Chung's exuberant functional wheel-thrown forms gracefully fuse with billowing cumulous shapes. Each piece presents a unique, albeit unanimously playful, feeling, with color leading the charge in drawing out an emotional intensity. The saturated and uniformly bright fields of color help flatten the shapes, with sharp black outlines adding a two-dimensional language that contrasts with the voluminous forms.

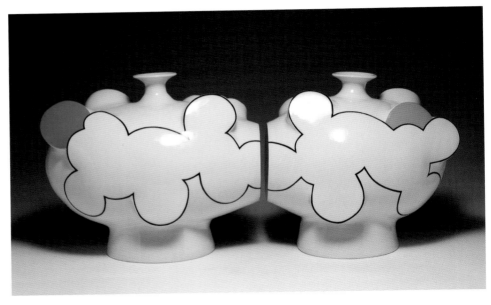

Cloud Vase *14 × 8 × 8 in. (35.5 × 20 × 20 cm), wheel-thrown, altered porcelain, clear glaze fired to cone 10. China painted with 3–5 applications and firings to cone 017.* SEE GLAZE AND PAINT DETAILS, BELOW.

Cloud Bottles *10 × 22 × 7¹/₂ in. (25 × 56 × 19 cm), wheel-thrown, altered porcelain, clear glaze fired to cone 10. China painted with 3–5 applications and firings to cone 017.* SEE GLAZE AND PAINT DETAILS, LEFT.

Cloud Teapot *7 × 9 × 5 in. (18 × 23 × 13 cm), wheel-thrown, altered porcelain, clear glaze fired to cone 10. China painted with 3–5 applications and firings to cone 017.* SEE GLAZE AND PAINT DETAILS, LEFT.

GLAZE AND PAINT DETAILS

HENSLEY CLEAR GLAZE (REVISED), *cone 10*
This recipe is from Kurt Heiser

F-4 feldspar	37.2
Gerstley borate	12.1
Barium carbonate	4.7
Whiting	7.9
Silica	27.0
Grolleg kaolin	9.3
Frit 3110	1.9
+ Tin oxide	1.0

RYNNE CHINA PAINTS, *cone 017*
China paints in the following colors are mixed with Jane Marcks "magic medium" oil:

Best Black
Cherry Red mixed with Cardinal Red
Bright Orange
Lemon Yellow mixed with Moss Green

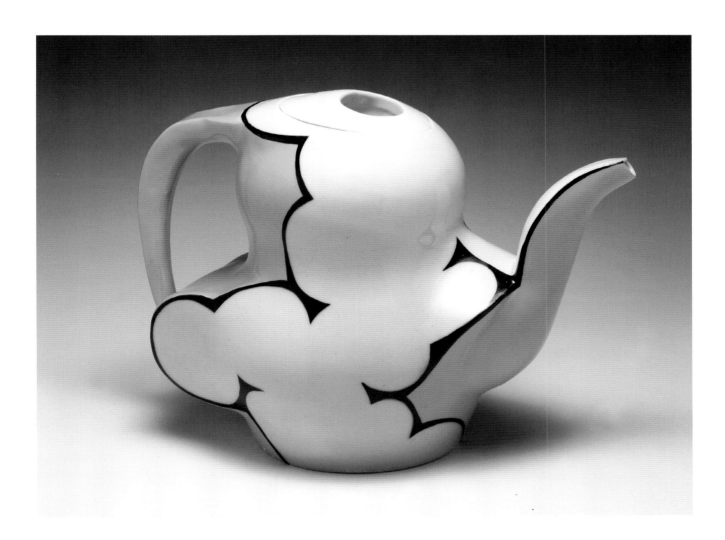

Technical Description

After bisque firing, Chung's porcelain pieces are dipped in clear glaze mixed to the consistency of whole milk. Fired to cone 10 with light reduction, the porcelain takes on a cool white hue, as opposed to the warm whites produced in oxidation. The colored china paints are mixed into an oil medium and carefully applied with a fine sponge in one layer and then the piece is fired quickly to cone 017. Second, third, and fourth layers, each followed by firing, are done as needed to achieve a consistent opaque coat. (If applied too thickly at once, the surface appears textured.) The black linework is applied carefully with a fine liner brush once the colors are finished. Chung notes that he fires the china paints with the lid propped open by $1/2$ in. (1.3 cm) to allow for fumes from the oil medium to escape the kiln.

● Black is used to outline the clouds, referencing the graphic examples that inspired the work.

● Each color adds distinct emotional content.

● Solid, opaque color flattens the form.

Linda Arbuckle

Linda Arbuckle's colorful majolica pots are inviting, indulgent, and playful. She intends her work to be a participant in the domestic life of its owner, with the objects not only fulfilling their duty at the table, but also bringing personal value and meaning into the home and to the rituals of use. Beginning with paper collage to experiment with new color combinations, Arbuckle looks to Josef Albers' color studies, fabrics, interior design magazines, and paintings for inspiration. Color is employed for the emotional tone it sets, particularly how it elicits enjoyment and cheerfulness. The bright, warm tones help cool colors pop in contrast and add vibrancy and exuberance to the gestural botanical imagery on her forms.

Small Pour: Golden Times *5¹/₂ × 2¹/₂ × 4 in. (14 × 6 × 10 cm), red earthenware, white majolica base glaze with in-glaze decoration. Color is brushed on, lines drawn, motifs wax-resisted, then a ground color laid on. Fired to cone 03 in oxidation. SEE GLAZE DETAILS, BELOW.*

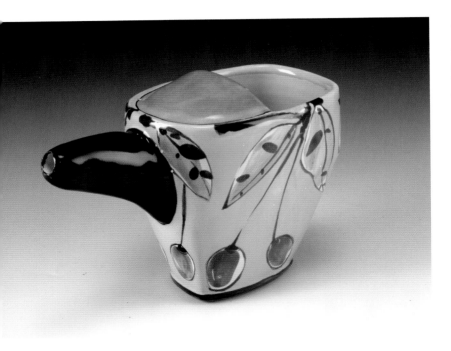

Technical Description

Pieces are first created in terra-cotta and surfaces are smoothed with a rib to eliminate pinholes and crawling in the viscous glaze. After bisque firing, the surfaces are dampened with a sponge or a quick rinse and then the piece is dipped in majolica glaze. A consistent single coat is desirable, as overlaps and thick areas may show or crawl. Colorants are then mixed with flux and bentonite and brushed over the dry majolica glaze. For a smooth color ground, Arbuckle first paints the motifs, coats them in wax, and then brushes the entire piece in the designated color. Pieces are then fired to cone 03 at 200°F (93°C) per hour.

Plate: Fall Leaves With Green Fruit *11¹/₂ × 8 × 1¹/₂ in. (29 × 20 × 4 cm), red earthenware, white majolica base glaze with in-glaze decoration. Color is brushed on, lines drawn, motifs wax-resisted, then a ground color laid on. Fired to cone 03 in oxidation. SEE GLAZE DETAILS, BELOW.*

GLAZE DETAILS

MAJOLICA ARBUCKLE, *cone 03*	
Frit 3124	65.8
F-4 feldspar or	
Minspar 200	17.2
Nepheline syenite	6.2
EPK	10.8
+ Tin oxide	4
+ Zircopax	9
+ Bentonite	2

Arbuckle colors her pieces with commercial colors, inclusion stains, Mason stains, and other colorants. With the exception of the ground color and the black lines, the colors are applied with a brush loaded with more than one color so that the colors mix in the stroke.

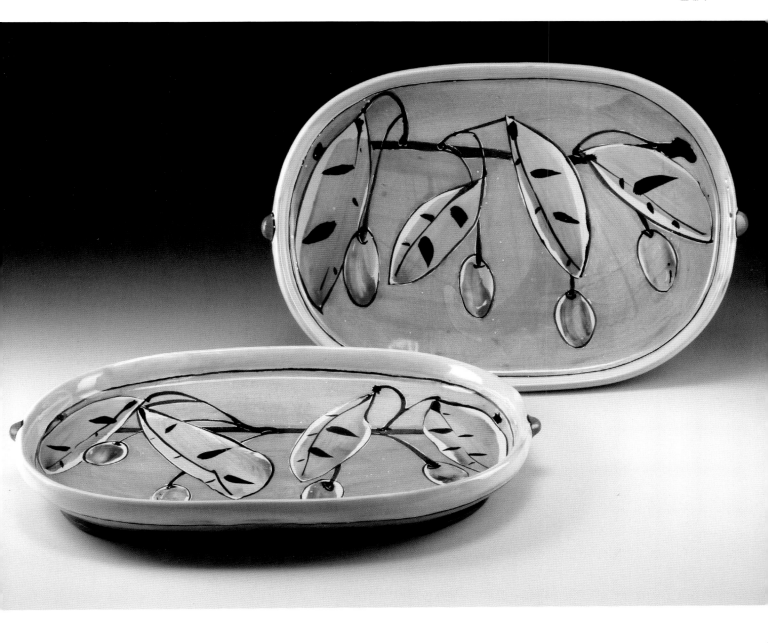

 Bold, bright colors are achieved as pigments are brushed on top of the milky-white majolica glaze, adding a painterly esthetic to the botanical imagery.

● The gray background tone with black linework helps the vivid orange and green colors pop.

● The white base glaze is used as a highlight color in the motifs, allowing for a full value range from white to black in the works.

Rain Harris

Inspired by common weeds and wildflowers, the abstracted, planar silhouettes of Rain Harris are anything but common. Colors are chosen specifically to convey an idea. In her piece *Tangerine*, Harris uses an orange hue to convey fall colors, but chooses a bright, highly saturated and unnatural shade, masking its derivation and offering a new perspective for interpretation. In these sculptural works, Harris toys with contemporary sensibilities in regard to style, design, and popular taste, producing works that vacillate between sexy and garish, succinct and tacky, minimal and excessive.

Hedgerow *19 × 38 × 6 in. (48 × 97 × 15 cm), slip-cast and hand-built cone 6 porcelain, blue glaze, multiple firings to cone 6, pine base, resin covered. SEE GLAZE DETAILS, BELOW.*

GLAZE DETAILS

20x5 GLAZE, *cone 5–6*	
EPK	20
Silica	20
Wollastonite	20
Custer feldspar	20
Frit 3124	20

Orange
+ 8% Orange Inclusion stain
(Cerdec-Degussa 239616
ZrSiCdSe)

Blue
+ 2% Robin's Egg Blue stain
(Mason 6376 ZrVSi)

66 Although my forms are derived from flora, I am interested in stripping away the 'organic' qualities and translating them into abstract silhouettes that bear little resemblance to their predecessors. 99

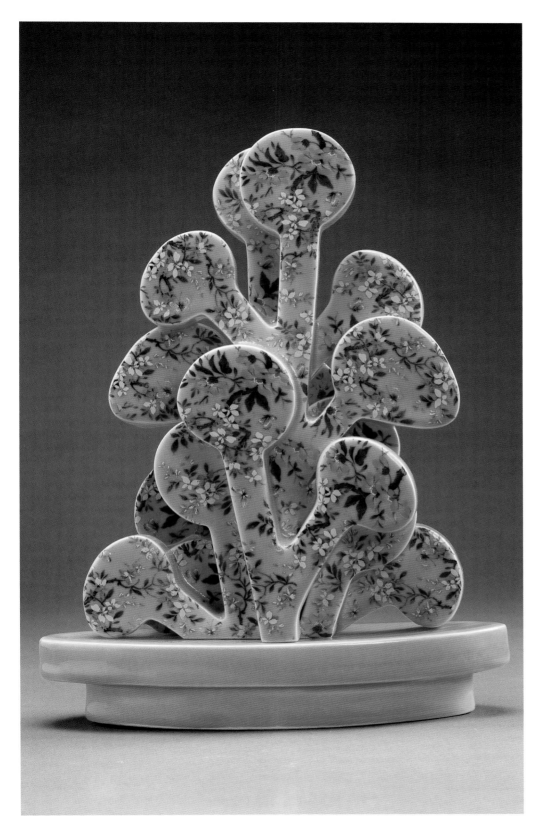

◁ **Technical Description**

Once bisque fired, pieces are placed on a Lazy Susan and glaze is poured over them. Glaze is then brushed onto any thin spots, and thick spots are scraped down to assure a consistent coat. Pieces are fired to cone 6 in an electric kiln. If the glaze appears thin or has pinholes, some CMC gum is mixed into some glaze, and this is reapplied and the piece refired. After the glaze firing, decals are applied and the piece is fired to cone 017. For the last step, the piece is thinly coated in resin.

Tangerine 13 × 10 × 3¹/₂ in. (33 × 25 × 9 cm), slip-cast and hand-built cone 6 porcelain, orange glaze fired to cone 6, vintage decals fired to cone 017, applied resin. *SEE GLAZE DETAILS, LEFT.*

John Utgaard

Taking its form from the water jet that is created when objects collide with still water, John Utgaard's piece entitled *Drop* captures a dynamic moment in time, in a metaphysically charged sculpture. The garish colors of the commercial underglazes are muted by the lithia overglaze, creating a surface permeated with an unexpectedly saturated color that seems to glow from within. The phenomenon of the melting layers of ceramic materials gives a sense of time, depth, and movement to the piece, with the pristinely symmetrical projection flowing from the rugged, geologic base.

Toric Void *7 × 17 × 10 in. (18 × 43 × 25 cm), hand-built earthenware, Flowing Lithia matte glaze brushed and sprayed over bright red engobe. The engobe on the textured area also contained granular iron oxide. Fired to cone 05 in oxidation.* SEE GLAZE AND ENGOBE DETAILS, BELOW.

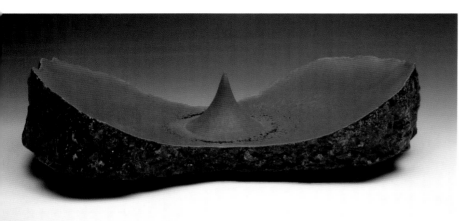

Technical Description ▷

Chartreuse underglaze was first brushed over the textured surface onto greenware. After bisque firing, orange engobe was sprayed onto the smooth surface area, while blue engobe was brushed over the textured surface. A sponge was used to wipe away and reveal some of the chartreuse underglaze, then the Flowing Lithia matte glaze was applied by spraying over the smooth surface, and brushing over the highly textured areas. The piece was glaze fired to cone 05 in oxidation with a slow ramp at the end (108°F/42°C per hour), and a 30-minute hold. The kiln was cooled at 200°F (93°C) per hour until 900°F (480°C).

> ❝ I try to create surfaces that are evocative of a more process-driven firing esthetic (anagama firing, etc.) but with a color saturation that is unexpected and out of place. ❞

GLAZE AND ENGOBE DETAILS

ENGOBE BASE, *cone 04*

Custer feldspar	4
Silica 3	4
Calcined kaolin	4
OM#4 ball clay	4
EPK	30
Nepheline syenite	28
Spodumene	11
Frit 3195	15

Blue
+ 25% Delft Blue stain (Mason 6320 CoAlSiSnZn)

Orange
+ 100% Orange inclusion stain (US Pigment 1352-0 ZrSiCdSe)

Bright Red
+ 100% Bright Red inclusion stain (US Pigment 50672 ZrSiCdSe)

FLOWING LITHIA MATTE GLAZE, *cone 04*

Lithium carbonate	36
Kaolin	13
Magnesium carbonate	13
Silica	36
Bentonite	2
+ Black stain	0.5–2

For the black stain, Utgaard has used both Mason Best Black 6600 CrFeCoNi and Mid-South Ceramics Cobalt Iron Chromite Black S-100 CrFeCoNi.

Note: Lithium carbonate is a health hazard and should be handled with gloves in its raw state.

CHARTREUSE UNDERGLAZE
Amaco Velvet V-343

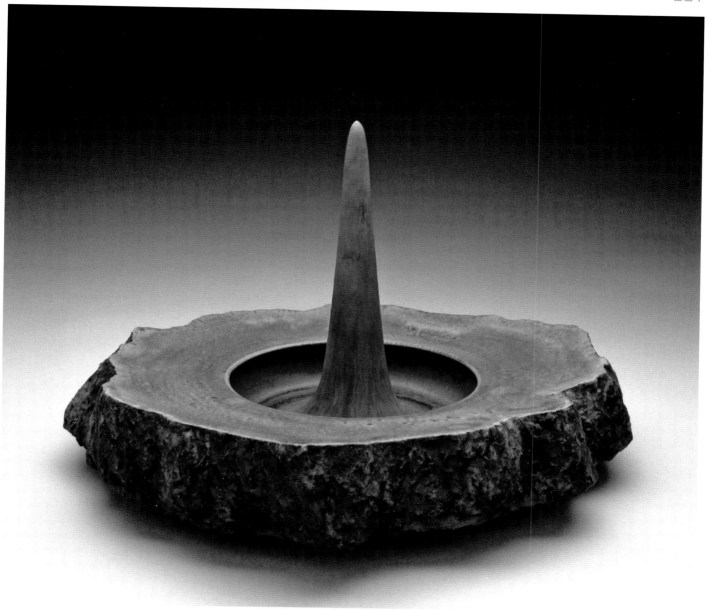

Drop *9 × 15 × 14 in. (23 × 38 × 36 cm),*
hand-built earthenware, Flowing Lithia
matte glaze brushed and sprayed over
chartreuse underglaze and orange- and
blue-tinted engobes. Fired to cone 05
in oxidation SEE GLAZE AND ENGOBE DETAILS, LEFT.

● *Bright orange is muted*
by the small amount of
black stain in the Flowing
Lithia matte glaze.

● *The smooth rust-orange*
is especially vivid next to
the dark, textured surface.

Wendy Walgate

Inspired by coloring books and tattered old toys that reference her childhood growing up in the 1950s, the colorful accumulations of Wendy Walgate's sculptures embody nostalgia. Although she incorporates found objects, manufactured molds, and commercial glazes, the pieces are meticulously handled and refined, with reverence for each object's ability to reflect the memories, dreams, and aspirations of its owner. Walgate uses her work to critique our use of animals as display, adornment, and commodity. By coating them all in saturated, brilliant glazes, the objects are brought back to life with each one wearing a unique color, as she attempts to call attention to their oft-overlooked individuality.

Migration Mantle
21 × 36 × 5 in. (53 × 91 × 13 cm), slip-cast white earthenware, commercial colored glazes fired to cone 06. Assembled post-firing, wooden mantle. SEE GLAZE DETAILS, BELOW.

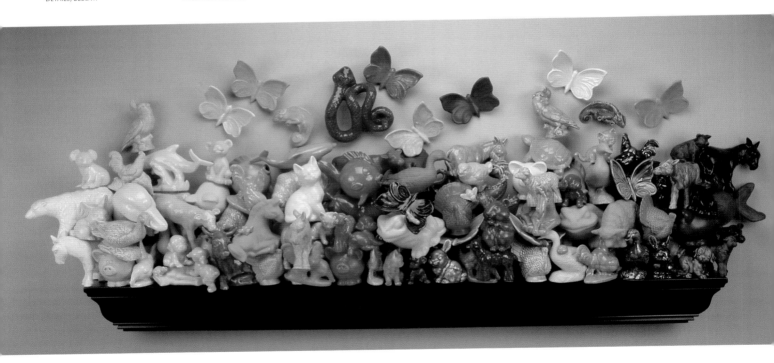

GLAZE DETAILS

COMMERCIAL GLAZES, *cone 06*
for Orange is Flamboyance
Cantaloupe (Duncan Envision IN 1054)
Orange Fizz (Duncan Satin SN 355)
Light Papaya (Duncan Concepts CN 041)
Tangerine (Duncan Gloss GL 632)
Terra-Cotta (Duncan Envision IN 1021)

Baroque Gold (Duncan Envision IN 1072)
Sunset Red (Duncan Envision IN 1004)
Pumpkin Orange (Duncan Envision IN 1781)
Florida Orange (Chromacolour 104)
Maple Sugar (Gare Non-Toxic Gloss NTG 9331)

Technical Description

Walgate's slip-cast earthenware pieces are first bisque fired to cone 04 and then brushed with three coats of commercial glazes before a cone 06 glaze firing. Once glazed, the pieces are carefully assembled and glued together inside or on top of the found structure.

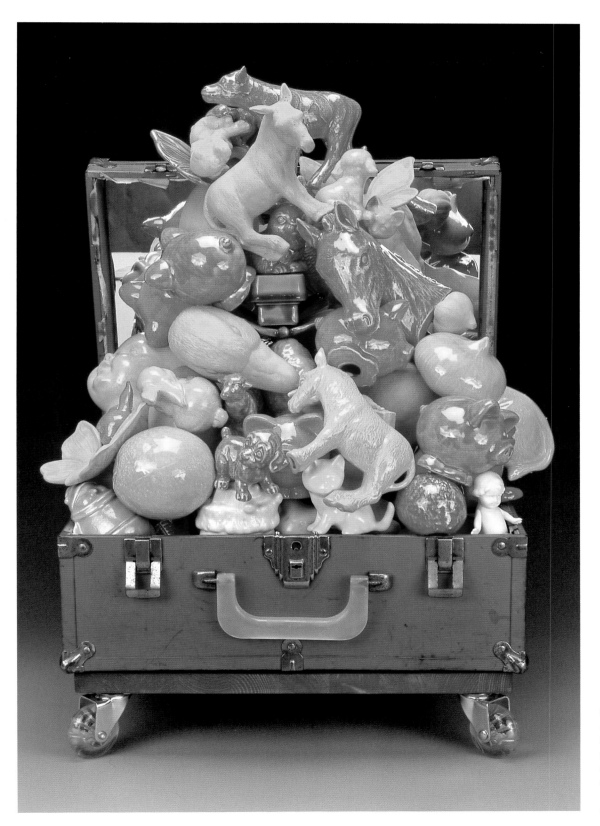

● The range of orange shades and analogous hues, including the found trunk, tie all of the disparate elements together and create a distinct emotive charge to the work as a whole.

● Despite the use of many different but analogous hues, the overall effect is unifying, requiring us to seek out the individual personalities in the accumulation.

● Bright colors, some matte and some glossy, add interest and keep the eyes moving around the piece.

Orange is Flamboyance
22 × 14 × 14 in. (56 × 35.5 × 35.5 cm), slip-cast white earthenware, commercial colored glazes, fired to cone 06. Assembled post-firing, 1950s' metal toy suitcase.
SEE GLAZE DETAILS, LEFT.

Paul Eshelman

A conscientious focus on intelligently designed functional forms characterizes Paul Eshelman's work. With a minimalist esthetic, Eshelman finds forms that are clean and succinct, requiring each considered element to add to the whole. Contrary to the pervasive whiteness of contemporary designed objects, Eshelman chooses rich red clay and bold colors that undoubtedly add content without detracting from the highly refined forms. He uses color for its potential to elicit joy and pays great attention to the role it plays as a complement to the food or flowers his objects contain and display.

> ❝ I wanted a satin matte glaze that would function well in use without marking or scratching and would be visually and tactilely inviting. ❞

Technical Description

Eshelman's pieces are all made from cone 4 red casting slip. He made hundreds of glaze tests to develop his prized and distinctive satin matte glazes. Each glaze is prepared meticulously, with water and dry material accurately measured with each batch for consistency. Test pieces are dipped in glaze to obtain a thickness of 0.5 mm when measured with a depth caliper. Once bisque fired, designated areas are waxed to leave them bare, and works are dipped with tongs into the glaze. Drips and tong marks are scraped once dry and touchups are performed as needed. The piece is glaze fired to cone 4.

Round Bottles *7¹⁄₂ × 5¹⁄₂ × 2 in. (19 × 14 × 5 cm) each, slip-cast, burnished red stoneware, satin glaze, fired to cone 4 in oxidation. SEE GLAZE DETAILS, BELOW.*

Handled Soup Bowls *4¹⁄₄ × 4¹⁄₄ × 5¹⁄₂ in. (11 × 11 × 14 cm) each, slip-cast, burnished red stoneware, satin glaze, fired to cone 4 in oxidation. SEE GLAZE DETAILS, BELOW.*

GLAZE DETAILS

SATIN BASE, *cone 4*	
Minspar 200	16
Petalite	16
Frit 3124	25
Dolomite	17
Flint 325 mesh	10
EPK	16

Orange
+ 0.5% Granular rutile
+ 10% Tangerine stain (Mason 6027 ZrSeCdSi)
+ 0.5% Dark Red stain (Mason 6088 ZrSeCdSi)

Red
+ 0.5% Granular rutile
+ 10% Dark Red stain (Mason 6088 ZrSeCdSi)
+ 0.3% Best Black stain (Mason 6600 CrFeCoNi)

Copen Blue
+ 0.5% Granular rutile
+ 10% Copen Blue stain (Mason 6368 CoZnAlSi)
+ 0.25% Best Black stain (Mason 6600 CrFeCoNi)

LAUREL'S SATIN WHITE, *cone 4*	
Minspar 4	16
Petalite	16
Frit 3124	25
Dolomite	17
Flint 325 mesh	10
EPK	16
+ Superpax	12
+ Rutile powder	0.5
+ Granular rutile	0.5

● *Areas of the clay are left bare so that the red clay can complement the bright glaze colors.*
● *The palette of colors is direct and simple, enhancing the streamlined forms.*

Sunshine Cobb

With an eye on bold color and modest forms, Sunshine Cobb has developed her current palette of five hues—orange, yellow, green, blue, and mint—to bring her approachable pottery to life. The vibrant glazes are applied in similar mono- or bi-chromatic fashion. She uses the sandblasting technique to etch away at their glossy new skins and reveal worn and weathered-looking surfaces and the rich red clay beneath. Cobb intends for the work to elicit a sense of nostalgia and comfort, with forms and a color palette that reference rusted industrial objects such as junkyard cars, painted oil drums, and old children's toys.

GLAZE DETAILS

COMMERCIAL GLAZES, *cone 3*
Pumpkin Orange (Duncan Envision IN1781)
Harvest Yellow (Duncan Envision IN1053)
Light Kiwi (Duncan Envision IN1062)

Pitchers *15 × 7 × 5 in. (38 × 18 × 13 cm) each, mid-range red clay, commercial glaze, fired to cone 3, sandblasted. SEE GLAZE DETAILS, LEFT.*

66 The color of the clay is extremely important to me; the right color of red that resembles a strong rust color, and how that reacts and interplays with the color of the glaze. The interplay helps evoke the sense of a weathered and well-used object. 99

● *The warm, super-saturated orange has the feel of old brick or rusted metal, reinforcing Cobb's interest in nostalgic objects.*
● *Sandblasting the forms adds dimension to the color and further reinforces the sense of time passing.*
● *The monochromatic work allows the color to play a symbolic role in the meaning of the work, while also supporting the form.*

Garlic Box *6 × 4 × 3¹/₂ in. (15 × 10 × 9 cm), mid-range red clay, commercial glaze, fired to cone 3, sandblasted. SEE GLAZE DETAILS, LEFT.*

Technical Description

Cobb's red mid-range clay pieces are glazed primarily by painting with a brush, though occasionally she will pour to coat interior volumes. The commercial mixtures call for three liberal coats for proper thickness; however, Cobb often thins her mixture slightly with water and applies only two coats. The pieces are glaze fired in oxidation to cone 3. After unloading, the pieces are sandblasted to remove just the top layer of glaze, effectively transforming the glossy surface to a matte one, but still retaining the bright color of the glaze. Tape is used to mask off areas where a matte surface is not desired, such as the interior surfaces of open forms that are intended for food, i.e., trays and baskets. After the sandblasting, the pieces are hand sanded with wet/dry sandpaper in order to softly polish and finish the surfaces.

Thomas Bohle

Thomas Bohle's simple and sleekly designed geometric volumes are cloaked with luscious red glaze and seductive drips, creating a dynamic duality between form and surface. The decisively controlled concave and convex curves are serene yet intense. Bohle combines traditional glazes such as Temmoku and copper reds to produce a startlingly beautiful "hare's fur" surface that resembles the flow of molten volcanic rock or dripping blood, lending a visceral quality to the stoic forms.

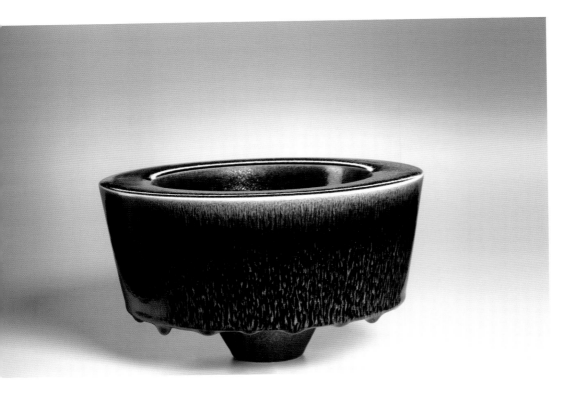

Technical Description ▷

This bowl is thrown as a double-walled form. After bisque firing, the form is brushed very thick with Temmoku glaze and then, while still wet, the copper glaze is thickly applied on top. The pieces are fired in a heavily reduced atmosphere beginning around cone 010 (1,650°F/900°C) up to cone 10.

Vessel *8 × 8 × 6 in. (20 × 20 × 15 cm), double-walled thrown stoneware, sprayed Temmoku and copper red glazes. Fired to cone 10 in reduction. SEE GLAZE DETAILS, BELOW.*

GLAZE DETAILS

COPPER RED GLAZE, *cone 10*	
Nepheline syenite	41.4
Potash feldspar	17.6
Quartz	16.0
Calcium borate	14.2
Whiting	7.7
Kaolin	3.1
+ Copper carbonate	0.4
+ Tin oxide	1.0
+ Suspension agent (similar to CMC gum)	0.3

TEMMOKU GLAZE, *cone 10*	
Potash feldspar	59.2
Quartz	20.4
Whiting	13.9
Kaolin	6.5
+ Red iron oxide	7.5
+ Suspension agent (similar to CMC gum)	0.3

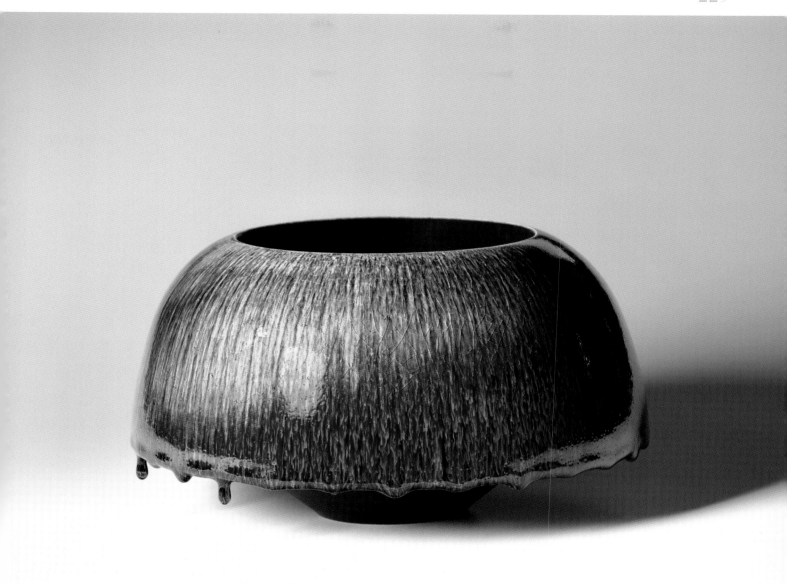

Bowl *11¹/₂ × 11¹/₂ × 6¹/₂ in. (29 × 29 × 16.5 cm), double-walled thrown stoneware, sprayed Temmoku and copper red glazes. Fired to cone 10 in reduction. SEE GLAZE DETAILS, LEFT.*

● *The golden-to-red glaze that drips off the form has not only intense chroma, but also a depth and texture beneath the glossy surface where the "hare's fur" effect becomes mesmerizing.*

● *The color palette alludes to fire, molten rock, and the intense heat of lava flow.*

Bean Finneran

Each curve in Bean Finneran's work is hand rolled, dipped, painted, and fired separately, and amassed later into delicate, geometric structures whose impermanence echoes their transformative beginnings. This labor-intensive process is tempered by a meditative approach, with each piece being treated as a singular element, yet the way they are combined suggests infinity. The fragile stacks of thin earthenware curves are painstakingly assembled *in situ*, held together by friction. In this way, they are ever-changing objects with continuity.

The role of color is paramount in Finneran's work, being the visual glue that binds each pile of curves together, making a mass out of the individual elements. The vibrant color is amplified by the glossy, glazed tips on each curve, flickering in the light and drawing the viewer into the saturated centers of each piece.

Red Cone at High Tide *42 × 42 × 60 in. (107 × 107 × 152 cm), 15,000 hand-rolled clay curves, earthenware clay, red low-fire glaze on tips, fired to cone 08, acrylic stain on curves. SEE GLAZE DETAILS, BELOW.*

Technical Description

Amazingly, each strand of Bean's sculptures is a hand-rolled coil that has been glazed individually. Pieces are sometimes brushed with Amaco velvet underglaze before bisque firing, while others are painted with acrylic paint and stains after the glaze firing. Each curve is bisque fired, then the tips are glazed, and the pieces then refired to cone 08 (approximately 1,700°F/927°C) propped over kiln posts so that the tips do not touch the shelves.

GLAZE DETAILS

COMMERCIAL RED GLAZES,
cone 08
Christmas Red (Duncan GL637)
Matador Red (Duncan GL614)
Calypso Red (Duncan GO134)
Christmas Red (Mayco hand brushed acrylic stain SS1762)

Red Ring *72 × 72 × 5 in. (183 × 183 × 13 cm), 7,000 hand-rolled clay curves, white earthenware clay, red low-fire glaze, fired to cone 08, acrylic stain. SEE GLAZE DETAILS, LEFT.*

66 All of my work is about color and composition and transformation. I am interested in color and the contrast between the very matte color surface of fired underglaze and acrylic stains, and the very shiny color surface of glaze, and what happens where the two surfaces meet. 99

● *The intense monochromatic red color exudes power, passion, and vibrancy.*

● *The red is extreme, saturated and artificial looking, contrasting dramatically with the natural background.*

Thaddeus Erdahl

The lifelike works of Thaddeus Erdahl feel intensely nostalgic. The evocative figure sculpture *Red* appears as a weathered and worn figurehead from an old whaling ship, or a decaying religious icon that has survived history. With a vacuous downcast stare, the simple gesture and melancholic gaze evoke a rich yet ambiguous narrative. Inspired by his love of old wooden toys and antique tin, Erdahl impeccably simulates aged and worn surfaces with cracks and crevices, chips and stains. Vividly capturing a sense of time, the work keeps the viewer puzzled about the material, amazed by the technical virtuosity, and endlessly curious about the supposed life the object has lived.

Technical Description

In the leather-hard to advanced leather-hard stage, Erdahl's piece is covered in layers of engobe, terra sigillata, slip, underglaze, and a wash. First, where a cracked surface is desired, the TB Engobe is brushed on the textured surface. Alternating layers of sig, slip, Riggs terra sigillata, and commercial underglaze are sprayed on (sometimes only in specific areas, sometimes over the whole piece). A very thin mix of the slip is brushed on the sculpture in specific areas and then drips and runs are encouraged with a water spray bottle. After a cone 08 bisque firing, Erdahl carefully works back through the layers with a metal file and wet/dry sandpaper (up to 800 grit) to simulate years of wear. Then the piece is coated in two layers of thinned Surface Activation Wash. The eyes are then painted with various underglazes; a final layer of Duncan Clear glaze and then the piece is fired to cone 04. After the glaze firing, encaustic wax with pigment is applied in areas with wood grain texture and to create the rouged cheeks. Finally, the entire piece is coated with Briwax and very carefully ignited with a torch. The carbon released from the burning wax is absorbed into the porous clay, adding to the simulated deterioration. Once the wax cools, the entire piece is burnished with a stiff-bristled brush.

> " The colors I choose are nostalgic to me. They are derived from colors that I have seen on antiques, toys, and other objects from history. "

SURFACE DETAILS

TB ENGOBE VARIATION, *cone 04*
This recipe is from Tom Bartel

Borax	4.5
Gerstley borate	9.1
Frit 3110	31.9
Ball clay	13.6
Kaolin	27.3
Silica	13.6
+ Magnesium carbonate	0.25

CASSIUS BASALTIC SLIP, *cone 04*
Aardvark Clay's Cassius Basaltic clay slaked down into a slip.

RIGGS TERRA SIGILLATA, *cone 04*
This comes from a recipe by Laura DeAngelis
3.5 gallons (15.9 l) water
1 tbsp sodium silicate
1 tbsp soda ash
15 lb (6.8 kg) XX Sagger ball clay

UNDERGLAZES
Medium Blue (Amaco Velvet V-326)
Avocado (Amaco Velvet V-333)
Turquoise (Amaco Velvet V-327)
White (Amaco Velvet V-360)
Velour Black (Amaco Velvet V-370)
Yellow (Amaco Velvet V-308)

SURFACE ACTIVATION WASH
2 cups soda ash
2 cups borax
1/2 tsp Gerstley borate
Mix with 2 cups hot water per 1 cup of powder.

CLEAR GLAZE, *cone 04*
Duncan Envision IN 1001

● The heavily layered surface takes on many colors that emerge and recede as if the piece has been eroded by years of weather.

● The red in the cap, though muted, is the brightest element in the piece, and brings out the blush on the cheeks and lips, adding hope and a bit of vitality to the weathered and worn figure.

RED *17 × 11 × 9 in. (43 × 28 × 23 cm), red earthenware, layers of engobe, terra sigillata, slip, and underglaze, sodium borate wash, clear glaze applied to eyes, fired to cone 04.*
SEE SURFACE DETAILS, LEFT.

Rebecca Chappell

Attracted to "found" colors such as vivid yellow lemons and bright green apples, Rebecca Chappell creates functional terra-cotta forms that are designed to amplify the vibrancy and richness of such inspiring colors, by complementing them with form and surface. Her installation titled *Red Carpet* encompassed a long, low table densely packed with a cityscape of vases designed to hold 850 red carnations perfectly level, creating a suspended field of red in the center of the gallery. Red glaze capped her vase forms, bridging the gap between clay and petal. Alluding to the grandeur of fame, the "carpet" of flowers pointed conspicuously out of the gallery's wall of windows and onto the bustling city streets of Philadelphia. Like much of Chappell's work, this piece was inspired by an intuitive sense that she cultivates through the process of making her vibrant, expressive, and dynamic pottery forms.

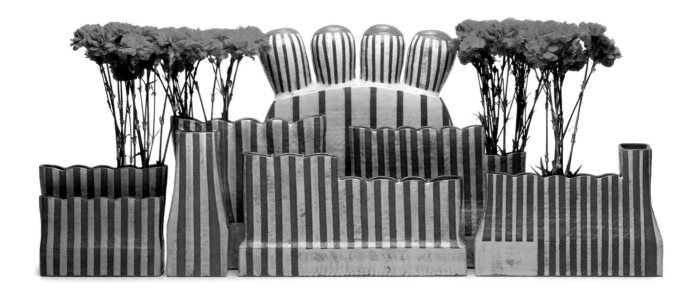

GLAZE DETAILS

SATIN RED, *cone 04*

Frit 3124	70
Dolomite	5
Zinc oxide	5
EPK	15
Flint	5
+ Dark Red stain (Mason 6097 ZrSeCdSi)	8
+ CMC gum	0.5
+ Veegum	1

Red Carpet *36 × 20 × 14 in. (91 × 51 × 35.5 cm), coil-built terra-cotta, Satin Red glaze, fired to cone 04. Red carnations. SEE GLAZE DETAILS, LEFT.*

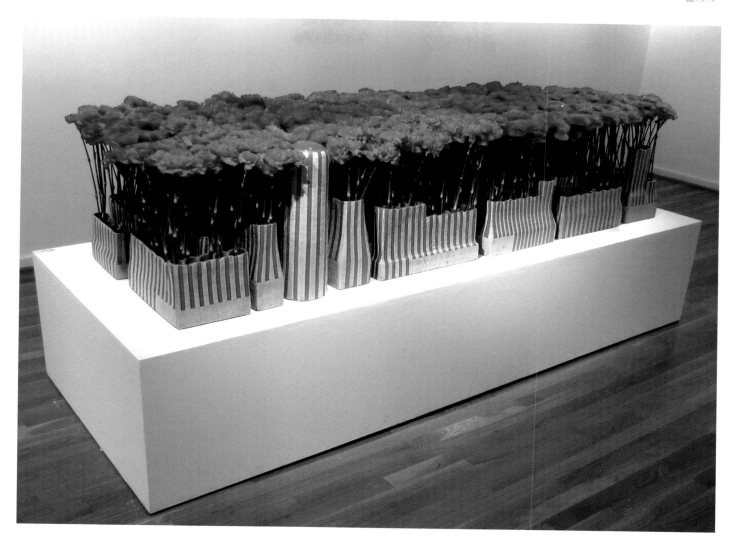

Technical Description

Chappell prepares the glaze on the thick side, sieves it three times, and then mixes in 0.5 percent CMC gum for brushability. After bisque firing, the terra-cotta pieces are brushed with three coats of the Satin Red glaze to achieve a good opaque coating. Brush strokes and pinholes are delicately rubbed down with a finger and the pieces are fired to cone 04.

● *The fire-engine red glaze that caps her vase forms mimics the vivid color of red carnations that create a carpet of color atop the cityscape-like vase assemblage.*

● *The red clay is punched up brighter when in contrast with the minty green stripes, bringing it closer to the brightness of the flowers and adding an earthy undertone to the three reds of the piece.*

Molly Hatch

Based on the textile collections at the Victoria and Albert Museum in London, Molly Hatch's *Lyon Silk II* is one in a series of plate paintings that ambitiously straddle the historic and contemporary canons of design, decorative, and fine arts. In this piece she skillfully blankets the plates in a pattern based on a gouache design for a woven silk, punctuated by fanciful flowers. Her utilization of vibrating blue and red hues adds an intensity to the otherwise tame decoration. Steeped in history, Hatch's work offers us the dynamic collage of form and surface as a window through which we can reevaluate our relationship with pattern, display, and functional pottery.

Technical Description

After bisque firing, Hatch's pieces are carefully decorated with a combination of engobes and commercial underglazes. The engobe is mixed thickly with a handheld blender and stains are added in ratios of stain to base from 1:4 up to 1:1 to achieve the desired color. To make brushing easier on the bisqueware, Hatch mixes a 1:1 ratio of CMC gum and Macaloid with hot water and then stirs small amounts into the engobe. Pieces are then dipped in glaze and fired to cone 8 with witness cones. The Kitten's Clear Gloss glaze is prepared on the thin side and is screened through 100- and 120-mesh sieve .

Lyon Silk II 26 × 22 × 2 in. (66 × 56 × 5 cm), after a textile design in the Victoria and Albert Museum, London, made in France 1765–1770. Hand-thrown and hand-built porcelain plates with commercial underglaze, engobe, and clear glaze, fired to cone 8. SEE GLAZE AND ENGOBE DETAILS, BELOW LEFT.

> ❝ Fascinated by how we live with objects, how and why we acquire objects, and what happens to them throughout history. I see this piece as a reflection of the life of surface pattern through the decorative art continuum. ❞

KITTEN'S CLEAR GLOSS, cone 5–6
This recipe is from Kathy King. It is intended for cone 5–6, but Hatch fires to cone 8.

Nepheline syenite	28.8
Wollastonite	7.7
Gerstley borate	20.2
Strontium carbonate	14.4
EPK	9.6
Flint	19.2

UNDERGLAZES
Radiant Red (Amaco Velvet V-388)
Violet (Amaco Velvet V-380)
Maroon (Amaco Velvet V-375)
Light Green (Amaco Velvet V-345)
Dark Green (Amaco Velvet V-353)
Black (Amaco LUG-1)

CINDY KOLODJESKI'S VITREOUS ENGOBE BASE, cone 04
This is meant for cone 04, but Hatch has tested with Mason stains in oxidation to cone 8 with success; it essentially turns into a glaze at higher temperatures.

Kaolin	5
Kentucky ball clay	15
Calcined clay	25
Frit 3110	18
Talc	15
Silica	20
CMC gum	1
Macaloid (similar to Bentonite)	1

Blue
1 part Cerulean Blue stain (Mason 6379 ZrV) to 1 part engobe base

Pink
6 parts Manganese Aluminum Pink stain (Mason 6020 MnAl) to 5 parts engobe base.

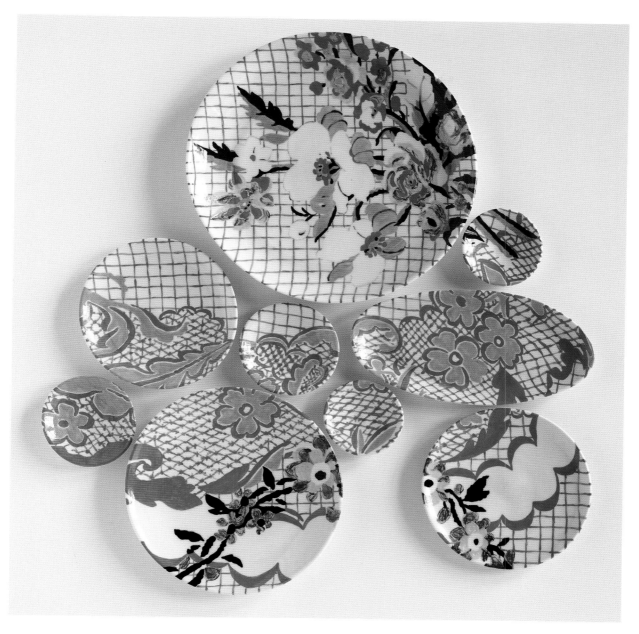

● The red and blue hues are of high saturation and equal value, causing them to visually "vibrate." This phenomenon intensifies the imagery, adding a vibrancy and edginess to the delicate pattern.

● The drastically enlarged imagery allows for the color and pattern to dominate the scene, with the plates creating a unique asymmetrical framework that breaks up the composition.

● The addition of several other hues, including the secondary purple, pulls the contrasting red and blue into a more complex and diversified pattern.

Shannon Goff

Thunder and Lightning
16½ × 14½ × 16 in. (42 × 37 × 41 cm), coiled and pinched earthenware and porcelain, multiple studio and commercial glazes, fired to cone 04.

Music, drawing, light, rhythm, and gravity all play an important role in the linear sculptures of Shannon Goff, as she embraces extemporaneous techniques in all facets of her process. The supersaturated colors and the yielding quality of the medium's materiality meld in the creation of her vivid, weblike structures, which reference elements of the real through a formalized abstraction. In her piece *Mars Rover*, the cluster of brilliant, satin-red lines is orchestrated to render the imagined surface of the distant planet tangible.

Technical Description ▷

The piece *Mars Rover* was constructed with earthenware—a heavily grogged brick and tile clay. The red Sinter engobe was applied by spraying and brushing, and the piece was then fired to cone 04 in a programmable electric kiln. Goff describes her process with a quote by Paul Simon: "Improvisation is too good to leave to chance."

> ❝ I try to observe color as phenomenon and as sculptural material. I try and enjoy color where I find it in the world. As Robert Irwin said, 'There's no palette as rich as a garden.' ❞

ENGOBE DETAILS

SINTER ENGOBE SE 10, *cone 04–1*

Kaolin	23
Lithium carbonate	5
Nepheline syenite	32
Quartz	22
Whiting	15
Zinc oxide	3
+ Lobster stain (Mason 6026 ZrSeCdSi)	15

Note: This engobe comes from the book, The Ceramic Process by Anton Reijnders.

Mars Rover *16 × 15 × 16 in. (41 × 38 × 41 cm), coiled and pinched earthenware, red Sinter engobe, fired to cone 04.* SEE ENGOBE DETAILS, LEFT

● *Red is specifically used to be the metaphor for Mars, "the red planet."*

● *The saturated red hue is fiery, forward, lively, and seductive.*

● *The satin-matte surface quality and monochrome treatment help our eyes focus on the form.*

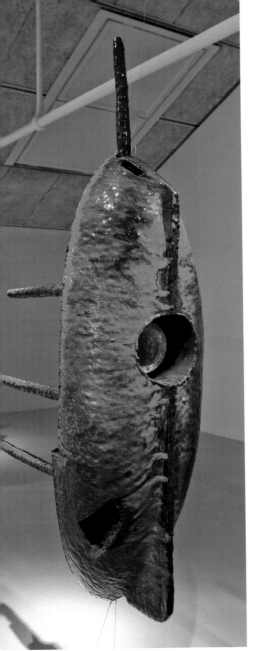

Neil Forrest

Within the small Kvernes Stave Church, a wooden model of the Northern Star, famously sunk by vice-admiral Tordenskjold, hangs in the aisle, between rows of pews. Roughly carved by sailor Sjur Kjol, it represents a significant battle in which fledgling Norway defeated a Swedish frigate. This suggestive and exotic "object within an object," as artist Neil Forrest puts it, was the initial inspiration for his elaborate and entrancing installation, *Hard Transits*.

The four ship forms are each based on specific vessels and were chosen for the particular dramas their histories hold. Within each vessel, a unique architecture exists, revealing unpredictable interior spaces, echoing the idea of a story within a story. With intense chromatic schemes and sensuous layering of glazes, the ships appear in some cases as fluid fields of lurid, viscous color, with a depth that suggests the weight of time and wear. The vertical orientation, dramatic colors, and relationship with the surrounding architecture all add to the dynamic narrative that permeates the work.

GLAZE DETAILS

JACKIE'S MATTE, *cone 06*
This recipe is from Jacqueline Rice
Gerstley borate	38
Nepheline syenite	5
EPK	5
Silica	42
Lithium carbonate	10
+ Zircocil or Superpax	10

COMMERICAL GLAZES
Red (Laguna fritted lead 940)
Yellow (Laguna fritted lead 941)
Transparent (fritted lead 1007)

Technical Description

Pieces are hand built from stoneware clay and bisque fired to cone 5 (2,160°F/1,182°C). A layer of Jackie's Matte (black) is brushed on as a base color, followed by a brushed layer of the desired fritted color, and another brushed layer of black matte, and then a final layer of the same fritted color is sprayed on. (Glazes are prepared with suspending agent CMC gum, which also improves brush application.) The pieces are then "down" fired to cone 06 (1,823°F/995°C). As part of the hanging system, metal fittings are epoxied into key locations that grasp ceiling wires.

Hard Transits: Gjøa
(detail). Whole ship: 54 × 14 × 16 1/2 in. (138 × 35 × 42 cm). SEE GLAZE DETAILS, LEFT.

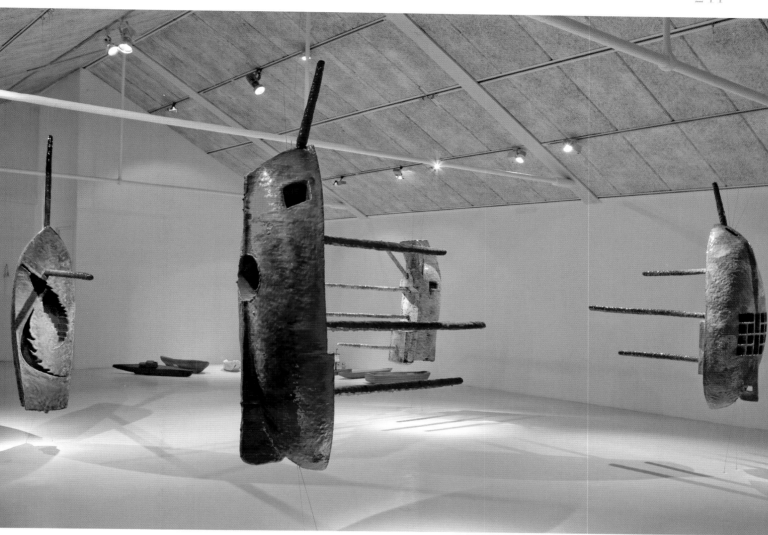

Hard Transits *Fram (red ship): 56 × 13 × 16¹/₂ in. (143 × 34 × 42 cm), hand-built stoneware, bisque fired to cone 5, Jackie's Matte and commercial red and yellow glazes, fired to cone 06, metal fittings.* SEE GLAZE DETAILS, LEFT.

● *Incredibly saturated red is electrifying, with its bloodlike, viscous flow.*

● *The rusty hues of the other ships act as a foil to the intense red, adding a unique dynamic to the piece.*

● *The black undertones of the surfaces echo the deep, dark, and ominous cutouts in the ship forms.*

66 Color is both discursive and subjective [and in this work] forms a continuous counterpoint to a freight of historical references. 99

Linda Swanson

Linda Swanson's works revolve around her very curious investigation of clay and glaze phenomena and how their materiality can manifest a sensual and optical ambiguity, and implicate our sense of temporality and corporeality. Vibrant colors that can be found in the landscape as well as the body are carefully chosen to allow her pieces to transcend both places, in an attempt to mirror our own sense of self in the objects, and to provoke a sense of wonderment with nature. Her poetic use of color and crystalline surfaces is both sensually tactile and phenomenally ambiguous.

Red Eye View *23 × 23 × 5¹/₂ in. (58 × 58 × 14 cm), slip-cast porcelain, Secret Crystalline glaze fired to cone 9 in oxidation, aluminum frame. The red color comes from local reduction of copper by silicon carbide.* SEE GLAZE DETAILS, BELOW.

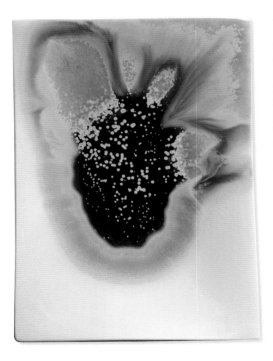

Technical Description

Swanson's crystalline glazes are never sieved and they are used immediately after mixing to avoid settling of the mixture. Sprayed on in multiple thick layers, the glaze is encouraged to move and settle as it melts and the porcelain relaxes. Colorants are applied unconventionally, sometimes by sprinkling powdered material over a sprayed base layer to achieve color variations. These pieces were fired to cone 9 with a hold upon cooling at 2,000°F (1,093°C) for 15–30 minutes to allow only small crystal growths to develop. The red color on *Red Eye View* comes from local reduction of copper by silicon carbide in the glaze. Swanson uses a cone 9 porcelain body, which provides a clear, bright color response and doesn't interfere with crystal formation.

Califactum Chartruese *6 × 4¹/₂ × 1 in. (15 × 11 × 2.5 cm), slip-cast porcelain, #11 crystalline glaze fired to cone 9 in oxidation.* SEE GLAZE DETAILS, BELOW.

GLAZE DETAILS

SECRET CRYSTALLINE GLAZE, cone 9	
Frit P-25	24.75
Frit 3110	29.7
Zinc oxide	24.75
Silica	19.8
Borax	1
+ Copper carbonate	1.5
+ Silicon carbide	1.5
(colorants are sprinkled)	

#11 GLAZE, cone 9	
Frit 3110	50
Zinc oxide	25
Flint	23
Titanium dioxide	2
+ Nickel oxide	2
+ Nickel carbonate	2

Note: The base glaze of Secret Crystalline Glaze came from a video entitled The Secret to Cystalline Glazing with Phil Morgan, *and Glaze #11 came from* The Art of Crystalline Glazing: Basic Techniques *by Jon Price and LeRoy Price.*

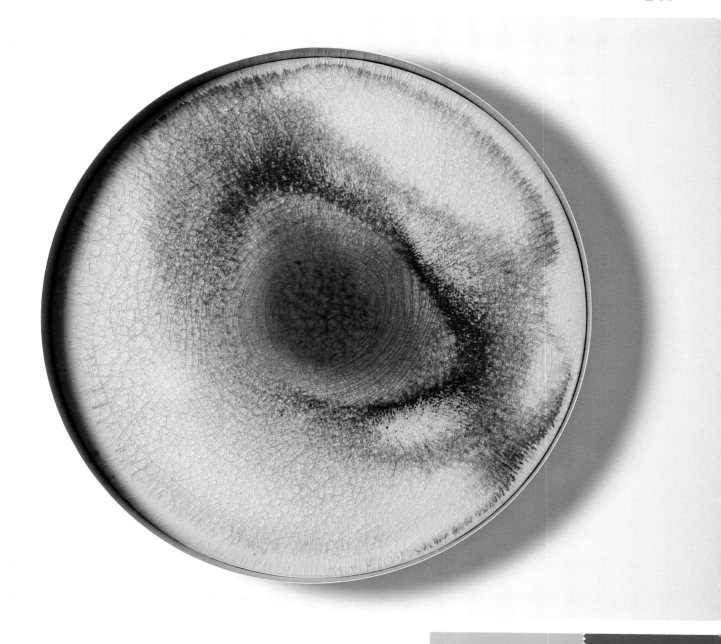

66 Solidifying into luminous formations, these glazes reveal something like a topographical map of the material tensions and stresses in the piece. 99

● Colors fade and shift in the deep pool of glaze, from blood red to crystal water blue.

● Colors relating to both landscape and the body offer different points of entry for the viewer.

● The depth, luminosity, and texture of the glaze material are integral to its coloring.

Daphne Corregan

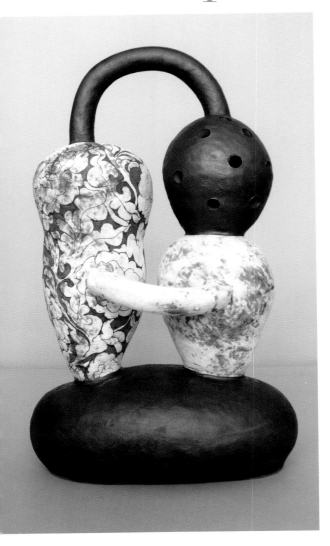

Suggestive of two heads, the massive conjoined volumes of Daphne Corregan's work are draped in a decorative peony motif inspired by traditional patterns from China's Song dynasty. These "undercover" objects are disrupted, even confused by the density of the flowers on the surface. Like a veil over their faces, the seductive peonies leave the viewer to ponder what expression may be hiding beneath. The black oxide wash burns through the white engobe, suggesting the carbonaceous effects of a raku firing, while the bright red of the terra-cotta fills the floral shapes with an earthy vibrancy.

Technical Description

Mixed to the consistency of liquid ink, a triple oxide wash is brushed onto the greenware piece. Next, Corregan brushes six to seven layers of the white engobe over the form, mixed thin to the consistency of milk. Once dry, she painstakingly engraves the floral pattern by carving through the engobe and wash layers to reveal the red clay beneath. This is all done without stencils or other aids in order to retain a lively flow on the surface. The piece is then slowly fired once in a gas kiln in oxidation to cone 2 (2,120°F/1,160°C).

Communicating Vessels *11 × 8 × 19 in. (29 × 20 × 48 cm), terra-cotta, black oxide wash, white engobe, sgraffito in the Song dynasty Peony design. Fired to cone 2 in oxidation.* SEE OXIDE AND ENGOBE DETAILS, BELOW LEFT.

OXIDE AND ENGOBE DETAILS

BLACK OXIDE WASH, *cone 2–10*

Copper oxide	33.3
Cobalt oxide	33.3
Iron oxide	33.3

Note: Adding a teaspoon of a low-fire transparent glaze to each 9 oz. (250g) preparation of oxide wash can help to "fix" it.

ENGOBE
White engobe (Ceradel E1)
Note: Corregan sometimes adds a dash of gum arabic to the white engobe for better adhesion.

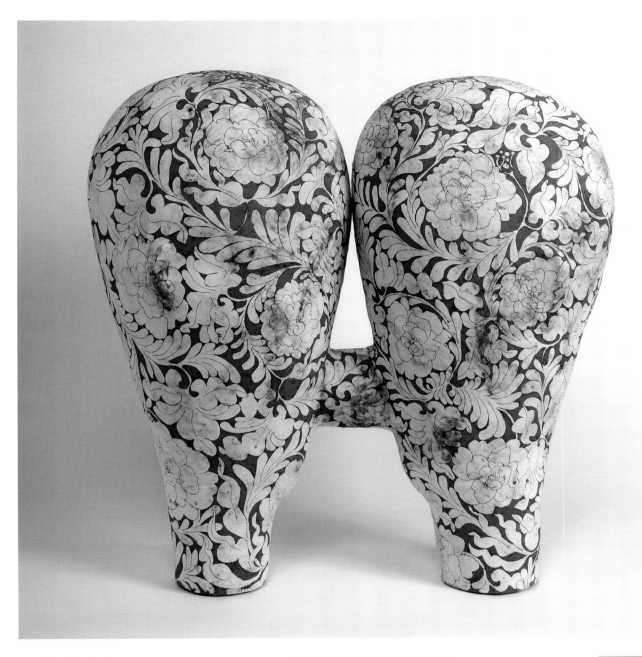

Breathing Under Cover *25¹/₂ × 15 × 25¹/₂ in. (65 × 38 × 65 cm), terra-cotta, black oxide wash, white engobe, sgraffito in the Song dynasty Peony design. Fired to cone 2 in oxidation.* SEE OXIDE AND ENGOBE DETAILS, LEFT.

● *The delicate carving into the terra-cotta clay reveals the dominant color, a very rich red-orange, like flesh or luxurious velvet.*

● *The oxide wash burns through the white engobe, adding an antique feel to the surface.*

Remon Jephcott

Thick with allegory, Remon Jephcott's work is directly influenced by the 16th- and 17th-century Dutch Masters' still-life paintings, and particularly the "Vanitas" works that depict the inevitability of death and the transient nature of earthly goods. The crackle in the glaze reveals its materiality while the amber-brown color exemplifies a very lifelike rotting from the core of the decaying fruit. The added silver fly and gold luster accents further exemplify a sense of indulgence and preciousness in the work that defies its unsavory content.

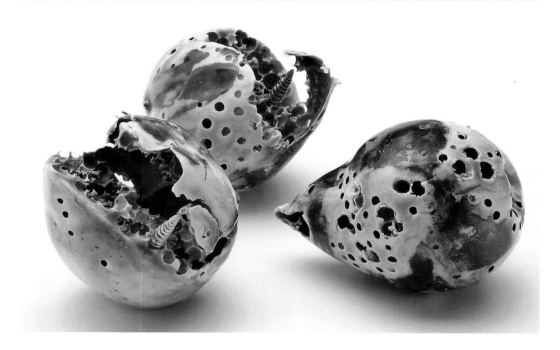

GLAZE DETAILS

PASSION RED UNDERGLAZE
Duncan EZ 075

GLAZE 1, *cone 04*

Lead bisilicate	68
Calcium borate frit	12
Kaolin	12
Flint	8
+ Intense Red stain (Contem GS26 ZrSiCdSe)	10
+ Fuchsia stain (Contem GS25 CrSn)	5
+ cobalt carbonate (a tiny amount, unmeasured)	

GLAZE 2, *cone 015*

Lead sesquisilicate	57.5
Whiting	19.5
Barium carbonate	9.0
Lithium carbonate	7.0
Kaolin	7.0
+ Copper carbonate	3.0
+ Vanadium pentoxide	5.0

Note: Lead is toxic and should not be used on functional work. It may also cause a hazard to the artist in handling and firing.

Pears *2 × 2 × 3 in. (5 × 5 × 8 cm) each, slip-cast earthenware clay with organic material, bisque fired to cone 02, glaze fired to cone 04, second glaze fired to cone 015, luster fired to cone 016, cast silver maggots.*
SEE GLAZE DETAILS, LEFT.

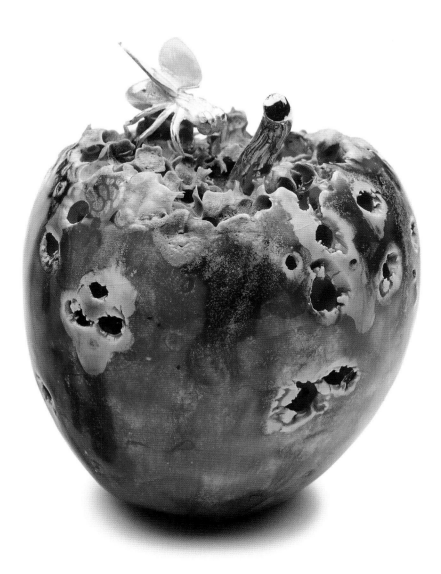

● *Brilliant red gives the apple realistic color that also signifies seduction.*

● *The interior amber color contributes to the decaying look of the piece.*

Technical Description △

The slip-cast apple form is made with combustible materials that burn out in the firing, leaving the desired effect of decaying holes. After bisque firing, the inside and any holes are first brushed with an oxide wash of copper carbonate and manganese, then the outside is given a coat of the Duncan red underglaze and fired to cone 02 (2,048°F/1,120°C). The outside is brushed with Glaze 1 and it is fired again to cone 04 (1,940°F/1,060°C). Next, the interior and any holes on the outside are brushed with Glaze 2 and it is fired to cone 015 (1,472°F/800°C). Finally, luster is applied to the stem, the piece is fired to cone 016 (1,418°F/770°C), and then the fly, made of cast silver, is attached.

Apple with Silver Fly *3 × 2 × 2 in. (8 × 6 × 6 cm), slip-cast earthenware clay with organic material, bisque fired to cone 02, glaze fired to cone 04, second glaze fired to cone 015, luster fired to cone 016, cast silver fly. SEE GLAZE DETAILS, LEFT.*

Susan Nemeth

Inspired by the background details of various works by famed painters like Henri Matisse and Paul Klee, Susan Nemeth uses color in an exuberant fashion to enliven her vessel forms. The pink-based color palette for her piece *Lillies 2* was specifically inspired by Matisse's 1912 masterpiece, *The Goldfish*. With a unique technical process, the vessel forms are given a mysterious yet revealing materiality. Patches of inlaid and stretched colors meld into the form seamlessly, yet the artist's mark is ever present in the raw surface. The simple, perfect arcs of her bowl forms act as an engaging canvas for her decorative abstractions to wrap around.

Technical Description

Color is achieved by blending stain mixed with a little water and her commercial porcelain clay body using a blender or drill mixer. Once the color is evenly mixed into the now thick slurry, the clay is dried to soft clay consistency on a plaster slab. Thin layers of clay and slip are laminated and small elements are hand cut from colored clay and set into the surface. With a sponge, Nemeth carefully erodes the surface around the inlays to reveal different layers below, and then the slab is rolled thin and draped over a hump mold. After forming, the bowl is transfered to a dish mold and a foot ring is added at the leather-hard stage. When dry, the piece is fired to a low bisque temperature of cone 08 (1,745°F/950°C), and then wet/dry sanded under water. Once dry, each piece is placed in a saggar and submerged in sand to keep the piece from warping during the firing. Pieces are fired to cone 9 (2,336°F/1,280°C) in an electric kiln.

> My ceramics are concerned with exploring the handmade mark. I am looking for the vulnerability and the essence of the human touch with all its imperfections. I am interested in working from the quick pure basic sketch and transforming it into clay. I use porcelain for its purity, sensitivity, fragility, and strength.

STAIN DETAILS

RED BODY STAIN, *cone 9*
Sneyd Ceramics SC 527 ZrSiCdSe

Approximately 1.5% of this stain is added to Audrey Blackman porcelain to create the pale pink.

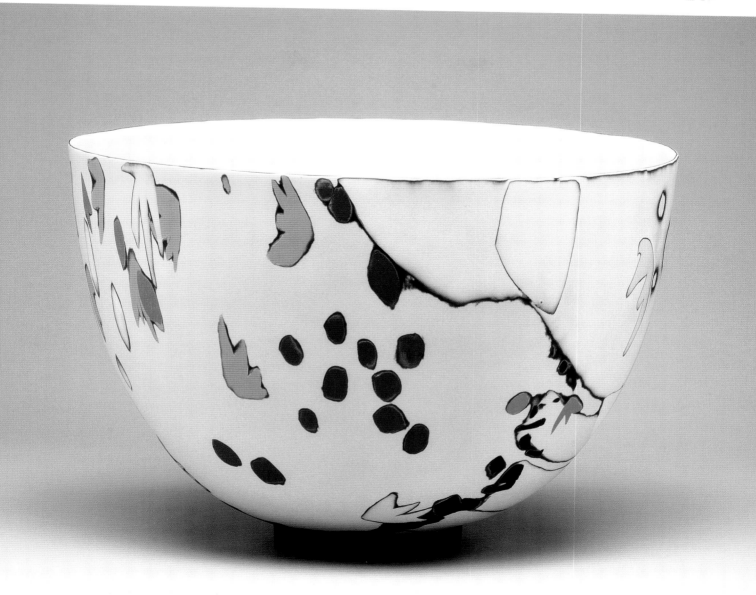

Lillies 2 *9 × 13 × 13 in. (23 × 33 × 33 cm), press-molded porcelain, inlaid using layers of stained porcelain and slips. Fired to cone 9 in oxidation. SEE STAIN DETAILS, LEFT.*

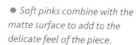

● *Soft pinks combine with the matte surface to add to the delicate feel of the piece.*

● *The pink, which often signifies femininity, is reinforced by the gentle bulbous curve of the form and the soft, floating flower petals.*

Emily Schroeder Willis

With a sense of economy in form and surface, Emily Schroeder Willis achieves a balance of elegance and functionality in her work. Simplified forms are designed for each line, mark, and curve to speak volumes. The touch of her fingertips on the clay leaves a permanent and intimate mark of time spent laboring over its creation, a mark that can be coveted and connected to through use. The subtle colors, satin surfaces, and gentle textures harmonize to complement the food or flowers for which they were designed. As the glazed surface "blushes" like soft, tender skin, the works reinforce a corporeal connection.

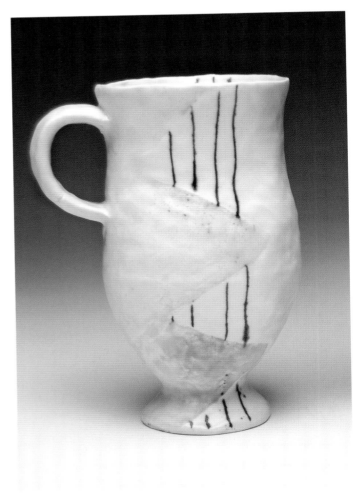

Cup *3 × 3 × 4½ in. (8 × 8 × 11 cm), brushed-on glaze, wax resist, dipped in glaze, etched black wash. Fired to cone 10 in oxidation.* SEE GLAZE DETAILS, BELOW.

Technical Description

After bisque firing, pieces are dipped or brushed with Val's Satin Matte glaze. Lines are drawn on the dry glazed surface with a pencil and then a coat of Aftosa Wax is applied over the lines. Tracing the line with a needle tool, Willis scratches through the wax and glaze and into the bisque-fired clay below. With a small brush, the black ink consistency wash is applied into the scratched line, and once dried the excess is wiped with a damp sponge. Pieces are fired in oxidation to cone 10 in a gas kiln. The pinks are a result of her glaze reacting with chrome in the etched-in stain and from tiles of chrome in the kiln.

GLAZE DETAILS

VAL'S SATIN MATTE GLAZE, *cone 10*
This recipe is from Val Cushing

Whiting	34
Cornwall stone	46
EPK	20
+ Tin oxide	6

Note: Blushes pink when it comes near chrome in the kiln.

TONY'S MAG MATTE, *cone 10*
This recipe is from Tony Flynn

Custer feldspar	18
Dolomite	12
Whiting	16
EPK	32
Silica	22

BLACK LINE WASH

Gerstley borate	60
Best Black stain (Mason 6600 CrFeCoNi)	40

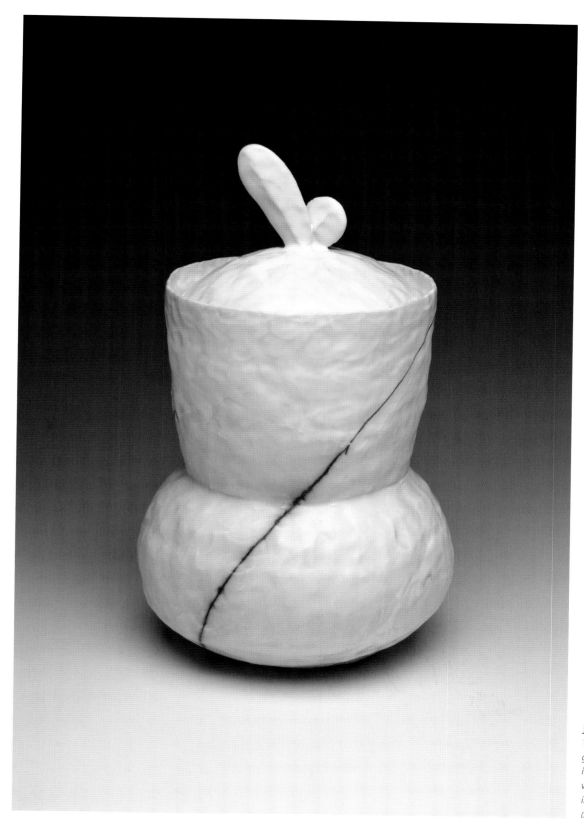

● *Chrome in the black
lines creates a blushing
of pastel pinks that
subtly fade to white
in the tin-white glaze,
adding softness to the
gentle forms.*

● *Thin, inlaid black lines
add a graphic element to
the pieces that enhances
the composition.*

Jar *7 × 7 × 12 in. (18 ×
18 × 30 cm), brushed-on
glaze, wax resist, dipped
in glaze, etched black
wash. Fired to cone 10
in oxidation.* SEE GLAZE
DETAILS, LEFT.

Eva Kwong

The anthropomorphic vase *Arethusa* is part of the long-running series entitled *Opposites Attract*, in which Eva Kwong draws on her Chinese upbringing to create works based on the concepts of duality and transformation. Adding a narrative element, the piece is titled after the character Arethusa from Greek mythology, who transforms from a nymph to a stream of water. Kwong describes the thin open stem and the voluminous enclosed vessel as being joined in a dynamic balance of "open/closed, matter/void, male/female, and absence/presence." The two binaries remain in flux, however, as when the form is put to use with flowers emanating from the stem, the roles are reversed. The stem becomes full of life while the vessel now seems to be a vacuous space. Through cycles of use and display, the form vacillates between fullness and emptiness, and like a metaphor for any relationship, it is always mutable.

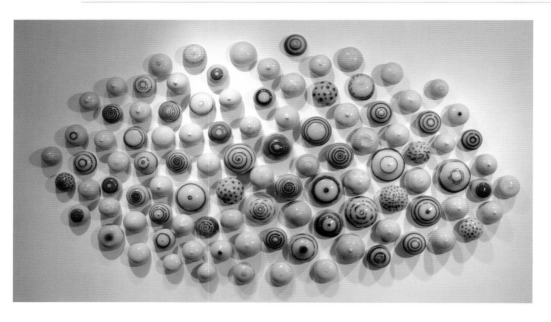

Energy Vibrations 60 × 110 × 6 in. (152 × 279 × 15 cm), wheel-thrown porcelain, clear glaze, tin/chrome oxide wash, fired to cone 6 in oxidation. SEE GLAZE AND WASH DETAILS, BELOW LEFT.

Arethusa Vase 10 × 8 × 8 in. (25 × 20 × 20 cm), wheel-thrown porcelain, clear glaze, tin/chrome oxide wash, fired to cone 6 in oxidation. SEE GLAZE AND WASH DETAILS, BELOW LEFT.

GLAZE AND WASH DETAILS

CLEAR, *cone 6*

Nepheline syenite	35
Wollastonite	10
Gerstley borate	10
Zinc oxide	10
Ball clay	10
Flint	25
+ Copper carbonate	0.25

The copper carbonate is only added sometimes—for a hint of color.

FLASHING MARKS WASH

Tin oxide	75
Chrome oxide	25

Note: This wash will be greenish when thick and pinkish when thin.

Technical Description

After bisque firing, the porcelain pieces are first dipped in glaze and allowed to dry. A tin/chrome wash mixture is then brushed on in decorative patterns (showing as green in the image) and the pink fuming occurs during the firing. Pieces are fired to cone 6 in an electric kiln.

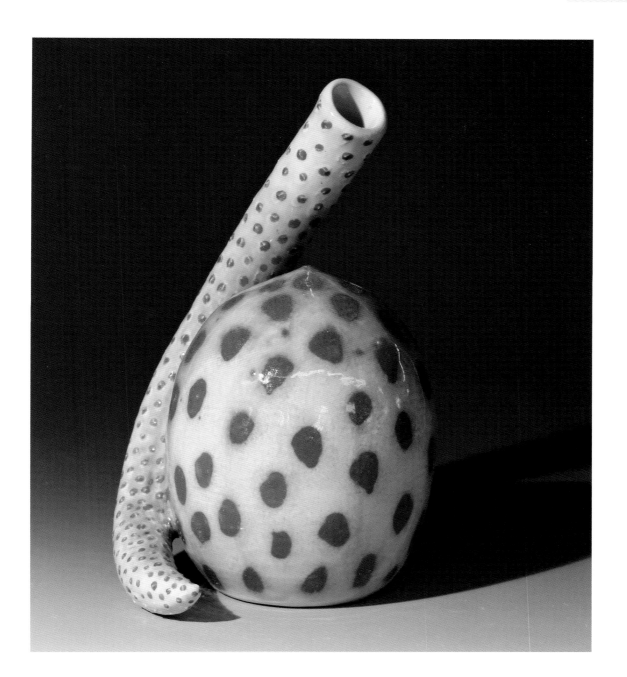

I think of color as bringing the sensuous, the abstract, the emotional, the symbolic, and the intuitive components to the composition. I believe color gives substance to the invisible. 99

● The "blushing" fleshy tone of the pink reinforces a visceral suggestion in the work.

● The chrome green dots blanket the belly of the form, adding a playful element that echoes the shape of the volume itself.

Dirk Staschke

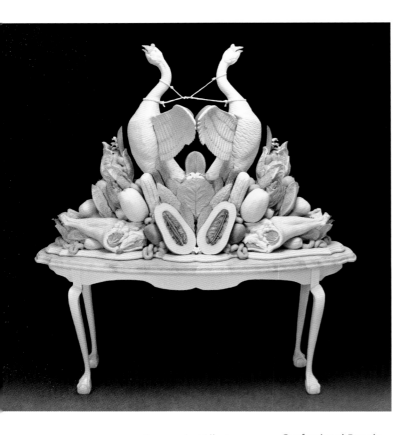

In this eloquent and masterfully created series, Dirk Staschke reinterprets "Vanitas" still-life paintings of 16th-century Northern Europe, in which opulent piles of food, flowers, and animals symbolize the futility of excessive pursuits and the inevitability of death. In *Confectional Façade*, a precarious tower of lavish deserts becomes a metaphor for gluttonous consumption and unfulfilling desires. The kaleidoscopic symmetry of *Consuming Allegory* combines seductive and beautiful objects that are decidedly subversive, poised with tension, revealing the complicated role that wanton appetites play in our actions. From decadent confections dotted with glossy, syrup-coated red cherries, to piles of fleshy, pale pink meats, Staschke's entrancing surfaces are wrapped in soft shades of color, adding to the surreality. Hard and hollow, the objects offer no sustenance, but rather the opportunity to reflect on their deceits.

Consuming Allegory
74 × 64 × 30 in. (188 × 162.5 × 76 cm), stoneware fired to cone 6, colored engobes, glaze fired to cone 04, gold luster. SEE GLAZE DETAILS, BELOW.

Confectional Façade
102 × 48 × 9 in. (259 × 122 × 23 cm), stoneware fired to cone 6, colored engobes, glaze fired to cone 04, gold luster. SEE GLAZE DETAILS, BELOW LEFT.

Technical Description

Staschke has developed his own clay and glazes to fit his needs for the work. He bisque fires the work to cone 6 to make it strong, sprays the pieces with glaze, and fires them again to cone 04.

GLAZE DETAILS

ALKALINE EARTHENWARE GLAZE, *cone 04*

F-4 feldspar	30
Barium carbonate	16
Lithium carbonate	10
Frit 3110	10
Whiting	7
EPK	15
Flint	12

Brenda Quinn

With an appreciation for the broad history of the decorative arts, Brenda Quinn finds endless creative motivation in the making of work that functions both esthetically and physically. The color, forms, and imagery of her beautiful, functional pottery are closely informed by nature, particularly nature's number system, the Fibonacci series. Multiple colors are used on her *Platter*, which break up the space, provide moments of focus, and add variety to the surface. Logical starting and stopping points for her glaze patterns are based on the ridges, curves, and corners of her forms. All-over pattern like the dots of white underglaze and the ornamental botanical line drawings span the entirety of the surface, uniting the various swatches of yellow and pink, and add depth to the surface.

Rectangular Vase *10 × 6¹/₂ × 4 in. (25 × 16.5 × 10 cm), porcelain, hand built with slab and coil, underglaze and glazes, sgraffito through glaze with inlaid underglaze. Fired to cone 6 in oxidation.* SEE GLAZE DETAILS, BELOW.

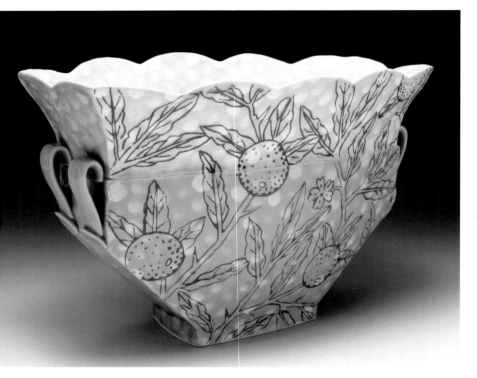

Technical Description

After bisque firing, Brenda Quinn's pieces are first dotted with commercial white underglaze using her finger. Then they are dipped in the color of choice and, once the glaze is dry, decoration is drawn on with a pencil. The surface is then coated in wax and, following the pencil lines, a small loop tool or X-Acto knife is used to scrape through the wax and glaze, revealing the clay beneath. Next, a gray underglaze is brushed into the carved lines where it adheres only to the exposed clay. Pieces are fired to cone 6 in an electric kiln.

> ❝ In an effort to have a range of tones, I have fine tuned the density of colors and the range of shades and tints of colors. ❞

GLAZE DETAILS

QUINN'S CLEAR, *cone 6*
This recipe is a variation on clear glaze from the Main Line Art Center in Haverford, PA

Gerstley borate	25
Wollastonite	8
Nepheline syenite	26
EPK	10
Silica	31

Pink
+ 3.5% Bordeaux Red encapsulated stain (Cerdec-Degussa 279497 ZrSiCdSe)
+ 3% White stain (Mason 6700 AlZrSi)

Yellow
+ 4% Praseodymium Yellow stain (Mason 6450 PrZrSi)

Blue
+ 8% Turquoise stain (Mason 6288 ZrVCrCaSi)

Green
+ 2.5% Praseodymium Yellow stain (Mason 6450 PrZrSi)
+ 5% Avocado stain (Mason 6280 ZrVCrFeCoZnAlCaSi)

UNDERGLAZES
White (Amaco LUG-10)
Warm Gray (Amaco LUG-15)

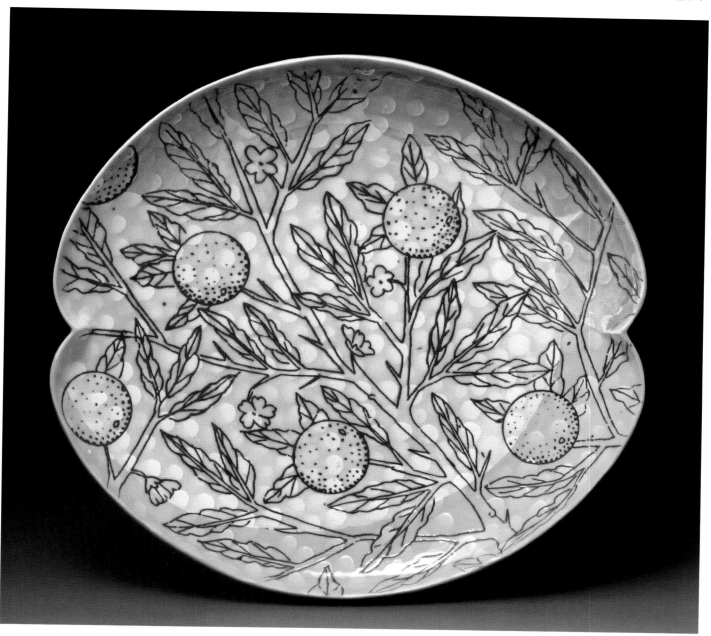

Platter *11 × 9 × 2 in. (28 × 23 × 5 cm), wheel-thrown and coil-built porcelain, underglaze and glazes, sgraffito through glaze with inlaid glaze. Fired to cone 6 in oxidation.* SEE GLAZE DETAILS, LEFT.

● *Solid and flat, yet translucent colors are used to enhance the layering strategy and add to the composition of the surface.*

● *The colors are quiet and don't dominate the form, allowing the precise and lovely gray botanical illustrations to be showcased.*

Lauren Gallaspy

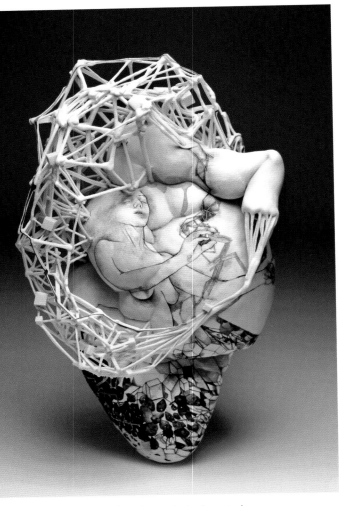

one need not be a house to be haunted
8 × 11¹⁄₂ × 6 in. (20 × 29 × 15 cm), cone 6 porcelain, commercial glaze fired to cone 6, underglazes fired to cone 1, post-firing gouache and varnish. SEE GLAZE DETAILS, BELOW.

American-born artist Lauren Gallaspy creates visual poetry with her uncanny sculptures. Relying on improvisation for the construction of her forms, Gallaspy follows her intuition as a way of finding meaning through the process of creation. Inspired by a phrase of Georgia poet Laura Solomon, her piece titled *into the brain like branches* is reminiscent of viscera, reminding us of our corporeal roots, and provoking an unsettling response. The fleshy pinks and reds reference the body, both inside and out, while the black illustrations suggesting co-mingling synapses and wiry limbs, paying homage to traditions in mark-making tools.

Technical Description ▷

Using a pitcher, glaze is poured carefully over the piece, especially over fragile areas. Thin coils are avoided and the line of demarcation helps to define the composition of the piece. When the glaze is dry, excess glaze is removed from fragile areas with a stiff brush and it is fired to cone 6. After sanding the unglazed portions to aid adhesion, underglaze is applied and the piece is refired to cone 1. A second application of underglaze is then applied and fired on to add depth and saturation to the linework. To further enhance and intensify colors, layers of gouache are applied after the glaze firing, and lastly, the piece is sealed with varnish.

> ❝ This piece may be, among other things, about the act of seeing, giving weight and visibility to something out of the corner of our eyes and minds. ❞

GLAZE DETAILS

CLEAR GLAZE, *cone 6*
Spectrum 1500

UNDERGLAZES
Gallaspy used Amaco Semi-Moist Underglaze Decorating Colors in the following colors on these pieces:
Pink (Amaco 41412H)

Peach (Amaco 41422T)
Rose (Amaco 41420R)
Red (Amaco 41425J)
Light Red (Amaco 41426K)
Salmon (Amaco 41432S)
Turquoise (Amaco 41409E)
Dark Blue (Amaco 41401H)
Warm Gray (Amaco 41413J)
Black (Amaco 41406B)

DARK RED ENCAPSULATED STAIN
Mason 6021 ZrSeCdSi
Applied with the underglazes after the bisque and glaze fire. Water is added to the powdered stain and integrated into the underglaze mixtures.

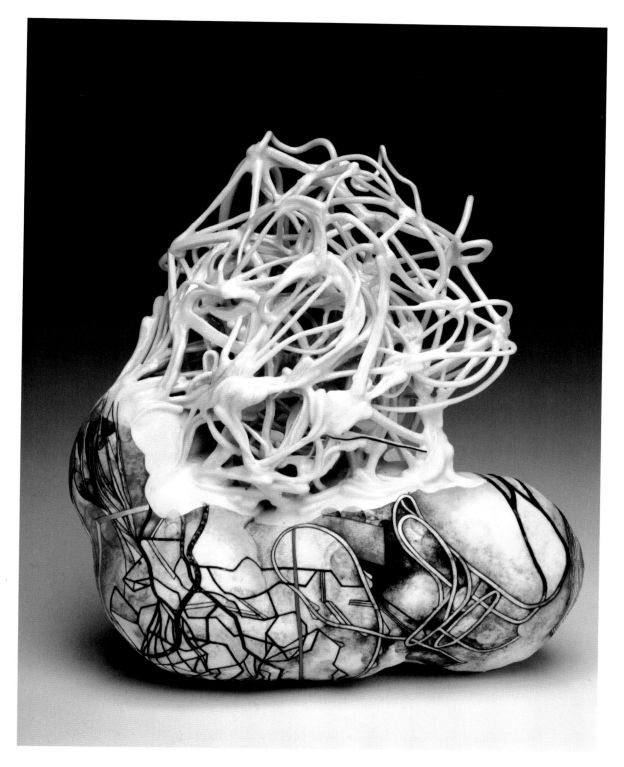

● Various shades of pink reference the body and flesh.

● White feels pure and clean.

● The black is used as a graphic element, drawing lines, grids, and tendrils that bridge the gap between the smooth decorated surface and the tangled web of white lines.

● Post-firing techniques add depth to the surface.

into the brain like branches *7 × 6¹/₂ × 3 in. (18 × 16.5 × 8 cm), porcelain, commercial glaze fired to cone 6, underglazes fired to cone 1, post-firing gouache and varnish. SEE GLAZE DETAILS, LEFT.*

Michael Eden

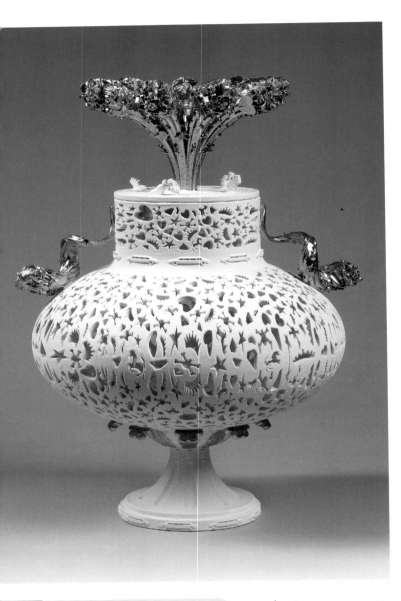

Michael Eden's *Wedgwoodn't Tureen* is a clever reinterpretation of the famous 18th-century tureens by Wedgwood. The Wedgwood productions used the latest technologies during the Industrial Revolution, and Eden has chosen a similar path. Using the innovative new ceramic materials that are part of the current Additive Manufacturing Revolution, Eden has created a form that would have been impossible to make using traditional techniques. Like Josiah Wedgwood, who often imitated other materials with his ceramics, so does Eden—giving the tureen the material properties of artificial bone. While the traditional forms were produced in such colors as jasper and basalt, Eden's piece utilizes an electrifyingly saturated hot pink that showcases the precocious, elegant object and becomes a signifier for how Eden is pushing the boundaries of ceramics as an art form.

Technical Description ▷

After being designed in Rhino 3D and FreeForm software, this form was manufactured on a ZCorp 3D printing machine and is composed of ZCorp 131 powder. Once the form was infiltrated with a curing agent that hardened it, it was coated with Ceral, an engineered ceramic mixture. Three layers of the ceramic coating were sprayed over the entire form carefully to avoid any drips. The piece was not fired, as the surface self-cures over the course of a few hours.

CERAMIC COATING
Ceral, a nonfired material developed by Axiatec in France

Note: This alumina/silica composition has a high powdered pigment content and specialized ingredients that activate upon application and cure the surface in a few hours.

COATING DETAILS

À Rebours *15 × 12 × 11 in. (38 × 30 × 28 cm), selective laser sintering, nonfired ceramic coating, liquid gold leaf. SEE COATING DETAILS, LEFT.*

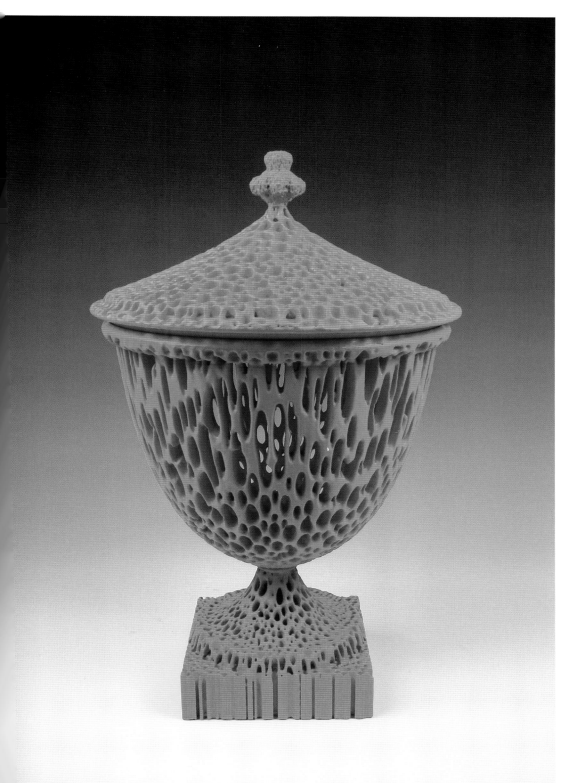

● *The fluorescent pink color is intended to be precocious and artificial, signifying the process by which the object is made.*

● *The monochromatic nature of the work showcases the intricate bone pattern.*

66 I wished for this piece to be radically different in order to emphasize the processes and thinking that underpin its creation. 99

Wedgwoodn't Tureen *16 × 10 × 6 in. (40 × 25 × 15 cm), 3D-printed ZCorp 131 plaster, strengthening infiltrant, three layers of Ceral ceramic coating, nonfired. SEE COATING DETAILS, LEFT.*

Marc Digeros

Marc Digeros molds and manipulates planar slabs cut into simple geometric shapes to craft inventive hand-built terra-cotta vessels. His humble pieces reveal their construction with lightly handled surfaces and visibly pinched seam lines. Using asymmetrical decorations with the addition of a singular, graphic zigzag line, he creates balanced compositions of form and surface. Vivid underglazes are covered with a sugary semi-matte glaze, transforming the synthetic hues into muted, inviting colors that add depth and character to his tactile pottery.

Technical Description

In the greenware state (and sometimes after bisque firing), the pieces are decorated with commercial underglazes. Turquoise semi-matte glaze is poured, dipped, or brushed on thinly to avoid excessive running. Clay and underglazed areas are often left unglazed as additional decorative elements. Pieces are fired to cone 04. Digeros notes that he only mixes up the amount of glaze he needs because of lithium's slight solubility.

Vase *5 × 5 × 9¹/₂ in. (13 × 13 × 24 cm), hand-built red earthenware with light green underglaze decoration and turquoise semi-matte glaze. Fired to cone 04 in oxidation.*
SEE GLAZE DETAILS, BELOW.

GLAZE DETAILS

TURQUOISE SEMI-MATTE, *cone 04*	
F-4 feldspar	31.9
Lithium carbonate	20.2
Strontium carbonate	12.7
EPK	15.9
Silica	12.7
Whiting	6.4
Magnesium carbonate	0.2
+ CMC gum	0.2
+ Copper carbonate	1.0

UNDERGLAZES
Light Green (Spectrum 556)
Hot Pink (Spectrum 570)

Small Geometric Bowl *9 × 4 × 2 in. (23 × 10 × 5 cm), hand-built red earthenware with hot pink underglaze decoration and turquoise semi-matte glaze. Fired to cone 04 in oxidation. SEE GLAZE DETAILS, LEFT.*

● *The sharp edges of the bright pink and green underglazes are softened and blurred by the glaze coating.*

● *The synthetic and neon colors complement the zigzags, creating playful contrasts that define how our eyes travel across the form.*

" I like how the glaze reacts to my underglaze decoration. Sometimes this reaction is subtle, sometimes not so. I feel that this glaze/underglaze combination often creates a mysterious interaction and the results can be challenging to ascertain. "

Katie Parker and Guy Michael Davis

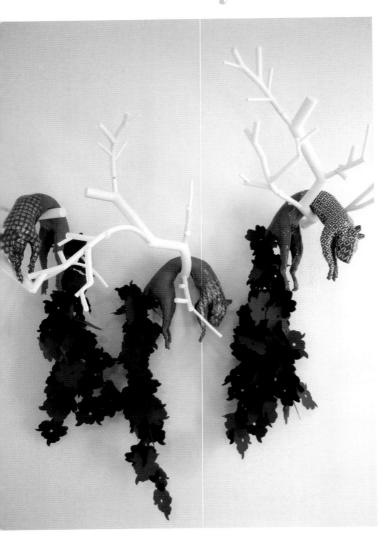

Using new technologies such as 3D scanning and 3D printing, along with traditional ceramic processes of slip casting and hand-painted decoration, Katie Parker and Guy Michael Davis transform elements of historical objects into overtly sampled contemporary sculpture. With *Alphonso Taft, Sèvres*, a marble bust of Alphonso Taft from the Taft Museum of Art in Cincinnati, Ohio was recreated in porcelain and enveloped with a pattern from a Sèvres tureen found in the same museum, creating a kind of decorative camouflage over the figure. This melding of revered historical sources offers a brazen yet sophisticated play on the roles and hierarchies of art objects within the context of the museum.

Technical Description ▷

The bust was sprayed with Kitten's Clear glaze, mixed slightly thin, then fired to cone 6. Next, pink china paint was applied with an airbrush and the piece was fired to cone 016. After that, decorative layers of china paint and gold luster were applied by hand with a small brush to create the delicate lattice pattern, and the piece was fired again to cone 016. These separate firings prevented any smudging when the decorative layer was applied.

GLAZE DETAILS

KITTEN'S CLEAR, *cone 6*
Nepheline syenite	26
Wollastonite	7
Gerstley borate	18
EPK	9
Flint	27
Strontium carbonate	13

Hanging Dead *15 × 20 × 14 in. (38 × 51 × 36 cm), slip-cast porcelain and porcelain with added cobalt, clear glaze fired to cone 6. Glazed surface hand-painted with china paint and luster, and fired to cone 016, die-cut paper tail. SEE GLAZE DETAILS, LEFT.*

66 Color for us is a way to highlight form—to add in another layer of history and ornament to the pieces we are creating. 99

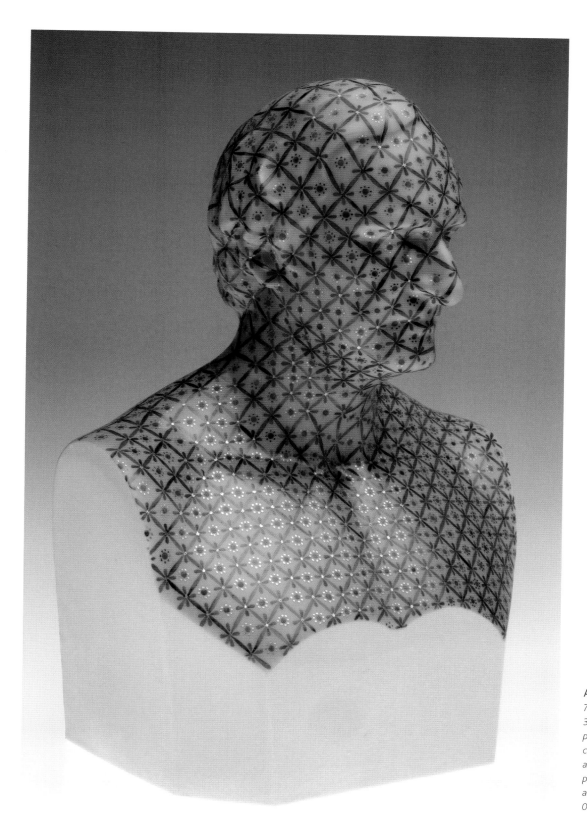

● *Colors are drawn from
historical Sèvres pieces.*

● *The pink decoration
feels feminine, which acts
subversively as it cloaks and
obscures the male figure with
ornamental camouflage.*

● *Crisp edges and detail from
china paint and luster appear
almost like a digital print.*

Alphonso Taft, Sèvres
*7 × 12 × 5¹/₂ in. (18 ×
30 × 14 cm), slip-cast
porcelain, glaze fired to
cone 6. Glazed surface
airbrushed and hand
painted with china paint
and luster. Fired to cone
016. SEE GLAZE DETAILS, LEFT.*

Kirk Mangus

Kirk Mangus created playful vessels based on ancient pyramids and ziggurats. With a sense of immediacy in the making of his forms, rows of expressive marks envelop the vessel, implying the rhythm of language and music. Miniature sculptures also adorn the work, loosely suggesting a kind of celebratory narrative. Inspired by color field paintings, especially the *Veil* paintings of Morris Louis, Mangus was drawn to bright colors that bleed, blend, and break over the red clay. From pinky-orange to blue-green and yellow, thick, viscous glazes embellish the forms, adding a vivid and lively richness to the surface.

Technical Description

This piece is made with a red clay that is glaze fired to cone 1 in an electric kiln. Each piece is first dipped in the Peacock base recipe. Several smaller batches of the glaze with varied colorant additions are mixed up and then splashed on top of the white glaze to create a rainbow effect. This food-safe glaze is sensitive to the clay body (opaque white over white clay, breaking red over terra-cotta). It can produce a dry surface when thin or run when thick, creating a "skirt" of drips. If overfired, this glaze becomes runny and glassy. Stains will affect the melt and should be tested.

66 Color illuminates my images. Glaze is different than paint. Light bounces around in the glass. I adore clay, but recently I have become fascinated with the glazed surface. It is how the glass and clay combine to fight and complement each other. 99

GLAZE DETAILS

PEACOCK GLAZE, *cone 1*

Gillespie borate	60
Nepheline syenite	20
Flint	20

Green
+ 5% Copper carbonate

Other Colored Variations
+ 8% Commercial stains

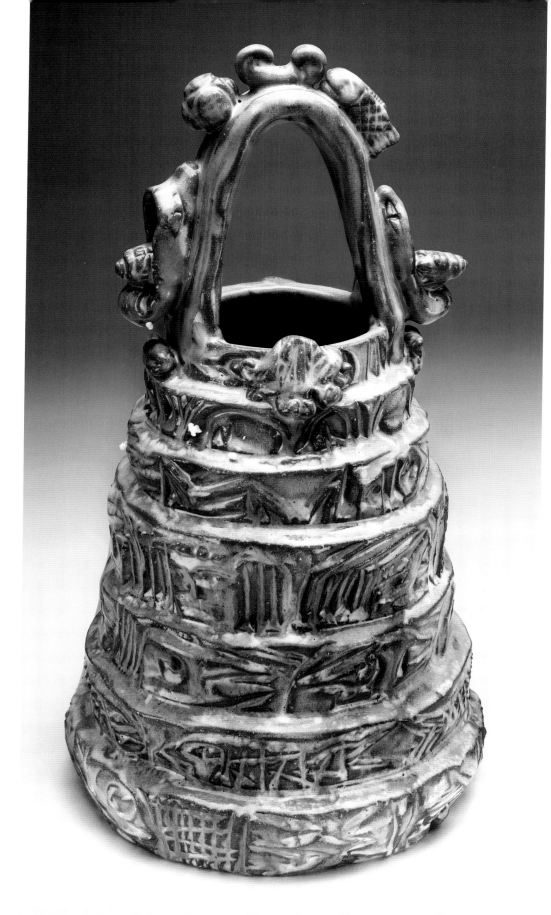

● *Stains are used to achieve a wide range of bright colors.*

● *Many colors are applied to each piece, creating a "rainbow effect."*

● *When applied thick, this glaze runs, blending together the various colored batches.*

● *Mangus had ten or more color variations ready to use to assist in composing a distinct color palette for each piece.*

Boat Life Ziggurat *18 × 9 × 9 in. (46 × 23 × 23 cm), terra-cotta, Peacock glaze base, colored glazes, fired to cone 1 in oxidation. SEE GLAZE DETAILS, LEFT.*

Nicholas Arroyave-Portela

Tall Cut Wave Form and Open Oval Crumpled Form *height: 18 in. (46 cm) (left), 11 in. (28.5 cm) (right), thrown and altered stoneware, sprayed terra-cotta terra sigillata, commercial clear glaze on the inside, fired to cone 4.* SEE TERRA SIGILLATA DETAILS, BELOW.

The refined vessels of Nicholas Arroyave-Portela conjure up the four elements of nature—earth, air, wind, and fire—with their deep and gently fading tones of land and sky. Driven to explore skin and volume in relation to water, this delicate body of work is inspired by a quote from the ancient Chinese philosopher Lao Tzu, who said: "The water that flows into the earthenware vessel takes on its form." Working to "channel the sublime," as Arroyave-Portela puts it, the work abstracts the qualities of water acting upon nature, with ripples, curves, and canyons defining the forms. The quiet vessels seem to capture the essence of this idea, with flowing volumes and majestic colorscapes.

Technical Description

Pieces are first thrown from white stoneware, altered, and allowed to dry to the bone-dry state. Colored terra sigillata is then sprayed on, allowing pieces to dry completely between coats so as to not saturate and destroy the piece. After a cone 06 (1,832°F/1,000°C) bisque firing, the interiors are coated with a quick pour of the terra sigillata and sometimes a second thin coating of a commercial clear glaze. Any clear glaze with a maturing temperature close to cone 4 (2,156°F/1,180°C) can be used. Going over this temperature will start to have a negative impact on the terra sigillata slip. Then the pieces are fired to cone 4 (2,156°F/1,180°C). Non-traditional terra sigillata preparation consists of ball-milling sodium hexametaphosphate and a chosen colorant or oxide to achieve very fine particles before adding to water and ball clay. Once mixed, the solution is screened to 200 mesh and then applied. There is no settling process.

TERRA SIGILLATA DETAILS

WHITE TERRA SIGILLATA
³/₄ gallon (3 l) water
2¹/₄ lb (1 kg) white ball clay
¹/₂ oz. (15 g) sodium hexametaphosphate

COLORANT ADDITIONS
These commercial stains are added to the white terra sigillata at about 8%
Cornflower Blue stain (Scarva 1047)
Kingfisher Blue stain (Scarva HFC452)
Discus Blue stain (Scarva HFC800)
Yellow stain (Scarva HFC899)
If using oxides, approximately 1–2% should be adequate.

TERRA-COTTA TERRA SIGILLATA
³/₄ gallon (3 l) water
2¹/₄ lb (1 kg) white ball clay
¹/₂ oz. (15 g) sodium hexametaphosphate
+ 4% Red iron oxide

- Thin coats of saturated colors leave the texture of the clay purposefully visible.
- Colors are sprayed on, which gives the piece the illusion of colored shadows.
- Matte surfaces give the piece weight, which is juxtaposed against the thin walls and glossy interiors.

66 I wanted to create the feeling that the water itself was creating the form of the vessel through its various processes and transformations. 99

Tall Zigzag Form *height: 18¹/₂ in. (47 cm), thrown and altered stoneware, sprayed colored terra sigillata, contrasting color sprayed from bottom. Fired to cone 4. SEE TERRA SIGILLATA DETAILS, LEFT.*

Morten Løbner Espersen

With over 100 glaze recipes in circulation, Espersen expertly builds his surfaces over multiple firings with glazes that not only pervade the form but redefine it with lumps, curdles, cracks, and drips of the thick, viscous material. Activated by heat and gravity, the voluptuous glaze is pulled south across his forms, as colors bleed into and emerge from prior layers. Engulfed in a turbulent tangle of organic forms and drenched with color, Espersen's *Horror Vacui* series embraces and exploits the vessel format. One can barely make out the silhouette of the beautiful vases with bulbous bodies, narrow necks, and trumpeting tops at the center of each piece. The forms succumb to the writhing projections of intertwining, pulsing limbs that consume them, relieving the "fear of empty space," which is alluded to in the title.

Yellow Cylinder, Vacui #1577 *9 × 12 × 12 in. (24 × 30 × 30 cm), hand-built stoneware with added glass fibers, brushed-on glazes, multiple firings to cone 9, final low firing to cone 08. SEE GLAZE DETAILS, BELOW.*

Horror Vacui #1570 *19¹/₂ × 23¹/₂ × 23¹/₂ in. (50 × 60 × 60 cm), hand-built stoneware with added glass fibers, brushed-on glazes, multiple firings to cone 9. SEE GLAZE DETAILS, BELOW.*

GLAZE DETAILS

215 YELLOW OCHER, cone 9
First firing

Nepheline syenite	60
Soda feldspar	5
Potash feldspar	20
Whiting	5
Yellow ocher	5
Kaolin	5
+ Bentonite	0.5

216 ZIRCON WHITE, cone 9
First firing

Nepheline syenite	50
Potash feldspar	18
Zinc oxide	8
Talc	8
Zirconium silicate	6
Kaolin	8
Frit	2
+ Bentonite	0.5

125 TIN WHITE, cone 9
Second firing and fourth firing

Potash feldspar	60
Limestone	17
Zinc oxide	3
Quartz	10
Tin oxide	1
Kaolin	9
+ Bentonite	0.5

220 ZIRCON WHITE, cone 9
Third firing

Potash feldspar	20
Soda feldspar	26
Whiting	21
Zinc oxide	6
Zirconium silicate	10
Kaolin	26
+ Bentonite	0.5

138 TURQUOISE MATTE, cone 9
Third firing

Nepheline syenite	60
Potash feldspar	6
Barium carbonate	22
Zinc oxide	6
Kaolin	6
+ Bentonite	0.5
+ Copper oxide	3

LEMON YELLOW GLOSSY GLAZE, cone 08
Fifth firing
Cerama Earthenware E-Glaze 2007

Technical Description

Espersen uses many glazes on each piece and refires multiple times. The work is made with a durable sculpture body with glass fibers for strength, which he bisque fires to cone 08 (1,740°F/950°C). Work is glaze fired in an electric kiln at 300°F (150°C) per hour up to either cone 08 (1,740°F/950°C) for low fire or up to cone 9 (2,315°F/1,268°C) with no soak. When mixing glazes, Espersen begins by measuring water, then adds his dry materials to get the thickness and texture he's looking for, preparing them anywhere from as thin as skim milk to as thick as Greek yogurt. Generally, he will add 0.5 percent bentonite to his glazes to enable them to adhere more readily to his forms and resist settling in the bucket. When he reglazes work, he either siphons off water to thicken the glaze or adds wallpaper glue to help it stick better. He applies his glazes either with a brush or a plastic card. Rarely, he will spray a glaze if he desires a very thin coat.

❝ No material that I know of comes even close to fired, glazed ceramic. The depth, the color, and the touch. It is beyond compare. ❞

Horror Vacui #1665 *22 × 17 × 17 in. (56 × 44 × 44 cm), hand-built stoneware with added glass fibers, brushed-on glazes, multiple firings to cone 9. SEE GLAZE DETAILS, LEFT.*

● *The veiny rivulets of glaze wrapping around the bulbous forms are visceral, but the intense purple hue alters the reference to suggest a more surreal, biomorphic landscape.*

● *Hyper-saturated hues in rich layers feel almost radioactive in their intensity.*

Robert Hessler

Robert Hessler's perfectly symmetrical and voluminous vase forms are designed to showcase his exquisite and enchanting glaze surfaces. The range of colors that sweeps between, under, and throughout the crystal formations is baffling, as they fade from north to south across the elongated forms like the most divine sunrise. The crystalline structures not only dazzle, but also offer a space for quiet reflection; a time to consider the crystals as a metaphor for the act of creation itself. The material phenomenon is frozen, contained within the glass matrix of the glaze, yet the fractal-like crystal growths imply infinity.

Technical Description ▷

Hessler's pieces are wheel-thrown cone 6 porcelain. Once bisque fired, glazes are brushed on in three layers, applied in horizontally delineated sections. Piece #2 was treated in three separate bands. Praseodymium yellow stain (Mason 6450 PrZrSi) was first brushed onto the pot, followed by three coats of the base glaze on the top band. The middle band has the same glaze with 2.5 percent iron oxide added, and the bottom band has 3 percent cobalt oxide added. In the electric kiln, each piece was carefully set on a raised foot ring with a collection dish below due to the very runny nature of crystalline glazes. The kiln was programmed to fire to cone 6 (2,235°F/1,224°C) with a 10-minute hold. The kiln was then lowered and held at 1,900°F (1,038°C) for 90 minutes to allow the crystallization to occur. Once the kiln cooled to 1,550°F (843°C), the bottom spy was pulled and small sticks were thrown in to instigate a reduction atmosphere until 1,200°F (650°C).

GLAZE DETAILS

CRYSTALLINE GLAZE FOR PIECE #9, *cone 6*

Potash feldspar	31
Zinc oxide	22
Whiting	8
Barium carbonate	5
Lithium carbonate	2
Gerstley borate	3
Tennessee #5 ball clay	3
Flint	26

Green/Red
+ 2% Copper carbonate

Dark Blue
+ 3% Cobalt carbonate

CRYSTALLINE GLAZE FOR PIECE #2, *cone 6*

Frit 3110	48.5
Zinc oxide	24.5
EPK	1.5
Flint	18.0
Titanium dioxide	7.5

Grayish Purple
+ 2.5% Red iron oxide

Dark Blue
+ 3% Cobalt oxide

#9 Crystal Glazed Bottle *19 × 5 × 5 in. (48 × 13 × 13 cm), thrown porcelain, crystalline glazes applied in two bands— commercial praseodymium yellow stain covered with base glaze containing copper carbonate at top and cobalt carbonate at bottom. Fired to cone 6, with controlled cooling in a reduction atmosphere. SEE GLAZE DETAILS, LEFT.*

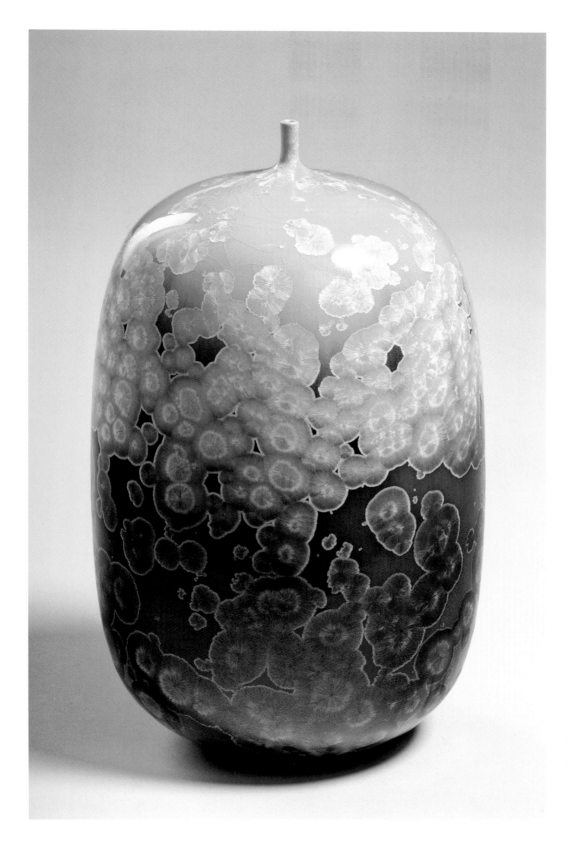

• The colors appear to be of a celestial palette with shades of blue, soft whites and grays, and bright yellow.

• The simple vertical volumes are designed with smooth surfaces to showcase the incredible array of crystalline and color variations.

• The contrast in color between the flat fade of the background and the dynamic variation of the crystals creates an illusion of depth in the form, as the crystals float atop the volume, which appears to become space itself.

#2 Crystal Glazed Bottle

11 × 6¹/₂ × 6¹/₂ in. (28 × 17 × 17 cm), thrown porcelain, crystalline glazes applied in three bands—commercial praseodymium yellow stain covered with base glaze at top, red iron oxide in the middle, and cobalt oxide at bottom. Fired to cone 6, with controlled cooling in a reduction atmosphere. SEE GLAZE DETAILS, LEFT.

Lauren Mabry

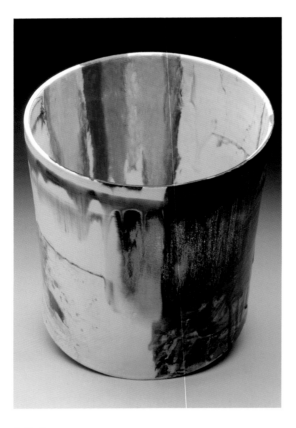

Cylinder *13¹/₂ × 12¹/₂ × 12¹/₂ in. (34 × 32 × 32 cm).*
SEE SLIP AND GLAZE DETAILS, BELOW.

With an esthetic driven by process, Lauren Mabry utilizes her cylindrical forms to showcase expressive abstractions. Mabry applies and reworks several layers of slip, underglaze, stain, and glaze using many techniques including brushwork, printing, and even her own fingers, to bring her work to life with a decidedly expressionistic and frenetic exuberance. Color is of primary concern as she builds her compositions, working first with lighter tones of slip, then moving to more saturated pigments. Luscious, wet glazes that drip along the form's surface add fluidity and an element of surprise to the process.

Technical Description

The whole piece is first covered in white slip to give a "blank canvas" and to help the color applied later to look brighter. Mabry creates an "underpainting" by first applying slips to leather-hard clay in blocks of color, using brushwork and painting with her fingers. These initial layers are sometimes scraped away and reworked, until she is pleased with the composition, and additional layers of underglaze are added. On occasion Mabry also incorporates a range of printing and transfer techniques. After bisque firing, underglaze and stains are applied in much the same way. The final touch is the application of various glazes, which are then fired to cone 04.

> ❝ I'm compelled by the scintillating, seductive energy created through formal dualities. Drips, swipes, and splashes of colorful glazes variously fold and float. In some passages bold hues intermingle with spells of quiet tints and shades. ❞

SLIP AND GLAZE DETAILS

LAUREN MABRY LOW-FIRE SLIP, *cone 04–03*
This recipe is adapted from a recipe by Victoria Christen

EPK	31
Ball clay	31
Silica	25
Talc	6.5
Frit 3124	6.5

C2 GLAZE BASE, *cone 04*

Frit 3124	80
Spodumene	5
Petalite	5
EPK	10

Colors
+ 5–15% Mason, Spectrum, or Degussa stains.

Mabry operates with a slip base and a glaze base and adds the same stains to both, increasing the percentage for more saturated hues.

Red
+ Intense Red inclusion stain (Cerdec-Degussa ZrSiCdSSe) layered over Amaco Velvet Radiant Red (V-388) underglaze

Yellow
+ Vanadium Yellow stain (Mason 6404 AlSnV)

White
+ 7% Zircopax

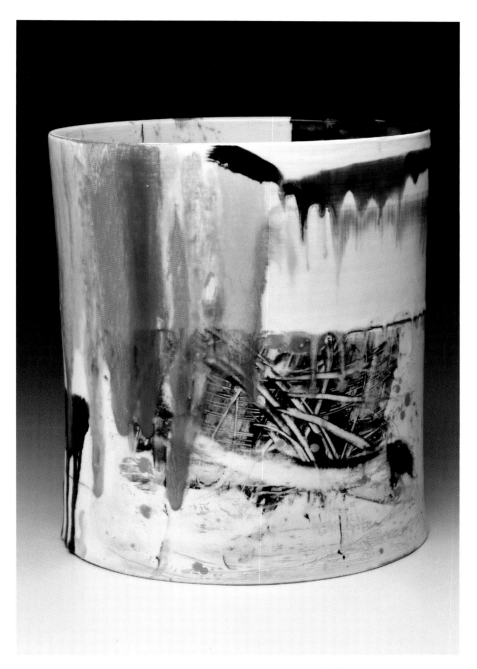

● *The colors of the spectrum are in full force in Mabry's work, adding vitality, expressiveness, spontaneity, and emotion to the work.*

● *In addition to splashes of color applied elsewhere, colors are arranged in rainbow order on prominent display, adding a playful tone to the work.*

● *Colors are applied before and after bisque firing, adding to surface depth and allowing for runs and blending.*

Cylinder *13¹/₂ × 12¹/₂ × 12¹/₂ in. (34 × 32 × 32 cm), red earthenware, slips, glazes, cone 04 electric kiln firing. SEE SLIP AND GLAZE DETAILS, LEFT.*

Peter Pincus

Using a set of Sèvres porcelain urns as a jumping-off point, Peter Pincus created his sharply articulated *Urn* with a precise methodology. The four distinctly planar sections of the urn are enveloped in sharp lines and darts of opaque, bright color, creating a tension between the flatness of the abstract composition and the volume of the form. The formal composition of Pincus' functional vessels is inspired by contemporary couture dress patterns, further enhancing their sense of style and grace.

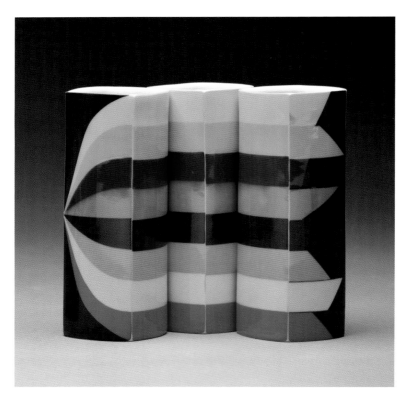

Tumbler Set *7 × 3¹/₂ × 3¹/₂ in. (18 × 9 × 9 cm) each, slip-cast, colored porcelain, clear glaze fired to cone 6. SEE GLAZE DETAILS, LEFT.*

Technical Description

Pincus utilizes colored slips and clear glaze for his work. First he mixes small batches of his slip-casting porcelain with Mason stains to create a full primary and secondary color palette, and a six-value grayscale. Each strip of color is applied in turn, by brushing slip onto the surface of his plaster molds. Clean lines are created by slicing the excess from each strip of leather-hard clay with an X-Acto knife, and wiping away any remaining residue with a sponge. Each new strip of color is added in succession until the composition is complete. After finishing the cast and bisque firing, pieces are glazed by dipping or pouring, and are glaze fired to cone 6 (2,232°F/1,222°C) in an electric kiln with a 5–20-minute hold. The glaze is mixed thin to minimize cloudiness. The longer the hold, the clearer the glaze, but also the more the porcelain may slump, so holding times vary depending on the specific piece.

> The predominant source of vitality in the work—color—creates a directional current, which is used to read the form. It also creates foreground/background relationships and hierarchies of line.

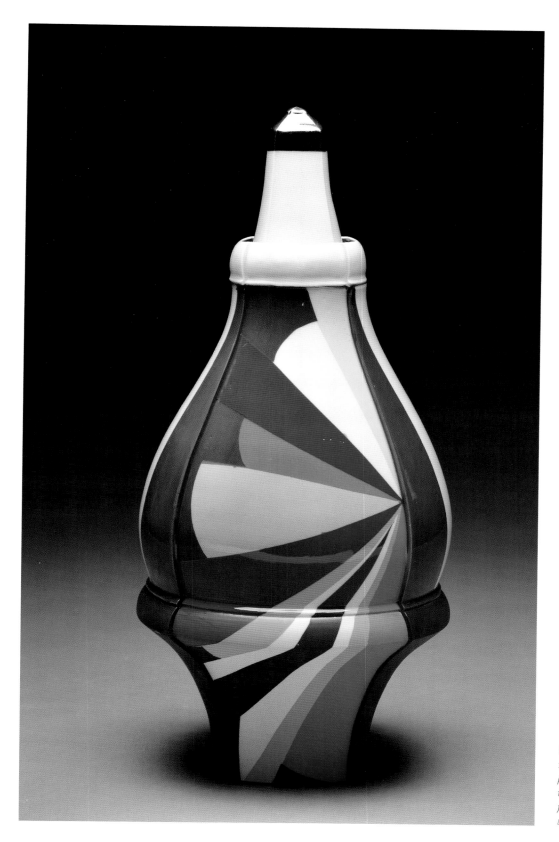

● *Sharp, flat colors are applied in vibrant patches, like bands of a rainbow.*

● *On the trio of tumblers, the color pattern begins to camouflage the forms, blending the three into one 2D image.*

● *The primary and secondary color palette is playful, while the graphic black and white are used to outline the forms and patterns.*

Urn *17 × 8 × 7 in. (43 × 20 × 18 cm), slip-cast, colored porcelain, clear glaze fired to cone 6, white gold luster fired to cone 018.* SEE GLAZE DETAILS, LEFT.

Meredith Host

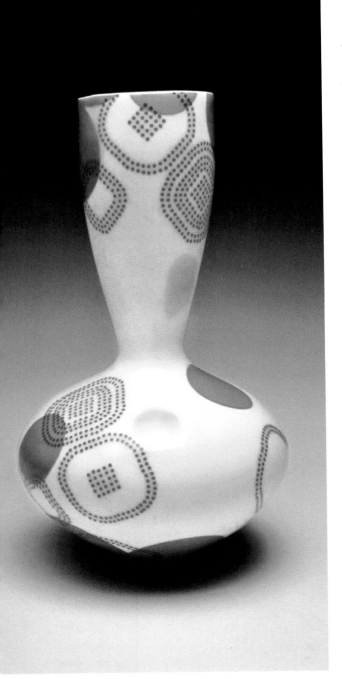

The ubiquitous yet overlooked patterns found embossed in toilet paper come under the spotlight in Meredith Host's bright and playful work. Vases, bowls, plates, cups, and tumblers become the canvas for the complex layers of bright-colored dots, scalloped swatches, and delicate decals. The subversive use of toilet paper and paper towel decorations on functional pottery is both a genuine celebration of decorative design and a tongue-in-cheek melding of our various associations with food. By converting something disposable into something permanent and precious, Host illuminates how we value material, and prompts us to see both humor and beauty in the objects we use in our daily activities.

Technical Description

Once forms are created in cone 6 porcelain, layers of stenciled and screen-printed underglaze decoration are added and then pieces are bisque fired. The Toilet Bowl White glaze, used as a liner, is poured in and out for a consistent covering. The Kitten's Clear glaze is then brushed on to eliminate bubbles that can occur around the slightly raised edges of underglaze. Pieces are then fired in an electric kiln at slow speed to cone 6 with no hold. Orange dots are applied by brushing Orange-A-Peel glaze over vinyl stencils and then fired to cone 05. Either iron oxide transfer decals (cone 05) or screen-printed china paint decals (cone 015) are added and then fired to their proper temperatures.

Dot Dot Rounded Square Vase $9 \times 4^1/_2 \times 4^1/_2$ in. $(23 \times 11 \times 11$ cm), slip-cast cone 6 porcelain, stenciled underglaze, Kitten's Clear and Toilet Bowl White glazes, Infected Phlegm glazed dots, fired to cone 6, screen-printed china paint decals fired to cone 015. SEE GLAZE DETAILS, BELOW.

GLAZE DETAILS

KITTEN'S CLEAR, cone 6
This recipe is from Kathy King
Nepheline syenite	24.0
Wollastonite	6.4
Gerstley borate	16.8
Strontium carbonate	12.0
EPK	8.0
Flint	32.8

TOILET BOWL WHITE, cone 6
Cornwall stone	34.5
Wollastonite	12.5
Whiting	12.5
Gerstley borate	5.2
Frit 3124	7.3
EPK	11.5
Bentonite	1.0
Flint	15.5
+ Zircopax	10

INFECTED PHLEGM, cone 6
Custer feldspar	40
Gerstley borate	18
Whiting	16
EPK	10
Flint	16
+ Praseodymium Yellow stain (Mason 6450 PrZrSi)	6
+ Chartreuse stain (Mason 6236 ZrVSnTi)	2

ORANGE-A-PEEL GLAZE, cone 05
Mayco Stroke & Coat SC-75

UNDERGLAZES
Chartreuse (Amaco Velvet V-343)
Turquoise Blue (Amaco Velvet V-327)
Yellow (Amaco Velvet (V-308)
Real Orange (Amaco Velvet V-384)
White (Amaco Velvet V-360)

Dot Dot Doily Dinner Set *height: 3–10½ in. (8–27 cm), thrown cone 6 porcelain, screen-printed and stenciled underglaze, clear and white glazes fired to cone 6, iron oxide transfer decals and commercial orange glaze dots fired to cone 05.* SEE GLAZE DETAILS, BELOW LEFT.

66 Decorating is really a balancing act: I play around with asymmetry in color and pattern on my forms to create dynamic surfaces. 99

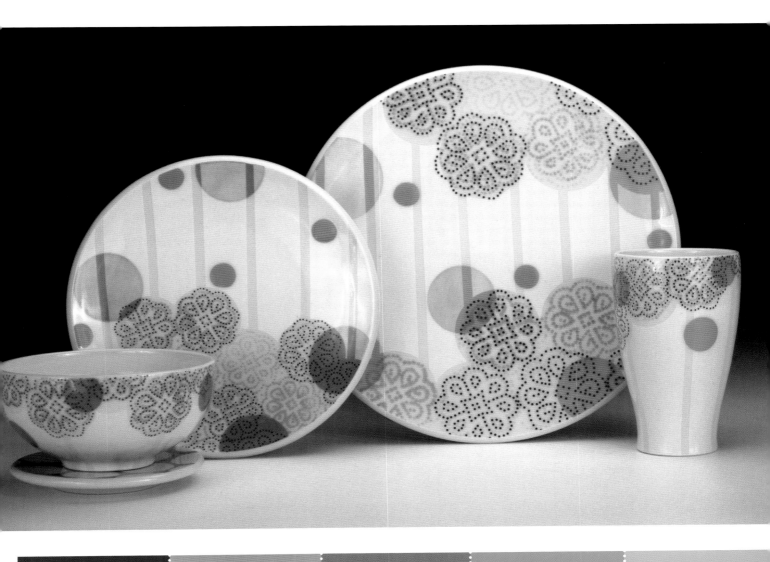

● *Layers of patterns are built up and bolstered by a wide range of colors, including the white overlays that produce depth in the piece.*

● *Small, bright pops of orange and blue punctuate the patterns and help to lead the eye around the form.*

Shalene Valenzuela

Striving to attain a somewhat *trompe l'oeil* effect, Shalene Valenzuela mimics the materials of her sculpted forms from vacuum bags to pattern paper using a range of surfaces, from shiny to satin and matte. These objects that are stereotypically reserved for the housewife carry scenes that question the role of the woman in the domestic setting and propose new considerations. In *Follow the Pattern: Free Samples* the paper sewing template becomes a metaphor for the daily patterns, habits, and ruts one may fall into. With her piece *Easy Vac: A Real Ace*, Valenzuela offers two scenes that beg the question: are these co-existing or alternate realties, and what might the ideal be? Her color palette is decidedly nostalgic, with salmon pink, turquoise, pumpkin orange, and chartreuse hues referencing vintage appliances and interior decorations. She also uses brighter yellows and reds to relate to their use in advertising, to catch attention and excite, giving her work the feel of propaganda from a bygone era.

Technical Description

Working with a white slip-casting body, forms are first cast and some elements of decoration are added by silk-screening underglaze onto soft leather-hard slip. After a cone 04 bisque firing, black lines and colors are added by brushing on underglaze and clear glaze. Edges are crisply defined by cutting away excess slip with a sharp knife, and pieces are fired to cone 6 in an electric kiln.

Follow the Pattern: Free Samples *15 × 23 × 2 in. (38 × 58 × 5 cm), porcelain with underglaze illustration and underglaze print transfer, fired to cone 6. SEE GLAZE DETAILS, BELOW.*

GLAZE DETAILS

UNDERGLAZES, *cone 6*
White (Amaco Velvet V-360)
Light Flesh (Duncan Cover Coat CC112)
Tan (Amaco Velvet V-310)
Peach (Amaco Velvet V-315)
Yellow (Amaco Velvet V-308)
Radiant Red (Amaco Velvet V-388)

Jet Black (Amaco Velvet V-361)
Blue Green (Duncan Cover Coat CC161)

TRANSPARENT CLEAR BASE GLAZE, *cone 6*
Custer feldspar	40
Gerstley borate	18
Whiting	16
EPK	10
Flint	16

Note: Although only the clear base is used on Easy Vac, for any color varieties, Valenzuela adds 5–10% Mason stain.

Easy Vac: A Real Ace
*42 × 11 × 14 in. (107 ×
28 × 35.5 cm), slip-cast
white clay with underglaze,
underglaze illustrations and
clear glaze, fired to cone 6.*
SEE GLAZE DETAILS, LEFT.

● *Colors are chosen
specifically to reference
a different era.*

● *The orange has
the look and feel of
parchment pattern
paper.*

● *Bright colors are used
to draw the eye around
the piece.*

❝ In making a seemingly realistic
vacuum out of clay, I am playing
with the notion that things are not
what they initially seem to be. ❞

Adero Willard

Adero Willard creates exuberant functional forms with rich, complex surfaces covered in patterns that reference textiles, painting, woodblock printing, and glass. Her palette is decidedly warm, with terra-cotta clay lending softness to the playful forms. Vibrant color adds vitality to the work, with flat layers of botanical and geometric imagery collaged together and built up to create an array of color combinations and surface processes that make the objects extremely pleasurable to use.

Tumblers *6¹/₂ × 3³/₄ × 3³/₄ in. (16.5 × 9.5 × 9.5 cm) each, terra-cotta, layered patterns created with slips, underglazes, sgraffito, and wax resist. Fired to cone 03 in oxidation. SEE GLAZE DETAILS, BELOW.*

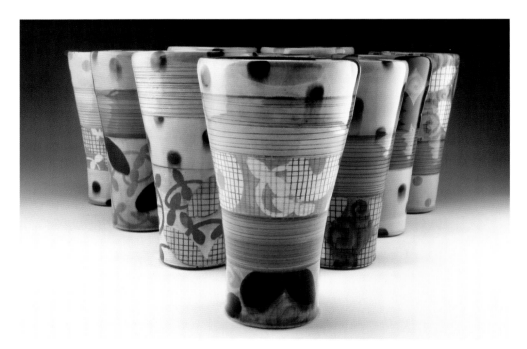

Technical Description

Willard's forms incorporate a variety of surface treatments applied at the leather-hard stage, with many layers of underglaze, sgraffito, and wax resist. Once bisque fired, the work is dipped in Pete Pinnell Clear glaze for 3 seconds for a shiny surface. If it is too thick, the glaze will run; if thinner, it will have a satin finish. The work is fired to cone 03 with a slow climb toward the end and a 30-minute hold, which helps diminish defects in the glaze.

GLAZE DETAILS

BILL'S BASIC LINER GLAZE, *cone 04–2*
For the inside of pots and vessels.

Frit 3124	65.8
F-4 feldspar	17.1
Nepheline syenite	6.3
Tile#6 kaolin	10.8
+ Zircopax	14

(Willard uses 10; use less Zircopax for a more translucent white)

+ Rutile	0.5
+ Bentonite	2

PETE PINNELL CLEAR, *cone 04–2*
This is the main glaze Willard uses. When fired between cone 03 and 2, it is a beautiful, hard, durable glaze. This recipe is from Pete Pinnell.

Frit 3195	73
Magnesium carbonate	10
EPK	10
Flint	7
+ Bentonite	2

UNDERGLAZES
Willard uses a number of underglazes by Amaco. LUG = Liquid Underglaze, V = Velvet Underglaze:

Dark Red (Amaco LUG-58)
Turquoise (Amaco LUG-25)
Yellow (Amaco V-308)
Deep Yellow (Amaco V-309)
Chartreuse (Amaco V-343)
Dark Green (Amaco V-353)
Jet Black (Amaco V-361)
Light Red (Amaco V-383)
Real Orange (Amaco V-384)
Bright Orange (Amaco V-390)
Flame Orange (Amaco V-389)
Electric Blue (Amaco V-386)
Bright Red (Amaco V-387)

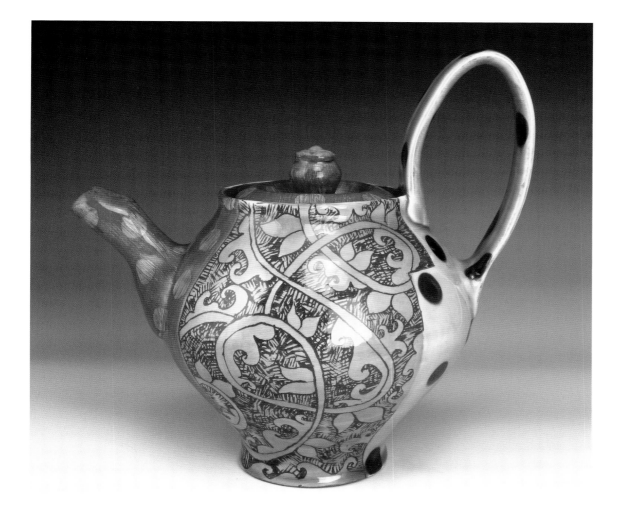

● Willard uses a warm, saturated palette.

● Varying neutral hues are complemented with accents of bright red and blue.

Teapot 7 × 8 × 5½ in. (17 × 20 × 14 cm), terra-cotta, patterns created with slips, underglazes, sgraffito, and wax resist. Fired to cone 03 in oxidation. SEE GLAZE DETAILS, LEFT.

Platter 13 × 13 × 2 in. (33 × 33 × 5 cm), terra-cotta, the initial pattern is created using sgraffito, then subsequent slip and glaze patterns are achieved with wax resist. Fired to cone 03 in oxidation. SEE GLAZE DETAILS, LEFT.

❝ Color is the way I navigate pattern, shape, form, and content. I find color to be cathartic, challenging, and energizing. ❞

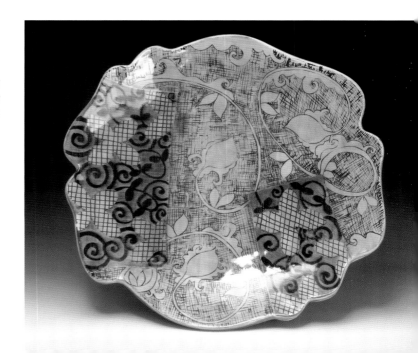

Brian R Jones

Brian Jones' playful pottery forms are a pleasure to engage with. Earnestly and effortlessly fulfilling their function when put to use, his cups, bowls, and butter houses evoke a sense of play in the user. With simple lines, grids, and swatches of bright color, they invigorate our desire to learn and explore. The colorful palette and patterns are intuitively based, as Jones sees them as a reflection of his own tendencies, like the way he dresses or arranges food on a plate. For Jones, the simple pleasures of finding pattern, form, and composition make for an endlessly rewarding task.

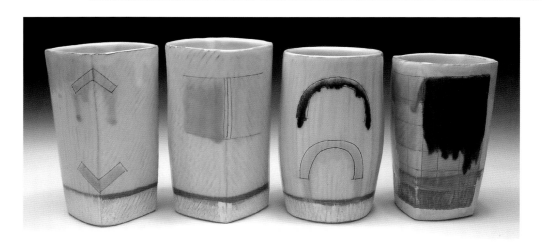

Tumblers *3 × 3 × 6 in. (8 × 8 × 15 cm) each (approximate), thrown and altered earthenware, slip, colored terra sigillata, Kari's Best, Woody's Icy Blue and Pink, and SWO glazes, fired to cone 03 in oxidation.* SEE GLAZE AND TERRA SIGILLATA DETAILS, BELOW.

Butter House *8 × 4 × 6 in. (20 × 10 × 15 cm), hand-built earthenware, slip, colored terra sigillata, Kari's Best Blue and Woody's Clear and Yellow glazes, fired to cone 03 in oxidation.* SEE GLAZE AND TERRA SIGILLATA DETAILS, BELOW.

GLAZE AND TERRA SIGILLATA DETAILS

PETE PINNELL'S WHITE SLIP, *cone 04*

OM#4 ball clay	40
Talc	40
Silica	10
Nepheline syenite	10
+ Zircopax	7

Note: For thin dunking slip, use 10–15% Zircopax.

WOODY'S BASE, *cone 03*
This recipe is from Woody Hughes

Gerstley borate	26
Lithium carbonate	4
Frit 3124	30
Nepheline syenite	20
EPK	5
Silica	10
Calcined EPK	5
+ Veegum	0.6

Yellow
+ 3.5% Sunshine stain (Mason 6479 SiCdZr)

Icy Blue
+ 3% Silica
+ 0.4% copper carbonate

Pink
+ 7% Shell Pink stain (Mason 6000 CrSnCaSi)

KARI'S BEST, *cone 03*
This recipe is from Kari Radasch

Frit P-626	25
Frit 3124	15
Gerstley borate	15
Spodumene	18
Wollastonite	7
EPK	20
+ Veegum	0.6

Blue
+ 1.5% Cobalt carbonate
+ 2% Copper carbonate

Note: Add 0.6% CMC gum to Woody's Base and Kari's Best to improve brushability. Do this only if you plan on brushing the glaze on.

WHITE TERRA SIGILLATA BASE
This recipe is from Pete Pinnell
3½ gallons (12.8 l) water
14 lb (6.4 kg) OM#4 ball clay
Approx. 2 tbsp sodium silicate (enough to deflocculate)

Note: add approximately 1 tsp of titanium dioxide per 1 cup of base to prevent the terra sigillata from peeling.

To color the white terra sigillata base, Jones adds the following per 1 cup of base.

Butter house blue
+ 2 tsp Cobalt carbonate

Butter house white
+ 3 tsp Titanium dioxide

Off-white
+1 tsp Titanium dioxide

Green
+ ½ tsp Chrome oxide

Tumbler blue
+ ½ tsp Cobalt carbonate

Black
+ 1 tsp Best Black stain (Mason 6600 CrFeCoNi)

Purple
+ 1 tsp Crocus martis

SWO GLAZE, *cone 03*

Frit 3124	72
Nepheline syenite	12
Silica	10
EPK	6
+ Veegum	2

Technical Description

The earthenware forms are first dipped in white slip when leather hard, and then to create drawings, Jones carves with an X-Acto knife. Once the piece is bone dry, terra sigillata is applied with a thick, moppy brush in three coats, allowing it to dry between coats. After bisque firing to cone 04, glazes are applied with a brush in three coats and glaze fired to cone 03 with a 30–45-minute hold. To his glazes, Jones adds CMC gum (for brushability) and Veegum (to prevent settling) by dry mixing and sieving first, then blunging in water.

I use glazes in the same way that I use gouache or watercolors; that is, I do not need to own the chemistry of the glaze in order to get what I want from it.

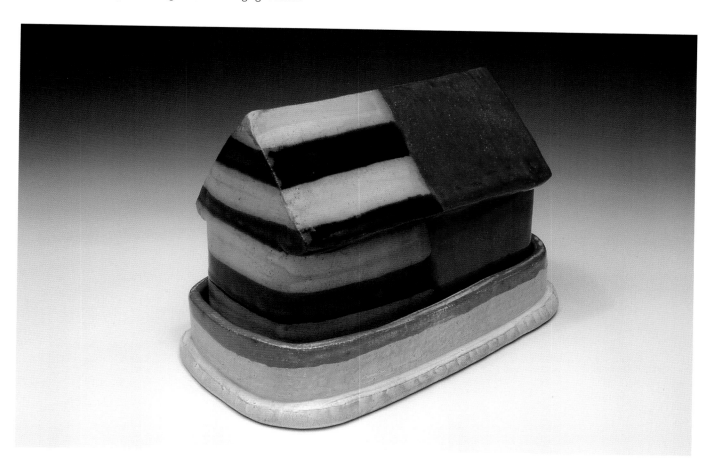

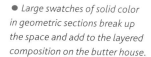
● *Large swatches of solid color in geometric sections break up the space and add to the layered composition on the butter house.*

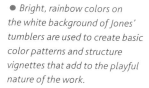
● *Bright, rainbow colors on the white background of Jones' tumblers are used to create basic color patterns and structure vignettes that add to the playful nature of the work.*

Johannes Nagel

As an improvisational tune may carry on, ending perhaps only when the player momentarily runs out of breath, so does Johannes Nagel, intermittently declaring moments of closure in his work. Existing as still lifes, though they defy stillness, the vessels are arranged as a suggestion, highlighting their never-ending potential and Nagel's affinity for the provisional. Emphasizing process over the final product, the simple pottery forms are rife with the marks of the maker: sawed, dug out, painted, patched, and stacked together to create large vase profiles. With bright-colored glazes fading in and out, designing patterns and cascading in drips across his forms, color acts as a vehicle for expression.

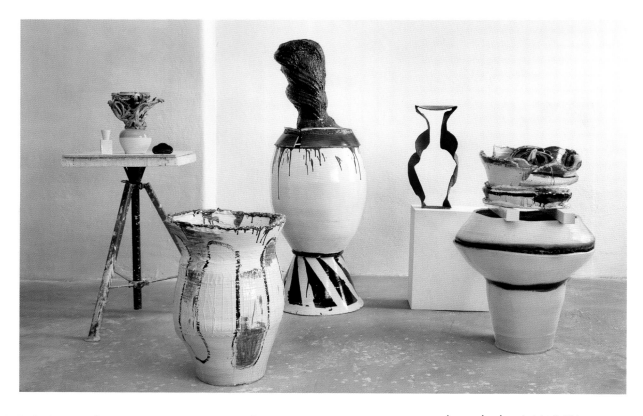

GLAZE DETAILS

TRANSPARENT GLAZE, *cone 8–10*
Imerys EK451T

Green
+ 5% Celadon stain

Blue
+ 5% Cobalt oxide

BLACK STAIN, *cone 06–10*
Börkey Keratech 43600
(CoFeCr)

ON-GLAZE COLORS
Hans Wohlbring Inspiration on-glaze colors in the following shades:
Delft blue (121635)

Light blue (121632)
Cobalt blue (121631)
Dark green (111640)
Chrome green (111630)
May green (111641)
Yolk (131638)
Ocher (131631)
Dark chestnut purple (771637)
Yellow iron oxide (used like an on-glaze color)

Improvisorium *height: 2–59 in. (5–150 cm), wheel-thrown stoneware and porcelain, cast porcelain, assembled and stacked, stains for underglaze painting, commercial transparent glaze fired to cone 8, on-glaze colors fired to cone 010. SEE GLAZE DETAILS, LEFT.*

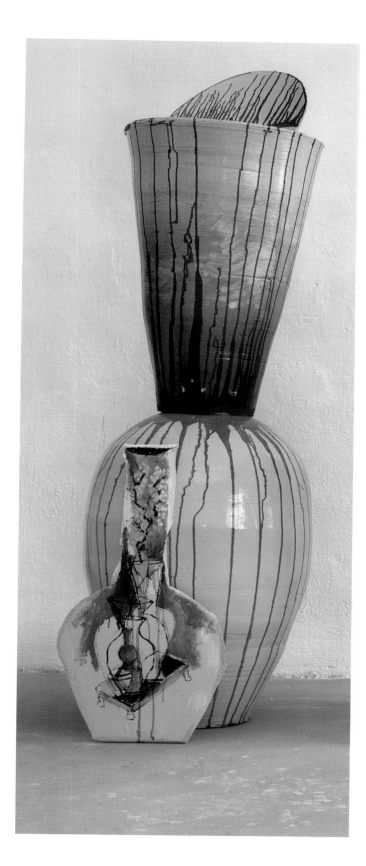

◁ **Technical Description**

Nagel incorporates a variety of making and glazing techniques into his works. The large stacked vase in *Vessels, Perhaps I* was assembled from three separate pieces, using stoneware coated in white casting slip before bisque firing. The transparent glaze is sprayed over the entirety of each piece and the top cone shape is sprayed to create a blue fade, using the transparent glaze with cobalt oxide added. Pieces are then fired to cone 8 (2,280°F/1,250°C). Next, different on-glaze colors are applied, allowing for dramatic drips and splashes of color, and pieces are fired again to cone 013 (1,560°F/850°C). The porcelain slab form leaning against the vase is painted with various on-glaze colors.

Vessels, Perhaps I *height: 63 in. (160 cm), wheel-thrown stoneware and porcelain, cast porcelain, assembled and stacked, stains for underglaze painting, commercial transparent glaze fired to cone 8, on-glaze colors fired to cone 013. SEE GLAZE DETAILS, LEFT.*

● *The painterly application of color has an expressive feel as it defines the form with brushy patterns and cascading drips.*

● *The white background further emphasizes the treatment of the vessel as a canvas.*

● *Variations of primary blue and red add a feeling of stability and familiarity to the color palette.*

Chiho Aono

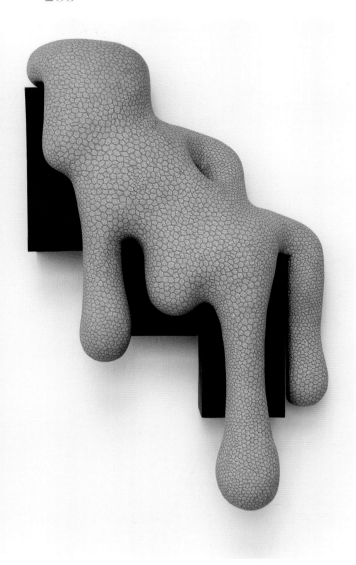

Japanese artist Chiho Aono creates patterned, aqueous forms that flow over black rigid cubes and stair structures. Incorporating water's own physical tension and its response to gravity, the pieces appear as curious, boneless masses of viscous drips. Aono's surfaces are inspired by aposematic animal patterning, or prey-repellant colors, with bright, vibrating combinations of contrasting hues creating a playful illusion of movement and depth across the quirky, bubbly forms.

Technical Description

Aono works with grogged stoneware containing manganese to give the clay a very dark coloration. Various colored slips and underglazes are delicately brushed on and sometimes she incorporates sgraffito, revealing a dark line of clay to separate colors. Colored slips are created from a commercial slip base (E-01), varying percentages of stains for color, and CMC gum for smooth brushing. Underglazes are sometimes blended to create new colors, as in the Orange on *Metamorphose—1*. Pieces are single fired to cone 02 (2,030°F/1,110°C).

SLIP AND UNDERGLAZE DETAILS

BRIGHT RED UNDERGLAZE
Amaco Velvet V-387

GREEN SLIP, *cone 02*
White earthenware slip
(Lehrer E-01) 82.51
Blue-green stain (Heraeus
Schauer FK605) 5.77
Light yellow stain (Heraeus
Schauer FK763) 10.72
CMC gum 1

LIGHT GREEN SLIP, *cone 02*
Green slip (Lehrer E-41) 49.5
Light yellow stain (Heraeus
Schauer FK763) 49.5
CMC gum 1

ORANGE UNDERGLAZE
Intense Yellow underglaze (Amaco
Velvet V-391) 50
Flame Orange underglaze
(Amaco Velvet V-389) 50

LIGHT BLUE SLIP, *cone 02*
White earthenware slip
(Lehrer E-01) 82.51
Turkish Blue stain (Heraeus
Schauer FK544 ZrVSi) 16.49
CMC gum 1

DARK BLUE SLIP, *cone 02*
White earthenware slip
(Lehrer E-01) 82.51
Cobalt blue stain (Heraeus
Schauer FK522 CoSi) 16.49
CMC gum 1

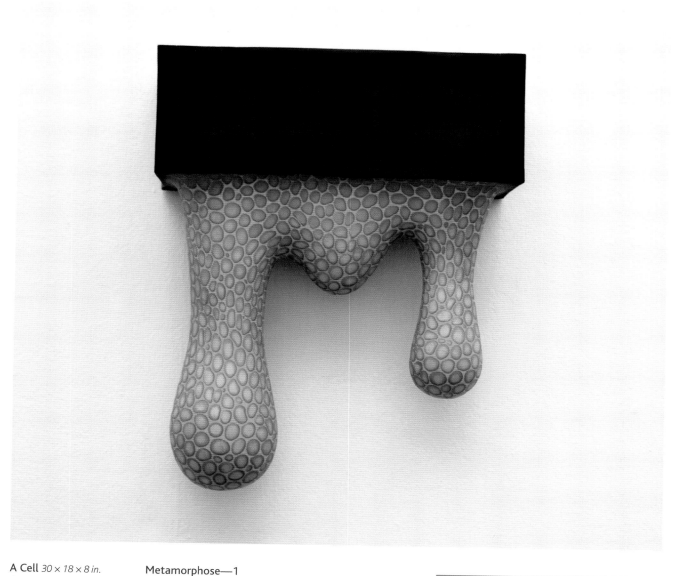

A Cell *30 × 18 × 8 in. (75 × 45 × 20 cm), slabbed and coiled manganese clay with 25% 3/16-in (5-mm) grog, decorated with red underglaze, light green and green colored slips. Fired to cone 02. SEE SLIP AND UNDERGLAZE DETAILS, LEFT.*

Metamorphose—1 *27 1/2 × 18 × 8 in. (70 × 45 × 20 cm), slabbed and coiled manganese clay with 25% 3/16-in (5-mm) grog, decorated with orange underglaze, light blue and dark blue colored slips. Fired to cone 02. SEE SLIP AND UNDERGLAZE DETAILS, LEFT.*

● *Highly saturated contrasting colors of the same tone enable the visual phenomenon of vibration to occur.*

● *The push and pull of various colors simulate a three-dimensional texture.*

● *Bright synthetic colors give the organic forms an alien or radioactive presence.*

Barry Stedman

Assertive and instinctive brush marks parade across Barry Stedman's effortlessly constructed forms. With streaks and sodden swatches of black, red, and green, his abstract compositions are reminiscent of Expressionist paintings. For these emotive vessels, Stedman found inspiration in a series of drawings of a dark green reflecting pool with glimmering patches of light and dancing shadows. He captures this with loose, gestural marks that feel as fresh and spontaneous as his muse.

Technical Description

Stedman's terra-cotta pieces are first dipped in white slip. Once slightly dry, they are brushed with another coat, left to dry a little, and then brushed in colored slips and oxides. After the bisque firing, further coats of oxide and slips are applied as required. Parts of the pieces are masked off with wax before being dipped for a thick coat of glaze and fired to cone 04 (1,940°F/1,060°C) with an hour-long soak.

Vessel with Green *height: 7 in. (17 cm), wheel-thrown terra-cotta clay, painted with white slip, colored slips, and oxides, partly glazed with lead-based glaze, fired to cone 04. SEE SLIP AND GLAZE DETAILS, BELOW.*

SLIP, cone 04
Note: Stedman fires this slip to cone 04 but it can go higher if required.

Kaolin	50
Ball clay	33
Potash feldspar	17

Colors are created by adding Potterycrafts underglaze powders to the slip, 4% for pale background colors. Strong colors are created by adding underglaze powders, cobalt oxide, and black iron oxide by eye to small amounts of slip.

TRANSPARENT GLAZE, cone 04
This recipe is from Nigel Wood

Lead sesquisilicate	74.0
Cornish stone	15.0
Kaolin	6.7
Flint	4.3

❝ I like to use color to change the way the form is read, with bright colors as focal points or key marks, and to try and set up interesting rhythms and relationships within the vessel. ❞

Slab Vessel with Red and Green *height: 12¹/₂ in. (32 cm), slab-built terra-cotta, painted with white slip, colored slips, and oxides, partly glazed with lead-based glaze, fired to cone 04.* SEE SLIP AND GLAZE DETAILS, LEFT.

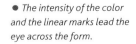

● *The intensity of the color and the linear marks lead the eye across the form.*

● *With each color equally vibrant, the green, red, and black excite the eyes and enliven the form.*

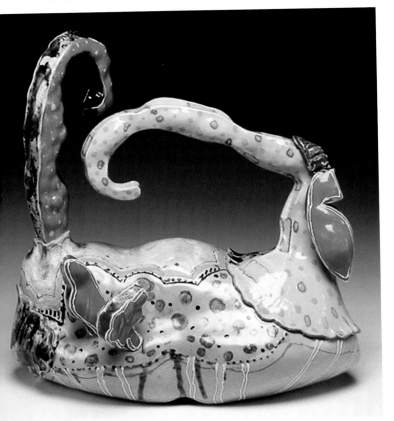

Alex Kraft

Organ, muscle, stem, and branch forms meld with fanciful, light-hearted ornamentations of draped piping and polka dots in Alex Kraft's motley sculptures, which bear nonsensical titles such as *Piddock Picornavirut*. Kraft captures floral and corporal systems in a collage of tactile surfaces. Her application of vivid color patches and variegated textures adds a sensorial super-charge to the fantastical, creaturelike forms.

Sploonk *14 × 14 × 8 in. (35.5 × 35.5 × 20 cm), mid-range porcelain, glazes, fired in oxidation to cone 6.* SEE GLAZE DETAILS, BELOW.

Piddock Picornavirut *10 × 11 × 9 in. (25 × 28 × 23 cm), mid-range porcelain, multiple glazes, multi-fired in oxidation to cone 6.* SEE GLAZE DETAILS, BELOW.

GLAZE DETAILS

PETE'S WEATHERED BRONZE, *cone 6*
This recipe is from Pete Pinnell

Nepheline syenite	60
Ball clay	10
Strontium carbonate	20
Lithium carbonate	1
Flint	9
+ Titanium dioxide	5
+ Copper carbonate	5
+ Bentonite	2

YELLOW BUTTER CREAM, *cone 5–7*
Base glaze from Jerry Bennett.

Nepheline syenite	20
Whiting	17
Zircopax	9
Custer feldspar	29
EPK	14
Flint	7
+ Titanium dioxide	8–10

MARK BELL'S LICHEN, *cone 6–8*

Magnesium carbonate	31
Talc	8
Zinc oxide	6
Frit 3195	6
F-4 feldspar	30
EPK	19

LICHEN BASE, *cone 04*

Magnesium carbonate	35.71
Lithium carbonate	7.14
Borax	35.71
Gerstley borate	21.43

PATRICK ECKMAN'S GREEN, *cone 6–8*

Custer feldspar	24.8
F-4 feldspar	9.5
Zircopax	4.8
Wollastonite	7.6
Ball clay	4.8
Flint	15.2
Talc	1.9
Gerstley borate	9.5
Whiting	15.2
EPK	6.7
+ Copper carbonate	2
+ Chrome	5

LILAC GRAY, *cone 5–6*

Nepheline syenite	34
Flint	41
Whiting	17
Kaolin	8
+ Tin oxide	1.5
+ Chromium oxide	0.55

LOVELY PINK, *cone 6*

Whiting	38.1
Custer feldspar	50.8
Grolleg kaolin	11.1
+ Magnesium zirconium silicate (or zircopax)	15.8
+ Shell Pink stain (Mason 6000 CrSnCaSi)	12.1

MATTE WHITE, *cone 6–7*

Nepheline syenite	50
Whiting	10
Dolomite	20
Flint	10
EPK	10
+ Zircopax	10

TYRIAN PURPLE, *cone 6*

Gerstley borate	20.0
Nepheline syenite	15.2
EPK	10.5
Whiting	19.1
Flint	30.5
+ Tin oxide	4.8
+ Chromium oxide	0.14

Technical Description

Employing experimentation as an important part of the process, Kraft incorporates myriad glazing strategies and surface treatments for her cone 6 porcelain sculptures. She uses slip trailing, mishima, wax resist, thermofax image transfer, and mono printing on the wet clay. After bisque firing, matte, satin, and glossy glazes, of both original and commercial origin, are layered on the pieces. They are combined with multiple glaze firings beginning around cone 7, to create great depth and texture in the surface.

● Kraft does not discriminate as she employs a wide range of quirky color combinations to elicit a sense of life in her work.
● The textured, phenomenal colors give the surface a capricious feel.
● The bright solid purple patch stands out in contrast to the yellow bubbling balls atop the form.
● The glaze that carries rivulets alludes to a network of veins due to its bright red hue.

66 By illustrating physicality through organic form, by varying surface texture and design, and by incorporation of sugary vivid color, works are imbued with primordial content. 99

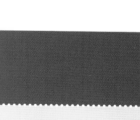

Albion Stafford

From inventively wheel-thrown forms to cleverly fractured and reassembled parts, Albion Stafford utilizes a variety of construction techniques to create deceivingly ergonomic and satisfyingly useful objects. Referencing pointillist painting as well as the pixels of contemporary digital images, randomized flecks of primary colors are intended to dot the surface with a celebratory, confetti-like flair. When the objects are handled, the dizzying decoration causes a slight perceptual pause, keeping the work lively within each moment of engagement.

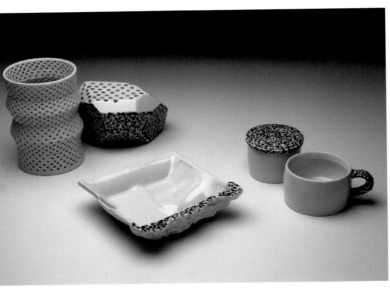

Technical Description

Stafford's forms are both press-molded and wheel-thrown porcelain fired in the electric kiln to cone 9. One molding technique he uses involves slicing a plaster mold and reassembling the parts slightly askew. Held in place by a support structure, the piece is press molded, resulting in a slightly different form each time. After dipping the bisqueware in a base glaze, Stafford applies one glaze color at a time with the trailer until the piece is enveloped by the accumulation of dots. The colored glazes are mixed slightly thicker to aid in the application through a small-nozzled trailing bottle.

Grouping *dimensions variable, colander: 9 in. (23 cm) tall, thrown and press-molded porcelain, slip-trailed colored glazes. Fired in oxidation to cone 9. SEE GLAZE DETAILS, BELOW.*

GLAZE DETAILS

SATIN MATTE GLAZE, *cone 9*	
Nepheline syenite	47
Dolomite	10
Whiting	8
Talc	7
Flint	28
+ Bentonite	2

Turquoise
+ 5% Vanadium Titanium Blue stain (Mason 6391 ZrVSi)

Gray
+ 1% Best Black stain (Mason 6600 CrFeCoNi)

GLOSSY GLAZE, *cone 9*	
Custer feldspar	28
Whiting	23
Zinc oxide	3
Grolleg kaolin	19
Flint	27

Red
+ 10% Dark Red stain (Mason 6021 ZrSeCdSi)

Yellow
+ 5% Vanadium Yellow stain (Mason 6404 AlSnV)

> ❝ The resulting form is a fractured and jumbled version of the original. In further fracturing of the surface through glaze, I seek to confound the user a little, offering them an object that seemingly is ever changing, constantly in a state of slow flux. ❞

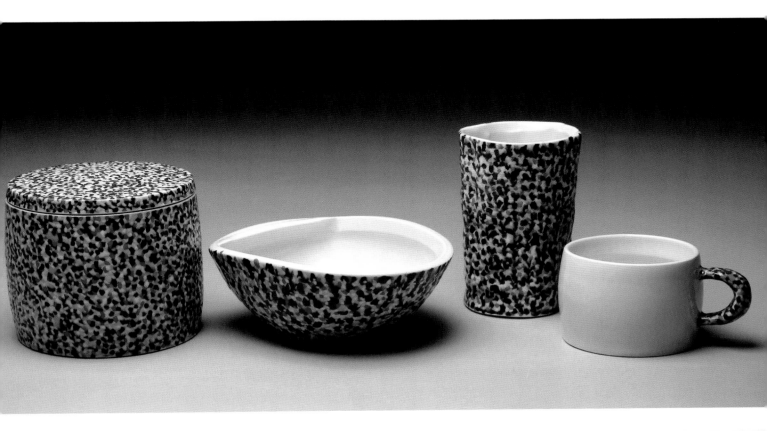

Lidded Jar, Bowl, Tumbler, Mug *dimensions variable, tumbler: 6 in. (15 cm) tall, thrown and press-molded porcelain, slip-trailed colored glazes, fired in oxidation to cone 9. Stafford's pleasing suggestion of an arrangement of pottery showcases how his confetti patterning affects various forms.* SEE GLAZE DETAILS, LEFT.

● *The white liner glaze leaves the interior forms clean and functional and provides a space for visual rest.*

● *Up close, the primary-colored dots are dynamic and brightly contrasting.*

● *Viewed from far away, the primaries visually blend to create a neutralized hue.*

Ursula Hargens

Decidedly decorative, with botanical motifs patterning each piece, Ursula Hargens' inviting, functional objects are an absolute pleasure to use. Her vessels and tiles are inspired by the relationship that humans negotiate with the natural world. The tension between real and imagined, destructive and regenerative, native and invasive, informs Hargens' expert ability to marry form and decoration. Employing a plethora of hues from muted greens, to sky blues, to bright reds, she is a master of synergizing colors to make a playful and pleasurable palette.

Pitcher and Tray
11 × 11 × 8 in. (28 × 28 × 20 cm), red earthenware with white slip, colored and clear Deb's Base and VC Transparent Satin glazes, fired to cone 04.
SEE GLAZE DETAILS, BELOW.

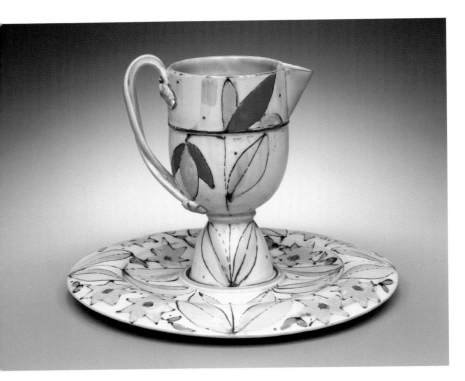

Technical Description

When leather-hard, Hargens' pieces are brushed with white slip of varying densities to reveal the red earthenware beneath. After bisque firing, glaze decoration starts with outlines of thick glaze trailed with a bulb syringe. Next, the outlined shapes are filled in with colored glazes, using the trailed lines as dams to keep the glaze in place. Cold wax is brushed over the colored glaze areas and a thin coat of clear glaze is dipped or poured over the piece. The thickness of each glaze mixture is very important to its successful application. Pieces are fired in an electric kiln with a slow temperature climb and a 15-minute hold at the end.

> I often use a commercial stain in combination with oxides to create new colors and differentiate them from the Mason stain palette.

GLAZE DETAILS

DEB'S BASE, *cone 05–04*
This recipe is from Deb Kuzyk
Frit 3195 — 45
Frit 3134 — 30
EPK — 25

Bright Red
+ 15% Lobster stain (Mason 6026 ZrSeCdSi)

Grass Green
+ 5% Naples Yellow stain (Mason 6405 FePrZrSi)
+ 1% Copper carbonate

Teal Blue
+ 3% Copper carbonate
+ 0.5% Cobalt carbonate

Orange
+ 8% Vanadium Yellow stain (Mason 6404 AlSnV)
+ 4% Tangerine stain (Mason 6027 ZrSeCdSi)

VC TRANSPARENT SATIN BASE, *cone 04*
Frit 3124 — 52
F-4 feldspar — 15
Gerstley borate — 17
Whiting — 3
EPK — 2
Flint — 11

Chartreuse
+ Chartreuse stain (Mason 6236 ZrVSnTi)

Bright Turquoise
+ 2% Copper carbonate

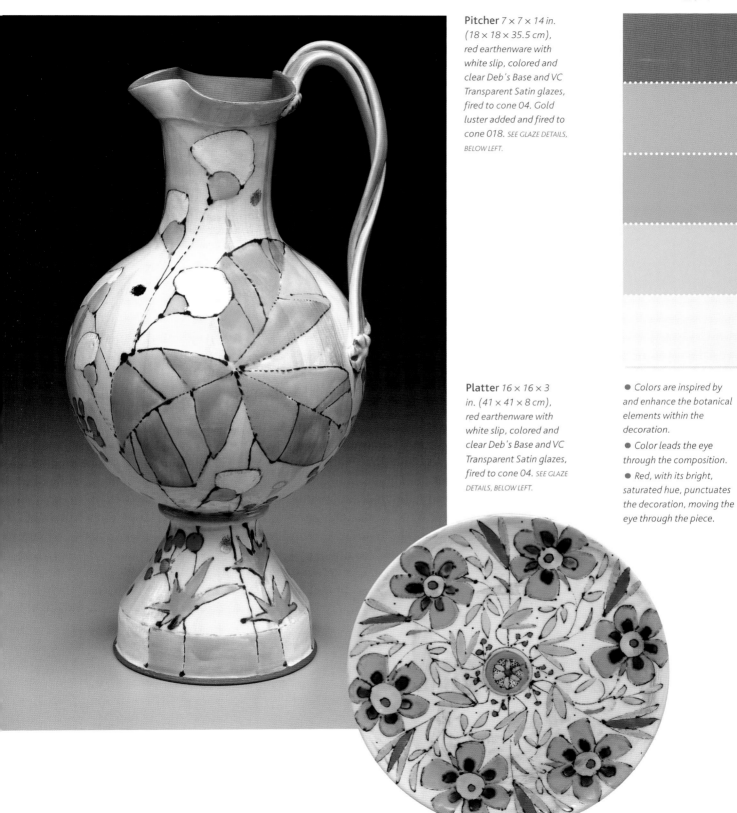

Pitcher *7 × 7 × 14 in. (18 × 18 × 35.5 cm), red earthenware with white slip, colored and clear Deb's Base and VC Transparent Satin glazes, fired to cone 04. Gold luster added and fired to cone 018.* SEE GLAZE DETAILS, BELOW LEFT.

Platter *16 × 16 × 3 in. (41 × 41 × 8 cm), red earthenware with white slip, colored and clear Deb's Base and VC Transparent Satin glazes, fired to cone 04.* SEE GLAZE DETAILS, BELOW LEFT.

● *Colors are inspired by and enhance the botanical elements within the decoration.*
● *Color leads the eye through the composition.*
● *Red, with its bright, saturated hue, punctuates the decoration, moving the eye through the piece.*

Marty Fielding

Mug *5 × 4¹/₂ × 3 in. (13 × 11 × 8 cm), thrown and altered mid-range clay, colored terra sigillata, colored commercial underglazes, Kelleher Gloss glaze, fired to cone 2–3.* SEE GLAZE AND TERRA SIGILLATA DETAILS, BELOW.

Marty Fielding combines styles of modernist architecture and abstract painting with intersecting volumes, like playful blocks, compiled to create robust architectonic forms. The rich surfaces become three-dimensional color fields, with the Cubist color patterns either highlighting or blending sections together, with opaque, saturated orange, and brushy, delicate gray and green. Fielding uses color to invoke a visceral reaction, as the power of color can strike a chord deep within us, producing an emotional effect that can harmonize with the activated pieces and continues to engage us.

Technical Description

Fielding's red clay pieces are created with both wheel-thrown and hand-built parts. At the bone-dry stage, sections are painted with colored and white terra sigillata in three layers, and at least eight hours are left between coats to allow pieces to dry. Once bisque fired, the piece is dry brushed with a thin black underglaze wash that is then partially sponged away, enhancing minor textures in the surface. A few sections are brushed with turquoise glaze and then waxed to repel the clear glaze. The teapot was sprayed with VC 5000 Satin Transparent glaze and fired to cone 04, and the mug was lined and dipped in Kelleher Gloss glaze and fired to cone 2, in an electric kiln.

GLAZE AND TERRA SIGILLATA DETAILS

VC 5000 SATIN TRANSPARENT, cone 04
This recipe is from Val Cushing

Frit 3124	77
F-4 feldspar	14
Whiting	7
EPK	2
+ Bentonite	2

+ Epsom salts to decrease settling (approximately 1 tbsp per 22 lb/10 kg).

TURQUOISE GLAZE, cone 03
This recipe is based on Ron Meyer's Transparent Glaze

Frit 3124	80
EPK	10
Flint	10
+ Bentonite	2
+ Copper carbonate	4

KELLEHER GLOSS, cone 3
This recipe is from Matt Kelleher

Frit 3134	27
Nepheline syenite	30
Strontium carbonate	10
Talc	2
EPK	13
Silica	18
+ Bentonite	1

WHITE TERRA SIGILLATA BASE
This recipe is from Pete Pinnell and Meredith Knapp Brickell
20 lb (9 l) water
10 lb (4.5 kg) XX Sagger ball clay
0.5% (22.7 g) sodium silicate

Note: To make red terra sigillata, use the same proportions as above, substituting Redart for ball clay.

COLOR ADDITIONS
To color the white terra sigillata base, experiment by adding between 1 tsp and 2 tbsp of oxide or Mason stain to 1 cup of base.

Yellow
+ 1tbsp Titanium dioxide
+ up to 2tbsp Titanium Yellow stain (Mason 6485 CrTiSb)

Pale Turquoise
+ 1 tsp Titanium dioxide
+ 1tbsp Turquoise stain (Mason 6364 SiZrV)

Orange
+ 1 tbsp Tangerine Inclusion stain (US Pigment 1352 ZrSiCdSe) added to mixture of ³/₄ cup of white sigillata and ¹/₄ cup red sigillata.

Pink
+ 2 tbsp Manganese Aluminum Pink stain (Mason 6020 MnAl)

Dark green
+ 1 tsp Dark Teal Green stain (Mason 6254 CrCoAlSiZn)

UNDERGLAZES
Apple Green (Mayco UG-68)
Pink Pink (Mayco UG-146)
Flame Red (Mayco UG-207)
Jet Black (Mayco UG-50)

Teapot *6¹/₂ × 10 × 4 in. (16.5 × 25 × 10 cm), slab-built red earthenware, colored terra sigillata, commercial black underglaze, and VC 5000 and turquoise glazes. Fired to cone 03. SEE GLAZE AND TERRA SIGILLATA DETAILS, LEFT.*

- *The streaky gray and green reveal the mark of the brush, enhancing surface texture.*

- *Some color combinations are chosen to harmonize, others to create tension through dissonance.*

- *The strong, saturated orange on the teapot draws attention to that part of the form.*

- *The red line on the teapot demarcates an area and leads the eye across the form.*

66 Showing the skin of the clay and preserving the revered leather-hard look in the finished piece has always been an interest for me. I predominantly use terra sigillatas on the surface because of the minimal layer they add to the skin. 99

Kari Radasch

In Kari Radasch's functional work, she combines playful and peculiar imagery with bright, candy-colored glazes in a wide range of hues, intended as a metaphor for joy. Radasch draws inspiration from her garden, her compost, mosaics, and contemporary textiles and ornamentation. The quick, animated nature of the decoration is grounded by the forms, which Radasch maneuvers and shapes with a sense of economy in her process and an expert familiarity with the materials. The red clay creates a "shadow" behind the white slip and colorful palette, which breaks along the edges, adding an earthy depth to her work.

Appliqué Cups and Saucers *5 × 5 × 5 in. (13 × 13 × 3 cm), terra-cotta, white slip, clear and colored glazes. Fired to cone 03, decals fired to cone 08.* SEE SLIP AND GLAZE DETAILS, BELOW.

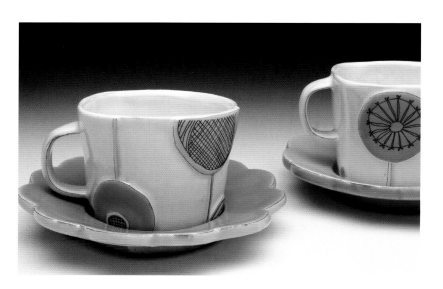

Technical Description

Radasch uses a terra-cotta clay and coats the pieces with white slip. Due to the high frit content of MereKari Clear, Radasch is sure to add both Veegum and CMC gum to keep it in suspension and make it more brushable. The bisque-fired pieces are sponged to remove dust and then spritzed with water right before glazing to lessen the absorption rate. Glazes are all brushed on with a "mop," or watercolor brush. First, Radasch applies clear glaze to the entire piece. Glaze is removed from the raised appliqué spots and colored glaze is then applied to them. Pieces are fired to cone 03 in oxidation with a 5–10-minute soak. After firing, Radasch applies laser decals printed at home onto the work and refires it to cone 08.

PETE PINNELL'S WHITE SLIP

OM#4 ball clay	40
Talc	40
Silica	10
Nepheline syenite	10
+ Zircopax	15

CLEAR TRANSPARENT GLAZE, cone 05

Amaco LG-10
For any place that appears "white" on Kari's work, this glaze is used on top of Pete Pinnell's White Slip.

MEREKARI CLEAR, *cone 03*

Originally Satin White Opaque by Val Cushing, modified by Meredith Knapp Brickell and Kari Radasch. This glaze is the base of all Kari's colored glazes.

Frit 3124	59
Frit P-626	14
Nepheline syenite	11
Silica	10
EPK	6
+ Veegum	1.6
+ CMC gum	0.6

COLOR ADDITIONS

Kari adds the following commercial stains to the clear base glaze for color:

Avocado (Mason 6280 ZrVCrFeCoZnAlSi)	4.5
Shell Pink (Mason 6000 CrSnCaSi)	8
Tangerine (Mason 6027 ZrSeCdSi)	5
Clover Pink (Mason 6023 ZrVCrSn)	6

Praseodymium Yellow (Mason 6433 PrZrSi)	6
Robin's Egg Blue (Mason 6376 ZrVSi)	4
Pea Green (Mason 6211 CrVSn)	5
Bright Green (Spectrum 2086)	5

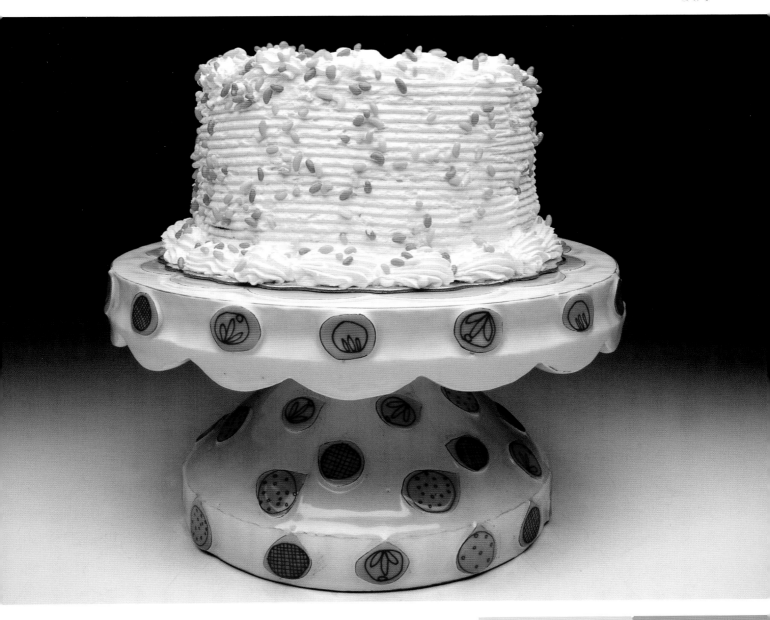

Appliqué Cake Stand *8 × 10 × 10 in. (20 × 25 × 25 cm), terra-cotta, white slip, clear and colored glazes. Fired to cone 03, decals fired to cone 08. SEE SLIP AND GLAZE DETAILS, LEFT.*

● *Bright, opaque, flat colors add to the playful nature of the work.*

● *Color combinations create a distinct feel on each piece, with orange and pink dots alternating across the cake stand. Our eyes can pleasurably bounce along.*

Glossary

Airbrush A device operated with an air compressor used for spraying glaze or other materials, either in overall coverage or decorative form.

Alkali Strong, basic oxides of sodium, potassium, and lithium used as primary fluxes in ceramics.

Alkaline earth Less active than primary fluxes, these refer to the secondary fluxes in ceramics, made of oxides of calcium, magnesium, strontium, barium, and zinc.

Atmosphere The environment in the kiln during firing (*see also* oxidation/reduction).

Atmospheric firing A type of firing in which a specific environment is created within the kiln to achieve various surfaces on the clay or glazes, usually through the use of volatile and combustible materials (*see also* wood firing, salt firing, soda firing, saggar firing).

Atmospheric glazing Using specifically designed glazes that contain volatile materials in order to heighten the surface effects in an atmospheric firing.

Back pressure Occurs in a kiln firing when the flow of air and fuel being pushed into the kiln is restricted from flowing out, creating more pressure within the chamber. This is most often achieved by pushing in the damper. By altering the path of the flame, back pressure can aid in evening out the temperature in the kiln and is often used to assist a reduction atmosphere.

Ball mill A mechanism consisting of a rotating container filled with flint or porcelain balls of various sizes, used to grind ceramic materials to their finest possible state; usually used to make terra sigillata.

Banding wheel A turntable operated by hand, used for decorating purposes.

Bisque firing (biscuit) The first low-temperature firing of ceramic ware, usually between cone 010 and cone 04, used to render the ware permanent and make it strong enough for glazing before the final firing.

Bisqueware (biscuitware) Ceramic ware that has been bisque fired, and has thereby undergone the irreversible chemical change altering it from "clay"

to "ceramic," making it durable yet still porous enough to glaze.

Blistering The forming of large bubbles, either closed or popped open, on the surface of a glaze.

Bloating Occurs when trapped gases form bubbles that push out from within the clay body.

Blunger High-speed mechanical mixer for slip or glazes.

Bone dry Greenware that has air dried completely but has yet to be fired (chemical water still intact).

Burnishing Compacting the surface of a clay, slip, or terra sigillata by rubbing it with a smooth, hard object such as a spoon, stone, or even the fingertips in order to polish it to an even surface with a slight sheen.

Calcine A form of purifying by heating oxides or compounds to drive out carbon gases or water and to reduce plasticity in powdered clays and then grinding them for use in other clay or glaze recipes.

Carbon coring Also known as black coring or carbon trapping. This phenomenon occurs when the introduction of a reduction atmosphere occurs too early in the firing and traps the carbon in the clay body, creating a gray or black area in the center of the clay piece that can discolor clay and glazes and potentially cause bloating.

Celadon First developed by the ancient Chinese, celadons are traditional high-fire green or blue reduction-fired glaze that is colored using iron oxide. They can be glossy or slightly opaque, and are normally used on porcelain.

Ceramic Any clay form that has undergone the permanent physical and chemical changes induced by being fired in a kiln.

China paints (*see* enamels).

Chun A traditional high-fire glaze developed by the ancient Chinese, characterized by its vivid blue or purple opalescent appearance.

Clay Chemically, a hydrated silicate of aluminum (Al_2O_3-$2SiO_2$-H_2O), which is the product of weathered rock. There are many different types, from primary china clays to secondary stoneware or earthenware clays. These different

types can be combined to form many different clay bodies that can be fired at a wide range of temperatures. Clay is a plastic, malleable material that "sets" upon drying and can be permanently changed by the heat in a kiln into a hard, waterproof material called ceramic.

Clay body A calculated and balanced blend of clay, minerals, and other non-plastic ingredients that makes up the material structure of the work. Different clay bodies can be developed to attain desired physical attributes that lend themselves to specific types of making, such as throwing or hand building.

Colloid Small, insoluble particles suspended in another substance, resulting in a mixture somewhere between a solution and suspension.

Colorants Also known as coloring oxides, a mixture of oxides and other materials or chemicals added to a glaze base to add color.

Cones (*see* pyrometric cones).

Cone pack A series of successive pyrometric cones set into a coil of clay for the purpose of monitoring the progression of heat work during a kiln firing.

Contraction A reversible physical shrinkage of clay or glaze during cooling, also called thermal contraction; can be expressed as a coefficient of expansion and contraction.

Copper red A traditional high-fire glaze colored with copper and developed by the ancient Chinese. When fired in oxidation the copper retains a turquoise color, while a reduction atmosphere will result in rich crimson or liver colors—thus the nickname *sang de boeuf* or oxblood glaze.

Crackle glaze A glaze that has intentional, desired hairline cracks or crazing; colorants or inks may be rubbed into the cracks to heighten the effect.

Crawling A condition in which the glaze pulls away from itself on the clay body, forming beads and leaving areas of bare clay.

Crazing A series of fine cracks in the glaze surface, caused by a glaze that has shrunken more than the clay body.

Cristobalite A crystalline form of silica with a high expansion and

contraction rate. The rapid heating or cooling of cristobalite, along with the spontaneous formation of it in some clays at high temperatures, can wreak havoc on work, and is thus something to consider when calculating clay bodies and kiln firings.

Crystalline structure Also known simply as crystal, this refers to the microscopic arrangement of the molecules that make up a substance.

Decals Pictures or text printed onto special transfer paper that are used for decoration by applying to an already glazed and fired ceramic piece, then refired to a very low temperature.

Deflocculation The suspension of a slip or glaze by the addition of a defloculant (a soluble alkali), causing the glaze particles to repel each other, thereby increasing fluidity and decreasing thixotropy without the addition of any additional water.

Density The weight of a material in comparison to water, also known as specific gravity.

Dipping Applying a glaze by immersion.

Draw tile A test tile taken from the kiln at specific points during firing or cooling in order to observe its condition and determine clay or glaze maturity or atmospheric conditions.

Dunting The creation of a clean-edged crack that runs through the glaze and the clay body, sometimes fracturing the piece.

Egyptian paste A highly alkaline body with low plasticity and alumina content. The soluble salts come to the surface in drying, leaving crystals that flux in firing to create a glazed surface, which is why Egyptian paste is considered the first "glaze." Coloring oxides can also be added to the body.

Enamels Low-temperature colors containing fluxes, usually applied on top of a fired glaze and refired to render them permanent. Also known as on-glaze or china paints.

Engobe A white or colored slip usually containing an amount of flux in order to allow it to be applied to bisqueware (as opposed to greenware) before glazing and firing.

Eutectic The chemistry of mixing two or more materials, usually in a glaze, in specific proportions in order to achieve the efficiency of the lowest possible melting point.

Expansion A reversible physical swelling of clay or glaze during heating, also called thermal expansion; can be expressed as a coefficient of expansion and contraction.

Extruder A tool, either hand operated or pneumatic, used to expel long, uniform, and compressed tubes of clay in various shapes; often used to make test tiles.

Firing The process by which ceramic ware is heated in a kiln to bring clay or glaze to maturity.

Flashing An effect on the surface of a clay or glaze caused by the flame passing directly over it, usually during an atmospheric firing (also called fire color). Certain glazes and slips can be made to accentuate this phenomenon.

Flocculation The aggregation of suspended particles by the addition of a flocculant (an acidic thickening agent), causing the glaze particles to attract, decreasing fluidity and increasing thixotropy in order to give proper consistency for dipping, casting, etc.

Flux An ingredient in a clay or glaze that causes it to melt readily, helping silica to form glaze or glass when fired.

Food-safe Clay or glaze that has been tested and determined to be safe for use with food or drink.

Frit Precise mixtures of ingredients that have been fused into a glass and finely ground and are used in a glaze to supply an insoluble source of oxides, give a more stable substance, and to render harmless any dangerous material, such as lead.

Glass former A clay or glaze material that, in combination with fluxes, melts and creates the glass essential to fired ceramics when heated in the kiln. The primary glass former is always silica.

Glaze A thin glass layer that fuses to the surface of a ceramic piece during firing.

Glaze base A glaze recipe before the addition of any colorants, opacifiers, or suspenders; one base recipe may render many finished recipes depending upon the additional ingredients added.

Glaze fault or flaw Any undesirable feature in a glaze, such as crawling or pinholing, which could be the result of a number of things, such as poor glaze fit or a poor firing cycle.

Glaze fit How well a fired glaze adheres to the clay body.

Glaze formula The recipe for a glaze, including a glass former, stabilizer, and flux as the glaze base, as well as any added materials such as colorants, opacifiers, or suspenders.

Glaze testing The act of, with the use of test tiles and test firings, checking the quality, performance, reliability, or any number of attributes of a glaze before putting it into widespread use. For example, testing colorants to find the perfect color before mixing a large batch of the glaze.

Greenware Any unfired clay ware, from wet to bone dry.

Grog Ceramic material that has been heated to a high temperature and ground; used as an additive in clay bodies and some glazes to help with shrinking and shock.

Heat work The unit of measurement used to calculate energy input during firing, normally represented in terms of temperature and time through pyrometric cones.

Hue (color) One of the infinite gradations or varieties of a color.

Hydrometer A device used to measure the specific gravity of a liquid, such as a slip or glaze.

Incise The process of carving a design into a raw clay surface for decoration.

Kiln The device in which clay is fired; fueled with wood, oil, gas, or electricity.

Kiln furniture Refractory pieces used to separate and support kiln shelves and ware during firing.

Kiln stack The way in which a kiln is packed for firing.

Kiln wash A coating of refractory material applied to kiln furniture.

Leaching An invisible phenomenon whereby soluble materials in the glaze are transferred to whatever is in contact with them, namely food and drink.

Leather hard Clay that is stiff but still damp; it is ideal for handling, joining, carving, and surface decorating.

Lichen glaze A heavily textured glaze also referred to as a lizard skin or leopard coat glaze. High amounts of magnesium carbonate cause intentional and exaggerated crawling to create a reticulated surface.

Line blend A method for testing glazes where proportional amounts vary through a series of samples set between two limits in order to gauge the best proportions of two ingredients.

Lusters Commercially made combinations of salts and metals painted over a glazed surface and refired at very low temperatures to give a lustrous or iridescent metallic decorative sheen.

Macrocrystalline Large patches of visible crystals on a glaze surface; crystal development easily seen with the naked eye.

Majolica A type of surface decoration in which colorants are applied on top of a raw tin-glaze surface. Historically used on low-fire earthenware to try to mimic porcelain.

Matte A soft glaze surface with little or no shine.

Matting agent Ceramic compound used to create matte surfaces when added to glazes.

Maturing temperature The temperature at which a clay body develops the desirable hardness, or at which glaze ingredients fuse into the clay body (see also vitrification).

Melt test Used to determine the temperature at which a clay or glaze will melt or flux out, or how much it will melt or run at a specific temperature.

Melting point The point at which a clay or glaze fuses and turns to a molten glasslike substance during firing.

Microcrystalline Crystal effects dependent on tiny crystals in the glaze surface, sometimes unseen by the naked eye.

Mishima Also known as inlay, Mishima is a decoration technique in which slip is painted over a carved clay surface, allowed to dry, and then scraped off with a rib, leaving the colored slip inlaid into the carving decoration.

Once firing Firing ceramics to temperature without a bisque firing, usually with a raw glaze or pigment applied at the leather-hard or bone-dry stage; also known as single firing.

On-glaze colors (see enamels).

Opacifier An ingredient that causes a glaze to become opaque, such as tin oxide or titanium dioxide.

Opaque Glazes that do not allow other colors to show through, as opposed to transparent glazes.

Oribe Traditional Japanese glaze fired in oxidation and identifiable by its brilliant green hue, produced by the addition of copper in the glaze.

Outgassing Also called offgassing, this refers to the release of dissolved, trapped, or internal gases during firing.

Overfiring Usually unintentional, when a kiln is fired higher than the intended temperature, or for longer than necessary, which can result in overfired clay, glaze faults, or melted ware.

Overglaze A material applied to a fired, glazed surface and then refired to be made permanent, including china paints and lusters.

Oxidation Firing ware in a kiln with sufficient supplies of oxygen.

Oxide A molecule made up of a combination of oxygen and another element. Oxides make up many ceramic materials, especially where glazes are concerned.

Oxygen probe A mechanism placed in the kiln during firing to indicate the amount of oxygen present, and therefore the atmospheric conditions within the chamber.

Peeling A glaze defect in which the glaze or engobe separates from the clay body in flakes.

Pinholing/pitting The forming of small pock marks that reach through the glaze to the surface of the clay, called pinholes or pits.

Pit firing Also referred to as sawdust firing. Pots are placed in a pit, which is covered with wood and fired.

Pyrometer An instrument used to measure the temperature inside a kiln chamber.

Pyrometric cones Small pyramids of ceramic material that are designed to melt when a particular ratio of temperature and time is reached during the firing in order to display heat work.

Quartz inversion The reversible crystalline and structural change of room temperature alpha quartz to beta quartz at 1,063°F (573°C), which is accompanied by expansion and contraction and can cause cracking if undergone too rapidly.

Raku A firing technique in which ware is fired to temperature and removed while red hot in order to be submersed in combustible material such as sawdust, hay, or newspaper, resulting in brilliant and metallic surfaces created by the extreme reduction atmosphere.

Raw glazing Glazing greenware in order to single fire it.

Reduction The process of reducing the amount of oxygen in the kiln during firing in order to enable a chemical change in the oxides within the clay and glazes and therefore affect their colors and surfaces.

Reduction cooling The process of cooling the kiln in a controlled, reduction atmosphere in order to achieve specific glaze effects.

Refractory Ceramic materials that are resistant to high temperatures.

Resist A decorative medium, such as wax, latex, or paper, used to prevent slip or glaze from sticking to the surface of bisqueware.

Rivulet A glaze characteristic in which drips or "streams" appear on the surface of the ware.

Saggar A box made from refractory material used to either protect ware from direct contact with flame or ash, or to create a local atmosphere inside the box for the ware.

Salt firing Introducing salt (usually in the form of sodium chloride [NaCl]) during a firing after it has reached temperature in order for it to volatilize in the atmosphere and create distinctive surface effects on either raw or glazed ware (this process creates HCl).

Saturation The point at which no more dry material will dissolve in a glaze.

Saturation (color) A property that defines how vivid or pure a color is, ranging from pure color (100%) to pure gray (0%).

Scumming Unwanted deposits of soluble salts on the surface of greenware or bisqueware, which can sometimes create a resistance to glaze adherence.

Seger, Hermann A. (1839-94) German chemist who developed the Unity Molecular Formula (UMF) and pyrometric cones.

Semi-matte A glaze surface that has a slight sheen to it, also known as a satin or waxy glaze.

Semi-opaque Colored glaze that generally only allows dark colors to show through.

Semi-transparent Slightly colored glazes that allow most colors to show through with only slight distortions.

Sgraffito The cutting or scratching through an outer coating of slip, glaze, or engobe to expose the different colored body or surface beneath.

Shino Traditional Japanese glazes with high feldspar contents and some type of iron content. Shinos tend to be glossy or semi-glossy, and create desirable crawling, crazing, and pinholing effects. Carbon trapping and other dark marks from the iron content are also common.

Shivering The opposite of crazing, this occurs when the glaze shrinks less than the clay body and consequently flakes off the surface like old paint.

Shrinkage Reduction in the size of a clay body or glaze as it undergoes drying, firing, or cooling.

Sieving To remove impurities or large particles by putting a clay, slip, or glaze through a metal sieve or screen; various mesh sizes are available.

Silica The primary glass former in glazes and clay, synonymous with flint, quartz, and silicon dioxide.

Silk screen Nylon mesh screen used for printing an image onto a flat ceramic surface or onto transfer paper.

Single firing (see once firing).

Sinter When the fluxes in a body cause the clay or glaze to melt enough to be considered a fused composition, though it may not be wholly vitrified.

Slake Immersing dry ceramic materials or chunks of dry clay in water in order to break them down quickly and easily. The result is a pile of fine material that can be made into a slurry.

Slip Liquid clay.

Slip trailing A surface decoration technique in which colored slips are squeezed through a nozzle.

Slumping When ware is deformed in the kiln due to overfiring or structural defects, either intentionally or unintentionally, also called warping.

Slurry/slop Any mixture of a pulverized solid with a liquid. In ceramics, usually clay particles or dry materials mixed with water.

Soak Holding the kiln at a specific temperature during the firing to maintain the level of heat in the kiln in order to accomplish or enhance various glaze finishes.

Soda firing Similar to salt firing, the firing process of introducing soda (usually in the form of sodium carbonate [Na_2CO_3]) during a firing after it has reached temperature in order for it to volatilize in the atmosphere and create distinctive surface effects on either raw or glazed ware (this process creates CO_2 and lye) .

Soluble/Solubility A material that is able to be dissolved in water./The measure of how soluble a particle material is.

Specific gravity The comparison of the densities (weights) of a specific liquid or substance and water.

Stabilizer (see refractory) A glaze material that is included for its refractory properties in order to create a glaze that does not run or melt off the ware when fired.

Stains Commercial pigment added to a glaze, usually resulting in vibrant colors made from various oxides.

Stilts Small shapes of refractory material, often with metal or wire spurs, used to support glazed ware during firing.

Striking A firing process in which a kiln is turned on again and put into reduction for a period of time after it has already reached its peak temperature and is cooling in order to achieve specific glaze effects. A glaze fired in this fashion is said to have been struck.

Temmoku A traditional Asian reduction glaze with a high iron content that fires to a glossy maroon, brown, or black and can form some different crystalline effects. Types of Temmokus include hare's fur and oil-spot glazes.

Terra sigillata A slip made of very fine particles used as a surface coating for burnishing or other decorative treatments. Latin for "earth seal."

Test tile A small piece of ceramic usually used alongside many others of the same type to fire trials of glazes and compare them to one another.

Thermal expansion The swelling that occurs in clay and glazes during firing.

Thermal shock Damage caused by the sudden expansion or contraction of a clay or glaze through rapid heating or cooling.

Thermocouple The temperature probe in a kiln that transmits information to the pyrometer.

Thixotropy The ability of clay suspensions to thicken up on standing (see also deflocculation and flocculation).

Transparent Clear base colors that are free from cloudiness and distortion.

Triaxial blend Method for testing three-way combinations of glaze materials or modifiers where amounts of each material vary proportionally between three set limits.

Underfiring Not firing ceramic ware hot enough or for long enough.

Underglaze A color that is usually applied to either greenware or bisqueware and in most cases is covered with a glaze.

Unity Molecular Formula (UMF) Also called the Seger Formula after the man who developed it, the UMF is a glaze formula that has been recalculated so that a particular group of oxides total 100 in order to compare the

Bibliography

proportions of other materials and make needed adjustments.

Value (color) The lightness or darkness of a color, light colors being referred to as tints (created by adding white) and dark colors being referred to as shades (created by adding black).

Viscosimeter An instrument used to measure the viscosity of a fluid, also called a viscometer.

Viscosity The property of resistance to flow in a fluid.

Vitrification point The combination of time and temperature at which clay particles fuse together.

Vitrified Ceramic ware or glazes that have reached maximum hardness and maturation (vitrification), and are thereby considered vitreous and non-porous.

Volatilize When a material becomes vaporous. Certain ceramic materials are more volatile than others and can be used to create various surface effects while firing.

Wash A mixture of a small amount of ceramic material with water. For example, a colorant mixed with water and applied to unfired ware by brush.

Witness cone A cone or cone pack placed strategically in the kiln chamber so as to be seen through a spyhole to gauge heat work during the firing.

Wood firing Firing ceramic ware in a kiln fueled by wood. Usually these are long, high-temperature firings (cone 10 or hotter) that yield many different surfaces due to specific glazes, the flame, ash, and other atmospheric conditions.

Bailey, Michael, *Glazes: Cone 6* (University of Pennsylvania Press, 2001)

Ball, Philip, *Bright Earth: Art and the Invention of Color* (University of Chicago Press, 2003)

Barnard, Rob, Natasha Daintry, and Claire Twomey, *Breaking the Mould: New Approaches to Ceramics* (Black Dog Publishing, 2007)

Beard, Peter, *Resist and Masking Techniques* (University of Pennsylvania Press, 1996)

Birks, Tony, *The Complete Potter's Companion: Revised Edition* (Bullfinch, 1998)

Birren, Faber, *Color: A Survey in Words and Pictures: From Ancient Mysticism to Modern Science* (University Books, 1963)

Blaszcyk, Regina Lee, *The Color Revolution* (The MIT Press, 2012)

Bloomfield, Linda, *Color in Glazes* (American Ceramic Society, 2011)

Britt, John, *The Complete Guide to High-Fire Glazes: Glazing and Firing at Cone 10* (Lark Crafts, 2011)

Burleson, Mark, *The Ceramic Glaze Handbook: Materials, Techniques, Formulas* (Lark Books, 2003)

Clayton, Pierce, *The Clay Lover's Guide to Making Molds: Designing, Making, Using* (Lark Books, 1998)

Connell, Jo, *The Potter's Guide to Ceramic Surfaces: How to Decorate Your Ceramic Pieces By Adding Color, Texture, and Pattern* (Krause Publications, 2005)

Constant, Christine and Steve Ogden, *The Potter's Palette: A Practical Guide to Creating Over 700 Illustrated Glaze and Slip Colors* (Chilton Book Company, 1996)

Cooper, Emmanuel, *The Potter's Book of Glaze Recipes* (University of Pennsylvania Press, 2004)

Currie, Ian, *Revealing Glazes: Using the Grid Method* (Bootstrap Press, 2000)

Cushing, Val, *Cushing's Handbook: Third Edition* (Val Cushing, 1994)

Daly, Greg, *Developing Glazes* (American Ceramic Society, 2013)

Diduk, Barbara, *The Vase Project: Made in China — Landscape in Blue* (Lafayette, 2012)

Eiseman, Leatrice, *Pantone Guide to Communicating with Color* (HOW Books, 2002)

Finlay, Victoria, *Color: A Natural History of the Palette* (Random House, 2003)

Fraser, Harry, *Ceramic Faults and Their Remedies* (A&C Black, 2005)

Gage, John, *Color and Meaning: Art, Science, and Symbolism* (University of California Press, 2000)

Gage, John, *Color in Art (World of Art)* (Thames & Hudson, 2006)

Goethe, Johann Wolfgang von, *Theory of Colors* (Dover Publications, 2006)

Hamer, Frank and Janet, *The Potter's Dictionary of Materials and Techniques: Fifth Edition* (University of Pennsylvania Press, 2004)

Hesselberth, John and Ron Roy, *Mastering Cone 6 Glazes: Improving Durability, Fit, and Aesthetics* (Glaze Master Press, 2002)

Hooson, Duncan and Anthony Quinn, *The Workshop Guide to Ceramics* (Barron's Educational Series, 2012)

Hopper, Robin, *The Ceramic Spectrum: A Simplified Approach to Glaze and Color Development* (American Ceramic Society, 2008)

Hopper, Robin, *Making Marks: Discovering the Ceramic Surface* (American Ceramic Society, 2008)

Itten, Johannes, Faber Birren, and Ernst Van Hagen, *The Elements of Color: A Treatise on the Color System of Johannes Itten Based on His Book the Art of Color* (Van Nostrand Reinhold Company, 1970)

Lynn, Martha Drexler, *Clay Today: Contemporary Ceramicists and Their Work* (Chronicle Books, 1990)

Martin, Andrew, *The Essential Guide to Mold Making and Slip Casting* (Lark Crafts, 2007)

Mattison, Steve, *The Complete Potter* (Barron's Educational Series, 2003)

Nichols, Gail, *Soda, Clay, and Fire* (American Ceramic Society, 2006)

Nigrosh, Leon I., *Low Fire: Other Ways to Work in Clay* (Davis Publication, 1980)

Obstler, Mimi, *Out of the Earth Into the Fire: Second Edition: A Course in Ceramic Materials for the Studio Potter* (American Ceramic Society, 2001)

Peterson, Susan, *Smashing Glazes: 53 Artists Share Insights and Recipes* (Guild Publishing, 2001)

Quinn, Anthony, *Ceramic Design Course: Principles, Practice, and Techniques: A Complete Guide for Ceramicists* (Barron's Educational Series, 2007)

Reijnders, Anton and the European Ceramic Work Centre, *The Ceramic Process: A Manual and Source of Inspiration for Ceramic Art and Design* (University of Pennsylvania Press, 2005)

Stewart, Jude, *ROY G. BIV: An Exceedingly Surprising Book About Color* (Bloomsbury USA, 2013)

Trilling, James, *The Language of Ornament (World of Art)* (Thames & Hudson, 2001)

Troy, Jack, *Salt-Glazed Ceramics* (Watson-Guptill, 1977)

Turner, Anderson, *Glazes: Materials, Recipes, and Techniques: A Collection of Articles from Ceramics Monthly* (American Ceramic Society, 2003)

Wood, Nigel, *Chinese Glazes* (University of Pennsylvania Press, 1999)

Zamek, Jeff, *Safety in the Ceramics Studio: How to Handle Ceramic Materials Safely* (Krause Publications, 2002)

Zelanski, Paul and Mary Pat Fisher, *Color: Sixth Edition* (Pearson, 2009)

Orton Cone Chart

Cone	Self Supporting Cones Regular 27	108	270	Iron Free 27	108	270	Large Cones Regular 108	270	Iron Free 108	270	Small Regular 540
022		1087	1094				N/A	N/A			1166
021		1112	1143				N/A	N/A			1189
020		1159	1180				N/A	N/A			1231
019	1213	1252	1283				1249	1279			1333
018	1267	1319	1353				1314	1350			1386
017	1301	1360	1405				1357	1402			1443
016	1368	1422	1465				1416	1461			1517
015	1382	1456	1504				1450	1501			1549
014	1395	1485	1540				1485	1537			1598
013	1485	1539	1582				1539	1578			1616
012	1549	1582	1620				1576	1616			1652
011	1575	1607	1641				1603	1638			1679
010	1636	1657	1679	1600	1627	1639	1648	1675	1623	1636	1686
09	1665	1688	1706	1650	1686	1702	1683	1702	1683	1699	1751
08	1692	1728	1753	1695	1735	1755	1728	1749	1733	1751	1801
07	1764	1789	1809	1747	1780	1800	1783	1805	1778	1796	1846
06	1798	1828	1855	1776	1816	1828	1823	1852	1816	1825	1873
05.5	1839	1859	1877	1814	1854	1870	1854	1873	1852	1868	1909
05	1870	1888	1911	1855	1899	1915	1886	1915	1890	1911	1944
04	1915	1945	1971	1909	1942	1956	1940	1958	1940	1953	2008
03	1960	1987	2019	1951	1990	1999	1987	2014	1989	1996	2068
02	1972	2016	2052	1983	2021	2039	2014	2048	2016	2035	2098
01	1999	2046	2080	2014	2053	2073	2043	2079	2052	2070	2152
1	2028	2079	2109	2046	2082	2098	2077	2109	2079	2095	2163
2	2034	2088	2127				2088	2124			2174
3	2039	2106	2138	2066	2109	2124	2106	2134	2104	2120	2185
4	2086	2124	2161				2120	2158			2208
5	2118	2167	2205				2163	2201			2230
5.5	2133	2197	2237				2194	2233			N/A
6	2165	2232	2269				2228	2266			2291
7	2194	2262	2295				2259	2291			2307
8	2212	2280	2320				2277	2316			2372
9	2235	2300	2336				2295	2332			2403
10	2284	2345	2381				2340	2377			2426
11	2322	2361	2399				2359	2394			2437
12	2345	2383	2419				2379	2415			2471
13	2389	2428	2458				2410	2455			N/A
14	2464	2489	2523				2530	2491			N/A

Heating Rate °F/hour (last 180°F of firing)

Cone	Self Supporting Cones						Large Cones				Small
	Regular			Iron Free			Regular		Iron Free		Regular
	\multicolumn										
	15	60	150	15	60	150	60	150	60	150	300
022		586	590				N/A	N/A			630
021		600	617				N/A	N/A			643
020		626	638				N/A	N/A			666
019	656	678	695				676	693			723
018	686	715	734				712	732			752
017	705	738	768				736	761			784
016	742	772	796				769	794			825
015	750	791	818				788	816			843
014	757	807	838				807	836			870
013	807	837	861				837	859			880
012	843	861	882				858	880			900
011	857	875	894				873	892			915
010	891	903	915	871	886	893	898	913	884	891	919
09	907	920	930	899	919	928	917	928	917	926	955
08	922	942	956	924	946	957	942	954	945	955	983
07	962	976	987	953	971	982	973	985	970	980	1008
06	981	998	1013	969	991	998	995	1011	991	996	1023
05.5	1004	1015	1025	990	1012	1021	1012	1023	1011	1020	1043
05	1021	1031	1044	1013	1037	1046	1030	1046	1032	1044	1062
04	1046	1063	1077	1043	1061	1069	1060	1070	1060	1067	1098
03	1071	1086	1104	1066	1088	1093	1086	1101	1087	1091	1131
02	1078	1102	1122	1084	1105	1115	1101	1120	1102	1113	1148
01	1093	1119	1138	1101	1123	1134	1117	1137	1122	1132	1178
1	1109	1137	1154	1119	1139	1148	1136	1154	1137	1146	1184
2	1112	1142	1164				1142	1162			1190
3	1115	1152	1170	1130	1154	1162	1152	1168	1151	1160	1196
4	1141	1162	1183				1160	1181			1209
5	1159	1186	1207				1184	1205			1221
5.5	1167	1203	1225				1201	1223			N/A
6	1185	1222	1243				1220	1241			1255
7	1201	1239	1257				1237	1255			1264
8	1211	1249	1271				1247	1269			1300
9	1224	1260	1280				1257	1278			1317
10	1251	1285	1305				1282	1303			1330
11	1272	1294	1315				1293	1312			1336
12	1285	1306	1326				1304	1324			1355
13	1310	1331	1348				1321	1346			N/A
14	1351	1365	1384				1388	1366			N/A

Heating Rate °C/hour (last 100°C of firing)

Directory of Ceramic Materials

The table is a list of specific, name-brand items typically found in the ceramics lab. These materials are the ones that will most often be listed as ingredients in your recipes.

...

This list is quite extensive, but cannot possibly be exhaustive, as there are mines all over the world, and different materials will be used in different labs depending on their location. The ones listed here are "core" materials that can be found in many parts of the world. Each material is accompanied by a brief description (which may help if you want to find a substitute) as well as its safety rating.

	Material name	Description/Chemical composition/Role in glaze
A	A.P. Green	Fireclay (no longer available)
	Albany slip	High-iron, low-melting clay
	Alberta slip	High-iron, low-melting clay (often used as an Albany slip substitute)
	Alumina (Alumina hydrate)	Refractory
	Antimony trioxide	Glass former and opacifier
B	Barium carbonate	Flux
	Barnard slip substitute	High-iron clay (contains manganese)
	Bentonite clay	Clay/plasticizer, suspension agent for glazes
	Bismuth subnitrate	Pearl surfaces, very strong flux
	Bone ash	Flux in clay bodies, opacifier in glazes
	Borax	Flux
	Burnt umber	Colorant, often containing manganese and iron
C	C&C Foundry Hill Creme	Ball clay
	Calcium carbonate	Flux (see Whiting)
	Cedar Heights	Fireclay
	Chrome oxide	Colorant
	CMC gum	Glaze hardener, suspension agent
	Cobalt carbonate	Colorant
	Cobalt oxide	Colorant

	Copper carbonate	Colorant
	Copper oxide, black	Colorant
	Copper oxide, red	Colorant
	Cornwall stone	Feldspar
	Crocus Martis	High-iron colorant
	Cryolite	Flux
	Custer feldspar	Feldspar
D	Darvan (7, 811)	Deflocculant
	Dolomite	Flux
E	Edgar plastic kaolin (EPK)	Kaolin
F	F-4	Feldspar (no longer available)
	FHC	See C&C Foundry Hill Creme
	Fluorspar	Flux, opacifier
G	G-200	Feldspar
	Gerstley borate	Flux
	Glomax	Calcined kaolin
	Goldart clay	Stoneware clay
	Grog	Coarse additive for clay bodies
	Grolleg	White kaolin
	Gum arabic	Glaze binder (vehicle)
H	Hawthorn bond	Fireclay
	Helmer	Kaolin
I	Illmenite	Colorant, glaze additive
	Iron chromate	Colorant
	Iron oxide, black	Colorant
	Iron oxide, red	Colorant
	Iron oxide, yellow	Colorant
J	Jackson ball clay	Ball clay
K	Kaopaque	Kaolin (slip casting)
	Kyanite	Coarse additive for clay bodies
L	Laguna borate	Flux
	Lincoln	Fireclay
	Lithium carbonate	Flux
	Lizella clay	High-iron, low-melting clay
	Luminite	(Cement) Caustic
M	Magnesium carbonate	Flux
	Manganese carbonate	Colorant
	Manganese dioxide	Colorant
	Minspar 200	Feldspar
	Molochite (30, 200 mesh)	Clay additive

N	Narco H.G. fireclay	Fireclay
	NC-4	Feldspar
	Nepheline syenite	Feldspathoid
	Newman Red Sub	High-iron, high-temperature, melting fireclay
	Nickel carbonate	Colorant
	Nickel oxide, black	Colorant
	Nickel oxide, green	Colorant
O	101 Clay (aka Yellow Banks)	Stoneware clay
	OM#4	Ball clay
P	Pearl ash	Flux (see potassium carbonate)
	Peerless 1 clay	Kaolin
	Petalite	Feldspar
	Plaster (Pottery #1)	Used for making molds
	Plastic vitrox	Feldspar
	Potassium bichromate	Colorant
	Potassium carbonate	Flux (see pearl ash)
	Pyrax H.S.	Clay additive
R	Red lead	Flux, highly toxic
	Redart clay	High-iron, low-melting clay
	Rutile (light, dark, granular)	Colorant
S	Salt Lick stoneware clay	Stoneware
	Sand	Clay additive
	Silica	Quartz, glass former
	Silicon carbide	Glaze additive
	Soda ash	Flux
	Sodium bicarbonate	Flux
	Sodium chloride	Salt
	Sodium silicate	Deflocculant
	Spanish red iron oxide	Colorant
	Spinks blend	Ball clay
	Spodumene	Lithium feldspar
	Sterling kaolin	Clay
	Strontium carbonate	Flux
	Super standard porcelain	Kaolin
	Superpax Plus	Opacifier

T	Talc	Flux
	Tennessee #10	Ball clay
	Tile#6	Kaolin
	Tin oxide	Opacifier
	Titanium dioxide	Opacifier
U	Ultrox	Opacifier
V	Vanadium pentoxide	Colorant
	Veegum	Glaze binder, suspension agent
	Velvacast	Kaolin (slip casting)
W	Wollastonite	Flux, glass former
	Whiting	Flux
X	XX Sagger	Ball clay
Y	Yellow Banks (aka 101 Clay)	Stoneware
	Yellow ocher	Clay containing yellow iron oxide, colorant
Z	Zinc oxide	Flux
	Zirconium silicate	Opacifier
	Zircopax Plus	Opacifier
	Frits	
	3110, 3124, 3134, 3185, 3195, 3288, 3292, 3403, 3626, 5301 CC-257, F-280, GF-129, P-29-P	Flux
	Mason stains	Colorant
	6000, 6020, 6021, 6023, 6024, 6026, 6027, 6088, 6097, 6126, 6211, 6236, 6242, 6254, 6263, 6280, 6288, 6304, 6315, 6320, 6333, 6360, 6364, 6368, 6376, 6379, 6385, 6391, 6404, 6405, 6433, 6450, 6464, 6485, 6527, 6530, 6600, 6616, 6666, 6700	

Index

Credits

Quarto would like to thank the following people for kindly supplying images of their work for inclusion in this book.

Åberg, Barbro, www.barbroaberg.com, p.53b

Aono, Chiho, http://www.chiho-a.com, pp.101br, 288–289

Arbuckle, Linda, www.lindaarbuckle.com, pp.216–217

Arleo, Adrian, www.adrianarleo.com, pp.130–131

Arroyave-Portela, Nicholas, www.nicholasarroyaveportela.com, pp.268–269

Baas, Maarten, www.maartenbaas.com, Photo: Maarten van Houten, p.59b

Bare, Daniel L., www.danielbare.com, pp.71t, 81b, 192–193

Beiner, Susan, www.susanbeinerceramics.com, pp.196–197

Bohle, Thomas, www.thomasbohle.com, Photo: Frigesch Lampelmayer, pp.100tl, 228–229

Brazelton, Jennifer, www.JenniferBrazelton.com, Photo: Wilfred J. Jones, pp.108–109

Bridgemanart, pp.12t/b, 13, 44, 45t/b

Campana, Jeff, www.jeffcampana.com, Photo by Artist, pp.188–189

Cassell, Halima, www.halimacassell.com, Photo: Jonathan Keenan, p.55c

Catterall, Rebecca, www.rebeccacatterall.com, Photo: Prodoto, pp.150–151

Chappell, Rebecca, www.rebeccachappell.com, Photo: John Carlano, pp.64t, 234–235

Chung, Sam, www.samchungceramics.com, Photo by Artist, pp.101tl, 214–215

Cobb, Sunshine, www.sunshinecobb.com, pp.6bl, 226–227

Coloured Vases (series 3), design by Hella Jongerius/ Jongeriuslab, production by Royal Tichelaar Makkum, photos by Gerrit Schreurs, pp.42–43

Córdova, Cristina, www.cristinacordova.com, pp.54t, 148–149

Corrregan, Daphne, www.daphnecorregan.com, pp.61c, 101bl, 244–245

Courtesy of Munsell Color © 2014, X-Rite, Incorporated, p.47bl/c

Daintry, Natasha, www.natashadaintry.com, p.95t

Dam, Wouter, www.wouterdam.com, pp.59t, 184–185

Dawson, Robert, Aesthetic Sabotage, www.aestheticsabotage.com, Photo: Tino Tedaldi, p.57cr

De Groot, Meike, www.miekedegroot.nl, pp.53tr, 168–169

DeBuse, Chandra, www.chandradebuse.com, pp.208–209

DeRocchi, Alanna, www.alannaderocchi.com, p.99t

Digeros, Marc, www.marcdigeros.com, pp.262–263

Doherty, Jack, www.dohertyporcelain.com, Courtesy of the Leach Pottery, www.leachpottery.com, p.38

Dr. Gail Nichols, Braidwood NSW Australia. www.craftact.oro.aulportfolios/ceramics, pp.5br, 100br, 122–123

Eden, Michael, www.michael-eden.com, Courtesy of Adrian Sassoon, www.adriansassoon.com, pp.260–261

Eichelberger, David, www.eichelbergerclay.com, pp.146–147

Erdahl, Thaddeus, www.tjerdahl.blogspot.co.uk, pp.232–233

Eshelman, Paul, www.eshelmanpottery.com, Photos by Artist, pp.62t, 224–225

Field, Adam, www.adamfieldpottery.com, Photo by Artist, pp.138–139

Fielding, Marty, www.martyfielding.com, pp.298–299

Finneran, Bean, www.beanfinneran.com, pp.65t, 230–231

Forrest, Neil, www.neil-forrest.com, pp.240–241

Frew, Adam, www.adamfrew.com, pp.7bl, 172–173

Furimsky, Erin, www.erinfurimsky.com, pp.180–181

Gallaspy, Lauren, www.laurengallaspy.com, pp.258–259

Galloway, Julia, www.juliagalloway.com, Photo: Lilly Zuckerman, pp.170–171

Gazivoda, Jelena, www.jelenagazivoda.com, p.67tl

Goff, Shannon, www.shannongoff.com, Photo: PD Rearick, pp.238–239

Green, Jason, www.jasongreenceramics.com, Photo by Artist, pp.190–191

Gustin, Chris, www.gustinceramics.com, pp.128-129

Hanum, Sidsel, www.hanum.no, Photo: Dannevig Foto AS, pp.5bl, 56t, 166–167

Hargens, Ursula, www.ursulahargens.com, Photo: Peter Lee, pp.296–297

Harris, Rain, www.rainharris.com, pp.63t, 218–219

Hatch, Molly, www.mollyhatch.com, pp.236–237

Hedden, Claire, www.clairehedden.weebly.com, pp.200–201

Heinz, Regina, Ceramic Art Regina Heinz, London, www.ceramart.net, p.76b

Hessler, Robert, www.roberthessler.com, pp.100bl, 272–273

Hicks, David, www.dh-studio.com, Photo: by artist, pp.60t, 212–213

Hicks, Giselle, www.gisellehicks.com, pp.52tl, 178–179

Hill, Steven, www.stevenhillpottery.com, Photo by the Artist, p.96t

Hirai Collingwood, Akiko, www.akikohiraiceramics.com, pp.102–103

Ho, Sin-ying, www.sinyingho.com, pp.162–163

Holms, Miranda, www.mirandaholms.com, pp.11r, 69b, 94t/c

Hopkins, Bryan, www.hopkinspottery.com, pp.174–175

Host, Meredith, www.meredithhost.com, p.278–279

Howard, Ashley, www.ashleyhoward.co.uk, Photo by Artist, pp.198–199

Ipsen, Steen, www.steen-ipsen.dk, pp.106–107

Jae Won Lee, www.jaewonlee.net, p.52b

Jephcott, Remon, pp.6br, 246–247

Jespersen, Stine, www.stinejespersen.com, p.61b

Johnston, Randy J, www.mckeachieJohnstonStudios.com, Photo Credit: Peter Lee Photography, p.53c

Jones, Brian R., www.brianrjones.com, pp.2, 284–285

Katie Parker and Guy Michael Davis (FUTURE RETRIEVAL), www.futureretrieval.com, pp.264–265

Kelleher, Matt, www.mattkelleher.com, pp.2, 126–127

Kieffer, Kristen, www.kiefferceramics.com, pp.57t, 164–165

Kim, Taehoon, www.taehoonkim.com, pp.100tr, 204–205

Knapp Brickell, Meredith, www.mbrickell.com, pp.134–135

Kotula, Paul, www.paulkotula.com, pp.110–111

Kraft, Alex, www.alexkraftart.com, pp.292–293

Krull, Bethany, www.bethanykrull.com, pp.116–117

Kwong, Eva, www.evakwong.com, pp.252–253

Løbner Espersen, Morten, www.espersen.nu, pp.67tr, 89bl/r, 270–271

Loder, Claire, www.claireloder.co.uk, Photo: John Taylor, pp.3, 104–105

Long, Matt, www.fullvictory.com, Photos by Artist, p.63c

Lopez, Linda, www.lindalopez.net, Detail of *From one pile to another*, pp.61t, 202–203

The Authors

To learn more about the authors, visit their websites at
www.brianjtaylorceramics.com and **www.katedoody.com**.

Author Acknowledgments

We would like to thank Quarto for this incredible opportunity and specifically Lily de Gatacre, Kate Kirby, and Sarah Bell for their guidance, assistance, and faith in us.

We're especially grateful for the contributions and technical feedback we received from John Britt, Linda Bloomfield, and Sarah Barnes, who have generously shared their knowledge with us.

We'd like to thank all of the contributing artists for being an inspiration, for graciously sharing their incredible talents and knowledge. In particular, thanks to David East and Kristen Keiffer for joining us in the initial stages of this project. It is the artists within these pages that truly make this book noteworthy.

We would like to thank our brilliant teachers from Alfred University, Utah State University, and The School of the Art Institute of Chicago for sharing their wisdom, for challenging us, and for enabling our success. Thank you to Anat Shiftan for being a mentor and confidant; for sharing your knowledge, your beautiful work, and your critical eye; for supporting our efforts; and for believing in our potential.

Thanks to Kate's students in the course Color: Objects and Installations at Massachusetts College of Art for making the book even better by creating some of the beautiful test tiles displayed within.

We are very thankful for the important roles John and Andrea Gill have played in our lives for more than a decade. As mentors they have helped catapult our creative pursuits and like family, they have opened their home to us and in very special ways provided opportunities for our success.

We would like to thank Shelsea Dodd for the many long days, weeks, and months she spent steadfastly by our sides. Her talents and contributions to this project are only bested by the caring support she provided for our family, which is invaluable and very special to us. We love you!

We are immeasurably grateful for Kate's mom, Carole Doody, who endearingly gave her time and unconditional love to Lainey as we were busy working away. Mom, you are an inspiration! We would like to thank our entire family, who (whether near or far!) are so close to our hearts, for their unwavering belief in us, their pride in our accomplishments, and their endless enthusiasm and support.

We are very proud of this accomplishment, yet we are humbled to recognize how many people love and support us throughout our personal and professional lives. We feel very lucky and deeply thankful.